A HISTORY OF PAINTING IN ITALY

BY J. A. CROWE & G. B. CAVALCASELLE

VOL. II
GIOTTO AND THE GIOTTESQUES

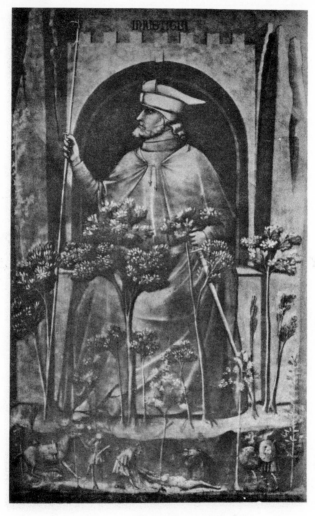

Injustitia.
By Giotto.
From a fresco in the Arena Chapel, Padua.

A HISTORY OF
PAINTING IN ITALY

UMBRIA FLORENCE AND SIENA
FROM THE SECOND TO THE SIX-
TEENTH CENTURY BY J. A. CROWE
& G. B. CAVALCASELLE
EDITED BY LANGTON DOUGLAS
ASSISTED BY S. ARTHUR STRONG

IN SIX VOLUMES ILLUSTRATED

VOL. II
GIOTTO AND THE GIOTTESQUES

NEW YORK
CHARLES SCRIBNER'S SONS
153–157 FIFTH AVENUE
1903

Reprinted 1972
Scholarly Press, Inc., 22929 Industrial Drive East
St. Clair Shores, Michigan 48080

Library of Congress Catalog Card No. 72-107171
ISBN 0-403-00431-4

CONTENTS OF VOLUME II.

CONTENTS

LIST OF ILLUSTRATIONS

VOL. II.

(Illustrations follow this list)

LIST OF ILLUSTRATIONS

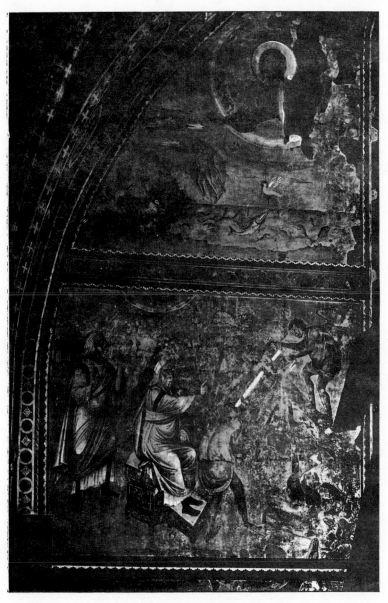

THE CREATION OF THE WORLD AND THE BUILDING OF THE ARK
SCHOOL OF CAVALLINI
From two frescoes in the Upper Church, Assisi

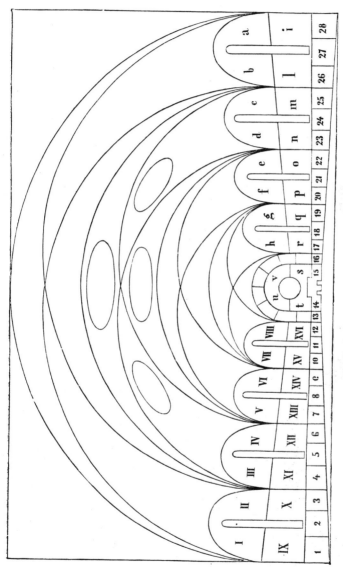

PLAN OF THE UPPER CHURCH, ASSISI

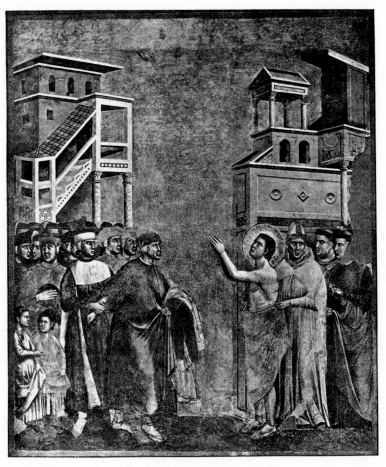

ST. FRANCIS RENOUNCES THE WORLD
By Giotto
From a fresco in the Upper Church, Assisi

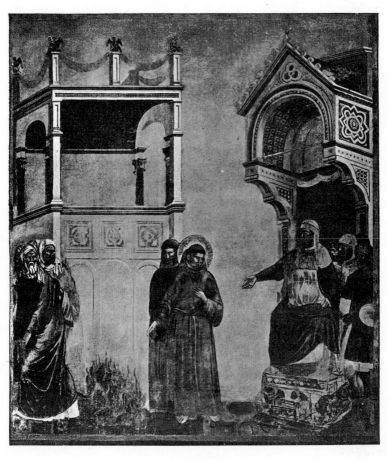

ST. FRANCIS BEFORE THE SULTAN
By Giotto
From a fresco in the Upper Church, Assisi

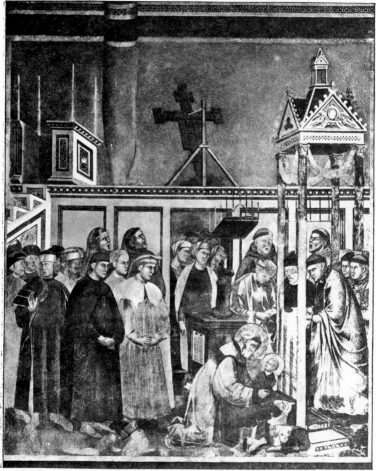

ST. FRANCIS INSTITUTING THE REPRESENTATION OF THE PRESEPIO AT GRECCIO
By Giotto
From a fresco in the Upper Church, Assisi

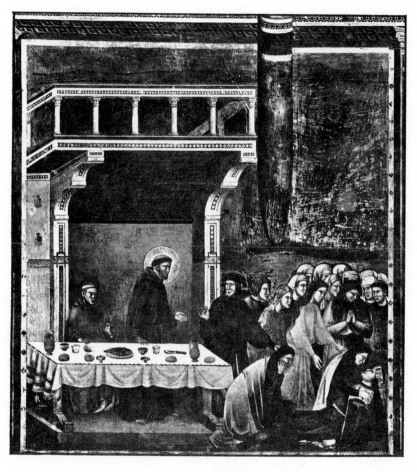

THE DEATH OF THE KNIGHT OF CELANO
By GIOTTO
From a fresco in the Upper Church, Assisi

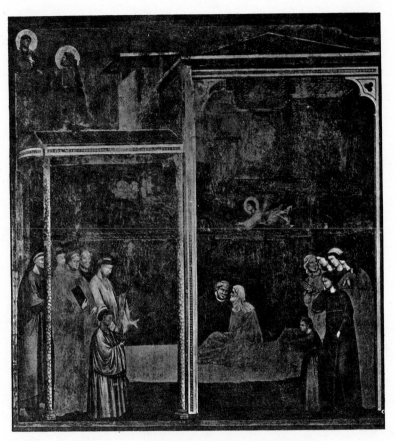

THE LAST CONFESSION OF THE WOMAN OF BENEVENTO
BY A FOLLOWER OF GIOTTO
From a fresco in the Upper Church, Assisi

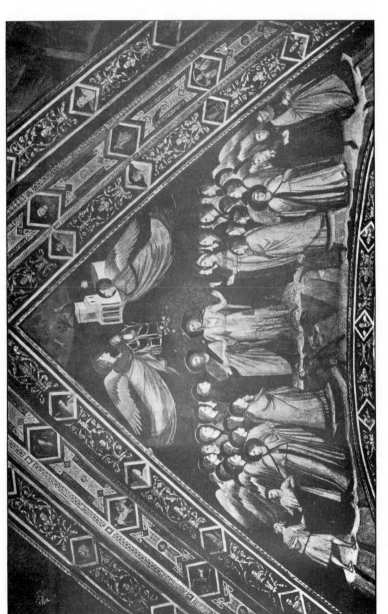

POVERTY
By Giotto
From a fresco in the Lower Church, Assisi

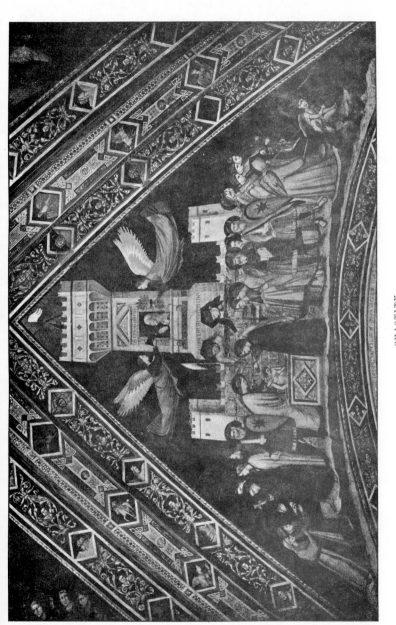

CHASTITY
By GIOTTO
From a fresco in the Lower Church, Assisi

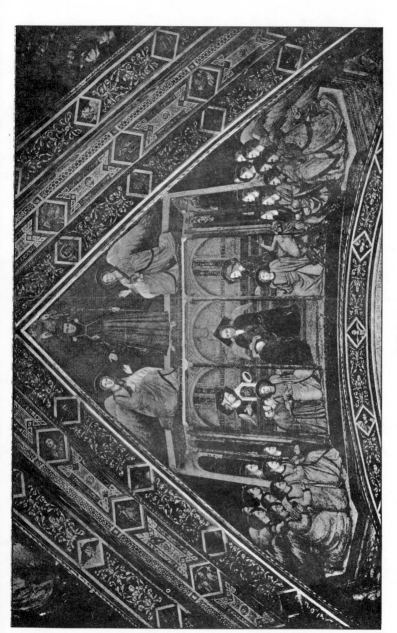

OBEDIENCE
By GIOTTO
From a fresco in the Lower Church, Assisi

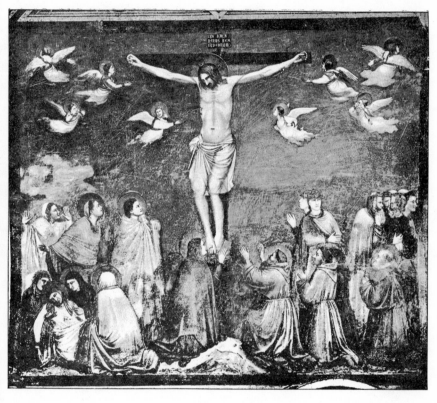

THE CRUCIFIXION
By Giotto
From a fresco in the Lower Church, Assisi

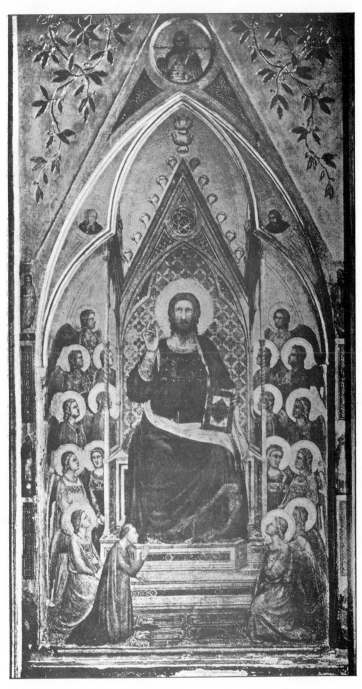

CHRIST ENTHRONED
By Giotto
From a portion of an altarpiece at S. Peter's, Rome

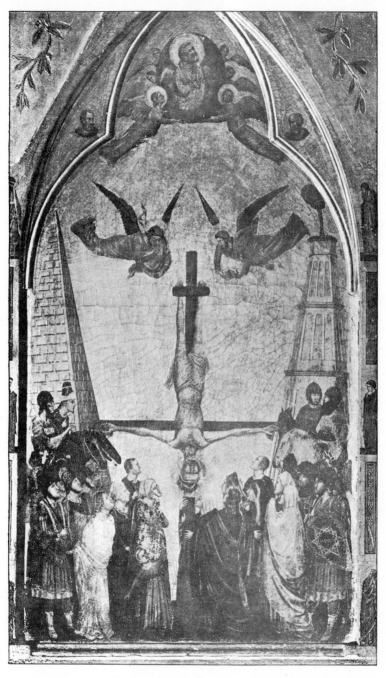

THE CRUCIFIXION OF ST. PETER
BY GIOTTO
From a portion of an altarpiece at St. Peter's, Rome

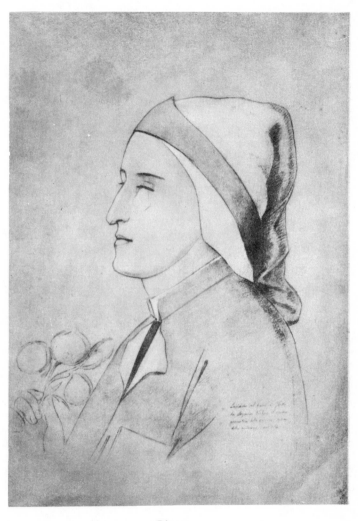

Dante.
By Giotto.
From the drawing by Seymour Kirkup of the unrestored head of Dante,
in the fresco in the Bargetto, Florence.

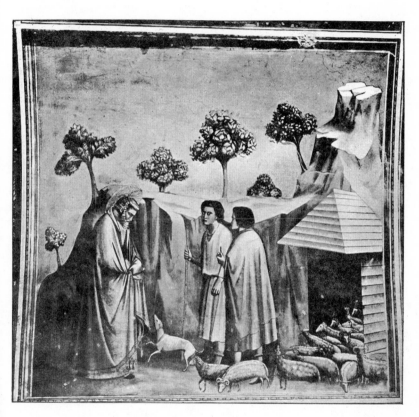

JOACHIM RETURNING TO THE SHEEPFOLDS
By GIOTTO
From a fresco in the Arena Chapel, Padua

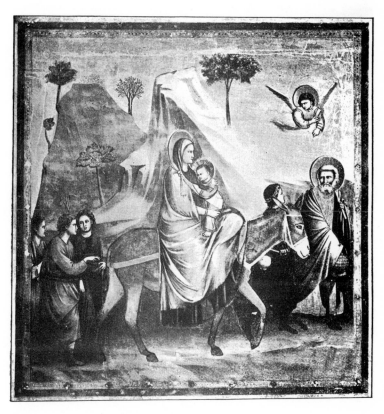

THE FLIGHT INTO EGYPT
By Giotto
From a fresco in the Arena Chapel, Padua

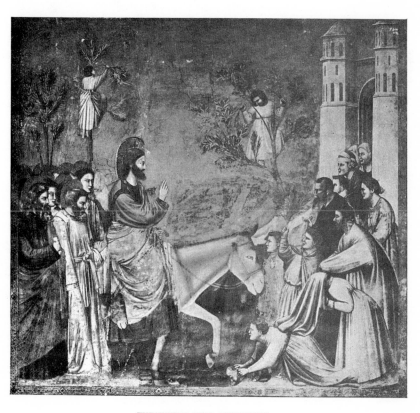

THE ENTRY INTO JERUSALEM
By GIOTTO
From a fresco in the Arena Chapel, Padua

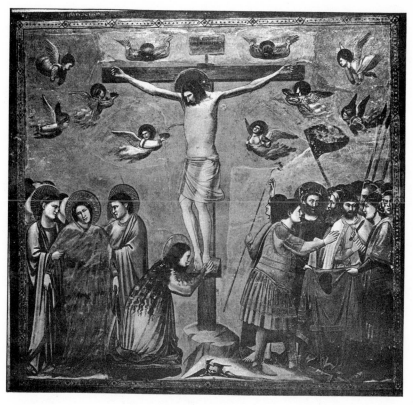

THE CRUCIFIXION
By GIOTTO
From a fresco in the Arena Chapel, Padua

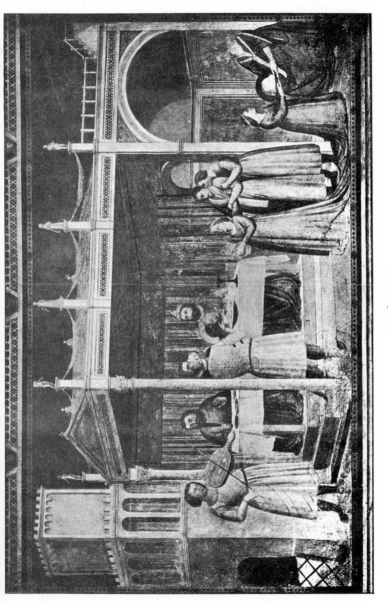

HEROD'S FEAST
By GIOTTO
From a fresco in the Church of S. Croce, Florence

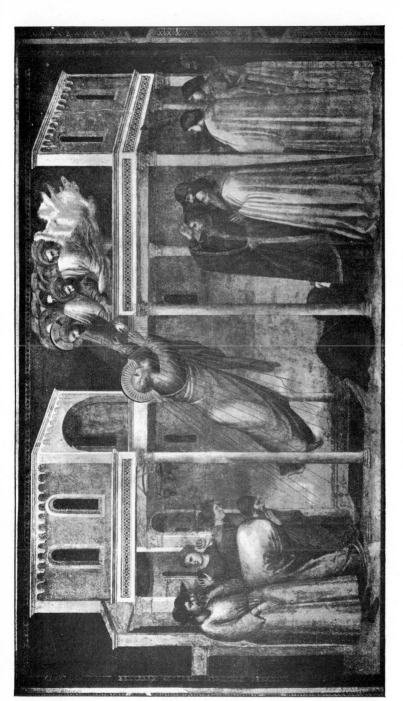

THE ASCENSION OF ST. JOHN THE EVANGELIST
By Giotto
From a fresco in the Church of Santa Croce, Florence

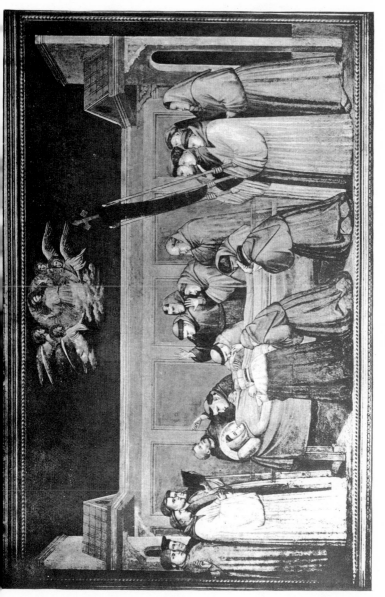

THE DEATH OF ST. FRANCIS
By Giotto
From a fresco in the Church of S. Croce, Florence

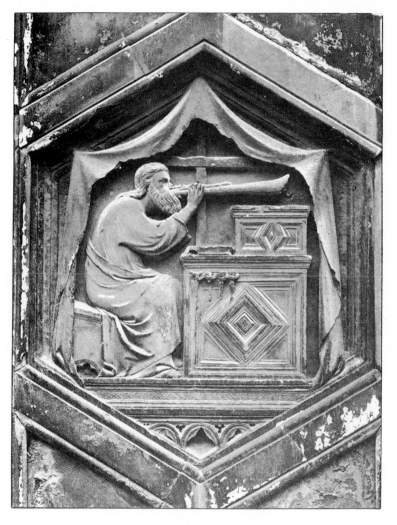

JUBAL
By Andrea Pisano
From a relief on the Campanile of Giotto

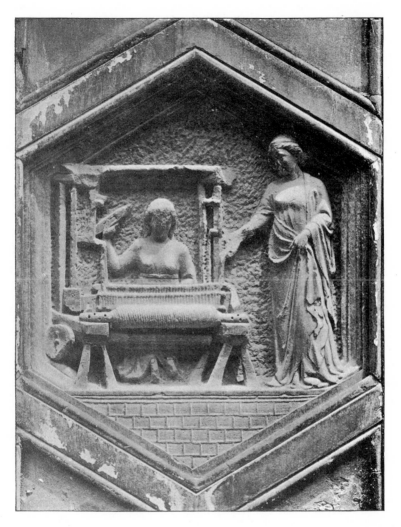

WEAVING

By Andrea Pisano

From a relief on the Campanile, Florence

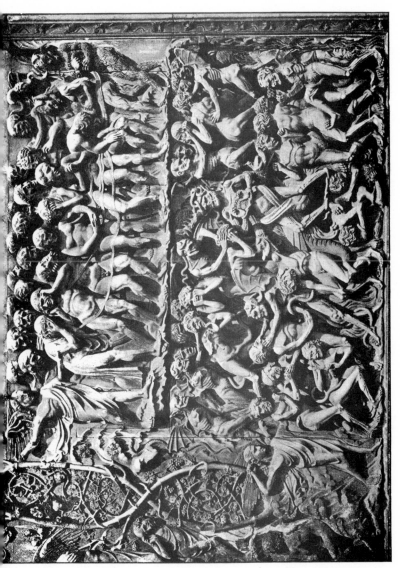

THE LAST JUDGMENT AND THE INFERNO
By Andrea Pisano
From a relief on the façade of the Cathedral, Orvieto

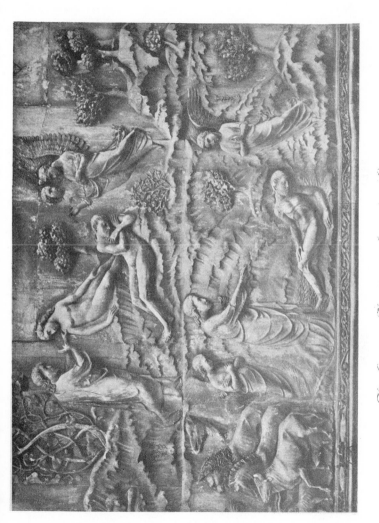

The Creation. Façade of Cathedral, Orvieto.
Sienese School.

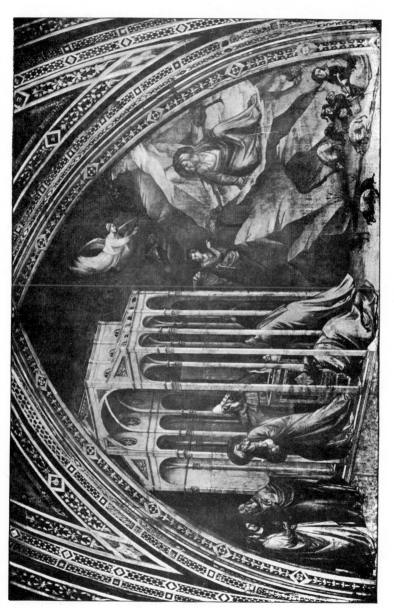

JOACHIM DRIVEN FROM THE TEMPLE
BY TADDEO GADDI

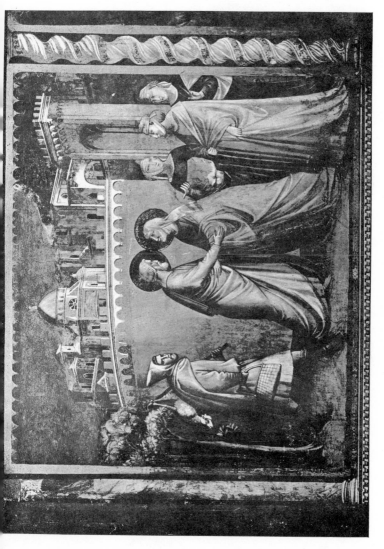

THE MEETING OF JOACHIM AND ANNA
By TADDEO GADDI
From a fresco in the Church of S. Croce, Florence

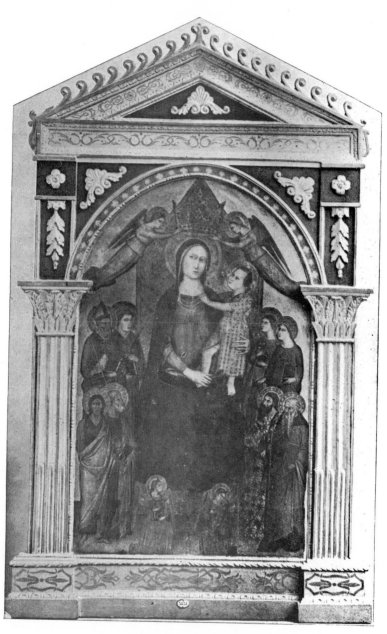

MADONNA AND SAINTS
School of Taddeo Gaddi
From a picture in the Musée Fol, Geneva

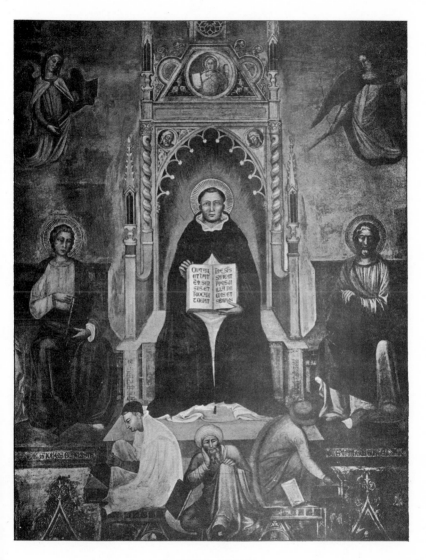

ST. THOMAS AQUINAS

A detail from a fresco in the Spanish Chapel, S. Maria Novella. Florence

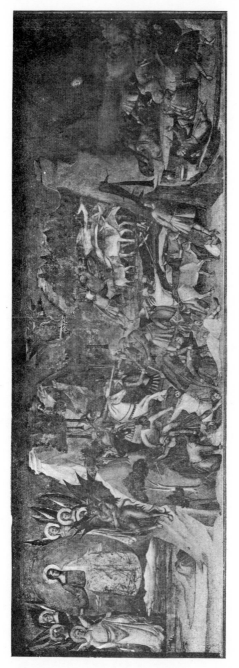

THE MISFORTUNES OF JOB
By FRANCESCO DA VOLTERRA
From a fresco in the Campo Santo, Pisa

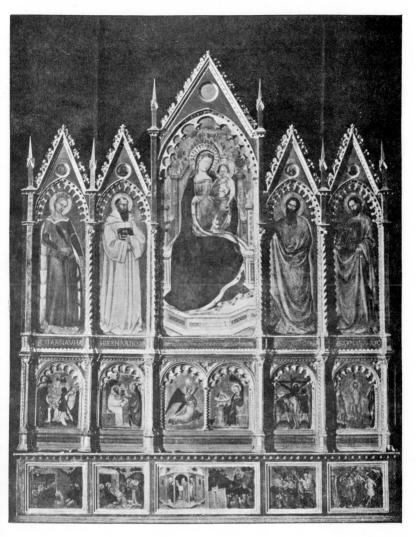

MADONNA AND SAINTS
By Giovanni da Milano
From an altarpiece in the Municipal Palace, Prato

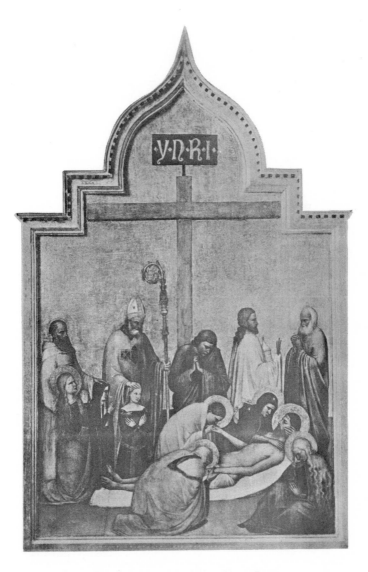

Deposition from the Cross, Uffizi.
Giottino.

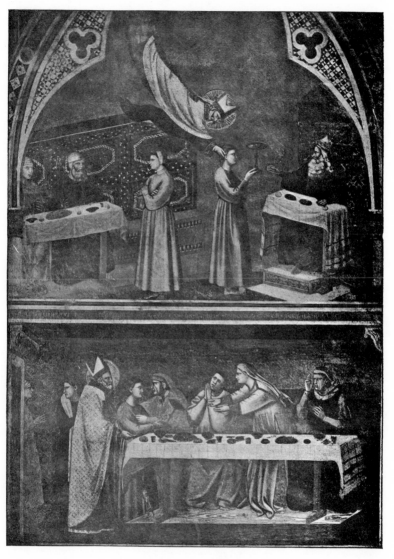

MIRACLES OF ST. NICHOLAS
BY GIOTTINO (?)
From a fresco in the Lower Church, Assisi

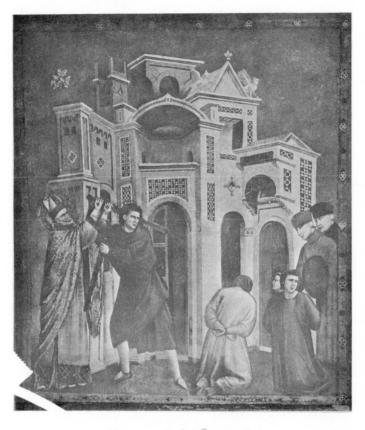

Miracle of S. Niccolo, Assisi.
Giottino.

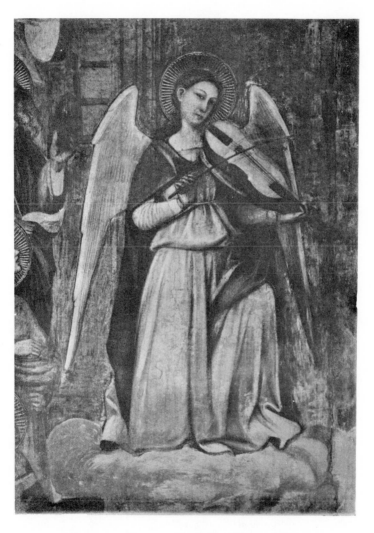

Angel in Church of S.M. Novella, Florence.
Andrea Orcagna.

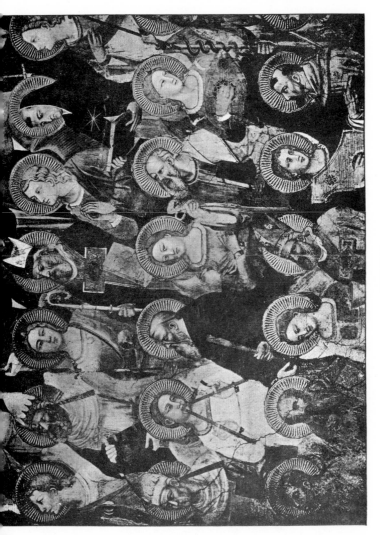

PARADISE
By Orcagna
A detail from a fresco in the Church of S. Maria Novella, Florence

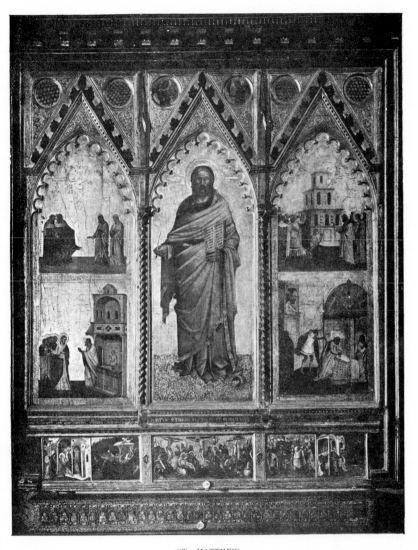

ST. MATTHEW
By Andrea and Jacopo Orcagna
From a picture in the Uffizi Gallery, Florence

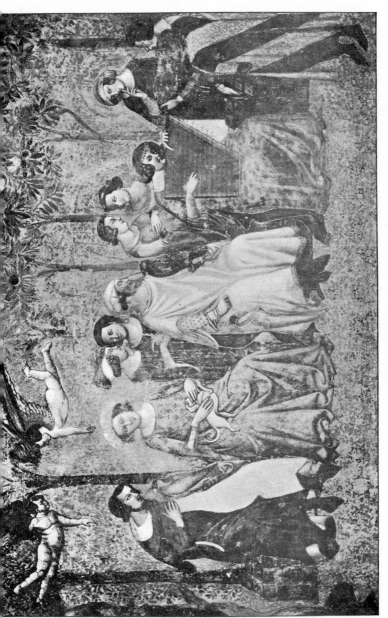

THE TRIUMPH OF DEATH
By Pietro Lorenzetti
A detail from a fresco in the Campo Santa, Pisa

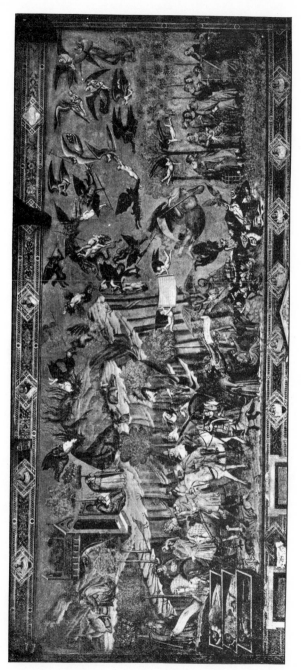

THE TRIUMPH OF DEATH
By PIETRO LORENZETTI
From a fresco in the Campo Santo, Pisa

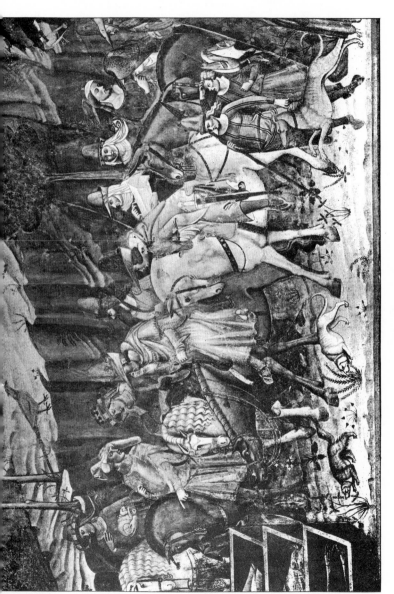

THE TRIUMPH OF DEATH

BY PIETRO LORENZETTI

A detail from a fresco in the Campo Santo, Pisa

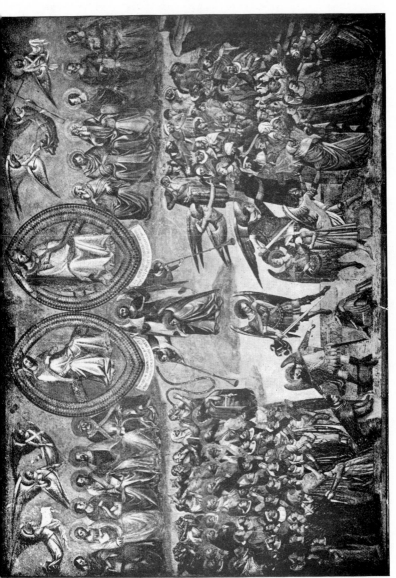

THE LAST JUDGMENT
By Pietro Lorenzetti
From a fresco in the Campo_Santo, Pisa

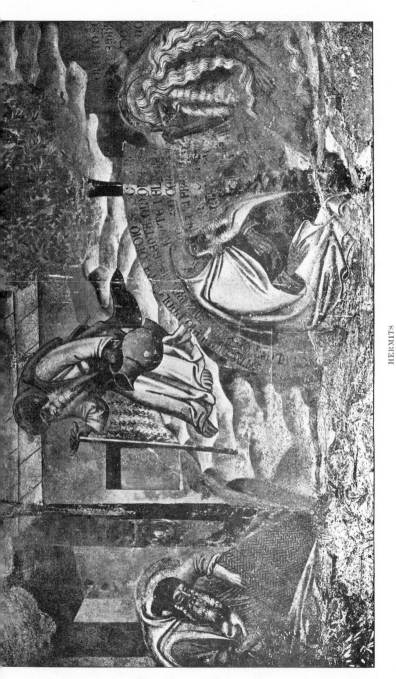

HERMITS

By Pietro Lorenzetti

A detail from a fresco in the Campo Santo, Pisa

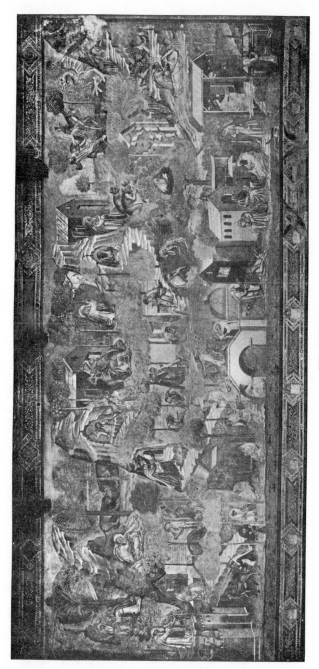

THE THEBAID

BY PIETRO LORENZETTI

From a fresco in the Campo Santo, Pisa

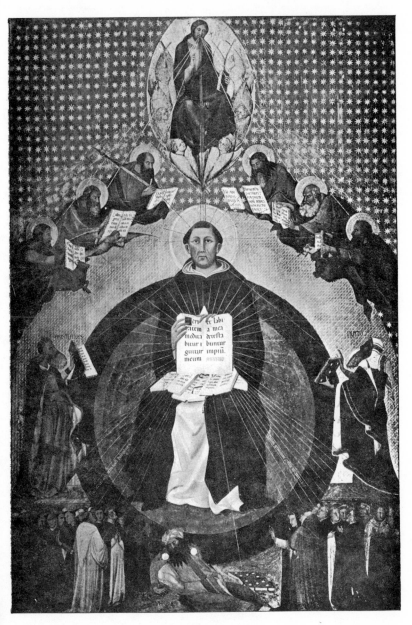

THE GLORIFICATION OF ST. DOMINIC
By Francesco Traini
From a picture in the Museo Civico, Pisa

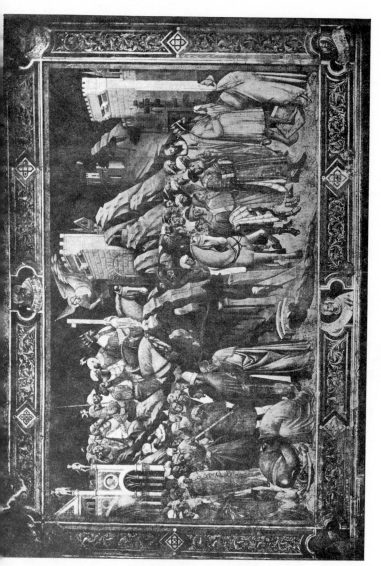

THE EMPEROR HERACLIUS BEARING THE CROSS
BY AGNOLO GADDI
From a fresco in the Church of S. Croce, Florence

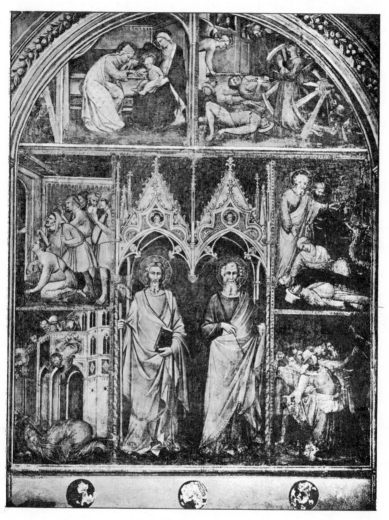

ST. JAMES AND ST. PHILIP
By Spinello Aretino
From a picture in S. Domenico, Arezzo

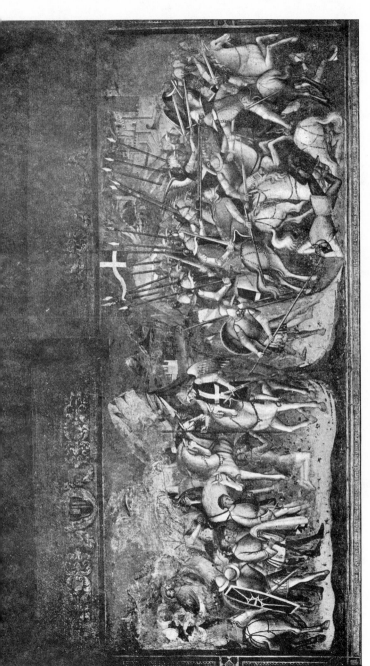

THE BATTLE OF ST. EPHESUS AGAINST THE PAGANS OF SARDINIA
By Spinello Aretino
From a fresco in the Campo Santo, Pisa

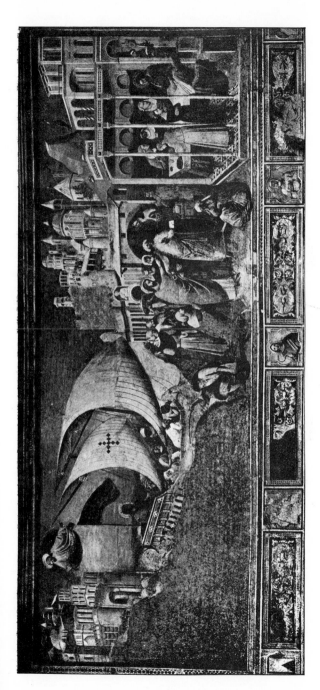

THE RETURN OF S. RANIERI
BY ANTONIO VENEZIANO
From a fresco in the Campo Santo, Pisa

THE FLAGELLATION
By Antonio Veneziano
From a dicture in S. Niccolò, Palermo

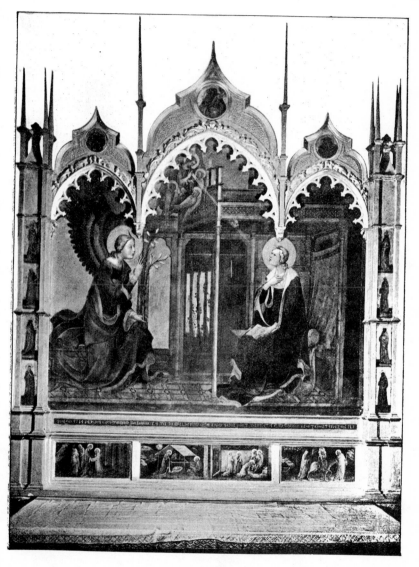

THE ANNUNCIATION
By Lorenzo Monaco
From an altarpiece in the Church of S. Trinita, Florence

CORRIGENDA AND ADDENDA.

Page 12, line 7. For "realisms" read "realism."

Page 91, note *4, 3 lines from the bottom of the page. For "sue" read "seu."
In the last line of the same page, for "x.u." read "xv."

Page 155, line 27. For "Catalinà" read "Catalina."

Page 179, line 6. After the word "London" place a comma instead of a full stop and add to the sentence the following words: "and is now in the collection of Sir Hubert Parry at Highnam Court, near Gloucester."

Page 179, note 3. The inscription now reads—

ANNO DÑI MCCCXLVIII BERNARDUS PINXIT ME QUEM FLORENTIE FINSIT.

At the end of the same note insert the words: "See an article by Mr. Roger Fry in the *Burlington Magazine*, July, 1903."

Page 258, line 11. For "wings" read "predella picture."

Page 258, note *2. Add the following sentence: "A fragment of this altarpiece is said to have been in the collection of the late Provost of Worcester College, Oxford."

Page 258, note 4. Add the following sentence: * "On the central panel, now in Mr. Quilter's collection, is the remainder of the inscription recording Spinello as the painter of the altarpiece."

NOTE.

The Editor's notes are marked with an asterisk.

GIOTTO AND THE
GIOTTESQUES

CHAPTER I

THE BASILICA OF ASSISI

ASSISI, the sanctuary of the oldest mendicant order, was celebrated in the earlier centuries by the martyrdom of Rufinus, and had already received some pictorial adornments at the time of the Lombard rule. Famed in the thirteenth century as the final resting-place of one whose life and miracles were audaciously compared with those of the Redeemer, it attracted the devotion of the peasants of Tuscany and Umbria, who humbly made pilgrimage to the shrine of St. Francis. The example of a wealthy youth, who had willingly surrendered his worldly substance to live a life of poverty and abstinence, was well calculated to strike the minds of a people superstitious indeed, yet still alive to the prevalent vices of both laity and clergy. But the power of an order which might boast that it had revived the spirit of religion, and supported the degenerate Church, was no slight cause of its further increase. Many a strong man esteemed it of equal advantage to his temporal and spiritual welfare to share the power and enjoy the blessings of the mendicants, and for that reason enrolled himself in the ranks of the lay brothers. Great was the enthusiasm, large were the contributions to the order; and San Francesco of Assisi arose, a monument of the zeal and the religious ardour of Umbria and Tuscany. One church was piled over another in honour of the saint, and in both pictorial art manifested his miracles in juxtaposition to the incidents of the life of the Saviour. Subjects, entrusted at

first to rude artists of St. Francis' own time, were repeated by the ruder hand of Giunta, who in his turn yielded precedence to Cimabue. A whole school of artists then formed itself in the sanctuary. Out of this emerged Giotto and his disciples,[1] who carried Florentine art to the ends of Italy, whilst in competition with them the school of Siena lent the talents of Simone and Lorenzetti. Assisi thus became equally famous in a religious and pictorial sense, and is now visited by the curious from all parts of Europe with little less frequency than, of old, by the pilgrims who came for the "pardon" of St. Francis.

In the Lower Church, of which the aisle had been painted in the early part of the thirteenth century, Cimabue probably adorned the right transept.[2] Surrounded by the works of Giotto, on the right hand of that part of the building, is one of an earlier date representing a colossal Virgin and Child between four angels.[3] Placed above the altar of the Conception, and much damaged by restoring, it reveals the manner of Cimabue. Its position among the frescoes of Giotto points to an earlier period of production, and allows us to suppose that Giotto was reverent of the work of his master[4] as Raphael afterwards was reverent of the work of Perugino, and that he spared it as a memento on that account. For the same reason we may also believe there still remains near the same spot a large figure of St. Francis, also by Cimabue.

In the Upper Church of Assisi, however, Cimabue was also

* [1] Giotto's true predecessors were the masters of the old Roman school, who also worked at Assisi. See *antea*, Vol. I., Chapters III. and VI.

[2] VASARI, ed. Sansoni, i., p. 252, assigns not only the aisle paintings, but those of the ceilings, to Cimabue.

* [3] It is by a different artist to the painter of the Rucellai Madonna.

* [4] There is no reason for the assumption that this picture was preserved because of Giotto's reverence for Cimabue. We believe this Madonna to be a Sienese work. There is no need to search for reasons for its preservation. How conservative the Franciscans were in regard to early paintings has been remarked in the course of the discussion of the early mutilated frescoes of the nave of the Lower Church. It is possible, too, that this Madonna had already become an object of devotion when Giotto painted here. Moreover, it was then a comparatively new work.

[5] The Virgin and Child above mentioned was till 1875 concealed in part by a framing and an altar, which covered the principal figures from the knees downward. By the removal of these *impedimenta* we can now see the Virgin's feet, the whole of the angels, and the steps of the Virgin's throne. Old retouchings and cleanings have altered much of the surface, and even some of the forms of Cimabue.

employed, but not alone. We cannot contemplate the series of
works which fills its transepts, choirs, aisles, and vaulted ceilings
without coming to the conviction that the history of early
Florentine art lies hidden under the ruins; that years elapsed
before the whole of the space was decorated, and that at least
two generations of artists succeeded each other in the sanctuary.
Nothing can be more interesting than to trace on those walls the
presence of Giunta, Cimabue, and a series of inferior men, who
exhibit at least a technical progress; and, finally, of Giotto,
whose style developed itself under the influence of the numerous
examples which might here instruct his mind, his eye, and his
already skilful hand. From the poor productions of Giunta in the
right to the superior ones in the left transept a step towards the
revival of form may be noticed. In the figure of the enthroned
Saviour, of which remains are visible in the latter, the character
of Cimabue may be traced. Its outlines indeed reveal the same
hand as the altarpiece of the Academy of Arts at Florence,
whilst, in comparison with the mosaic of the apsis in the Duomo
of Pisa, it displays a slighter and feebler character, due no doubt
to its greater age. The angels in the left transept likewise reveal
the somewhat angular and heavy style of Cimabue, and the con-
tinuation of the same manner appears with little alteration in
the central ceiling of the transept.

Here the space is divided by diagonals, the ornament of which
issues from vases, and is enlivened with quaint conceits, which
recall the late Roman style of Jacopo Torriti:—

The Evangelists, with their symbols, sit enthroned in stately chairs,
inspired to the task of composing the Gospels by angels flying down from
heaven to lay their hands upon their heads. Behind each Evangelist is
a view of a city—Judea, inscribed in the ground behind St. Matthew,
Achaia behind St. Luke, Italy behind St. Mark, indicating the painter's
intention to depict the capitals of those provinces.[1] Deprived by time
of their colour, these figures, of slight frame and weighty head, betray

[1] Dr. J. STRZYGOWSKI, in a pamphlet entitled *Cimabue and Rome* (8vo, Vienna,
1888), pp. 87-160, shows that there are some common features in the view of
houses inscribed "Italia" behind St. Mark and old figured maps of Rome. But
he ventures upon the strength of this fact to assert that Cimabue visited the city,
and he strengthens his case by quoting a notary's deed drawn at Rome on the 8th

in their outlines the hand of the painter of the left transept; whilst the angels, with their slender forms, exhibit some progress in the art of rendering motion, but where traces of colour remain the tones are raw and sharply contrasted. A different spirit marks the ceilings of the nave, two of which, adorned with figures, alternate with two more which merely represent a blue sky studded with golden stars. In that nearest the transept the diagonals form an ornament growing out of vases, at each side of which stands an angel bearing the host and the labarum. The green branchings of tracery with foliage on a red ground open out into ellipses filled with cupids, whilst blossoms give birth to horses. In the four spaces of the ceiling medallions are set, representing the Saviour in the act of benediction, St. John, the Virgin, and St. Francis. Compared with the Redeemer in the cathedral of Pisa, or in general with the works of Cimabue, the figure of Christ is more natural than before, especially in the forms of the features and eyes. The latter indeed are more an imitation of the reality than is usual in Cimabue, who, as before remarked, sought to produce expression by long closed lids and an elliptical iris.[1] The Virgin displays the same peculiarities with more regular proportion and better action than is to be found in the altarpiece of Santa Maria Novella, whilst in the drawing of the hands taper forms are given up for small and short ones. But whilst in these and the two remaining figures a certain progress in the study of nature may be noticed, the feeling of Cimabue has disappeared and made room for a more common art, little dissimilar from that which will be found in the works of Rusuti or Gaddo Gaddi.

Another and a different style is apparent in the ceiling nearest the portal, where, in the intervals of an ornament rising out of vases, supported by cupids, and enlivened with flowers and animals, the four doctors of the Church teach their lessons to the clerks of the Franciscan order.

Sitting in high chairs opposite to the monks who attend to their

of June, 1272, and signed by "Cimaboue pictore de Florencia." But there is no evidence to show that the Roman witness and the famous Cimabue are identical.

* But even if Dr. Strzygowski's explanation of the reference is correct, and the document does refer to Cimabue, the pre-eminence of the old Roman school is not affected by it. It is probable, then, that Cimabue, like Giotto, was artistically a scion of Rome.

*[1] These frescoes have, in fact, little in common with the tempera pictures attributed to Cimabue. They seem to be works of the Roman school. The long half-closed lids and the elliptical iris are to be found in pictures by other masters of the period.

words, they collect or whisper their thoughts.[1] In the centre of the ceiling the Saviour, winged, seems to give a heavenly sanction to the spiritual teaching of the doctors.

Here, again, regularity and proportion beyond the acquirements of Cimabue are allied to a weighty style, equally devoid of expression and of feeling; whilst in conception everything seems to have been made subservient to a conventional principle, grand of its kind, but inanimate and empty as that of the mosaics of the twelfth and thirteenth centuries. At a distance the decorative effect is good, because the work is well distributed and carefully harmonised; but the orange-red shadows and grey-green half-tones or whitish lights, and the division of space into angular shapes, with straight lines of drapery, betray the habits of church ornamentists rather than the subtler instinct of more cultivated artists.

In the four arched divisions of the nave, where the spaces are parted into well-marked fields by the windows of the edifice, the painters of Assisi have unfolded, in two courses of subjects, the history of the Jews from the Creation to the finding of the cup of Benjamin, and the life and Passion of the Saviour. Following the old consecrated forms of composition, which they sometimes improve and sometimes mar by a mixture of the homely, they group their figures with more skill, and give them occasionally more repose and better proportion than their predecessors; but they frequently, on the other hand, exaggerate action and neglect the drawing of nude form. The importance of these pieces as a guide to future investigation will justify the following detail of the subjects, of which the first eight occupy the upper fields in the archings, and eight more form a second course below these, the numbering beginning in each case from the corner nearest the choir.

I. The Creation of the Animals and of Man. To the left of the window, and high up in the picture, the Eternal, guarded by angels, appears in half length in the sky, and commands the despatch to earth

[1] St. Gregory speaks under the inspiration of the Holy Ghost, which, in the usual form of the dove, whispers in his ear. St. Ambrose, St. Augustine, and St. Jerome combine or express their ideas in a similar manner.

of the first man, who descends in an almond-shaped glory of light. Circles to the right and left symbolise the sun and moon, beneath which a landscape represents the earth, with rudiments of creatures— of animals and fishes.

II. God creates the First Man. He sits on the orb of the world, and Adam rises before him.

In the vaulting of the arching above I. and II. there are thirteen half lengths of saints, of which six are fairly preserved.

III. God creates Eve. Here, again, God sits to the left on the orb, clothed in a red mantle. At his command Eve rises from the side of Adam, and extends her joined hands towards the Creator; Adam, meanwhile, sleeps with his head on his right hand. The lights of the Eternal's dress are touched with gold.

IV. The Temptation. Of this there remains only the figure of Adam and a vestige of the serpent. The right side of the composition is a blank.

The vaulting over these two subjects contains twelve half lengths, all of which are in a bad state, though three may still be fairly distinguished.

V. The Expulsion from Paradise. The angel, with outstretched arms, takes a long stride, and putting one hand on the arm of Adam, lays the other on the shoulder of Eve, who turns to look at him. Both are thrust out. But the Paradise from which they are expelled is reduced to a fragment of trees.

VI. This field is empty.

In the arching, thirteen half figures of saints are dimly traceable.

VII. Obliterated.

VIII. Cain slays Abel. The remains of this subject are—the body of Abel without the head, Cain moving away in the background, and the hand and arm of the Eternal in the sky.

IX. Noah and the Ark. The upper part of this field to the left is bare. In the foreground on that side Noah is seen looking up to the hand of the Eternal in the sky. Nearer the middle of the foreground he superintends some top-sawyers cutting a beam; below them, to the right, a carpenter is hewing a billet of wood with an adze.

X. Obliterated.

XI. Abraham, offering up Isaac, stands with one foot on the base of an altar, upon which Isaac kneels with his wrists tied behind his back. With one hand on Isaac's head, the patriarch swings a sword and looks up to heaven. The angel or the hand which should arrest the stroke is obliterated.

XII. Three Angels come to Abraham. There are but faint outlines of the patriarch kneeling and of the three angels who stand before him.

XIII. Jacob obtains the Blessing. Isaac, on his couch, feels with his left hand the hairy hand of Jacob, who carries the savoury meat, whilst Rebekah stealthily looks on, holding back a curtain. Much injured, except in the hand of Isaac.

XIV. Esau comes eagerly to his father with the savoury meat on a dish. Isaac is troubled, and half raises himself on his couch, stretching out his hand to Esau. In the background Rebekah looks on, holding a vase, and Jacob retires in the distance. The head of the last figure is obliterated, and here and there parts of other figures are abraded.

XV. Joseph in the Pit. The body of Joseph is half in the orifice, one arm being held by one of the brothers, of whom vestiges only are left. Traces, too, of other persons, one of them holding a dress.

XVI. Benjamin's Cup. Joseph sits on a throne to the left, and looks at his brothers kneeling before him and at a man who comes forward, pointing to the brethren and showing the cup. This picture is almost colourless.

Facing this double stripe of subjects which covers the right-hand wall of the nave as seen from the main portal, we have a similar set on the left-hand wall, which begins near the transept with :—

(a) The Annunciation. The angel enters with open wings and gives the message to Mary, who stands near the seat on which she has been resting, with one hand on her bosom and the other holding a book.

(b) The subject of this composition is lost. There are two heads—one male, the other female—left on the wall.

In the arching above the two fields nine half lengths of saints may be discerned, of which five are better preserved than the rest.

(c) The Nativity. The Virgin sits in the centre of the composition at the foot of a conical rock, above which two angels in flight sing canticles from scrolls in their hands. Lower down in the air to the right and left two other angels announce the coming of Christ to two shepherds in the foreground, whose profession is indicated by a sheep in front of them. In a cave in the rock near the Virgin the new-born Saviour rests in a cradle, and Joseph sits pensive in a corner of the left foreground.

(d) The Epiphany. The field which once contained this subject only preserves traces of the Virgin and the Magi.

Fifteen half lengths originally in the arching above. The two subjects are now reduced to ten.

(*e*) The Presentation in the Temple. On the left side of the foreground Simeon holds the Child, which he has just taken from the outstretched arms of the Virgin. These figures are colourless, but better preserved than those of the Prophetess and Joseph at the sides of the tabernacle, which are mere vestiges.

(*f*) The Flight into Egypt. We guess the subject from the hindquarters of the ass and a bit of St. Joseph, the rest being obliterated.

In the arching above these pictures only three half lengths are preserved.

(*g*) Christ and the Doctors in the Temple. It is only with diffidence that one ventures to name the subject of which most parts have disappeared.

(*h*) The Baptism of Christ. The Redeemer stands with his feet in the water facing the spectator; the Dove is poised above his head. To the right, on the bank, St. John stands, and stretching out his right hand pours water from a cup on Christ's head. At the opposite side of the water two angels hold the cloths.

In the vaulting there remain nine half lengths, of which three are fairly visible.

Returning to the transept, the second course begins with :—

(*i*) The Marriage of Cana. The bride and bridegroom sit in the centre, richly dressed in Oriental costume. To the right of the couple are traces of the Virgin turning towards Christ, who sits at the head of the board, but is only recognisable by a few outlines. Traces elsewhere remain of a servant with a cup and another pouring water out of a vase into an amphora. Others bring cups of wine and dishes to the guests. The background of arras and the accessories are unfortunately bleached or blackened.

(*k*) Obliterated.

(*l*) The Capture. Christ, facing the spectator, with a cruciform nimbus around his head, holds a scroll in his left hand, and is arrested on his way by Judas, who meets and embraces him. St. Peter stoops on the left to strike Malchus, heedless of the sign which Christ makes with his right hand. The companions of Iscariot stand around.

(*m*) Obliterated.

(*n*) Christ, on the road to Golgotha, carries a very large cross. He is preceded and followed by the guards, of whom two on horseback are still well seen. Part of the group of the Marys is missing.

(*o*) The Crucifixion. All but gone. Of the principal figure the upper part of the trunk is wanting, also the right arm and right leg

and the left leg from the knee to the ankle. Of other fragments we can trace part of the Evangelist and one of the Marys.

(*p*) The Lamentation over the Dead Body of Christ. The Redeemer lies with his head to the left horizontally along the foreground. Mary has raised his head to her lap with the help of St. John, who kneels in rear of the body, with a woman near him in tears and another kissing the left hand. The Magdalen on the right raises the left leg and embraces the foot. Nicodemus and Joseph of Arimathea stand mourning at her side, whilst two women at the back of the group witness the scene, and angels, seen in flight above a rock that rises into the sky, wail in various movements.

(*q*) The Marys at the Sepulchre. Of this picture the plaster has dropped so unfortunately that the heads of the three women on the left and of the two angels sitting on the sepulchre are gone. But the preliminary outlines on the stonework beneath the plaster show how the injured parts must have been. The four guards sleeping on the foreground remain.

The nave at the end nearest the portal is strengthened by an arch on pilasters, on the face of which there are sixteen saints and martyrs of both sexes with palms under arched niches in couples.

In the wall above the portal, and at the sides of the rose window, are medallions of St. Peter and St. Paul, with, below them, the Ascension of Christ from Earth (on which the apostles remain) to Heaven (where there are three circles of angels) and the Descent of the Holy Spirit.

In the arching are twelve half lengths of female saints, of which seven are in good condition.

This vast series of wall pictures, reduced to a state almost verging upon destruction in some of its parts, is still sufficiently preserved to illustrate the condition of painting in the thirteenth century. The Gospel subjects which the artists treat are the old ones, but the interest with which they are studied is increasing. We notice the effort to fathom depths which have hitherto been unexplored. Painters become ingenious in expressing themselves fitly, and they strip art of some inherent coarseness. Their success is partial, no doubt, but it is measurable, and we plainly see that an impulse is given which promises a rapid progress. Nor is this a small matter, since it is clear there is a body of tradition which the artist is required to respect, and an habitual

mode of representation to which the patron clings. We shall touch upon some of these points as lightly as may be.[1]

The Creation is a subject which tried the genius of painters for many centuries. Michael Angelo at last conceived it as a work of the Eternal sweeping through ether and producing the globe as he passes. The men of Assisi begin with the fiat delivered in heaven. Adam descends to earth in a mandorla, and finds the beasts and the fishes and the sun and moon in being. His own form is a rude imitation of the antique.

God creating Adam and Eve sits on the orb of the world, and yet in the ground where the orb rests we also see the forms of our first parents. The subject was one which had been treated before at Monreale and Sant' Angelo-in-Formis, and was preserved in its old shape perhaps because it was traditional. But the action at Assisi is already manifested by movement more grave and dignified than the coarsely demonstrative action of the earlier mosaists—the grouping is better, the proportions are more correct; yet progress of this kind is counterbalanced by want of selection and heaviness of frame and limb in many figures, which at the same time display an extraordinary overweight of head.

Straightforwardness of purpose may be a quality in the Expulsion, but there is something trivial as well as coarse in the way in which the angel pushes our first parents out of Paradise. Eve, however, is not without grace when compared with the sturdy disproportioned Adam, and in these exceptions we note the superiority of Assisi over Monreale or Sant' Angelo-in-Formis. But not in this alone. The same elements of comparison exist in the pictures of the building of the ark, where the painter

* [1] As we have already stated in Vol. I. (p. 96), we regard Nos. I., II., III., IV., V., IX., XI. and XII., that is to say, the Creation of the World, the Creation of Man, the Creation of Woman, the Temptation, the Expulsion from Paradise, Noah and the Ark, the Sacrifice of Isaac, Abraham and the Three Angels, the Betrayal, and the Nativity, as works of the school of Pietro Cavallini. We believe that they were painted about the year 1280. Although they are obviously less mature works than the frescoes of S. Cecilia-in-Trastevere, and are more uneven, too, in quality, owing, no doubt, to the intervention of assistants, the authors, we think, underrate their fine qualities. The Sacrifice of Isaac, with all its faults, is in advance of the early works of Giotto in those very qualities in which Giotto excelled.

of Assisi is quite ahead of the South Italians in the correct rendering of movement and detail, though still awkward in the conception of action and feeble in his choice of models.

Exaggerated strength or mannered attitude are as conspicuous as broken line and angular hardness in the Sacrifice of Isaac. Yet there is some dramatic force behind these defects and affectations which contrast favourably with the coldness and helplessness of the earlier men at Monreale, who merely indicate Abraham's purpose by putting a knife in his hand.

It is not possible to dismiss the pictures of Isaac's meetings with Jacob and Esau without noting that the idea of blindness is well suggested, and the composition is arranged according to classic rules.

Even in the New Testament scenes progress is exhibited, in spite of the clinging to traditional embodiments of subjects. The Annunciation and the Nativity are designed on the lines familiar to us in the illustrations of the Central Italian crucifixes and the mosaics of Santa Maria Maggiore or Santa Maria-in-Trastevere at Rome. The omission in the second of these compositions of the group of women washing the Infant, which finds a place even in Niccola's pulpit at Pisa, is probably due only to want of space.[1]

The Baptism of Christ, though differing little in the essentials from the same incident at Ravenna or the Pontian catacomb at Rome, is better distributed and more naturally put together than elsewhere, and seems imbued with so much more Christian feeling that it appears to be a fit prelude to the Baptisms of Giotto at Padua and Ghiberti at Florence.

The reverence with which artists, even in this age, looked up to the antique is apparent in the imitation of old amphorae and cups, of which fragments still remain in the Marriage of Cana.

The Capture reminds us in its arrangement of the similar designs at Monreale, Sant' Angelo-in-Formis, and in the crucifix of Santa Marta at Pisa. The old lines are made more interesting by additional life, finer connection of parts, and nobler men in the principal figure. But the feeling still predominates that the

* [1] These works are by some unknown master of the Roman school, who was strongly influenced by Cavallini.

form of Christ should exceed in stature and girth that of ordinary mortals.

On the other hand, we make a descent to the trivial in the Calvary, where weariness and pain are coarsely expressed by exaggeration of the size and weight of the cross and grimace on the features of the Sufferer. It is evident from the remains of the Crucifixion that coarse realisms and distortion are elements with which Cimabue was quite as familiar as Giunta or Margaritone. The angels are appropriately represented in an agony of grief. But grief is vulgarly suggested or only made manifest by grimace.

The Pietà, on the contrary, displays more harmony of line and more appropriate arrangement than we can find in combination in any earlier delineation of the subject. Exaggerated size again characterises the figure of Christ; but, in many small points, the artist marks a transition to the grander effort of Giotto in a more genuine rendering of sustained and reverent grieving, and more subtle varieties of mourning, illustrated by appropriate thought and gesture.

The same improvement in the old forms of Sicily and South Italy is also apparent in the Marys at the Sepulchre; and the angel whose movement suggests that he is telling of the empty sepulchre is as good as the action of the women, which is in no way inferior to that of Giotto in his more celebrated embodiments of the subject.

Even the Descent of the Holy Spirit and the Ascension are better thought out than the companion subjects of an earlier date.

Well did Vasari observe of this vast complex of subjects that it was so truly grand, varied, and well conducted that it would naturally fill the world in those days with astonishment. "To me," he continued, "it appeared all the finer as I considered how it was possible that Cimabue should have seen so well in such a period of darkness."[1] But Cimabue, according to Vasari, deserved all the more credit for his performance because he went to Assisi in company with certain Greeks, whom he rapidly succeeded in surpassing. Yet Vasari cannot have failed to observe, even in the parts which he assigns to Cimabue, the great variety of hands

[1] VASARI, ed. Sansoni, i., p. 253.

which characterises the paintings of the transept, ceilings, and upper part of the aisle. Had he thought the matter more worthy of observation, or been less intent on giving to Cimabue alone the credit of reviving the degenerate art of Italy, he might have traced in the right transept the passage from an earlier manner to that of Cimabue; he could have dwelt on the change which art again underwent in the paintings of the ceilings; how, under a succession of men, impressed essentially with the weighty style of the school of Florence, a certain technical progress was manifested, and more attention was paid to the equilibrium of masses and to true principles than before.[1] He might have seen that, in the paintings of the Upper Church, the grave character of Tuscan composition manifested itself; and he could have inferred the presence at Assisi of more than one Florentine artist. Having neglected to do all this he attributed to Cimabue the whole of a series of paintings which bears the impress of numerous hands; he condescended to stop there and to say that Cimabue had hardly entered upon the lower series of paintings which were to illustrate the life of St. Francis when he was called away, and left the incomplete work to be finished "many years after" by Giotto.[2] Yet when we contemplate the lower series of frescoes in the aisle of the Upper Church of San Francesco at Assisi, it is

* [1] The authors overrate here the importance of early Florentine art, and underrate the influence of the Roman school and of the schools of Siena and Pisa on the development of painting in the thirteenth century.

* [2] We hold to the view that these frescoes were painted by Giotto and his assistants before his sojourn in Padua, and that they are amongst Giotto's earliest existing works. As these paintings have suffered much from repainting, stylistic arguments as to their date can only be based upon considerations of composition, draughtsmanship, and technical method. In these respects the whole series seems to be experimental. We discover in it none of the sureness and harmony that we find in Giotto's other great series of frescoes. Some of the scenes are crowded and badly arranged. The artists seem to be ill at ease, and are continually changing their scale. These faults, too, are particularly noticeable in the earlier frescoes of the series, after the first. The general decorative impression of the whole series as regards scale, pattern, and spacing is unharmonious and bizarre. We feel that the whole series is not a properly co-ordinated work. In technique, too, it is experimental. Giotto here paints *a secco* as his immediate predecessors did in the upper courses. On further examination we find that a great master, working under admirable conditions, and with at least two able assistants, has been gradually acquiring a mastery

obvious that the same technical style is displayed there as already
marks the subjects of the upper courses, and that here again
a continuation and gradual development of Florentine art is
apparent.

It would have been difficult for Vasari, looking at the twenty-
eight scenes from the life of St. Francis in the order in which
they were completed, not to admit that those which illustrate the
earliest incidents of the life of the saint were executed in a
mechanical manner, hardly superior to that of the frescoes in
the upper courses; that as the life of St. Francis unfolds itself,
the power of the artists increases, the pictures are better com-
posed, the figures exhibit more animation and individuality, until,
towards the close, an art apparently new, another language, ex-
pressive of higher thought, reveals the development of the talent
of Giotto.

But the frescoes of the Upper Church of Assisi[1] do not merely
tell the story of art, they were intended to declare the abstinence,
the piety, and the miracles of St. Francis. And a sketch of these
from the legend may be welcome to the reader.

Son of Pier Bernardone, a rich citizen of Assisi, St. Francis was
born to affluence, but preferred, even in those years in which the
passions prompt youth to the pursuit of pleasure, the exercise of charity.
Of a kindly and generous disposition, it is related of him that his
conduct very early became exemplary, and that he was reverenced by
the poor and simple. So great was that reverence that a man once
threw his cloak into the dust that the youth might tread on it.[2] Like
St. Martin, he did not hesitate to give his cloak to one who seemed to
want it.[3] Then visions came upon him in the night, foretelling that he
should save the church which was obviously nodding to its fall. In a
dream he saw a splendid edifice[4] adorned with arms and ensigns, and

of the art of composition. The Upper Church at Assisi may be called Giotto's
laboratory. In it we can study a great style in the making.

It is noteworthy that in the architecture we find stronger evidences of Cosmatesque
influence, and fewer Gothic features, than in Giotto's later works.

 * [1] We hold that these frescoes were executed in the years 1302–1306.

 [2] This subject is the first of the series at Assisi, and is marked No. 1 in the plan.

 [3] No. 2 of plan.

 * [4] According to St. Buonaventura the beautiful palace was shown to St. Francis

with the symbol of the Saviour's crucifixion,[1] and this was the edifice
of the church which, by command of God,[2] he was to restore.[3] This
and other dreams led him to expend the money given to him by a
prodigal father in the erection of a church. But Pier Bernardone, who
at first was willing to gratify all his son's desires, was angered by this
species of extravagance, and cited Francesco before the consuls. The
bishop interfered. But the father, followed by a crowd of relatives,
called on his son to restore the funds he had spent. Francis, however,
had nothing left but his clothes, which, stripping himself, he offered to
his angry progenitor. The bishop covered the youth's nakedness with
the episcopal robe; and as the children around picked up the stones
which they intended for Francis, he entered *de facto* into the order of
the mendicants.[4] Then followed the well-known series of incidents
which led to the foundation of the Franciscan order. Innocent III.
saw the poor brother in a dream supporting the crumbling church[5]
—he approved the rules of the new order.[6] Disciples followed the
path which he had opened, and spread the fame of his miraculous
power. One of them saw from the pulpit[7] his form in a heavenly car
brilliant with light.[8] St. Francis saw a seat reserved for himself in
heaven, and heard a voice which promised that he should one day
occupy it.[9] The monks of the order cast out devils in his name.[1] He
visited the lands of the infidel, and—a second Daniel—went through
the ordeal of fire before the Soldan and shamed the false priests.[2] He
was in constant communion with the Lord, and had been seen by his
followers with awful reverence, kneeling in a cloud and receiving the
instructions of the Eternal.[3] In obedience to supernatural orders he
represented the Adoration of the Shepherds at Greccio.[4] He quelled
the thirst of a man by a miraculous draught of water.[5] He could
discern that the sparrows twittered praises to the Almighty, and at his
bidding they forbore and flew away.[6] He prophesied sudden death to

"to make known to him that the charitable deed done to poor soldiers for the love
of the great king of heaven should receive an unspeakable reward."
 [1] No. 3 of plan.
 * [2] A voice, says St. Buonaventura, spoke to St. Francis from the crucifix
bidding him build up the church, which was falling into ruin.
 [3] No. 4 of plan. [4] No. 5 of plan. [5] No. 6 of plan. [6] No. 7 of plan.
 * [7] The friar saw the vision of the chariot of fire from a hut in the canon's
garden at Assisi. [8] No. 8 of plan. [9] No. 9 of plan.
 [1] No. 10. * This fresco represents Brother Sylvester, at St. Francis' bidding,
driving the devils from Arezzo. [2] No. 11. [3] No. 12.
 [4] No. 13. * Master John of Greccio, a follower of St. Francis, saw the Holy
Child in the arms of St. Francis. [5] No. 14.
 [6] No. 15. * This fresco represents St. Francis preaching to the birds at Bevagna.

his host, who accordingly died immediately after confession.[1] He
preached with such fervency before Innocent III. and his cardinals
as to convince them that his words were the real wisdom of God;[2] and,
though absent in the flesh, he comforted the Beato, Antony of Arles,
as he preached in the cathedral, by appearing to him in the act of
benediction.[3] The supreme proof of his communication with heaven
was, however, when, on the rugged rock of the Vernia, the Saviour
appeared to St. Francis in the form of a Seraph, crucified, and impressed
miraculously on his hands, feet, and sides, the stigmata.[4] A church had
already been erected, with the contributions of the faithful, at Santa
Maria degli Angeli; but St. Francis frequently came away from this,
the first asylum of his order, to the episcopal palace of Assisi, where, a
short time before his death, he was staying. Here, foreseeing his
approaching dissolution, he resolved to withdraw to Santa Maria, and
being unable to walk he was carried by the brethren and followed by a
respectful crowd. Outside the town he stopped, and looking back at
Assisi gave it his blessing. Retiring then into Santa Maria, he lay
down on his pallet, and on October 4th, 1226, departed to another
world. It was observed by one of the brethren that his form had
ascended to heaven.[5] At this very moment the bishop of Assisi, who
was on a journey and then stopping at San Michele di Monte Gargano,
was miraculously assured of the death of him, whom twenty years
before he had covered with his protection, as he forsook the world for a
life of poverty.[6] The miracle of the stigmata had not so much credence
but that some still doubted of its reality, and accordingly, one Girolamo,
a doctor of Assisi, made his way into the cell of St. Francis, as he lay
after death, for the purpose of testing its truth. With his finger in the
wound he imitated the incredulity, and gained the conviction of St.
Thomas.[7] The body was brought in great pomp from Santa Maria or
La Portiuncula to Assisi, where, in the church of San Damiano, his
sister, Santa Chiara, embraced his remains.[8] He was canonised in
San Giorgio at Rome by Gregory IX.,[9] whose unbelief had ceased when
St. Francis, in a vision, presented him with a vial containing blood from
his side.[1] His apparitions after death were numerous and convincing.
To a lady near Beneventum who had never confessed, and was about to
die, he spared a heavy penalty in the next world by arresting her death
till she had made her peace with God.[2] Before this he had, at Ylerda,

[1] No. 16. [2] No. 17. * The pontiff is Honorius III., not Innocent III.
[3] No. 18. [4] No. 19. [5] No. 20. [6] No. 21. [7] No. 22.
[8] No. 23. [9] No. 24. [1] No. 25. [2] No. 27.

saved the life of a wounded man given up by the doctors,[1] and he liberated a prisoner of Assisi confined by the orders of Gregory IX.[2]

The life of St. Francis is depicted on the walls of the Upper Church of Assisi in the very form of the legend. It is a life abounding in subjects well suited for pictorial delineation, and it has been, in some instances, rendered with admirable illustrations at the bidding of the Franciscans of the thirteenth century. But if we look at it closely we shall find that it was illustrated by a succession of artists of various gifts, rather than by the skill of a single individual; and we shall come to the conclusion that the earlier numbers of the series were not very different in merit from the frescoes of the Old and New Testament above them, till, as they progressed, the younger hands employed improved in mastery, and finally produced the skilled work in which we recognise the power and the genius of an artist who is no other than Giotto. If we start from the first pictures on the left side of the nave near the transept, and set aside the first as a composition of a superior order, we trace, in about fourteen consecutive compositions, the defects which mark the frescoes of the upper course and ceilings, improved, it may be, by a broader style of drapery, more freedom of hand, and a more studied arrangement, yet still conceived and worked out on the old lines.[3] In the scene where the angry Bernardone grasps the clothes of his son and is with difficulty held back by his relatives from assaulting Francis, whose nakedness is covered by the mantle of Guido, there is room for a display of the most varied action and expression—of anger in the father, of supreme trust in the bounty of heaven in Francis, of surprise or compassion in the bystanders, of triumph . in the bishop and clergy. The intention of action and expression is manifest, and its real absence the more noticeable. Two children with their clothes tucked up evidently contemplate

[1] No. 26.

[2] No. 28. *According to St. Buonaventura, this man was a certain Peter of Alesia.

[3] Nos. 3, 4, and 5 have been damaged by lime. It may be well to state at once that the wall painting at Assisi so far is not *buon fresco*, that is fresco on wet plaster, but painting on the dry wall, or *a secco*.

* Here again, as in the composition of this series, we have proof of its early and experimental character.

throwing the stones concealed in the folds of their garments; and here may be traced that tendency to combine in a solemn subject one of those simple ideas which have been urged as one of the blemishes in the style of Giotto. But Rumohr, who thought that Giottesque art was whimsical because he considered it too simple in its truth, did not realize that, in following such a tendency, Giotto was only fulfilling his true mission, which was to infuse reality into an art which had become hardened into immobility. Compared with the remains of the same subject in the Lower Church, this fresco reveals a modern and more finished art. The same incident repeated by Giotto in the Bardi Chapel at Santa Croce of Florence merely manifests a further improvement in the same direction.[1]

In all the first numbers of this Franciscan series the same defects are constantly recurring. In the quarrel with Bernardone, where the human form is rendered with some truth, yet comparatively without feeling, the stiff square nude of Francis, his coarse extremities and defective articulations, are rendered in a state of repose approaching to rigidity, and remind us for that reason of some figures in the upper course of frescoes, or the four doctors in the ceiling, where the handling is not dissimilar from that developed at Rome by Gaddo Gaddi. The drawing is striking for its dark wiry line and its mechanical rudeness. The leaden red shadows, verde half tints, the ruddy stain on the lips and cheeks, the white lights, the broken contrasts of tones, are those of a mosaist.[2] The rest of the scenes, till we come to that in which St. Francis predicts the death of his host, offer more or less the same general features, though even in these a general progress in arrangement, and sometimes in execution, is· visible. Looking at the picture where St. Francis supports the falling church, we note the good proportion and appropriate movements of the figures.[3]

[1] A flaw disfigures the right side of this fresco. It has obliterated the house and part of the neck and breast of the man in the foreground near the bishop, and cuts across the figure of the bishop and the foot of Francis.

*[2] These frescoes were restored and in part repainted at the beginning of the fourteenth century, and they have frequently been restored since.

[3] Part of the plaster has fallen and carried away the church.

* This fresco has been very much repainted.

Ecstatic expression is well rendered in the eleventh picture, where the saint is represented communing with the Lord.

The mode in which the thirsty man is shown drinking at the miraculous stream is truly worthy of the praise which Vasari so abundantly distributes.[1]

We cannot find in earlier Christian compositions one more forcible, expressive, and natural than that in which the gentleman of Celano "suddenly dies as he rises from table in fulfilment of the prophecy."

St. Francis is no longer of the square and stiff form which characterises the earlier numbers of the series. He stands behind the table calm in the foreknowledge of the event, whilst the distracted relatives support the dying man, or exhibit the agony of their grief. The old vehemence of action is not yet given up; but the figures are more natural and truthful in form and expression, and are more deeply studied than they had been hitherto. Without stopping to analyse minutely the three next scenes, we pause at the twentieth fresco, where St. Francis lies on a pallet over which the bending forms of his grieving brethren stoop. One of them, looking up, sees the image of the founder of his order carried in a glory to heaven by ten angels.[2] Interesting as this picture must be to those who study the gradual progress of the art of composition in the Florentine school, it is still more so with reference to the improvement of the human form as shown in the angels, who seem gently wafted through the air by their wings, and whose features already express that repose and kindliness which so strongly contrast in the Giottesques with the vehement action and grimace of the old style. Nor is the semblance of flight merely a result of the attitude; it is due also to the sensible improvement of the flying drapery, which essentially helps to develop the form and its action.[3]

Fine as a composition, and beautifully arranged as regards the groups of monks with tapers and crosses, is the twenty-second

[1] No. 14. See VASARI, ed. Sansoni, i., p. 377.

[2] Great part of the colour and some of the plaster of this fresco are gone, mutilating the angel to the left who carries the saint to heaven, and cutting off on the right some of the background and friars with tapers.

[3] No. 21 is much damaged by a crack in the plaster which divides vertically into two the whole fresco, including the bishop, who lies in a dream.

fresco, representing the incredulity of Girolamo.[1] But superior still is that where the body has been carried on a trestle towards the church of San Damiano.

The bearers have just dropped their load, and St. Clara bends in grief over the remains. Whilst two nuns kiss the hands of the corpse, others bend over it. A couple communicate their thoughts, and the crowd behind look on in lamentation. The grief of the monks on the left, issuing in a column from a neighbouring convent, is well depicted, and an affecting sense of genuine regret is visible in all the faces. In the females, graceful form; in the head of St. Francis, select features and a fine feeling for the repose of death; in the figures generally, true proportion and flowing draperies, varied attitudes and individuality; in the artist, an improved knowledge of drawing—a great variety within the bounds of nature combine to manifest the progress already made by the artists of Assisi.[2]

The fresco of the canonisation is unfortunately obliterated, with the exception of a group of women and children who witness the scene; but, as regards composition, the next picture, which represents Gregory IX. in a dream receiving from St. Francis the flask of blood, is grand and well conceived.

St. Francis stands behind the couch on which the pope lies. He raises his right hand to the offering, whilst the monk with his right points to the stigma in his side. The figure of a sleeping attendant, two others in converse, and a fourth telling his beads, could not have been better arranged.

A triumph of distribution, action, and expression is to be found in the twenty-sixth fresco, where the wounded man is brought to life by St. Francis, whilst his wife and servant dismiss the hopeless surgeon at the door.

The latter, by his look and gesture, seems to say there is no hope. The lady who has followed him bears her grief nobly, and still seems

[1] The colour in No. 22 is in great part gone.

[2] Part of the intonaco of the foreground has fallen, injuring the church, the lower part of the nun nearest Santa Chiara, and the upper half of the head of her neighbour. A crack runs through the head of Santa Chiara, another hole injuring one of the bearers, and some injury is visible in the nun kissing the saint's foot.

The first subject of the upper series is Christ enthroned and blessing the world, in a circular halo, supported by four angels. To his left, the Virgin is accompanied by St. Paul, St. James, and another saint. To the right are the Baptist, St. Peter, St. Andrew, and a nameless apostle. Symbols of the four Evangelists and figures of angels fill the space above these groups.

The style of Philip Rusuti, whose name is inscribed on this mosaic, is Florentine rather than Roman.[1] The forms which he displays have an amplitude unknown to Torriti[2] or the Cosmati, though familiar to us in the work of Cimabue.[3] Yet the rhythm and lines of the Christ and attendant angels are more regular than those of Cimabue, and vaguely recall the Saviour, the Virgin, St. John, and St. Francis, in the medallions of the ceilings in the Upper Church of San Francesco of Assisi. There are delicate varieties also to be noticed in Rusuti's handling, as compared with that of his contemporaries at Rome. His familiarity with the time-honoured models of early ages is shown as clearly in the circular contours and high cheek-bones of the Saviour as it is in the Christ of Assisi. But his outlines are simple and even, his modelling rounded, his drapery naturally cast, his colour harmoniously balanced, in contrast with those of Jacopo Torriti; and these are characteristics which apply with a certain force to the ceiling medallions of Assisi, and justify us in believing that Rusuti may have been one of those who carried on the work which Cimabue left incomplete when he retired from San Francesco to Florence.

Beneath this mosaic a second stripe contains a series of episodes illustrating the legend of the foundation of Santa Maria Maggiore. Four pictures are placed without much regularity about the spaces occupied by a circular window, and Vasari certifies that the work

* [1] The editors maintain that there is nothing in the style of Rusuti that is foreign to that of the Roman school as we now know it.

* [2] The authors seem to us to underrate the achievement of Torriti.

[3] The words : PHILIPP RUSUTI FECIT HOC OPUS are inscribed on the margin of the circular halo. The mosaic is on gold ground, and somewhat impaired in value by so-called restoring.

* As we have already stated, we are not familiar with the artistic qualities of Cimabue.

is attributable to Gaddo Gaddi.[1] The first striking feature of this series is that the subjects are legendary and illustrative. One of them represents Pope Liberius with the Virgin appearing to him in a dream in a glory carried by four angels; another a vision of the same kind seen by the patrician Giovanni; a third depicts an interview between the patrician and the Pope; whilst the fourth shows Liberius attended by priests and followers tracing the foundations of Santa Maria Maggiore under the protection of Christ and the Virgin in a heavenly glory.[2]

The spirit of the compositions, and the shape they assume, are very clearly related to those of the Franciscan legend at Assisi. The handling is less antiquated than that of Rusuti. The framings are designed in the same taste and fashion as are those of the ceiling above the inner portal of the Upper Church of San Francesco at Assisi. But, besides this, there is a distinct similarity in the distribution and shaping of the figures in the mosaics of Rome and the wall paintings of Assisi—the pictures more alike in this respect being the Meeting of the Patrician and Liberius, in the mosaic series, and the Charity of St. Francis, or the Quarrel of St. Francis with his Father, at Assisi. But the points of similarity are not only those of arrangement and form. Characteristic besides are dusky and heavy outlines, imperfect drawing of extremities, compensated here and there by natural action or a fair balance of light and shade, and last, not least, an evident identity of make in faces and figures common to both mosaics and frescoes.[3]

There is nothing in the circumstances which appear to surround the production of these pieces to throw doubts on Vasari's statement that Gaddi designed the mosaics of Santa Maria Maggiore.

* [1] As Vasari assigns to Gaddi works of very different characteristics, and as none of his statements are confirmed by early documentary evidence, his statements in regard to Gaddo Gaddi's achievement are of very little value.

[2] The Virgin and Child and the angels in the Vision of Liberius are the only parts in fair preservation. In the Vision of the Patrician the Virgin and some figures of watchers at the foot of the bed are partially renewed. The arms of the Colonna on the mosaics show that the churchman who gave the commission was a dignitary of the Colonna family which patronised Jacopo Torriti (VASARI, ed. Sansoni, i., p. 347).

[3] The Pope in the third compartment at Santa Maria Maggiore is similar to the saint in a dream in the third fresco of the Franciscan series at Assisi.

The date of 1308, which he assigned to them, is confirmed by the
fact that the patron who gave the commission was one of the
Colonna, who also employed Torriti. 1308 is the time when
Gaddo Gaddi, having finished his labours at Assisi, might have
been called to Rome. He was then of mature age, having been
born about the year 1260, and enjoyed the friendship of Cimabue,
as well as that of Giotto. We are told, indeed, that Giotto was
godfather to Gaddo's son, Taddeo, who subsequently became his
chief assistant. It was after his return from Rome that Gaddo
settled at Florence. In 1312 he took the freedom of the Guild of
Surgeon Apothecaries, which then included painters, and he lived
a respected citizen of the republic till 1333.[1]

Judged by the standard of the mosaics of Santa Maria
Maggiore, Gaddo is an able disciple of Cimabue, but distinctly
inferior to Giotto. Vasari tells us that he learnt the practice of
mosaic-work from Andrea Tafi, and assigns to him a Coronation
of the Virgin above the inner portal of Santa Maria del Fiore at
Florence, and he is considered to be the author of certain parts of
the mosaic decoration of the Florentine Baptistery and an egg-shell
mosaic in the Uffizi at Florence. But we shall presently see that
there is little warrant for any of these statements, and if we
should accept the Coronation of Santa Maria del Fiore as one of
his genuine productions, it would only be because we might admit
that at an early period of his career Gaddo combined the early
forms of the so-called Tuscan Byzantines with those of Cimabue.[2]

There is no striking analogy between the style of the prophets
in the course of mosaics beneath the windows in the baptistery
at Florence and the mosaics of Rome or the frescoes of Assisi,[3]
nor would these figures justify the encomiums of Vasari, who says
they brought to Gaddo a great repute.[4]

The mosaics above the inner portal of Santa Maria del Fiore are at
least bright in colour and fairly relieved by balanced light and shade.

[1] See VASARI, ed. Sansoni, i., pp. 345–357.

* [2] On the evidence before us we cannot say whether or not Gaddo Gaddi was a
follower of Cimabue. If he executed the mosaics of S. Maria Maggiore, he probably
belonged to the Roman school.

* [3] We have already remarked upon the heterogenous character of the catalogue
of works Vasari gives to this supposed pupil of Cimabue.

[4] VASARI, ed. cit., i., p. 348.

The figures are strongly built and weighty, and thus distinctly Florentine. But these qualities are more than compensated by defective drawing of features, and hands and feet, sharp angular outlines, and flat expanses of drapery tints cut into map work by lines and gold light. The subject, we have said, is the Coronation of the Virgin, the space a recess above the portal, in which the Saviour and his mother are seated on the same throne attended by angels sounding trumpets. The Virgin bends reverently towards her son, but the faces of both are disfigured by angular wrinkles, protuberance of nose, and absence of forehead. The symbols of the Evangelists occupy the space above the throne.[1]

If the master's name is really applicable to the mosaic which is assigned to him in the gallery of the Uffizi, Gaddo can only have been an artist of small repute who inherited the traditional defects of older craftsmen without the power to acquire any modern improvement.

The mosaic represents our Lord giving the blessing and holding the gospel (part of the book and hand mutilated). The contours are red in the light and black in the shaded sides, the shadows are brown, the drapery indicated by a maze of lines tipped with gold. Characteristic features are a long face with a sharp nose and pointed beard, and a broad, stunted hand.

The mosaic can hardly be assigned to Gaddo unless we deny his authorship in respect of other works of the same nature.[2]

Vasari states that Gaddo Gaddi was a mosaist as well as a painter. If it be admitted that, in the former capacity, he laid out the mosaics in the portico of Santa Maria Maggiore, it must be conceded that he also painted at Assisi.

Any further search for the works of Gaddi would be vain. His Ascension of the Virgin, a mosaic described by Vasari, in the chapel of the Incoronata in the cathedral of Pisa, has made way for a more modern production of the close of the fourteenth

[1] The heads of the Virgin, as well as other parts of the mosaics, are injured by restoring.

[2] This piece is assigned to Gaddo because it is said to be made of egg-shells, and VASARI (ed. Sansoni, i., p. 348) says he executed work of the kind in San Giovanni at Florence. The egg-shell cubes are set in wax and coloured.

century.[1] It will be sufficient to have pointed out the probability that Gaddi and Rusuti both took part in the works of the Upper Church of Assisi. The presence of these Florentine artists at Rome enables us to compare the progress of Florentine and Roman art; and the comparison between Gaddi and Rusuti, and the Cosmati and Cavallini, will be found not very disadvantageous to the latter. It must be granted that the Roman school was not inferior, at the close of the thirteenth century, to that of Florence.[2] It may be affirmed that Roman craftsmen remained superior to the Florentine until Giotto appeared. Rusuti and Gaddo Gaddi belong to a class of decorative painters, whilst the Cosmati and Cavallini display more nature and more individuality, more character and power in the rendering of form, than their Florentine rivals.

[1] Amongst the works of Gaddo which have perished since Vasari's time, are the mosaics in St. Peter at Rome (VASARI, ed. Sansoni, i., p. 348), the mosaics of the old Duomo outside Arezzo (*Ibid.*, i., p. 348), and the altarpiece of the screen of Santa Maria Novella at Florence (*Ibid.*, i., p. 348).

* [2] The authors wrote before Pietro Cavallini's frescoes at S. Cecilia-in-Trastevere had come to light. These frescoes prove that the authors underrated rather than overrated the greatness of Cavallini and of the Roman school. At S. Cecilia Cavallini reveals himself as a great master with a distinctly personal style. See *antea*, Vol. I., Chapter III.

CHAPTER II

GIOTTO

THE early training of Giotto at Assisi may not have been without influence on the development of his career. Two mendicant fraternities, originally founded by St. Dominic and St. Francis, divided with their influence the bulk of society in Central Italy, at the close of the thirteenth century. But the Franciscan Order appealed more naturally to the feelings of the masses than the Dominican, and certainly took the lead in representing its sovereignty in a majestic edifice which the art of successive painters adorned. It is difficult to appreciate exactly the services which art and letters yielded to the order of St. Francis, but the pen of Dante and the pencil of Giotto were both devoted to it, and hence probably the connection which arose between two men, of whom one sprang from the ranks of the nobility, the other from the cottage of a peasant.

The legend of Giotto's [1] birth and education as it was known

* [1] The name of Giotto has long been a subject of controversy. Some authorities hold that it is an abbreviation of Ambrogiotto or Parigiotto or Angiolotto, others that Giotto was the master's baptismal name. Undoubtedly the weight of opinion is on the side of those who regard the name as an abbreviation. On this side are to be found Baldinucci, Domenico Manni, the editors of the Le Monnier edition of Vasari, and P. Liño Chini, the learned historian of the Mugello. The opponents of this view point out (1) that the name *Joctus* or *Giottus* is that given to the painter in legal documents, and that, for that reason, it cannot be a mere abbreviation or familiar name, and (2) that this name was given to other persons as a Christian name. To this it may be answered that (1) the notaries of the Middle Ages often gave in legal documents an abbreviated name or a nickname when that was the name by which the person they wrote of was generally known by in public and private, and (2) that this name was not used as a baptismal name until the fourteenth century.

Is it possible that Giotto is identical with the Parigiotto who took part in an arbitration as to the price to be paid for the thirty-four small pictures which were

28

blindfolded and symbolic of Lust. Her form is youthful and her head is crowned with roses, but she has claws instead of feet, and from her shoulder hangs a quiver and a string of human hearts. Behind, the skeleton of Death grasps the hand of a figure emblematic of impure passions and hurls it into the flames of the everlasting abyss. The penitent is aided against his foes by three females wearing helmets, one of whom pricks Lust with a lance, whilst another repels her with a vase, and the third with the cross and the remaining symbols of the Passion. Behind these again are three helmeted warriors holding lances. Chastity, in profile, stands in prayer in the upper part of the tower guarded by Purity and Fortitude. Two angels in air at the sides of the tower offer her a crown and a vase, out of which a palm is growing. The tower itself, the symbol of the force of chastity, stands in a quadrangular keep flanked with square turrets crenelated triangularly after the Florentine fashion. A bell at the top indicates the necessity of vigilance.

Under the name of obedience Giotto symbolises also the rules of the order of St. Francis, the practice of which secures a place in heaven. On the right foreground he depicts an animal of three natures—part man, part horse, and part dog—advancing with a red cloak on his shoulder, and symbolising pride, envy, and avarice. The beast is arrested by a ray which glances on his face from a mirror in the hand of a double-headed figure of Prudence, sitting on the extreme left of a portico, accompanied by Obedience and Humility. The portico is the sanctuary of St. Francis. In front of it, and beneath the figure of Prudence, an angel comforts and holds by the hand one of two kneeling figures. The first looks at the repulse of Sin. The second, following the gesture of an angel, casts its glance towards Humility, who stands in the portico to the right with a torch in her hand. In the centre of the portico Obedience, in the dress of a Franciscan and wearing a yoke, inculcates silence and imposes on the shoulders of a kneeling monk a wooden yoke. St. Francis is then seen in the air drawn up by the yoke to heaven, and two angels at each side of him hold scrolls on which the rules of the order are inscribed. On each side of the foreground angels kneel, the two nearest carrying cornucopias, the others in prayer.

In the fourth compartment Giotto represents St. Francis in glory, holding the book and cross, surrounded by angels varied in attitude and motion.[1] The centre of the diagonals is a medallion with a figure

[1] These four frescoes are on gold ground.

of the Eternal as he appeared to St. John; that is, the figure of "one girded about the paps with a golden girdle; his head and his hairs white like wool, as white as snow; . . . and out of his mouth went a sharp two-edged sword." This vision of the Eternal holds in its left a book inscribed LIBER ECCLESIAE DIVINAE, and in its right the keys. In the ornament of the diagonals, the Lamb, with three crowns; the symbols of the four Evangelists, winged; "the white horse," and he that sat upon him holding a bow; "the black horse," and he that sat upon him holding a pair of balances in his hand; "the red horse," and the rider wielding a great sword; Death on the pale horse; angels, seraphim, and emblematic figures of the virtues.[1]

Rumohr says of these ceiling frescoes that the "allegory which they illustrate is monkish-childish, and was certainly so ordered by the friars and not thought out by Giotto."[2] No doubt the allegory was not his, nor was it in his current of thought; but if the aim of an artist be to explain his meaning clearly there is no fault to be found with Giotto, whose thoughts are expressed with the same distinctness as if they had been conveyed in rhyme or prose.

These allegories are not less interesting than the frescoes of the Upper Church of Assisi. They yield a clue to the progress which Giotto had made as he entered on the enjoyment of independent life. In the frescoes of the Upper Church of Assisi the laws of composition and distribution are successfully developed. Dignity and grandeur are attained by a judicious distribution of space, and by an artful simplicity of grouping. The painter always tells his story. Not a movement but suits the general action; not a figure of which the character is not befitting his quality and the part allotted to him in the scene; not a personage whose stature is not well proportioned, whose form is not rendered with intelligence of the action, or of the nude. Even architecture[3] and landscape, though still imperfect, are so improved as to exhibit at least greater truth, taste, and elegance of proportion, and a purer style in decoration and ornament than of old. This alone would

[1] Rev. i., 13, 14, 16; iv., 6; v., 6; vi., 2, 4, 5, 8.

[2] RUMOHR, *op. cit.*, ii., p. 67.

* [3] The architecture, as we have seen, shows strong traces of Roman Cosmatesque influence.

point to Giotto as the author of the latest of the series of frescoes in the Upper Church of Assisi. In the ceilings of the Lower Church, known and admitted to be by him, they are to be discerned, in conjunction with a greater facility of hand and better study of nature than are found in earlier productions of the master. In one direction, indeed, the progress of Giotto was more remarkable than in any other. In the frescoes of the Upper Church at Assisi his drawing is slightly hard, his figures are tall and slender, his colour cold in general tones, somewhat raw and ill blended. In the ceilings of the Lower Church the figures are more lifelike and in better proportions. The extremities are less defective. Excessive action gives way to a quieter and truer movement. The outlines determine form with greater accuracy. The draperies are reduced to the simplest expression by the rejection of every superfluous fold. A spacious mass of light and shade imparts to the form relief and rotundity. The system of colouring undergoes a considerable change, and whilst it gains in breadth of modelling and blending preserves great lightness and clearness. The general undertone, instead of being of a dark verde, is laid on in light grey. Over it warm colour, glazed with rosy and transparent tints, gives clearness to the flesh. The high lights are carefully worked up and fused without altering the general breadth of the masses. Giotto owed certain peculiarities of form to Cimabue.[1] We noted how the latter substituted long closed lids and an elliptical iris to round staring eyes. In Giotto the progress of this reaction may be observed. As regards colour, Cimabue, with his clearer tones, seems to protest against the dark and sharply contrasted scale of colours of his predecessors. Giotto's flesh tones are also pale at times, but this is probably more apparent now than in Giotto's own day, because the light glazes which gave warmth and life to the surface have frequently been lost. In judging of Giotto's creations, it must never be forgotten that he is a painter of the thirteenth century, from whom it would be vain to expect the perfection of the sixteenth. His work, nevertheless, is so suggestive that we must again revert to an analysis of it :—

* [1] We are unable to say what peculiarities of form Giotto owed to Cimabue.

In the first allegory Poverty is represented by Giotto as a lean sufferer dressed in a patched robe, torn so as to expose a breast, of which the anatomy is fairly rendered. Long hair confined beneath a white drapery, bound round the head with a yellow and gold cincture, incloses a face worn by toil, but still smiling. St. Francis, in ecstasy, as he accepts the ring, admirably renders the poet's thoughts :—

> " La lor concordia e lor lieti sembianti
> Amore e maraviglia e dolce sguardo
> Facean esser cagion de' pensier' santi."

No painter has so well contrasted the sympathetic form of an affectionate youth, surrendering his dress to the poor, and those of the riper man, richly clad but of hard and vulgar features, who grins as he indecently gesticulates to mark his preference for mundane pleasures. Rigid decorum may object to the grossness of certain actions, but decorum was variously conceived in various ages, and even now is judged according to different standards by divers nations. Significance and clearness of intention were thus prominent qualities in Giotto, and this is fully illustrated by the various movements and expressions of the men with scourges in the allegory of Chastity. It would have been difficult to express more kindliness or gentleness than Giotto gives to St. Francis welcoming the aspirants to the order. In the allegory of St. Francis in glory, ecstasy and triumph are delineated. Amongst the angels round the saint some are marked by the grand and masculine character peculiar to the school of Florence. In the other frescoes a softer character prevails. It was, however, from the former that the powerful characters of Ghirlandajo and Michael Angelo were afterwards developed. The nude in all these frescoes is not as yet mastered as Giotto afterwards mastered it, but it is carried out in accordance with the laws of proportion. The drawing and form are subordinate to a general idea, and Giotto evidently cared more for the whole than for the parts. An arm, as he painted it, may still be wanting in the anatomy of the muscles, in the completeness of its details; it is never defective in the action of the limb itself.[1]

Giotto thus became at a very early period eminent as a composer, a designer, and a colourist. A natural division occurred after his death. Some of his disciples clung to the more special

* [1] Since Crowe and Cavalcaselle wrote, Giotto's power of rendering form has become a commonplace of the critics, but it has never been more accurately defined than in this last paragraph.

aim of developing form, and in this were at first not very success-
ful; others chose colour, or relief; others again made a searching
study of accessories or detail. None took up art in all its
branches where Giotto left it. His pupils had neither their
master's genius nor his talent; and art declined in their hands,
because, as Leonardo said, they copied Giotto's pictures instead of
studying Giotto's principles.[1]

Giotto was not confined at Assisi to the decorations of the
Upper Church, or the painting of the ceilings of the Lower Church.
He undertook to complete a series of scenes from the lives of
Christ and St. Francis in the lower transept, which have not
always been accepted as his handiwork, but which are now
acknowledged as such by an overwhelming consensus of opinion.[2]

These frescoes cover the eastern and western walls of the right

[1] See LEONARDO DA VINCI, in HEATON and BLACK, *op. cit.*, p. 124.

[2] These frescoes have been assigned by Rumohr to Giovanni da Milano, in
accordance with a very arbitrary reading of Vasari. It is quite true that the
biographer says of Giovanni that in Assisi "he painted the tribune of the high
altar, where he executed the Crucifixion, the Virgin, and Santa Chiara, and on the
faces and sides, scenes of the life of the Virgin"; but the frescoes of the south
transept are evidently not those meant by Vasari, firstly, because the tribune of the
high altar is not the transept, and secondly, because the subjects in the transept
are different from those given by the biographer. RUMOHR (*u.s.*, ii., p. 87) contra-
dicts the positive statement of Ghiberti (comm. 2. In VASARI, ed. Le Monnier,
i., p. xviii.): "Dipinse (Giotto) nella chiesa di Asciesi quasi tutta la parte di sotto."

* We hold that these frescoes were painted after those in the Arena chapel at
Padua. This view, which is not shared by some modern critics, is based upon the
following considerations : (1) In the frescoes in the Lower Church the architecture
is better in scale and more Gothic in character than the architectural backgrounds
in the Arena frescoes, in which we find some Byzantine features. In fact, the
architecture in some of the Assisi frescoes, the Visitation, for example, is in better
state and better designed than that in the master's works at S. Croce. (2) In most
cases the Assisan frescoes show a distinct advance in composition. The two most
notable examples of this advance are the Visitation, the Adoration of the Magi, the
Massacre of the Innocents, and the Crucifixion. In those frescoes, too, at Assisi, of
which the composition is not superior to that of the representations of similar
subjects at Padua, the Assisan compositions are more complex, more ambitious,
more fully developed. At Padua Giotto was content in some cases merely to follow
the traditional recipes of the Byzantine manuals. But even where the design is
largely his own, the composition is crude in comparison with his best works at
Assisi. In the Lower Church we find nothing of so early a character as the Christ
driving the Moneychangers and Merchants from the Temple. (3) In the harmony
and beauty of their colour schemes these frescoes are markedly superior to those at
Padua.

transept in three courses, beginning at the top of the latter with the Birth of Christ and the Salutation, and continuing with the Adoration of the Magi, the Presentation in the Temple, and the Crucifixion. On the east face are, in similar order, the Flight into Egypt, the Massacre of the Innocents, Christ in the Temple, Christ taken home by his parents, the miracle of the resurrection of a child of the Spini family, an effigy of St. Francis by the side of a skeleton of Death, and above the lunette of a door a half figure of the Saviour. All these subjects are divided from each other by painted architectural ornament, interrupted by small figures of prophets, on gold ground, and miniature allegories.

In the Birth of the Saviour, which is very symmetrical, there is a feeling of quiet stillness which is charming.

The Virgin smiles as she lies on the couch holding the swaddled Infant in her arms; a choir of angels sings in the air of the hut, at the bottom of which the ox and the ass ruminate. Another choir hovers about the roof, which is cleft in the centre by a ray from heaven. An angel, flying down to the right, apprises two shepherds of the birth of the Saviour, and the soft expression and swift motion of the messengers contrast admirably with the energetic attitude, the surprise of the shepherd, whose flock treads the foreground. St. Joseph, pensive as in old typical compositions, sits in the left-hand corner of the picture, with his head on his left hand. In the centre is the usual group of nurses preparing to wash the Infant.

The improvement wrought in this composition is evident, if we compare it with that of the Upper Church.

The Salutation is a composition of the severest artistic metre, and of much religious feeling.

In the Adoration the Virgin sits in front of a portico, guarded at each side by an angel, one of whom already holds the offering of the oldest of the Magi. One of the kings, kneeling, kisses the foot of the infant Saviour, whose tiny hand is imposed on his head in token of blessing. To the left the second king removes his mantle, that he may more reverently appear in the sacred presence, whilst the other holds a cornucopia. Behind stand the suite and two camels.[1]

* [1] This fresco has been much repainted.

This subject is composed with natural simplicity. Religious decorum and repose prevail in the well-proportioned and dignified figures.

The Presentation in the Temple is a very animated composition in a beautiful groined interior, in which Simeon is represented looking up to heaven as he takes the Infant from the hands of Mary. The Crucifixion is a masterpiece of arrangement and powerful expression.[1]

The figure of the Saviour on the cross is noble in shape and features; and now for the first time we observe the final arrangement under which the feet of the Sufferer are superposed, and both transfixed with a single nail.

The angels about the cross still vehemently express their grief, some holding their cheeks, others tearing the tunics from their breasts. One receives in a cup the blood from the lance wound; at the foot of the cross the Magdalen; at its left side, St. John and the Marys supporting the swooning Virgin; to the right, St. Francis and other monks of the order, and a more distant group of figures complete the picture. In the Saviour absence of contortion or grimace, bleeding wounds avoided, in the general outline of the forms great simplicity and flexibility make the figure a startling contrast with previous attempts to reproduce this subject. St. John, looking up, wrings his hands in grief. A female behind him shows her despair by throwing back her arms and shoulders. A second, still more in rear, makes a gesture of surprise. Consummate skill is displayed in expressing various phases of grief or passion. The senseless Virgin is raised up under the arm by one of the Marys, and supported by the two others at each side of her. The group is full of truthful nature. Amongst the bystanders on the right, two reasoning with each other, one tearing his beard, others angry and turning away, express the variety of the feelings which animate their souls. With this, grand lines of composition, religious fervour, and features of a noble type, combine to fetter our attention.

The Flight into Egypt is simply arranged. St. Joseph, with a

* [1] Signor Palmarini, in his *L'Arte di Giotto* (Florence, 1901), compares Giotto's Crucifixion with that of Duccio at Siena to the advantage of the latter. In it he complains of Crowe and Cavalcaselle's exaggerated praise of this work of the master. It is curious to note that the authors, who both died before Signor Palmarini's book was written, had struck out of their text some of the laudatory sentences of which he and others have complained.

pilgrim's pole and gourd, leads the ass upon which the Virgin rides, carrying the infant Saviour in the drapery of her mantle; a youth pushes the ass along from behind, whilst an old woman follows with a load on her head. In the distance, castles and hills, and two angels guide the way. The figure of the Virgin is elegant and graceful, that of the old woman with the load classic and reminiscent of the antique. The religious feeling which Angelico intensified is again apparent, and we recognise in the correct form and action of the ass the universality of Giotto's genius.

In the groups of the Massacre of the Innocents energy of action is combined with an absence of concentration. Of three women on the left, one weeps over the body of the child on her lap, another kisses a little corpse, and a third rends her clothes. In the foreground to the right, a woman fainting in the arms of a soldier contrasts with another of these executioners seizing and threatening with his sword an infant whose mother strives to elude his grasp. In a tower Herod orders the massacre.[1]

Wonder and dislike are well depicted in the faces of the doctors disputing with the youthful Saviour in the middle of the temple.

In the return, St. Joseph keeps a firm hold of the Saviour for fear he should escape. A majestic half-length of the Redeemer is in the vaulting of the door.

To the right of this opening St. Francis, fronting the spectator, points to a crowned skeleton of Death, in which a deeper study of anatomy is revealed than has ever been conceded to Giotto. It is evident, indeed, from this example alone that the master had a fair knowledge of the proportion and conformation of the human frame, of the bones and their articulations. It may even be affirmed that he carried this study further than artists of a later time. Luca Signorelli's skeletons in the Duomo of Orvieto are in quick motion, but the forms of the bones are sometimes exaggerated and false. Signorelli, therefore, great as he unquestionably appears, had, to a certain extent, an incorrect language of art which contrasts with the true and simple one of Giotto, his precursor. Giotto ably reproduced nude form, because he was scientifically acquainted with the position of the human bones and muscles.

* [1] This fresco also has been much repainted.

The Miracle of the Resurrection of the Child of the Spini Family is the next subject of interest.[1]

To the left the child is seen falling, feet upwards, from a tower. In the court below the body has been picked up by a friar, and, being raised up by him and restored to life, joins its hands in prayer. Near this couple a man and a woman look on with surprise, and four other women kneel in close proximity. A friar, too, is on his knees in prayer. Anxiety, curiosity, and confidence may be traced in the faces of the women, who are all enveloped in white draperies. One of these looks at the infant with anxious tenderness. Her hands are joined in prayer. Around this first kneeling circle, a second, of males, upright, in various attitudes, expresses thanksgiving in some, hope in others. Of those to the right of the principal group some are monks, one of whom looks up to heaven, and seems to perceive the form of St. Francis, accompanied by an angel, of which some traces remain.

For just proportion, for ample and spacious masses of drapery, and foreshortening of folds, there is no finer example than this in the early Florentine school.[2] The heads are veiled in mantles with elegance and art. Some of the profiles are full of expression. In the softness of some, or the masculine nature of others, as much versatility is shown as in the rendering of forms such as those of neck, breast, arms, and hands. Nor are the figures, though crowded, without relief to keep them in place: the quality which afterwards became so conspicuous in Masaccio is already apparent,[3] and Giotto manifests a due sense of the importance of aerial perspective. The colour is clear and light, and blended with great dexterity. Drapery tints are well

[1] It is not long since the organ loft, which concealed part of the painting, was removed. Of the four kneeling women on the left, one has lost her arms and hands, the second, turned towards the falling child, has lost the left arm and shoulder. The back of the child restored to life is also abraded. The whole scene is laid in the space in front of a convent, out of which the monks appear to have issued.

[2] A fragment from the border of the fresco, once No. 29 of Herr Ramboux's collection at Cologne, and called by him in error "Sancta Paupertas," is now in the Museum at Pesth (Première Salle, No. 30). Mr. Ramboux purchased it from Sig. Cavalier Frondini. It was a head in the rib ornament just above the fresco under notice. Veiled in white round the chin, this head has a flame issuing from the ornament in the hair.

* [3] Here again the authors insist upon Giotto's power of rendering form as the most prominent quality of his style.

harmonised. The outlines are firm, and the manipulation exhibits a marked advance upon that of the ceilings.

Whether Giotto more than once visited Assisi is difficult to say; but these frescoes were without a doubt produced after the ceilings of the Lower Church. That he was already a master, and that he was aided by numerous assistants, is probable. It would be presumptuous to affirm which of his pupils helped him in this or that fresco. It is sufficient to say that these works are only less vigorous and dramatic than those of the Arena at Padua, that they are stamped with the qualities of Giotto's earlier time, and marked by a simplicity and religious feeling peculiar only to himself. Some uncertainty exists as to the time when Giotto completed the various series of frescoes which indicate his presence at Assisi.

At Rome, to which he was invited, probably after painting the ceilings of the Lower Church of San Francesco, he lived under the protection of Boniface VIII., who prepared and successfully celebrated the Jubilee of 1300. Shortly after the opening of this centenary, Boniface drew up a bull of indulgence, which he published in person from the window under the portico of San Giovanni Laterano, then called the Mother of all Basilicas, and he subsequently caused the sides of the portico to be decorated with frescoes in memory of the event. Unfortunately, the edifice caught fire twice during the following half-century, and was afterwards modernised; and in consequence, no doubt, of these disasters, mere fragments of the frescoes were preserved, of which one on a pilaster to the right, inside the portal, represents the Pope in his tiara and robes giving the blessing, after the bull has been read by a clerk in presence of two cardinals. There are only parts of four figures now visible, and these are assigned to Giotto. It is curious, and some have thought suspicious, that the existence of these wall paintings should not have been reported by any historian of authority. Even Vasari, it has been observed, omits to notice them. Yet they must have been visible in Vasari's time, since they are mentioned in a description of the Roman basilicas by Panvinius, who says they were in a fair state of preservation in the second half of the sixteenth century, and were then supposed to have been painted by Cimabue. Be this as it may, the

fragment in San Giovanni Laterano is dimmed by age, and injured by cracks and repainting, and it would be hazardous to assert as a fact that it was executed by Giotto, though the remains certainly point to an artist of the time of Boniface, and the manner, even now, appears not unworthy of the best of the early Florentine craftsmen.[1]

Vasari would lead us to believe that the Pope who asked Giotto to Rome was Benedict XI.[2] But if the Jubilee fresco was really painted by Giotto, as we have supposed, he can scarcely have done so at the bidding of any other pontiff than Boniface, who would naturally express a desire to commemorate a festival which brought two millions of pilgrims to the Eternal City. It is equally natural to assume that Boniface, informed of the successful decoration of Assisi by Giotto,[3] should have indulged the wish to make San Pietro equally attractive, and invited the master, previous to the opening of the Jubilee, to undertake the adornment of the basilica and its high altar. Historians who are silent as to the portico of San Giovanni Laterano—Ghiberti, Alberti, Albertini, Vasari—are all ready to tell us that Giotto painted five scenes from the life of Christ in the choir, an altarpiece on the high altar, subjects from the Old and New Testaments in the aisle, an angel of colossal stature above the organ of San Pietro. They also state that he made the portico bright with frescoes and a mosaic, in which the ship of St. Peter was seen sailing in a storm, and St. Peter himself was prevented from sinking by the Saviour.[4]

The crowd of pilgrims that thronged the old basilica doubtless admired the works of a painter whose like had not been seen since the days of the ancient Greeks, and, if it is possible to regret that old San Pietro should have perished to make place for the San Pietro of our day, it would be because with the time-honoured edifice there perished all the frescoes of the great Florentine master,

* [1] There is an early drawing of the complete fresco in the Ambrosian Library at Milan. [2] He writes Benedict IX. by mistake (i. 320).

* [3] We believe that Giotto passed some years in Rome in the closing decade of the thirteenth century. We hold that his frescoes in the Upper Church at Assisi were painted in the years 1302–1306.

[4] LEON BATTISTA ALBERTI in *De Pictura* (12mo, Basil, 1540), p. 80; VASARI, ed. Sansoni, i., pp. 384, 386; ALBERTINI (F.), *Opusculum de Mirabilibus Nove et Vet. Urb. Roma* (8vo, Rome); GHIBERTI, in VASARI, ed. Le Monnier, i., p. xviii.

and this in spite of the efforts of Pierino del Vaga, who, having a commission to paint where Giotto had painted before him, and seeing the masons prepare to demolish the old, preparatory to the erection of the new walls, gave orders to save a Madonna and other pieces, and place them in frames in the organ-loft. Unfortunately, the fragments were not put away or kept with the same veneration as that of San Giovanni Laterano, and no trace of them is now to be found.[1] The altarpiece, which Ghiberti described as the ornament of San Pietro, was seen by Vasari in the sacristy, and in the sacristy of the canons we still see it now, the sole memento, besides the ruined mosaic of the ship of Peter, which remains of Giotto's practice during six years at Rome.[2]

It would seem that in the days of Giotto the superintendence of the basilica of San Pietro was exercised by a canon, and this canon, in the days of Pope Boniface, was Jacopo Gaetani Stefaneschi, nephew of the pontiff and one of his first cardinals. Baldinucci prints a record which he saw in the archives of San Pietro, stating that the mosaic of the portico was executed by Giotto, at Cardinal Stefaneschi's request, in 1298, at a cost of 2,220 florins, that he paid the master 500 golden florins for the paintings in the choir, and 800 florins for the altarpiece.[3]

The mosaic, which was moved four times before being finally replaced under the portico of San Pietro, in which it originally stood, represents Christ saving Peter from the waves, whilst in the background the ship, manned by the apostles, struggles with the winds, allegorically represented as Eurus, Notus, and Boreas in the clouds. Other figures, four in number, look down from heaven on each side of the composition. Stefaneschi in prayer shows his head and shoulders in the right-hand corner of the picture, whilst on the left an angler fishes in the water.[4] The

[1] VASARI, ed. Le Monnier, x., p. 169.

[2] GHIBERTI, 2nd Com., in VASARI, ed. Le Monnier, i., p. xviii.

[3] BALDINUCCI (F.), *Opere* (8vo, Milan, 1811), iv., p. 132.

* The *Necrologium* in the Vatican Archives states that it was the mosaic of the Navicella that Cardinal Stefaneschi caused to be executed in 1298.

[4] ALBERTINI, *u.s.*, notices this mosaic as being then under the portico of St. Peter. It was transferred August 24, 1617, with the assistance of Marcello Provenzale, to the wall above the stairs. Marcello then reset the figure of the fisherman and the figures in the air.

Urban VIII. caused this mosaic to be taken inside and above the high portal of

mosaic has been so extensively restored that it is difficult to fix the time of its execution or the hand which produced it. Still, when closely considered, a part representing the vessel and the crew has the character of a work of the close of the thirteenth century, and something of the manner of Giotto. A more certain and satisfactory example of his manner is the series of three panels, painted on both sides, now in the sacristy of the canons of San Pietro, with three panels evidently forming part of the predella upon which the principal ones rested. This is no doubt the altarpiece of Cardinal Stefaneschi, the form of which may be assumed from the representation of it in miniature in the hand of a bishop kneeling before a majestic figure of St. Peter on the altarpiece itself.

On one side is the Redeemer, in a blue mantle strewn with white flowers, adored by Cardinal Stefaneschi in purple, an effigy of simple outline, and a choir of angels ranged in formal ranks above each other, but neither devoid of feeling nor of diversity in character. The Saviour sits under a trefoil gable, in the upper curve of which is a half-figure of the Eternal, with the orb and keys, and a two-edged sword issuing from his mouth. In the trefoil, also, are two medallions of prophets. The Eternal wears a gold tunic and belt, and a blue mantle. In each pilaster, supporting the gable, a beautiful ornament is interrupted at equal intervals by three figures of Saints and Evangelists.[1]

We are still struck by the tendency to express the superior majesty of Christ by a disproportionate increase of size, and the dread of his

San Pietro, June 12, 1639. It was replaced by Innocent X., 1644–55, on the wall above the stairs, where Paul V. had put it.

Alexander VII., 1655–8, having finished the new portico, caused the mosaic to be taken down. It lay in danger of being consumed by time, till Clement X., 1670–6, caused it to be redone in the design of Lorenzo Bernini, by Orazio Manetti, who put it up where it now is.

The Saviour and St. Peter, the cardinal, and the two figures of the winds have also been restored, whilst the four saints above are obviously modern additions. The whole mosaic was engraved by Girolamo Mosciano (VASARI, ed. Le Monnier, ix., p. 290). The original drawing of it, without the fisherman, was once in the collection of the Richardsons. See *An Account . . . of Pictures in Italy* (8vo, London, 1722), p. 293.

* There is a drawing of this subject, by an early master, in Lord Pembroke's collection, at Wilton House. See STRONG, *The Drawings in the Collection of Lord Pembroke.*

[1] This panel has suffered from cleaning, but not from restoring. Some heads, particularly those of the uppermost angels, have lost colour by rubbing.

command by cold immobility united to symmetry of shape and propor-
tions. The same idea of symmetry is apparent in the angels.

To the left is the Martyrdom of St. Peter, to the right the
Martyrdom of St. Paul.

Living and unmoved, St. Peter is crucified with his head downwards.
The nude is rendered with surprising intelligence, the parts being
divided according to rule, and the articulations and muscles being set
in their true places. Even the external outlines, showing the flexibility
of the flesh and its adherence to the muscles and joints, the play of the
parts about the neck and collar-bone, are analysed with precision. The
only indication of suffering which Giotto ventures upon is the contraction
of the toes and muscles of the feet, nailed separately to a cross-board.
A female, emulating the grief of the Magdalen, grasps the foot of the
instrument of death, whilst behind and in front of her women wail over
the tortured saint in varied yet chastened attitudes. One of these
females, seen from behind, throws back her arms with a motion which
is often repeated in Giotto's pictures. On both sides, soldiers on foot
and horseback are grouped around the principal figure. In rear of the
women, to the left of the saint, one with the face of Nero holds a
hammer in his hand. Two pyramidal towers form the background on
each side, and above the cross two angels fly downwards to comfort the
tortured saint. In the upper curve of the trefoil St. Peter, winged,
kneels on a cloud carried to heaven by angels. In the point of the
gable Abraham draws the sword to sacrifice Isaac. In the sides of the
trefoil two medallions of prophets, and in the pilasters the figures of
saints.

In the Martyrdom of St. Paul the saint kneels after decapi-
tation.

On the ground lies the nimbed head, whilst in front the executioner
thrusts his sword into the scabbard. Pain and lamentation are well
depicted in the faces of two women bending over the trunk of the
fallen saint, and that of a man contemplating the consummation of
the sacrifice. Groups of trumpeters and soldiers on each side with
shields, lances, and banners balance the composition. A man on the
left looks up and sees two angels darting downward wringing their
hands. St. Paul is carried in a cloud to heaven by two angels, and
his mantle falls towards a man on a distant hill.

On the back of these panels St. Peter sits on a throne, holding the keys and giving the blessing. He sits between two angels and two adoring bishops with their attendant saints.

The bishop to the left of the throne is Jacopo Stefaneschi, recommended by St. George the patron saint of San Giorgio-in-Velabro, of which the prelate was cardinal. He is also the donor of the altarpiece, of which he presents a hexagonal model showing how the panels were originally arranged. To the right the second bishop is nimbed, and kneels with a book in his hand, supported by a saint in a rich ecclesiastical dress.

Here, again, St. Peter is superior in size to the saints and bishops at his sides. His figure is of imposing gravity, but the prelates are well and naturally portrayed.[1]

On the panels at each side are St. Andrew and St. John the Evangelist, St. James and St. Paul.[2] The predellas are three in number, and of these two are divided into five compartments each, in the first of which the Virgin and Child are enthroned between two angels—St. Peter and St. Andrew; in the second are five standing apostles; in the third are busts of St. Lawrence and two other saints. The three remaining predellas are gone. Mary in this predella is sad and grave, as in older representation of the earlier ecclesiastical painters, but the shape is well proportioned and the Virgin's mien is dignified. The infant Christ sucks its fingers with a playful air.[3] This triptych alone proves

[1] The panel is dimmed by time and injured by a split. Some of the gesso has fallen out. The pilasters are ornamented with arabesques. In the medallion of the gable is an angel with a book. The marble foreground has lost its colour and under gesso.

[2] In the medallions at the points of the gables are a prophet and an angel. The figure of St. John is damaged and blackened. St. James, holding a book and staff, is youthful and finely rendered. St. Paul carries the sword on his shoulders; both this and the St. James stand in niches, and above them is a figure of a prophet holding a scroll.

[3] In the vestments of the Madonna the drapery is grand. The angels, holding censers on each side, are in just motion. St. Peter, with his well-known head, short grey beard, and austere features, was seldom presented in better character. Nor in the other figures of apostles is Giotto wanting in variety or propriety. Though time has dealt unkindly with this series of Giotto's works, and parts have suffered damage, no restoring has taken place, and the student can fully instruct himself as to the manner of the greatest of the early Florentine masters.

that Giotto was not only the reformer of the art of painting, but
the founder of a school of colour, and that as a colourist he was
as great in altarpieces as in fresco. The tone of the panels is of
the same quality as that in the wall paintings of Assisi, being
light, transparent, and warm; of a grey verde in the shadows,
verging into warm ruddy semitones and well-blended lights of
massive breadth. The draperies, in clear bright keys, are softly
harmonious, and cast with an ease superior to that of any previous
example.[1]

Though we have it on the authority of Vasari and Platina that
Giotto painted scenes from the lives of the martyred Popes in
one of the rooms adjacent to San Pietro,[2] none of his works, in
addition to those already noticed in these pages, have been pre-
served at Rome. The mighty influence of his genius upon
Roman artists, and especially upon Pietro Cavallini; the readi-
ness with which Cavallini adapted his style to that of Giotto,
will not have been forgotten. Cardinal Stefaneschi, who em-
ployed the one, also protected the other; and the fresco of the
apsis of San Giorgio in Velabro, with the mosaics of San Paolo-
fuori-le-Mura, still prove the influence which he wielded.

The career of Giotto now becomes more intimately connected
with that of his native state; and leaving Rome, he revisited
Tuscany at a very critical period of its history.[3]

After a long and frequently doubtful struggle, Florence had
finally asserted her superiority in Italy, but a feud divided the
city into two camps. Corso Donati led the party of the Neri,
Vieri de' Cerchi that of the Bianchi, which numbered amongst its
partisans the immortal Dante. The poet had had occasion to
cultivate Giotto's acquaintance at the Jubilee in Rome,[4] and

[1] At Rome Giotto painted, in the church of the Minerva, a crucifix in tempera,
which perished; but in this church a wooden crucifix is assigned, for no
imaginable reason, to Giotto (VASARI, ed. Le Monnier, i., p. 323; GHIBERTI, 2nd
Com., in VASARI, ed. Le Monnier, i., p. xix.). [2] VASARI, xi., p. 309.

[3] The Virgin Annunciate which Vasari describes in the Badia of Florence, is by
Lorenzo Monaco. It is now in the Academy, No. 143. See *postea*, pp. 299, 300. The
picture of the high altar is lost (VASARI, ed. Sansoni, i., p. 373).

[4] Dante says himself, in canto xviii. of the *Inferno*, v. 28 :—
"Come i Roman, per l'esercito molto,
 L'anno del giubbileo, su per lo ponte
 Hanno a passar la gente modo tolto."
See also VASARI, ed. Le Monnier, i., p. 311.

during the short period which intervened between his return to Florence and his embassy to Pope Boniface VIII., this acquaintance might have matured into friendship. It was therefore about this time, and no doubt previous to April, 1302, that Giotto laboured in the chapel of the Palace of the Podestà or Bargello of Florence, and painted on one of the walls an incident illustrating the memorable feud of the "Blacks" and "Whites." Neither the lessons which the pictures of this chapel were intended to convey, nor the presence in one of them of Dante, were sufficient to save the building from desecration. The beautiful chapel of the Podestà, which appeared to Vasari to have no attraction superior to that derived from the paintings of Giotto, was divided into two stories by the introduction of a false ceiling. The upper part became a prison, the lower a magazine, and some, at least, of the walls were whitewashed. The false ceiling was subsequently removed, the chapel was cleared, and the frescoes were recovered in an injured state. In the paintings of Giotto thus restored, every charm of colour has disappeared. Nothing remains to please the eye. In many parts the compositions are mutilated, in others totally effaced; yet the design and the drawing are preserved, and are of incalculable value to the student of Giotto's manner.[1]

Constructed in the form of a rectangular oblong on an area of 936 feet, and ornamented with a waggon roof, the chapel of the Podestà is entered through a door at one of the small ends, above which is a fresco of the Inferno. On the opposite side, the wall, lighted by a window, is adorned with a fresco of Paradise. On the principal spaces at the sides there are incidents from the lives of the Magdalen and Mary of Egypt. The wall to the right of the entrance is pierced with two windows. That on the left is divided into a double course of four frescoes, commencing near the door, with a scene from the life of St. Mary of Egypt, and continuing with the communion of the saint, a scene from the life of Mary Magdalen, and the Noli me Tangere. The only remains here visible are those of the Magdalen in part, and a portion of another

[1] The rescue of this interesting work of art was achieved by Seymour Kirkup, Mr. Henry Wild, and Mr. O. Bezzi. At their request, Cav. Remirez di Montalvo and the Marquis G. Ballati-Nerli ordered that the restoration should be executed at the charge of the Tuscan treasury. The height of the chapel is sixty feet, the area about thirty-six by twenty-six.

figure holding a heart. Above, in the same order, the Marys at the sepulchre, a subject now destroyed, the resurrection of Lazarus, and the Magdalen anointing the feet of Christ. All these compositions are divided by a beautiful ornament, at the corners of which lozenges contain half figures of angels. One of these, pouring water from a vase, is extremely graceful. On the opposite side, right and left of the windows, is a double course of single frescoes, representing fragments of the dance of the daughter of Herodias, the miracle of the merchant of Marseilles, and an episode now obliterated. Between the two windows is a saint of which we shall presently speak. In the sides of the windows are escutcheons and roses; and in the key of one, a head of the Saviour. The vaulted ceiling is divided into four parts, framed in the same ornament as the rest, interrupted by lozenges in which figures of angels, now almost gone, are depicted. In the centre the Lamb stands on an altar supported by two hippogriffs, and around it are the symbols of the four Evangelists.[1]

The figure between the two windows on the wall to the right represents San Venanzio with a book and a palm, whose identity is established by a cartello on which there is a prayer or invocation to San Venanzio, concluding with the date MCCCXXX . . . (1337)." On a lower border are also the words : HOC OPUS FACTUM FUIT TEMPORE POTESTARIE MAGNIFICI ET POTENTIS MILITIS DOMINI FIDESMINI DE VARANO CIVIS CAMERINENSIS HONORABILIS POTESTATIS. It is important to note that the inscriptions above quoted apply to the figure of San Venanzio, the patron saint of Fidesmini di Varano, who was Podestà of Florence in 1337,[2] and not to the frescoes on the remaining walls. There is abundant proof in the earliest historians of Florence, that Giotto had been employed to paint the frescoes of the chapel of the Podestà; and it is not without interest to cite some authorities to that effect. The earliest is Filippo Villani's *De origine civitatis Florentiæ*, etc., a MS. of the fourteenth century which states that "Giotto painted himself, with the aid of mirrors, and his contemporary Dante in the *altarpiece* of the chapel of the Podestà." The Italian version of the same MS., published in the beginning of the fifteenth century,

[1] The ceiling was painted blue with gold stars, but is now white, the blue having fallen out. In one of the lozenges is still an angel holding a censer.

* [2] Fidesmini was podestà in the year 1331, and it was probably about this date, shortly after his return from Naples, that Giotto painted this fresco.

omits all mention of the altarpiece, but, alluding to the frescoes on the walls, says: "Giotto painted himself, with the aid of mirrors, and his contemporary Dante Alighieri on the wall of the chapel of the Podestà." The poet Antonio Pucci, born at Florence in 1300, turned Villani's MS. into verse, calling it the *Centiloquio*. In this rhyme chronicle, published for the first time in the *Delizie degli eruditi Toscani*, Pucci alludes to Giotto's portrait of Dante in the frescoes of the Cappella del Podestà,[1] and says the poet was painted there as if in Paradise amongst the blessed (merite sante).[2]

Gianozzo Manetti, in a *Life of Dante*, written in the first years of the fifteenth century, says that Giotto painted Dante from life, and used the portrait in the frescoes of Santa Croce and the chapel of the Podestà. Ghiberti and Vasari both assign the latter, without hesitation, to Giotto,[3] and Vasari specially alludes to them as containing Giotto's portraits of Dante, Brunetto Latini, and Corso Donati.[4]

[1] In the following words :—

> " Questo che veste di color sanguigno,
> Posto seguente alle merite sante,
> Dipinse Giotto in figura di Dante,
> Che di parole fè si bell' ordigno.

> " E come par nell' abito benigno,
> Cosi nel mondo fu contutte quante
> Quelle virtù, ch' onoran chi davante
> Le porta con affetto nello scrigno.

> "Diritto paragon fu di scutenze :
> Col braccio manco avinchia la scrittura,
> Perche signoreggiò molte scïenze.

>

> " Perfetto di fattezze equi dipinto
> Coní a sua vita fu di carne cinto."

[2] See the reprints of this canto in the pamphlet, *In Lode di Dante*, published for the celebration of the wedding of Bongi-Ranalli, at Florence, January 15th, 1868.

[3] GHIBERTI, Com. in VASARI, ed. Le Monnier, i., pp. xix., 311.

* Vasari's unconfirmed testimony in such a matter as this, relating to an early master, is not of much value. When, however, it is supported by the statements of such early writers as Filippo Villani, Antonio Pucci, Gianozzo Manetti, and Lorenzo Ghiberti, nothing short of absolute disproof can overthrow it.

[4] These lengthened quotations are necessary to establish the claim of Giotto to the execution of these frescoes, a claim contested by two very high authorities— Gaetano Milanesi and Luigi Passerini—in a report presented to the government at

The portrait of Dante by Giotto in Santa Croce was so well
known in Vasari's time that when Michael Angelo's funeral
service was celebrated in San Lorenzo, and the church was hung
with pictures illustrating Florentine art, one of the canvases
represented Giotto holding a portrait of Dante on panel, after the
original by him at Santa Croce.[1]

But this evidence is almost superfluous for anyone acquainted
with the style of Giotto.

In the first scene which adorns the side walls, St. Mary of Egypt
kneels and receives the blessing of Bishop Zosimus enthroned in a
church. Fragments of four other figures still remain.[2] In the Com-
munion, the saint kneels before Zosimus, who presents the host and the

Florence on the occasion of the centenary of Dante. These gentlemen affirm that
the frescoes are by another hand, for the following reasons. First, the portrait of
Dante in the fresco is that of a man of twenty-five, and would, if this were so, have
been painted in 1290, when Giotto was hardly fifteen years old; second, Dante would
never have been represented in a contemporary fresco in company of his arch enemy,
Corso Donati; third, Giotto's works, had they ever been in the chapel, must have
perished in the fire which broke out in the Palazzo del Podestà on February 28th,
1332, and at the expulsion of the Duke of Athens, the palace having required entire
rebuilding in consequence in 1345; fourth, beneath a figure kneeling in the fresco of
the Paradise is a scutcheon with the arms of Tedice de' Fieschi, Podestà of Florence
for the year 1358-9. To all these reasons a short and conclusive reply can be given.
First, the portrait of Dante, before its restoring, was that of a man of thirty to
thirty-five years old; besides, if Giotto was born, as we have shown, in 1266, he
would have been twenty-four and not fifteen years old in 1290. Second, it is idle to
suppose that Giotto could not represent Dante in company of Corso Donati, if the
fresco were intended to commemorate a transient peace in 1301. Third, if the
chapel of the Podestà had been destroyed with the Palazzo in the fire of 1332, how
comes the inscription beneath the figure of San Venanzio to be dated 1337? Fourth,
the arms on the scutcheon are truly those of Tedice de' Fieschi repainted, as anyone
can see, over those of a previous potestà.

[1] VASARI, ed. Le Monnier, xii., p. 302.

* The critics who have followed Milanesi in denying that the frescoes of the
Bargello are by Giotto have added nothing of importance to his arguments.
Milanesi's argument, in its second and revised form, is to be found in his edition of
Vasari (VASARI, ed. Sansoni, pp. 413-422). Dr. Ingo Krauss has fully discussed all
the portraits of Dante in the Monatsberichte über Kunstwissenchaft u. Kunsthandel.
München, 1901, fasc. 11, 12; and 1902, fasc. 1, 2, 9. After a patient and exhaustive
examination of all the evidence on the subject of the authorship of the Bargello
frescoes, the author concludes that these frescoes are by Giotto. See also KRAUSS,
Das portrait Dantes, Berlin, B. Paul, 1901.

[2] Two headless figures with tapers stand near the bishop. To the right of the
kneeling figure two heads of angels are still preserved. Above are vestiges of angels
carrying a figure to heaven.

cup. A figure on the right bears a taper.[1] In the "Noli me Tangere,"
the upper part of the Magdalen, the lower part of the Saviour remain,[2]
but from the movement of Mary's head and its longing glance the
beauty of the whole picture may be judged. The power of expression
conveyed in this single face is indeed remarkable. Though totally
devoid of colour, there is an exquisite feeling in the outlines and in the
movements of the features and neck.[3] Most of the composition of the
Marys at the sepulchre remains in outline only.[4] A fine character and
movement mark the Saviour in the Resurrection of Lazarus, whilst in
the kneeling Mary and Martha life and animation are pleasingly con-
veyed.[5] The outlines of the Magdalen, prostrate before Christ, who
sits with Simon and another, whilst a servant brings in the meat, are all
that remain of that composition. Herod, a guest, and part of the
dancing figure of Salomè, are the only pieces extant of a subject, of
which another and more perfect example by Giotto may be seen in the
Peruzzi chapel at Santa Croce.[6] The Miracle of the Merchant of
Marseilles looks better preserved. It illustrates the legend according
to which a merchant of Marseilles, having seen St. Mary Magdalen in a
vision, vowed to her that he would turn Christian and visit the Holy
Land if he should be blessed with offspring. On a journey at sea, the
merchant's wife gave birth to a child and immediately afterwards died.
The body was landed on a rocky island, and the merchant, having no
means of feeding the babe, left it with the corpse. Returning to the
spot two years later, the merchant recovered the child, which he found
miraculously preserved by the side of the corpse. In the fresco the
wife lies dead under a coverlet in the foreground; at her feet the
merchant on his knees, looking up to heaven; and close at hand five
men, spectators of the scene, observe the child running away. In the
distance a vessel rides at anchor, and a fragment of a figure appears in

[1] The flesh tone of the kneeling female is gone, but the engraved lines of face,
hands, and feet remain; whilst the rest of the figure is boldly laid in with a brush
in red. It would seem, indeed, as if the lines had been engraved with a style
running over a cartoon.

[2] Part of the sepulchre and distant trees may still be seen.

[3] The usual preparation of light verde is still visible. The forms are traced in
red. The mantle, prepared in red, was glazed in blue.

[4] The chief parts are gone, but the form of the angel on the sepulchre is beautiful
and noble in attitude. Part of the landscape distance is still visible.

[5] The figure of Lazarus has vanished. At the angle of this composition is an
angel bearing a lance, beautifully designed in a lozenge ornament.

[6] At the angle on this side, also, is a beautiful archangel overcoming the demon,
drawn in a lozenge.

the act of benediction in the sky. The technical execution of this piece is not equal to its conception. The remains are defective in drawing and opaque in colour; and it is possible that these defects may be due to a restorer who was also the painter of the figure of San Venanzio.

The Inferno, like the rest, is discoloured; but many figures are seen, as they were sketched with red on the wall and shadowed with a deeper tinge of the same colour.

The colossal Lucifer stands in the centre of the space, exactly in the form afterwards described by Dante in the *Inferno*.[1] In his grasp two sinners; about his frame serpents, and bodies chained or clubbed by demons, a centaur, and one holding his head in his hand.

This Lucifer and the fantastic groups about him display the varied nature of Giotto's studies. Yet, as in Dante the imagery is often literal and the contrasts are terrestrial, so in Giotto, who probably took the Dantesque idea from Dante himself, nothing more than a fantastic materialism is exhibited. In this, however, both poet and painter embodied the thought and traditions of older times.[2]

The Saviour in Glory, in the space opposite the Inferno, presides over the array of the blessed. Little of the upper part has been preserved, but the lower affords matter for most interesting studies; because, under the semblance of a paradise, Giotto obviously embodies pictorially the transient peace which Cardinal d'Acquasparta, in the name of his master Boniface VIII., imposed on the Florentines in the winter of 1301.[3]

[1] *Inferno*, canto xxxiv., *v.* 38 and fol.

[2] The colour has fallen without affecting the polish of the plaster on which the outlines of the Lucifer are engraved. The rest of the forms are firmly lined and shadowed with reddish brown. The joinings of four great portions are still visible, on which it would seem that the outlines were in part éngraved and part painted whilst the plaster was still wet. This part has been in a great measure preserved. The colouring of the flesh and draperies, according to the old method, is that which has not resisted time, whitewash, and restoring.

[3] AMMIRATO (SCIPIO), *Dell' Istorie Fiorentine*, etc. (Florence, 1647), pp. 214, 215.

* The Cardinal Matteo d'Acquasparta twice visited Florence as a peacemaker, once in June, 1300, and again in December, 1301. It was on this second occasion that his efforts met with some temporary and partial success. The Pope wrote that he sent his envoy "to second Charles' efforts (for peace), by checking dissension

Uniting the two principal groups at each side by two figures of angels, now in part obliterated, which stand guard over the lily of Florence,[1] he represents to the right of these, near the lower angle of the window, the standing figure of a prince, wearing over the long hair of the Frenchmen of the period a coroneted cap. This youth, of somewhat disdainful glance but of majestic mien, with his arms folded in ample sleeves,[2] heads a procession of standing figures, and seems too proud to imitate the kneeling posture of one in magistrate's robes in front of him.[3] The look and dress of this youth reveal Charles of Valois, called to Florence, and admitted as pacificator by the unwilling Florentines. Behind him stand Dante Alighieri, Corso Donati, Brunetto Latini,[4] and a fourth person whose features have been lost. Behind these again, other dignitaries in varied attitudes; and in rows above them saints of both sexes, nimbed, crowned, bareheaded, or draped; marked by a graceful variety of features and expression, and full of life and nature.[5]

In the same order on the left side of the window, a cardinal of square and muscular build stands in prayer, evidently Matteo d'Acquasparta, in front of whom a magistrate of Florence kneels, with a dagger at his side[6] and a shield of arms beneath him.[7] Behind Acquasparta stands a group, headed by a row of three, the hindermost of whom is worthy of special remark as being not dissimilar from one in the frescoes of the Arena at Padua, generally considered to be Giotto himself.[8]

amongst the citizens and by converting them to peace and charity." The Cardinal's hopes of ultimate and complete success were rudely dispelled by the affray of the Africo Bridge, which resulted in the deaths of Niccola de' Cerchi and of Corso Donati's son Simone. The Pope's letter is in POTTHAST, *Regesta Pont. Rom.*, p. 2,006. Professor Villari has given a luminous description of these events in the second volume of his *History of Florence*. See the English Edition, pp. 143–161. Professor DEL LUNGO's *Sull' Esilio di Dante* (Florence, Le Monnier, 1881) may also be consulted. [1] Now newly painted in. [2] Part of the face has been lost.

[3] Great part of the head of this figure is gone.

[4] Dante, certainly. The rest are conjectured to be the persons named.

[5] These qualities will be admitted after a close observation, for some of the heads are in part damaged, whilst many are obliterated.

[6] In a red cloak lined with white fur. Spots of the original red still remaining. The head-dress is in part effaced and part of the head gone. The face seems to have been broad, and the nose is short.

[7] The arms on the shield are in a great measure obliterated, but are those of Tedice de' Fieschi repainted over an older scutcheon.

[8] This figure, the most distant of a row of three, close to Cardinal Acquasparta, is that of a man about twenty-five years of age, having a broad forehead over-

The head of Dante corresponds in every sense to the well-known mask which was taken after his death. The high forehead, the curved brow, and deep sunken eye, the hooked nose, classic mouth, and pointed chin, are all equally characteristic. But this, which was true when the head was first rescued from whitewash, is much less so now.[1] The profile has been outlined afresh and spoiled. A portion of the eye and a part of the cheek has been supplied anew by the restorer. The bonnet is not only restored, but altered in colour and shape. The change wrought in it is so great that the art is no longer that of the time of Dante. Ungraceful beyond measure is the red cap with a hanging whitish bag, of which the original colour appears to have been most unfortunately altered.[2] The change of colours, and the introduction of a seam fastening the hood to the rest of the cap, are the more unpardonable because there is evidence that Dante usually wore a red cap. The Florentine Domenico Michelino painted a posthumous likeness of the poet in 1465, which may now be seen in Santa Maria del Fiore, and he dressed Dante in a red hood and vest, and there is no reason to doubt that Michelino executed this likeness with the assistance of those which Giotto

shadowed by a cap, out of which a few hairs are straggling. A yellowish dress is fastened at the neck by a small short collar. His look is directed towards Dante on the opposite side of the window. At the Arena of Padua, in the Paradise, in the third rank of the blessed, and second from the left side of the picture, is a figure like this, but more aged. This figure at Padua is traditionally honoured as that of Giotto. This, however, and the similar one in the chapel of the palace of the Podestà, have no likeness to the portrait (so called) of the painter at Assisi, but more to that which, a century after his death, was executed for Giotto's monument in S. Maria del Fiore of Florence.

[1] To the late Mr. Seymour Kirkup is due the merit of having taken an exact tracing of the head of Dante previous to the restoration. With this in hand it was possible to compare the restoration with the original, and detect the changes. Mr. Kirkup's tracing has also been published by the Arundel Society.

[2] This is obvious from a close inspection of the bag, and of the repainted red part. The scraper, in removing the whitewash, took out the colour of a portion at the back of the head and of the pendent part, which may now be seen gashed by the razor ; but here and there a red spot by chance remains, even in the pendent portion, showing that the bonnet was red all over. The seam which now unites the bag to the rest of the bonnet never existed before, and is a mere fancy of the restorer, who at the same time has falsified the outline by raising the point of the hood. When he repainted with red that portion which covers the back of the head he might have repainted with red also the pendent hood.

had executed in the chapel of the Podestà and in the church of
Santa Croce.[1]

Corso Donati, if it be the ambitious leader of the Neri who is
here depicted, has a most characteristic head. His hands are
joined in prayer, and part of the fingers remains. Half the face
of Brunetto Latini is preserved. Like Corso, he wears a cap.
Yet it is difficult to account for his presence in the position
assigned to him, for though he was Dante's tutor, he was consigned
by his pupil to the Inferno.[2]

A general charge of sameness has been admitted against Giotto
even by some of his greatest admirers, but in the fresco of the
chapel of the Podestà this charge cannot be sustained. Each
form varies, yet harmonises with the other. In the features the
character of the person portrayed is distinctly revealed, and the
figures of Dante, Corso, Brunetto, and Charles of Valois, are the
best possible illustrations of the master's power of individualisation.

Nothing in the subject and arrangement of these frescoes but
suggests the date of 1301-2.[3] It may be inferred that Dante
would hardly have been introduced into a picture so conspicuously
visible as this, had not the poet at the time been influential in
Florence. United by family ties to the Donati, being married to
Gemma, a daughter of that house, and intimate with Forese and
Piccarda, the brother and sister of Corso, he was still by policy
a partisan of the Bianchi, and his influence did not survive their
fall. His exile and theirs dates from April, 1302. Dante's age
in the fresco corresponds with this date, and is that of a man of
thirty-five.[4] He had himself enjoyed the highest office of Florence
from June to August, 1300. In the fresco he does not wear the
dress of the "priori," but he holds in the ranks of those near
Charles of Valois an honourable place. We may presume that
the frescoes were executed previous to Dante's exile, and this

[1] As for the rest of the costume, in which the poet was painted by Giotto, it
consists of a white under cap, a red vest fastened at the neck with a lace, turned over
on the breast and relieved at the chin by a strip of white collar. Beneath the vest at
the bosom a green under coat appears. Dante holds in his left hand a book, and in
his right a stem with three pomegranates.

[2] DANTE, *Inferno*, canto xv., *v.* 30 ; BALBO, *Vita di Dante*, p. 54.

[3] Charles of Valois entered Florence on November 1, 1301.

[4] Dante was born in 1265.

view is confirmed by the technical and artistic progress which
they reveal. They exhibit the master in a wider sphere of
development than at Assisi and Rome.[1]

[1] It is worthy of remark that many years later, but still before the death of
Giotto, a decree was issued at Florence, prohibiting any rector or official of the people
or "comune" from painting, or causing or allowing to be painted, in any house
or place inhabited or used by such officers in the exercise of their duty, any picture;
and further ordering all such pictures, or statues, as manifestly existed, in contempt
of this decree, to be destroyed, with the exception of such as should represent the
Redeemer and the Virgin, or such as should represent a victory, or the capture of
a city to the advantage of the Florentines. Giotto's pictures in the chapel of the
Podestà were saved, no doubt, under one of these exceptions; but it would be curious,
were a list to be found of pictures or statues destroyed under this decree, which is
dated 1329. See the original in GAYE, *Carteggio Inedito*, tom. i., p. 473.

CHAPTER III

GIOTTO AT PADUA

THE well-known story of the O has been told by Vasari to illustrate the cause of Giotto's visit to Rome. The gist of it is that Benedict IX. of Treviso, having resolved to test Giotto's ability, sent a messenger to Florence to make the necessary inquiries. The messenger, having introduced himself as the envoy of the Pope, explained the intentions of his master, and asked for a specimen of the painter's skill. Giotto took a sheet of paper and a brush dipped in red, and, pressing his elbow to his side, described with one sweep of his arm a perfect circle. The Pope, to whom this specimen of Giotto's art was shown, accepted it as evidence of extraordinary cleverness, and the story, repeated from mouth to mouth, became the foundation of a pun on the word *tondo;* for it became proverbial to say of men of dull or coarse character that they were rounder than the O of Giotto.[1] Vasari prefaces this anecdote by saying that Benedict was led to make these inquiries because the fame of Giotto's illustrations to the life of Job in the Campo Santo of Pisa had reached him. We may accept the broad features of this story as genuine without blaming Vasari too severely for his ignorance of history. We know that Benedict IX. lived two and a half centuries before Giotto. We also know that Benedict XI. only ascended the papal throne after Giotto had been at Rome, and we shall refer the anecdote of the O to the period when Benedict XII. held his court at Avignon. The Job of the Campo Santo, we may have occasion to note, was the work of a later painter than Giotto.

In 1301 Enrico Scrovegno, a rich citizen of Padua, was raised

[1] VASARI, ed. Sansoni, i., p. 383.

to the rank of a noble by the republic of Venice, and devoted
some portion of his wealth to the erection of a chapel which was
completed in 1303 and dedicated to the annunciate Virgin.[1] The
painter employed to adorn its walls was Giotto, whose stay in
Padua we are able to establish in 1306,[2] about which time there
is evidence to show that Dante was on a visit to the city also.
It might be difficult to prove that Giotto was employed by
Scrovegno to erect as well as to decorate the chapel; but the
perfect manner in which the interior is adapted to its pictorial
adornment suggests and might justify that assumption. The fine
series of pictures which covers the walls of the Arena chapel is
so much in the spirit of Christian thought, so dramatic in the
force with which the pictures are designed, yet so simple in
form, that their meaning must be apparent to the least gifted
of mankind. They reveal in Giotto, young as he then was, an
intimate acquaintance with the character, the types, and the
passions of men.[3] They are conceived and distributed according
to the highest maxims of art, and presuppose uncommon taste
united to remarkable technical powers.

Erected in the form of a single vaulted rectangle, with a choir
merely separated from the body of the chapel by an arch, the

[1] BENVENUTO DA IMOLA in MURATORI, *Antiq. Ital.*, i., p. 1186; PIETRO
BRANDOLESE, *Pitture, etc., di Padova* (8vo, Padua, 1795), p. 213; ANONIMO, ed.
Morelli (Bassano, 1800, 8vo), pp. 23, 146; SCARDEONE, *B. Hist. Patav.*, vi., p. 378,
p. III. *Thes. antiquitatum*, J. G. GRÆVII (Lugd. Batav., 4to, 1722). A record
proves that the consecration took place only in 1305. *Vide* SELVATICO, *Scritti*
(Florence, 1859), p. 284.

"Dantino, quondam aligerii de Florentia nunc stat Paduæ in contrata Sancti
Laurentii," says a public record of 1306 published in *Novelle Letter*. (Florence, 1748),
p. 361, quoted in BALBO, *Vita di Dante*.

Vasari affirms that Clement V. asked Giotto to accompany him to Avignon
(VASARI, i., p. 323). The story of this journey we shall prove to be deserving of no
credit. Besides, in 1306 Giotto was at Padua, and though many paintings exist in
Avignon in the cathedral and papal palace, they are not by Giotto, but by Simone
Martini of Siena, as may be more fully proved hereafter.

* [2] The evidence as to the exact date of these frescoes is by no means conclusive.
It is certain that the construction of the chapel was begun in 1303, and that the
building was consecrated in 1305; but it is not known certainly whether it was
painted before or after its consecration. The probability is that the decoration of
the church was subsequent to the consecration. See LISINI, *Notizie di Duccio
Pittore, Bulletino Senese di Storia*, anno v., 1898, fasc. i., p. 43.

[3] "Adhuc satis juvenis," says Benvenuto da Imola.

building is lighted by six windows piercing the side to the right of the portal. Giotto arranged the subjects in obedience to traditional rules, but with a clear sense of their mutual value. On the wall above the entrance is the Last Judgment; on the arch leading into the sanctuary, the Saviour in Glory guarded by angels; beneath, the Annunciation; and in a triple course along the walls thirty-eight scenes of the life of the Virgin and Christ. These subjects are inclosed in a beautiful painted ornament, interrupted at intervals by framings containing subjects from the Old and New Testaments. All rest on a painted marble cornice supported on brackets and pilasters, in the intervals of which fourteen figures in monochrome represent the virtues and the vices. As in the chapel of the Podestà, so at the Scrovegni, the waggon roof is spanned by two feigned arches. The field of the vault is blue and starred, adorned in the centres with medallions of the Saviour and the Virgin, and, on the sides, with eight medallions of prophets. By this division of subject and of ornament an admirable harmony is created. The feigned cornice and bas-reliefs illustrate the ability with which Giotto combined architecture with sculpture and painting; whilst in the style of the ornaments themselves the most exquisite taste and a due subordination of parts are combined. We are at once struck, as we enter, by the grandeur of one great episode—that of the Saviour in Glory. Beneath him, as we have seen, the Annunciation; on the wall, at one side, the Salutation, and, facing it on the other side, Christ betrayed by Judas, prefigure the birth and death of the Redeemer. The incidents of the lives of Mary and of Christ follow in rapid succession on the side walls. Facing each other on the marble skirting, the virtues and antagonistic vices are pitted against each other. At the lowest part of the arch, leading into the choir, two interiors, in each of which there is a burning lantern, symbolise the light which guides man to virtue and the light which saves from vice. The practice of all the virtues leads to Paradise; accordingly, Hope is appropriately turned towards that part of the Last Judgment which comprises the happy. The pursuit of vice leads to the everlasting abyss; and Despair is seen drawn by a devil towards the everlasting fire of the Inferno.

From the earliest centuries peculiar attention had been directed to the distribution of certain classes of subject in sacred edifices. At Ravenna the majesty of the Saviour is fitly honoured in the apsis of basilicas. At Sant' Angelo in Formis the Redeemer stands in glory in the choir, and the Gospels are illustrated in the nave. The prophets are displayed beneath, and the Last Judgment above, the portal. At S. Maria Pomposa, where a modern hand has painted anew scenes from the Old and New Testament and from Revelation, the latter are placed on the arches of the aisle. In San Francesco of Assisi the incidents of the life of St. Francis, to whom the church is dedicated, are painted beneath those of the Old and New Testament. At the Scrovegni of Padua the place of honour in the chapel devoted to the Virgin annunciate is still reserved to the figure of the Redeemer, about which the gospel pictures are concentrated as already observed.

If we direct our attention to the order in which the episodes of the proto-evangelion and New Testament are placed, we shall find the first story told in the upper course of the side wall, to the right of the Saviour in Glory. The numbers then run round the building, and the thirty-eighth fresco is the lowest of the last course, by the side of the arch of the sanctuary, and to the left of the Saviour in Glory. It would ill suit the purpose of these pages to attempt a minute description of all these works in succession. An index, with such remarks as may be necessary to explain the actual condition of each fresco, will, however, be useful. Those subjects which deserve a more special notice may be dealt with at greater length afterwards. The series begins with :—

No. 1. The Rejection of Joachim's Offering. A well-preserved fresco.

No. 2. Joachim retires to the Sheepfold. Fine and grand are the figures of the old man with two shepherds watching the flock.

No. 3. The Angel appears to Anna. A well-preserved subject. It may be noted that in the movement of an old servant spinning, at one side of the picture, the painter has not merely reproduced a most natural action, but that he delineates as well as discerns the difference of quality between the types of various classes of people.

No. 4. The Sacrifice of Joachim. A middling composition.

No. 5. The Vision of Joachim. The angel appearing is here very

fine and natural in movement. The attitude of Joachim is well chosen and ably rendered.

No. 6. The Meeting at the Golden Gate.

No. 7. The Birth of the Virgin. The sky abraded or bleached.

No. 8. The Presentation of the Virgin. A fine and well-preserved subject.

No. 9. The Rods are brought to the High Priest. St. Joseph, nimbed, is of a well-defined character. The fresco is in a good state.

No. 10. The Watching of the Rods. In good condition.

No. 11. The Betrothal of the Virgin. The blues of draperies have all disappeared.

No. 12. The Virgin's Return Home. A very fine composition, but much damaged by time. The youths preceding the bridal pair and sounding trumpets have especially suffered.

No. 13. The Angel of the Annunciation, kneeling.

No. 14. The Virgin of the Annunciation, kneeling. This figure is agreeable and beautiful in movement and features, the face full of a serene and grave majesty.

No. 15. The Salutation is marked by much affectionate feeling.

No. 16. The Birth of Christ.

No. 17. The Offering of the Wise Men. A fine composition, in which the feeling, afterwards developed by Fra Angelico, may be noticed. The arrangement is the same as in the south transept of the Lower Church of Assisi. Again the blue of the Virgin's dress has vanished, and the red preparation alone appears.

No. 18. The Saviour before Simeon—the Warning. The angel is very fine, and the composition able. The blue draperies are obliterated.

No. 19. The Flight into Egypt. The affectionate action of the Virgin as she holds the infant Saviour, the admirable manner in which the two figures are grouped, are as remarkable as in the similar composition at Assisi. They also recall the bas-relief cut by Giovanni Pisano on the pulpit of Pisa. But here a beautiful angel leads the way. The blue draperies are rubbed off, and the red underground visible.

No. 20. The Massacre of the Innocents. This composition is scattered and less able than that of Assisi. The forms of the children are by no means fine, but the action is still very animated. The blues as usual have vanished.

No. 21. Christ among the Doctors. This fresco has been greatly altered, and is blackened by damp. The colours are in part gone, and where they remain are raw and unpleasant.

No. 22. The Baptism of Christ.

No. 23. The Marriage in Cana. This subject is preserved, and a few spots only disfigure the blues. We may note the classic forms of the vases.

No. 24. The Raising of Lazarus.

No. 25. The Entrance into Jerusalem. Much damaged, particularly in the blues of drapery and sky. Two or three heads are quite gone.

No. 26. Christ Expelling the Pharisees from the Temple. The composition does not lack beauty, but the vulgarity of certain heads is remarkable.

No. 27. The Hiring of Judas. A demon behind the traitor grasps his shoulder.

No. 28. The Last Supper. The blue draperies have all disappeared, and the nimbuses, with the exception of that of the Saviour, have become black.

No. 29. Christ Washing the Feet of the Disciples. This is by no means one of the finest of the series, and the execution is rude. The draperies, as usual, gone.

No. 30. The Kiss of Judas. Rude, but the colour of the lower parts of the figures has fallen, laying bare the under preparation.

No. 31. Christ before Caiaphas. Middling composition and rudely carried out. The red preparation for blues visible.

No. 32. Christ Scourged. A poor composition, ill rendered. The Saviour is stiff, motionless, and gazing.

No. 33. Christ bearing his Cross. Giotto is not free from the reproach of embodying the somewhat trivial idea of weariness in the Saviour because of the great weight of his cross. The expression of the Virgin is more masculine than is necessary. The draperies are in general damaged, and the figures in the background have suffered a great deal.

No. 34. The Crucifixion.

No. 35. The Pietà.

No. 36. The Noli me Tangere.

No. 37. The Ascension. This is a fine composition, in which the painter really conveys the idea of a form in motion, and a great advance is made upon the primitive representation of the same subject in the Upper Church of Assisi. Whilst there the Saviour's form is partly concealed, here he is completely visible rising on a cloud, surrounded by a choir of angels. Below him are the apostles.

No. 38. The Descent of the Holy Spirit.

It will be remarked that in this series of sacred history the upper course of frescoes is much better preserved, and more bright in colour, than the lower course.

Giotto has had to depict the birth of the Virgin as well as that of the Saviour. In the first he brings some of the usual graceful incidents together in a very charming way; in the second the moment is chosen when the Infant is given by its Mother to an attendant.

Two splendid figures in converse on one side of the Presentation in the Temple give quite a superior attraction to that noble picture.

The high priest in his *loggia* accepting the branch in the Presentation of the Rods (No. 9) is one of the most admirable of Giotto's studies of expression.

Feebler, yet still very fine, the Watching of the Rods remains impressed on the memory because of the grandeur of some of the kneeling figures of worshippers.

Giotto, in representing the episode of the Saviour's baptism, did not venture to alter a composition which had been repeated without change since the seventh century. The Saviour stands in a hole, St. John on the right, accompanied by two followers, pours water from a cup, whilst, on the left, two angels hold the Redeemer's vestments.

The Marriage of Cana is comparatively coarse in arrangement, and probably altogether a school fresco.

The Raising of Lazarus shows how literally the Bible text was followed by Giotto. The body and legs are twined in a sheet, as described in Scripture. Swaddled and incapable of motion, Lazarus is placed erect on the right receiving the blessing of the Saviour, before whom, to the left, Martha and Mary kneel in attitudes and with action highly expressive of confidence and hope. Surprise and thanksgiving are displayed in the features of the bystanders. The composition is superior to the execution in many parts, which were evidently executed by assistants.[1]

Though dramatically treated, the Crucifixion at Padua is less

[1] Two figures on the right of the foreground are replacing the cover of the sepulchre.

successfully presented than that of the Lower Church of Assisi.[1]
The proportions of the Saviour are correct, the form well chosen,
and the expression dignified and gentle, but pain is visible in the
features, and though we have parted with the hideous contortions
of past ages to resume the old form of serenity, the hands are
still a little contracted. The head is inclined in the direction of
the Virgin, who faints in the arms of the holy women and St. John
Evangelist. The group, however, is distinguished by force rather
than by feeling; and this may be noted as a general feature in the
frescoes of the Scrovegni chapel, where Florentine gravity more
constantly prevails than it does at Assisi. The Virgin is but an
ordinary woman in a swoon, but the angel, "uccel divino," whom
Dante so beautifully describes, tears his white dress and bares his
breast with extraordinary energy.

A better expression of the majesty and dignity of the Saviour
is to be found in the crucifix painted by Giotto for the Scrovegni
chapel, but now in the gallery of Padua. The head there is full
of repose and resignation, and renders the purely Christian idea of
the Saviour who perished for the sins of the world better than
any that has been hitherto noticed. Yet even here force, energy,
and thought are displayed rather than pure religious feeling.
Giotto painted many crucifixes, and an authentic record exists of
one which he executed in the early part of the century for the
church of Santa Maria Novella at Florence. In his will, dated
the fifteenth of June, 1312, Riccuccio quondam Pucci, of the
quarter of Santa Maria Novella, left a legacy of five pounds in
small florins for the purchase of oil to feed a lamp, all the year
round, before the crucifix painted in the church of the Dominicans
by "egregium pictorem nomine Giottum Buondonis, qui est de
dicto populo Sancte Marie Novelle." The same Riccuccio left
twenty pounds as a legacy to the Dominicans of Prato for a lamp
to burn before a picture by Giotto in the church of their convent.[2]
The crucifix now in Santa Maria Novella at Florence, though it
has been assigned to Giotto, is too obviously by one under the
influence of old defective models to be genuine. It has something

*[1] We have already noted that in several respects the Paduan frescoes reveal a
less developed style than those in the right transept of the Lower Church at Assisi.

[2] See VASARI, ed. Le Monnier, i., p. 329, note 4.

Giottesque in the attitude, and may be by Puccio Capanna, though
this is by no means certain.[1] But in San Marco and in the Gondi
Dini chapel of the Frati Umiliati in Ognissanti at Florence, two
crucifixes, evidently by Giotto, exist;[2] whilst a third, in San Felice,
may be placed, though with less certainty, in the same class.
These works embody a subject which was the test and touchstone
of the genius of the Christian painter in the fourteenth century.
They display the talents of Giotto at the opposite pole from that
of the painters who immediately preceded him. It would seem
that after a series of efforts, which lasted for centuries, Giotto
struck out the noblest and fittest ideal of the Saviour on the
cross. That it was difficult to create a better one is proved by
the sequel of Florentine art history. Not one of Giotto's pupils
improved the type of which he became the founder. Angelico
alone, after him, was able to realise the feeling of angelic resigna-
tion ; but in doing this he sacrificed the energetic reality which
characterised the age of Dante, and substituted for the more
natural type of Giotto one more becoming the essentially religious
feeling of a genuine monk. The crucifixion of Angelico in the
monastery of San Marco may be taken as the best illustration of
this truth.

The early conception of the Saviour, erect and alive on the
cross, is undoubtedly superior to that of the dead and suffering
Christ which later Pisan, Lucchese, and Aretine artists painted.
Giotto alters and improves the position of the figure, which he
represents almost erect though lifeless, and with the head softly
inclined. The proportions which he assigns to the frame are the
most correct that can be found; but his triumph is the regenera-
tion of the type. In the calm repose of a noble frame anatomi-

[1] Vasari mentions a crucifix in Santa Maria Novella partly by Puccio Capanna.
If the crucifix now in Santa Maria Novella be that to which Vasari alludes, it may
be by Puccio, whose style is not known; but the design is certainly not Giotto's
(VASARI, ed. Sansoni, i., p. 394).

* [2] Many modern connoisseurs deny that these works are by Giotto himself. It
appears to the editors that the crucifix in San Marco is nearer to the style of the
master than that at the Ognissanti. But the editors do not regard either crucifix
as a work of Giotto himself. There is another crucifix of the school of Giotto in
the Museo dell' Opera di S. Croce [No. 3]. These works came perhaps from Giotto's
bottega.

cally realized in muscle and articulation, he renders suffering
without contortion, and rivets attention by perfect harmony of
lines. There is no material display of muscular form, no useless
exhibition of ribs and tendons as in the sculpture of the Pisans.
The perfection of form which the old mosaists preserved is no
doubt unattained, but the result is an ideal certainly in accordance
with Christian feeling.

One peculiarity of the crucifixes of the fourteenth century is
the disappearance of the side panels, which may be noticed in the
crucifix of Giotto at San Marco of Florence.

At the extremities of the arms are the busts of the Virgin and St.
John in desolation. Above the Saviour's head a pelican strips its
breast, whilst at the foot of the cross a death's head with a small figure
in prayer typifies Adam.

The crucifix in the Gondi Dini chapel at Ognissanti is surmounted by
a medallion figure of the Saviour in the act of benediction and holding
the book. The youthful head, with its abundant locks, is of a fine
contour, and regular and dignified in type. The calm features of the
crucified Redeemer, on the other hand, contrast with the agitated look
of the Virgin and St. John at the extremity of the horizontal limbs.
Again, the position of the crucified body, the lines of the frame are less
simple in direction and curve than those previously noticed ; the anatomy
is more studied ; more suffering is expressed in the head, and the hips
are of more than usual breadth ; the feet are nailed over each other ;
and some contraction in the hands indicates pain. Nor is the subordina-
tion of the parts as well maintained as might be desired ; but the general
outline is the most perfect as yet rendered by Giotto.[1]

In the crucifix of San Felice at Florence, which presents the
character, type, and outline of those of Giotto, a certain progress in
the art of moulding out the articulations with studied anatomy is
noticeable. The Virgin, and St. John resting his head on his hand,
both in desolation at the extremities of the horizontal limb, are very
expressive figures. The lights and shades are well managed throughout,
but the execution is an advance upon the age of Giotto. Yet it would
puzzle us to say which of his pupils, supposing Giotto not to be the
author, could attain to such perfection.

[1] In the crucifix of San Marco the flesh tone is light and clear. In that of
Ognissanti the light and harmonious colour is a little livid, as if Giotto intended
to give the idea of a dead body. See VASARI, ed. Sansoni, i., p. 394.

Returning from this digression we resume the examination of the frescoes in the Scrovegni chapel at Padua.

In the Pietà, Giotto not only produced one of the finest arrangements in the edifice, but one almost equal to the best composition that he ever created.

The gradual transformation of this subject, from its typical form in the aisle of the Upper Church of Assisi to one more artistic in the present series, is most interesting to study. At Assisi the Saviour lies stretched on the verge of the foreground. The Virgin, the Marys, and the Evangelist are placed by the painter at the head, feet, or side of the principal figure, which is thus in full and unobstructed view. Giotto, with consummate art, now adds three figures to the group, placing them so as to form a composition, the balance and distribution of which are perfect. The Virgin has raised on her lap the head and shoulders of the dead Saviour, whilst in a circle round her three women stoop, grieving or assisting. Two females at each side of the body kiss the lifeless hands, and in rear of them St. John Evangelist bends his looks and frame to the Redeemer, and throws back his arms in the attitude which had now become a favourite of the master. The Magdalen holds the Redeemer's feet. Ten angels flutter over the scene with wild grief, terror, and surprise in their features. The painting of this fresco is most careful, and, in the Saviour, minute to a surprising degree. But side by side with this careful handling appears that of the master himself giving the final touches, and with a broad and sweeping hand laying in masses of spacious light.

The Noli me Tangere, though of less absorbing interest than the Pietà, is still worthy of special attention. Yet the Magdalen has not the look of supreme longing which is so attractive in the same subject at the chapel of the Podestà. The figure of the Saviour here may explain, also, that which is wanting in the mutilated one at Florence.

The Virtues and Vices are the complement of the lesson which the painter here attempts to give. The former are naturally all turned in the direction of the Paradise; the latter face the Inferno above the door of the chapel.

Hope had been represented by Niccola Pisano, in the pulpit of Siena, as a female looking up to heaven. It was afterwards conceived in the bronze gates of the baptistery of Florence by Andrea Pisano as a winged female, seated, but raising her face and arms with supreme

confidence towards a crown above her. Giotto, at Padua, imagined the
figure winged, but erect, and, as it were, raised from the ground by the
ardent desire to attain the crown held up to her view by the Saviour.
In the costume, the drapery, the cast of the profile and dress of the
hair, Giotto almost attains the severe elegance of an antique bas-relief.
Despair is a vulgar female with clenched hands, struggling in the
agonies of death, self-imposed with a cord. The devil with a prong
drags the figure towards the abyss close by.

Charity stands with a triple flame issuing from her head, a garland on
her brow, and a vase of flowers in her right hand. Looking up, she
offers a burning heart to the Lord.[1] Envy, on the opposite side, is
a fine contrast. Grasping, with claws instead of hands, a purse, the
horns on her head twisted round with a piece of drapery, and standing
in the midst of flames, she is bitten on the forehead by a serpent
issuing from her own mouth.

Faith, a majestic figure, with a diadem, faces the spectator, resting a
cross on a prostrate idol, and holding a scroll inscribed with the Creed.[2]
Unbelief, at the opposite side, is signified by a helmed warrior, winking,
and with his right holding an idol. The idol, bound to him by a string,
leads him towards the flames that burst from the left-hand corner of the
foreground. Unbelief, whose ears are covered with the lappets of a
cap, seems deaf and heedless.

Impartial justice is ably suggested by Giotto in a majestic sitting
figure, crowned, in a tunic and mantle, holding at an equal height the
disks of a balance. In one disk an angel, like an antique Victory,
crowns Industry, seated behind an anvil.[3] In the other an angel cuts
off the head of a criminal.[4] The symbolic meaning of this allegory is
aided by a feigned bas-relief beneath it, in which a group of three
figures is beautifully depicted in dead colour. A player clashes cymbals
for two dancers; whilst, on each side, two figures on horseback are
seen returning from the chase.

The natural counterpart is Injustice, in the dress of a judge, resting
his left hand on his sword, and with his right, which is a claw, grasping
a double hook. He sits within a fortress, the approach to which is
impeded by trees. In a feigned bas-relief below, the figure of a female

[1] This figure is badly damaged by a vertical split in the wall, which cuts it into
two. There was here originally a door.

[2] Two heads at the upper sides, of an angel and a spirit, have some meaning,
now difficult to divine.

[3] The head of this figure is obliterated.

[4] The head of this figure is damaged.

lies stripped near a pond, and three soldiers are plundering her. On the left a restive mule is held by a thief near the dead body of a man.

Temperance is indicated by a draped figure curbed with a bit and holding a sword, of which the blade is tied to the scabbard, Anger by a woman with swollen features and dishevelled hair tearing the dress from her breast.[1]

Fortitude, which Niccola Pisano had represented in the guise of a youthful Hercules in the pulpit of Pisa, is represented by Giotto as a female in a cuirass, protected by a shield up to the eyes. On the shield, embossed with a lion, the arrows of fortune have fallen and been blunted. In her right hand she carries a mace; on her head the face of a lion.

Inconstancy is a girl vainly trying to balance herself on a wheel rolling over polished marble. She has already lost her veil, which flies away and gives to the scene a semblance of motion.

Prudence, with two heads, the one aged, the other youthful, holding a mirror and sitting with a compass at a desk, is contrasted at the opposite side by Folly, a pot-bellied and grotesque personage, wearing a head-dress of feathers, shaking a mace in his right, and making a gesture of defiance with his left.[2]

In the principal series of frescoes it is obvious that Giotto was aided by his pupils. His own hand probably traced every one of the Vices and Virtues. He never exhibited more care in the choice of the materials, or displayed greater qualities of mind or of hand, than are here to be found united. Beauty of form and of drapery, variety in expression, good design, precision of hand, great blending of colour, and broad relief of light and shade, all combine to make these allegorical figures worthy of study.

In the Last Judgment above the portal of the chapel, Giotto was assisted in covering a vast space by the industry of his assistants; and it is apparent that, in the Inferno at least, their labour was below the standard of the rest of the paintings in the building. Yet as regards distribution, the Last Judgment must be admitted to fulfil the requirements of the highest art.

[1] The mouth is contracted by anger. The head of the figure is slightly damaged.
[2] Completely new on fresh intonaco; traces of Giotto's figure visible at the sides of the new one. These figures will be found marked alphabetically in the plan of the Arena chapel, from *a* upwards, in the order in which they are described.

On each side of three small windows throwing light into the edifice from the highest elevation, two warrior angels seem to hold back a curtain, disclosing, as it were, a hall of justice, over which the sun and the moon shed their light. Warriors with shields and swords, angels with flags and tapers, hold guard in three mighty divisions over the majesty of the Saviour, who sits below them in a glory, borne by countless cherubs and seraphim. At the four cardinal points the archangels sound the trumpets of the judgment, whilst the Redeemer, with the features of perpetual youth,[1] holds up his right hand to bless the happy, and curses the evil-doers with his left. At his sides two winged figures in armour, and lance in hand, with aged heads, the bodies of centaurs, and the limbs of goats, stand in attitude of watchfulness.[2] In a long row of thrones on each hand the apostles sit, all marked by their peculiar and individual character, and for the first time in perspective order.[3] To the left of the Saviour's feet the Virgin, crowned with a diadem,[4] majestically draped, and carried by angels in a glory of rays, heads the procession of the happy, leading the aged St. Anna. Monks, bishops, saints, male and female, follow, guarded by angels.[5] Amongst them, in a corner to the left, three figures stand in profile, the centre one of which is, according to tradition, the portrait of Giotto himself.[6] The cross, symbol of redemption, held aloft by two angels in the centre of the space, separates the elect from the doomed. Between it and the procession to Paradise, the donor, Enrico Scrovegno, in a purple dress and bonnet, kneels before a group of three female figures, presenting, as it were, to their notice the model of the chapel, supported by a priest in white. The Virgin, heading the group, stoops to receive the homage. In the foreground the Resurrection completes that side of the picture. From the Saviour's feet a torrent of fire pours its fury out on the right, sweeping away a host of struggling souls in its course. Lucifer, the chief of this seething

[1] In a red tunic and blue mantle ; but the latter has fallen from his shoulders.

[2] Of these two figures, that to the right is partly effaced.

[3] A part of the left side of the fresco is damaged and the intonaco gone. One of the apostles and half of another are completely obliterated, and likewise several figures beneath them.

[4] She wears a gold tunic and white mantle.

[5] Many figures in the procession are gone, others damaged, and in some places the intonaco threatens to drop.

[6] Yet here the face is that of a man older than the so-called portrait of Giotto in the chapel of the Podestà at Florence, and certainly contradicts the words of Benvenuto da Imola, which describe the painter as "satis juvenis."

domain, sits in the lowest part of the abyss, colossal and triple-headed, on two dragons, whose mouths engulf sinners, his ears being two serpents with figures in their jaws, whilst a crowned head grins between his legs. It is a confused and rudely executed scene of torment.[1] The figure of Lucifer is not carried out as in the chapel of the Podestà at Florence, and the pupils of Giotto, together with restorers, have effectually reduced the value of this portion of the fresco.

Whatever may have been Giotto's reputation previous to the completion of this noble work, it could not but have increased. In wealthy Padua it was acknowledged and rewarded by numerous commissions; and the frescoes recovered not many years ago in the church of Sant' Antonio not merely testify to his industry and skill, but prove his prolonged residence in the city.[2]

The church of Sant' Antonio was commenced about the middle of the thirteenth, and finished, with the exception of the cupola over the choir, in the first years of the fourteenth century.[3] Giotto painted in the chapter house incidents of the lives of St. Anthony and St. Francis.[4] But the edifice having been three times burnt out, in 1394, 1567, and 1749, these paintings were destroyed or mutilated by repairs. A new vaulted roof was built beneath the original ceiling; and the principal subjects, which doubtless were placed above the painted cornice at present visible, were lost. "The beautiful chapel," which Vasari was still able to describe in the sixteenth century,[5] was thus altered in shape, and now forms a species of hall in the vicinity of the sacristy, lighted

[1] The colour here is in part altered, in part obliterated. Three figures of a more modern kind seem painted over others of a better style, of which the vestiges can still be distinguished.

[2] " Et tantum dignitas civitatis eum commovit, ut maximam suæ vitæ partem in ea consummaverit" (MICHELE SAVONAROLA, "De Laudibus Patavii," in MURATORI, *Rer. Ital. Scrip.*, tom. xxiv., col. 1170). Savonarola wrote in 1440. Vasari makes Giotto pay two visits to Padua (ed. Sansoni, i., pp. 388, 400). In the second only, according to the Aretine, Giotto painted in S. Antonio, being commissioned for that purpose by the Scaligeri.

[3] "Anno M.CCC.VII opus illud perfectum est." BERNARDINI SCARDEONII, "Hist. Pat.," in *Thes. antiquitatum*, by J. G. GRÆVIUS (Lugd., Bat., folio), vi., part iii., p. 104); BRANDOLESI (P.), *Pitture, etc., di Padova* (Padua, 1795, 8vo), p. 23.

[4] "Capitulumque Antonii nostri etiam (Giotto) sic ornavit" (SAVONAROLA, Com., *u.s.*, MURATORI, xxiv., col. 1170.

[5] VASARI, ed. Sansoni, i , p. 388.

from the cloisters of the old convent. It was apparently white-washed after the change, and is now in a state not unlike that of the chapel of the Podestà at Florence. Still the drawing and movement of several beautiful figures enable us to admire Giotto's majestic forms and variety of individual types.

Entering the hall from a door recently opened from the sacristy, to the total destruction of some amongst the remaining frescoes, we may still see the remnants of six figures in niches, supported on a painted cornice and separated from each other by painted pilasters. In one is the standing figure of St. Clara, whose face is one of the least damaged in the building. In others, St. Francis, without hands, and repainted as to the feet, but fairly preserved as regards the head; part of the features of an aged saint, of stern aspect; a much-damaged representation of a prophet; and an equally damaged one of a personage crowned with a diadem. On the opposite wall, at each side of an altar, in similar niches, three figures; one, of an aged person of grave character, much altered by damp; another of a youth, holding up his hand as if in the act of speaking; St. Anthony with a scroll in his hand, partly rubbed out and partly restored; and a portion of a painted skeleton.[1] Little has been saved of the painting on the wall to the left of the entrance, except the two lunettes. In one of these, St. Francis receiving the Stigmata from the Saviour in the form of a Seraph, we have the mere outline of a composition similar to that of the picture in the Louvre[2] by Giotto. In the other, besides the Annunciation, the Martyrdom of the Franciscans at Ceuta is partially preserved, and the tyrant, who orders the execution, may be seen enthroned in the centre of the space. In the Annunciation, the figures of which are diminutive, it is worthy of note that Giotto expressed in the face and raised arms of the Virgin, a certain surprise and terror at the visit of the angel: a new mode of representing the subject, which moved Vasari in another place to some wondering remarks. It is characteristic of the haste with which he wrote that, whereas he might with propriety have made those remarks upon the Virgin at the Santo, he lavished them upon a picture falsely assigned to Giotto and now proved to be by Lorenzo Monaco.[3]

[1] The figures in two of the niches are gone.
[2] The outlines and first preparation in verde are here alone preserved.
[3] VASARI, ed. Sansoni, i., p. 373.

It has been affirmed that Giotto also painted in the great Salone of Padua.[1] In one of the compartments of the hall, to the right of the principal entrance, an astronomer is represented sitting, beneath which the name of Giotto is inscribed. Yet, neither this nor any other fresco of the vast number which now decorate the walls, is in the manner of Giotto; and it is clear the Salone, as it now stands, was adorned by several hands, a part of whom only were under the influence of the Giottesque manner at the close of the fourteenth century.[2]

Vasari states that Giotto went from Padua to Verona, where he finished for Can Grande a portrait and other works, and, for the church of San Francesco, an altarpiece. None of these paintings exist, and we know of nothing that can be assigned to Giotto except the two grand kneeling profiles of William of Castelbarco and the prim Danielo Gusman on the archisesto of the choir in the church of San Fermo.[3] At Ferrara also, as Vasari relates,[4] Giotto produced various paintings in the palace of the Duke of Este and in the church of Sant' Agostino, but these also have disappeared. At Ravenna, however, we find original frescoes by Giotto in a ceiling in the first chapel to the left, in the church of San Giovanni Evangelista.[5]

Here Giotto depicted, in a ceiling divided by two diagonals, at the centre of which the lamb and cross are painted in a medallion, the four doctors of the church and the four Evangelists enthroned, and above

[1] RICCOBALDO FERRARESE, in his *Compilatio chronologica*, says : " Zotus, pictor eximius Florentinus agnoscitur . . . Testantur opera . . . quæ pinxit in Palatio Comunis Paduæ, et in ecclesia Arenæ Paduæ." MURATORI, *Rer. Ital. Script.*, tom. ix., p. 225. Riccobaldo died in 1313, and the paintings of Giotto must therefore have been executed previous to that time. See JÖCHER (C. G.), *Gelehrten-Lexicon*, Bremen, 1819, and Muratori's preface. The Salone was burnt down in 1420.

[2] In the mortuary in the church of the Eremitani at Padua, there is an enthroned Virgin and Child with a kneeling patron, Giottesque in style.

[3] The figure of Castelbarco in a baronial cap and red dress, with the model of a church in his hand, is injured. But this fresco is not to be confounded with others higher up on the same wall which are by a painter of the sixteenth century. Consult VASARI, ed. Sansoni, i., p. 388.

[4] VASARI, ed. Sansoni, i., p. 388.

[5] *Ibid.* The frescoes in San Francesco are missing.

* Some critics regard the frescoes of S. Giovanni as the work of one of the followers of Giotto, who painted in Ravenna and its neighbourhood.

them the symbols of the Evangelists. Though much damaged by restoring, and veiled as it were with a greyish glaze, there can be no doubt of the authenticity of this fresco, in which Giotto exhibited all the qualities of which he was so complete a master in his prime. St. Ambrose and St. John sit facing each other in one compartment, the former, with his hand on a scroll, looking at the Evangelist, who holds a book half open on a desk in front of him.

St. Augustine, who reads, is inspired by St. Matthew, who mends his pen. St. Jerome reads, while St. Luke holding a pen looks at him. St. Gregory sits with his right hand in the act of enforcing speech, while St. Mark sits pensive with a pen in his hand. Each of the figures has a gold nimbus and the background is a starred heaven. The symbolic figures above each hold a book and are nimbed. The lion is fine, the angel in admirable repose. Yet all these figures have been retouched.

Many churches and edifices in Ravenna are adorned with paintings attributed to Giotto, but they will not bear the test of examination, any more than those of S. Maria Pomposa which Federici assigns to him. Like those of Santa Maria in Portofuori outside Ravenna, and in the ex-chapel of the abandoned church of Santa Chiara (now attached to a riding school[1]) in Ravenna itself, these paintings are by humbler artists, as we shall have occasion to observe.

* [1] Now the Ricovero di Mendicità.

CHAPTER IV

PERUZZI AND BARDI

AMONGST the potent families of Florence in the fourteenth century that of the Peruzzi was most distinguished, for the extent of its trading connection, the greatness of its fortune, and the generosity with which it patronised the church of Santa Croce. From the time when that edifice first rose from its foundations, the Peruzzi subscribed largely to its erection, and built at their sole expense a chapel or sacristy, which was adorned with frescoes by Giotto. "Nor," says Cesare Guasti, "did the reverence of the family for those sacred walls and for art diminish with the lapse of years; but there came a time when that reverence was obscured by a fatal niggardliness, when to restore meant to destroy." So when we read on the floor of the chapel that Bartolommeo di Simone Peruzzi caused it to be restored in 1714, we guess that the brush of a whitewasher ruthlessly covered the pictures which Giotto had painted on the walls.[1] In 1841 the dance of the daughter of Herodias was uncovered; later, the Ascension of the Evangelist; and at the commencement of 1863 the rest of the scenes from the lives of the two St. Johns were restored to the light. We have no authority upon which any reliance can be placed to fix the time when these frescoes were executed. But there is some evidence to show that Giotto, who had been at Padua in 1306, had returned to his old abode in Florence in the following year;

[1] GUASTI, *Opuscoli*, p. 6. Confirmed by the fact that when Cinelli, in 1677, republished the *Bellezze di Firenze* by Bocchi, the paintings of the Peruzzi chapel were still in existence; whilst in 1754, when Richa published his *Chiese Fiorentine*, they were no longer visible.

and if, as a local annalist affirms, Giotto made a donation to the
Company of Or San Michele in 1307, we may assume that he was
then in a position to begin the finest series of frescoes which he
ever produced.[1]

Passing under eight half-figures of prophets in the vaulting of the
entrance arch of the Peruzzi chapel, many of which are damaged by
restoring, passing by the symbols of the Evangelists in the ceiling, we
meet with two series of subjects on the walls of the chapel. One side
is devoted to the life of the Evangelist, the other to that of the Baptist.
In the lunette of the latter Zacharias stands on the steps of the altar
waving a censer, with two lute-players and a piper behind him, when
suddenly he draws back at sight of the angel, who appears under the
altar-porch, and gives him the news. Two women behind the angel
witness the scene. The lower course contains a fine composition of the
Precursor's birth: St. Elizabeth on her bed (head repainted) hardly
attends to the question of a maid, near whom another maid, with a vase
in her hand, looks at a grand figure with his back to the spectator. A
partition separates this from the next scene, where Zacharias, to the left,
writes the child's name in a tablet on his knee. He glances as he does
so at the infant, held up naked before him by a male and female figure,
behind whom stand three others. Beneath again (third or lowest course),
Herod sits with two guests behind a table in a portico. In front of him
a soldier presents the nimbed head of St. John the Baptist on a plate.
The daughter of Herodias dances in front of the table to the sound of
her own lyre, timing her steps to the strains of a viol played by a youth
who stands to the left of the picture. Two figures behind her converse
as they look at the dance, whilst to the right Salome kneels with the
head before Herodias. In the lunette of the opposite side the Vision of
Patmos is depicted: the Evangelist asleep on a solitary rock, above him
in a cloud "the Son of man" holding in his hand a scythe, on his right
the angel calling on time to reap, the travailing woman pursued by the
dragon, the mystic child in its cradle, the angel and the four beasts; the
whole much damaged and repainted. Beneath this is the Resurrection of
Drusiana: the saint on the left of the picture, with one kneeling at her
side; two followers; a cripple on crutches, and two other spectators
behind; in front, the kneeling relatives of Drusiana, who has risen on
the couch held up by a bearer behind her; the priests and clergy.
Finally, in the lowest course, the Resurrection of the Evangelist.

[1] RICHA, *Chiese.*, *u.s.*, i., p. 13.

None of Giotto's wall paintings is more perfect as a composition than the Apparition of the Angel to Zacharias. The troubled look of the priest as he waves the censer and shrinks before the messenger is very well rendered. No painter of the time has given a finer form to an angel. In the Birth of the Baptist we admire the grandeur of the composition, the antique pose of Elizabeth, the grace of the females at her bedside, and the masculine force and concentration of the standing figure. The grave Zacharias, close by with his legs crossed, reminds us of the classic statuary of the Greeks. We are struck by the natural motion of the aged man who grasps the infant's shoulder, and the portly stature of the woman, who looks on smiling.[1]

Although little beyond the outlines of the dance of Herodias is preserved, that little displays a faultless precision of arrangement. In no picture by Giotto are the figures distributed with more art, or the groups bound together with more nature. The viol player is comely and admirably set on his legs; his action is perfect, his expression full of contentment; his eyes are no longer indicated in the old conventional way, but drawn in perfect accordance with nature. His foreshortened features are rendered with perspective truth. The purest profile is given to Salome kneeling before Herodias;[2] and surprise is ably depicted in Herod's guest, who sits at the end of the table with a knife in his right hand, and his left raised in wonder.

But Giotto surpassed himself in the next series, where, if we set aside the composition of the Vision, much damaged by various accidents, the Miracle of the Resurrection of Drusiana and the Ascension of the Evangelist display a classic grandeur which, in spite of the absence of colour,[3] may be considered a marvel of the

[1] We grieve at the fact that in the whole of these three compositions the backgrounds have been so repainted by the restorer in heavy tones as to damage the general aspect of the whole, to deprive the figures of aerial perspective and the outlines of their softness.

[2] The head of Herodias is a mere outline, and that of Salome, kneeling before her, has lost the freshness of its colour, but has great beauty of form, as well as of expression. The hand of Herod is damaged, as is likewise the head of the saint in the hands of the soldier. The form of the viol-player is perhaps a little broad. Behind him in the background is a fine, double-storied, square tower.

[3] The colour is altered by abrasion, and retouched in many places; and the outlines are mostly refreshed.

age. Life and animation are conspicuous in the kneeling females at the Evangelist's feet, particularly in the woman in profile, whose face expresses undoubting faith. The true figure and form of the cripple,[1] the fine movement of Drusiana,[2] the interesting group on the right, the beautiful play of lines in the buildings, all are calculated to enhance the impression which the picture creates.

The Ascension is, if possible, still more severe and classic.

Giotto imagines St. John rising from the tomb in the centre of the church, the lines of which are broken by the descent of the Saviour and his celestial guard, who stoop to help the aged apostle to ascend, and shed around him the rays of their glory. To the right of the opening a prostrate man is struck by the wondrous brightness that prevails, and hides his head in his hands. Another, looking up, protects his eyes with his fingers. The ministers of religion appear with the cross, the book, and tapers. To the left of the grave one with his finger to his mouth stands in doubt; immediately in front of him an aged disciple bends an inquiring glance into the grave; a third in rear of the latter rises from a stooping attitude with an air of conviction; a fourth expresses wonder; whilst a fifth, looking up, is surprised, as he sees St. John ascending.

In these five figures Giotto realises a sequence of ideas as plainly almost as if he had spoken. The maxims illustrated in the miraculous healing of the sick man at San Francesco of Assisi are here applied anew and with increased power. The laws applied to a single group are maintained at the same time in the connection of each group with the other, and with the architecture, to which light and pleasing proportions are given. It would be difficult to find a figure more grand than that of the ascending apostle, one in finer and more energetic movement than that of the prostrate disciple, or one more natural than that of the man veiling his eyes from the light emanating from the Saviour. Not less remarkable is the ability with which Giotto

[1] His arms and legs are repainted.

[2] What shall be said of the restorer here, who makes Drusiana point with her finger towards the Evangelist: a senseless motion which Giotto would never have conceived.

repeated in this fresco the figures of the resurrection of Drusiana, without sameness of attitudes, movement, or expression.[1]

In Santa Croce Giotto painted three chapels besides that of the Peruzzi for the families of Bardi, Giugni, and Tosinghi and Spinelli;[2] of the two last the frescoes are still under whitewash, but those of the Bardi chapel are once more exposed to view.

Ridolfo, the son of Bartolo de' Bardi, who filled the highest offices of the republic in the thirteenth century, was bred to the profession of arms. He fought against Louis of Bavaria and the Ghibellines in 1327, and was conspicuous amongst the patriots who warred against Mastino della Scala. Almost ruined by the insolvency of Edward the Third of England, yet still powerful enough to rouse the jealousy of the Florentines, his family preserved its influence, conspired against the State, and tasted the bitterness of exile. At what period a man so busy as Ridolfo was found time to build and adorn a chapel, it seems now useless to inquire. It is sufficient to observe that he could scarcely have done so previous to 1310, when Bartolo de' Bardi died. Like many Florentine nobles, the chief of the Bardi family showed partiality to the mendicant order,[3] and his chapel was exclusively adorned by Giotto with episodes of the life of St. Francis. In three courses upon two of the walls he represented the saint surrendering his worldly substance, the institution of the order, the ordeal of fire before the Soldan, the apparition to Anthony of Padua at Arles, the transfer to Santa Maria degli Angeli, the bishop's dream, and the death of St. Francis.

[1] The preservation of this fresco is not good; and it is again surprising, not that one should find in it beauty of composition, but that the impress of the painter's thought and versatility in expression should still be there. Yet this is so, and to Giotto, for these works alone, must be awarded this praise, that having studied and thought out every possible phase of his subject, he displayed them all in composition, movement, expression, and design. Happily for the student, this fresco has only been partially restored—the figure most damaged by this operation being that on the right in profile. The restorer, having gone so far, perceived that he was only spoiling the fresco, and left the outlines of the remainder as he found them. It may therefore still be observed that the picture was painted in large and few portions on a surface of excessive smoothness. The broad and well-modelled shadows were painted in with a soft ashen colour, merging through clear half-tints into broad massive lights—the whole nicely fused together.

[2] VASARI, ed. Sansoni, i., p. 374.

[3] CESARE GUASTI, *u.s.*, *Opuscoli*, p. 28.

In the first of these scenes, which covers the lunette to the left, Giotto closely follows, yet improves the subject as represented in the Upper Church of Assisi. The angry father, held back by the consuls and his friends, seems desirous of darting at his son, whose clothes he holds on his arm. But St. Francis is already under the protection of the bishop, who covers his nakedness with the episcopal mantle. In form the saint is youthful and more agreeably depicted than at Assisi. The subject also, as given in the legend of St. Buonaventura, is better composed, yet more literally carried out, than before. A child on the left is held back by a woman who prevents him from throwing stones. Another mischievous varlet on the right threatens to stone St. Francis, and is restrained by a priest of the bishop's suite. The idea in embryo at Assisi is thus fully developed in the very words of the legend.[1] In the opposite lunette St. Francis kneels and receives from the pope, enthroned with two bishops at his side, the approval of the rules of the order. The principal charm of this composition lies in its simplicity.[2]

The Soldan may be seen, in the course below the first lunette, seated on a throne, and energetically pointing out to his reluctant imams the example of St. Francis, who approaches a fire with the intention of passing through it, to the astonishment of the attendant monk, whose attitude and look are those of doubt and hope. On the left two attendants of the Soldan endeavour to encourage the infidel priests to imitate the firmness of St. Francis, whilst they retire with consternation in their faces. The energy of movement and expression in this much-damaged fresco is remarkable.[3]

The apparition of the saint to Anthony in the church at Arles is given with less energy than at Assisi. The expression may have been better in the fresco at Florence, but this we can no longer clearly discern.[4]

As St. Francis was carried on his bed to Santa Maria degli Angeli, he stopped on the road to bless the city of Assisi. His death was revealed at the very hour of its occurrence to the Bishop of Assisi on Mount Gargano. These two subjects Giotto represents in one fresco at

[1] This lunette has suffered, but is that which has received the least subsequent restoration; but we notice retouches in the flesh of St. Francis, and the dresses of other personages. The background is a fine piece of architecture.

[2] Much injured at the sides of the composition are four lay spectators in couples.

[3] The figures are in great part repainted, amongst the rest the whole of the background and the lower part of the figure of St. Francis.

[4] St. Francis, in both frescoes, appears in the centre of the church, Anthony standing in the attitude of a preacher at the left end of it, whilst the audience of monks is seated in a triple row along the picture.

the Bardi as they had already been given in the great sanctuary, but in a more appropriate form. A monk raises the curtain of the bed as St. Francis sits up with his hands in prayer. Another reads at the foot of the bed, whilst the rest of the brethren stand around grieving. Close by the saint appears at the foot of the couch, on which the bishop sleeps, and is seen by an attendant crouching at the head of it. A second attendant sleeps at the foot. Little of the original design remains unimpaired.[1] Where St. Francis, on his death-bed, lies outstretched and bewailed by the brethren, the incredulous Girolamo kneels at his breast, and puts his finger in the wound. Two monks kiss the dead saint's hands, two more his feet. Four behind the litter stoop, looking at the corpse with grief and regret. The clergy, with tapers and cross, stand at the foot, whilst the funeral service is read at the head. One monk, looking up, sees with wonder the ascent of the saint to heaven, in a glory supported by angels. The composition of this scene is a masterpiece which served as a model to Ghirlandaio and Benedetto da Maiano.[2]

The ceiling of the chapel, cut into four by diagonals, is adorned with the three virtues peculiar to St. Francis, and proclaimed by the brothers of his order.[3]

At the sides of the altar, and in the entrance vaulting of the

[1] After the fresco was whitewashed a monument placed against the wall cut away the whole of one and the greater part of the other figure of St. Francis, besides one half of the monks on the left side of the first subject. The remainder has suffered from retouching.

[2] A tomb placed against this fresco damaged the three figures kneeling in front of the bed, and part of the standing clergy at its head and foot. One may mark two spectators on the extreme left of the picture, one of whom, according to Vasari, is Arnolfo, the architect of Santa Croce. St. Francis in the glory is new, but the angels are in part preserved. The rest has all been more or less retouched, and no judgment can be given as to the colour of this or any other of these works.

[3] Poverty, Chastity, and Obedience, and St. Francis in Glory, occupy each a space in the ceiling. Poverty, a lean but graceful figure, crowned with roses and briars, is dressed in a tattered garment, bound to the waist by a cord. In her left hand she carries a stick, with which she seeks to defend herself from a dog that barks at her. It is a figure which, being less damaged than many in the chapel, discloses the versatility of Giotto in rendering a subject already differently treated at Assisi. The figure is, like its companions, framed in a pentagon of curves. Chastity, a mantle covering her head, is seen from behind, in her tower, with two angels flying at her sides. Obedience is symbolised by a monk with a yoke, and his fingers to his lips. St. Francis, with his arms up, shows the stigmata. They are on blue ground, and all more or less retouched.

chapel, saints are represented, of which a St. Clara best preserves its original character.[1] Outside, above the arched entrance to the chapel, a figure of St. Francis receiving the stigmata has recently been cleared of superincumbent whitewash. It is a very powerful representation of a subject which Giotto frequently painted.

On the outer arch of the Tosinghi chapel another fresco of the master has recently been discovered. It represents the Virgin in a glory taken to heaven by angels, of which, unfortunately, little that is worthy of admiration has been preserved by the restorer.

The church of Santa Croce was quite a museum of the works of Giotto, for, besides the frescoes in the private oratories of four or five great Florentine families, it contained a vast picture on panel with which the Baroncelli adorned their chapel. A sepulchral monument, to the right of its entrance, contains an inscription to the effect, that in February, 1327, the chapel was completed by Bivigliano Bartoli, Salvestro Manetti, Vanni, and Pietro de' Baroncelli in honour of God and of the Virgin Annunciate to whom it is dedicated. It is not to be assumed that Giotto's altarpiece of the Coronation of the Virgin was executed in 1327, for it may have been finished later. The Baroncelli chapel was not decked out with frescoes till 1332, when Taddeo Gaddi completed a very beautiful series of paintings on its walls. It seems natural that the frescoes and the altarpiece should have been finished about the same time. No traveller to Florence will have failed to visit Santa Croce or to study the Baroncelli altarpiece. It was long a standing piece for the critics of Giotto's style. It will therefore be needless minutely to describe the beauties of the principal group, the Saviour crowning the Virgin, or the varied qualities of the attendant saints and angels.[2]

It may be sufficient to note the calm kindliness, the tender solicitude in the action of the Saviour, the deep humility in the attitude and expression of the slender Virgin, and to point out that Giotto was

[1] On the wall behind the altar the two SS. Louis, Elizabeth of Hungary, and Clara. Of St. Louis of Toulouse the hand with the book is new. The St. Louis of France is quite new, St. Elizabeth almost completely so. The figures in the vaulting have mostly been renewed.

[2] Beneath the cornice on which the panels rest are the words: OPUS MAGISTRI JOCTI. The five panels forming the altarpiece were set up anew in the fifteenth century, when part of the central one was shortened at the top.

equally able in the representation of a quiet religious scene and in the expression of dramatic power or playful incidents. We mark also how admirably the idea of a heavenly choir is rendered; how intent the choristers on their canticles, the players on their melody; how quiet, yet how full of purpose, how characteristic and expressive are the faces; how appropriate the grave intentness and tender sentiment of some angels; how correct the action and movements of others; how grave, yet how ardent, are the saints; how admirably balanced the groups. Nor shall we pass by without a less than cursory glance the five figures in the lower hexagons—the Ecce Homo, with a broad chest and wasted arms, calmly grieving, but a type reminiscent of more distant times; the wild, austere, and emaciated Baptist, with his long unkempt locks, and arms reverently crossed on his naked breast; and St. Francis showing the stigmata. To perfect decorum and repose, Giotto adds in this altarpiece his well-known quality of simplicity in drapery.[1]

Many and important were the works which Giotto executed, in addition to those already mentioned, in the church of Santa Croce. We are told of a crucifixion, with the Virgin, St. John, and the Magdalen grasping the foot of the cross, "above" the tomb of Carlo Marzuppini, and the Annunciation "above" the tomb of Leonardo Aretino, both of which have perished. Not so the panels of the presses in the sacristy of the church—the Root of Jesse, the Crucifixion, scenes from the life of St. Francis and St. Louis, and the Last Supper—all of which fill the end wall of the old refectory of Santa Croce. But all these panels and frescoes must be assigned to pupils or followers of Giotto, and may as such be treated of later.[2]

[1] His art as a colourist is not fitly represented, successive varnishes having dulled the usual lightness and transparence of his work, and substituted a yellow opacity of tone. In the Ecce Homo, though it is rubbed down, we still discover the under-tone laid on with bold sweep of brush, a broad distribution of light and shade, and greyish shadows, well fused into the half-tones by stippling. Partial restoration and a darkening of the fine engraved outlines may be noticed.

* Many connoisseurs now deny that the Baroncelli altarpiece was executed by Giotto himself. Like some other works of similar quality, it was probably executed in the master's *bottega* in his last period, when commissions crowded thick upon him.

[2] Besides the crucifixes of S. Marco and Ognissanti which have been noticed, Giotto painted, in the latter church, an entire chapel, and four pictures (VASARI, ed. Sansoni, i., p. 396), one of which still exists in the Academy of Arts at Florence; in the Carmine, it is said, the chapel of St. John the Baptist, of which fragments

The Virgin, from the Frati Umiliati at Ognissanti, may now be seen in proximity to that of Cimabue, in the Academy of Arts,[1] and the comparison shows how Giotto transformed the art of his time.

Sitting in majesty on a throne amidst saints and angels with the Infant on her knee, the Virgin must have appeared singularly venerable to the crowds that knelt at her shrine. The picture is of an imposing character, arranged with much order and symmetry as regards the groups, and harmonious in the juxtaposition of colours. The angels have a peculiar elegance of stature and movement, great feeling in the expression of the features, and simple flowing draperies. The Virgin and Child, of a stature still superior to that of the surrounding angels, are both archaic and grave. There is some doubt whether this is or is not the altarpiece above the door leading into the choir of Ognissanti, which is mentioned in Ghiberti's commentary and recorded in a deed of 1417 preserved in the Magliabecchiana at Florence.[2]

The following gives account of the so-called remnants of Giotto's frescoes at the Carmine :—

Of the frescoes at the Carmine at Florence six episodes and five heads have been published in the work of Patch.[3] It is impossible to

remain (*ibid.*, p. 376); in the Palace of the Parte Guelfa, a fresco of "the Christian faith," containing a portrait of Clement IV., which has perished ; in the convent of the nuns of Faenza, frescoes and altarpieces, which disappeared with the edifice that contained them ; a votive picture for Paolo di Lotto Ardinghelli, representing that person, his wife, and St. Louis, in the church of Santa Maria Novella (*ibid.*, pp. 394, 395) ; a small picture for Baccio Gondi, a Florentine (*ibid.*) ; a small crucifix for the Camaldole convent of the Angeli at Florence (*ibid.*, p. 396); a Virgin which Petrarch willed to a friend (*ibid.*, pp. 401, 402); a Virgin for the Dominicans of Prato, painted before 1312 (see note to VASARI, ed. Sansoni, i., pp. 394, 395), by order of one Riccuccio: all of which have been lost.

* It is to be borne in mind that in the case of some of these pictures we have only Vasari's word that they were the work of Giotto himself.

[1] No. 15, gallery of large pictures. Fourteen figures in all. Two angels in front, kneeling, present vases of flowers ; two others, standing, a box of perfumes and a crown ; the Infant, as usual, blessing.

[2] See GHIBERTI, *u.s.*, in VASARI, ed. Le Monnier, i., xix., and RICHA, *Chiese, u.s.*, iv., 259. Whilst the surface of the altarpiece has been rubbed down, many outlines have been retouched and blackened, particularly in the angel to the left bearing the crown, whose forehead is in part repainted. As usual, the ground is gold.

[3] *Selections from the works of Masaccio, Fra Bartolommeo and Giotto* (fol., Florence, 1770, 1772), part iii., by THOMAS PATCH.

say to which portion of the church the fragments belong which have been thus reproduced. Two heads of St. John and St. Paul, now in the National Gallery in London, are remnants from the Carmine which most recall the style of Giotto. Three fragments in the Liverpool Gallery, with the holy women presenting the infant John to Zacharias and the daughter of Herodias receiving the head of St. John the Baptist, have been so much damaged and are now so dark of outline that, though Giottesque in style, it would be difficult to affirm that they are his.[1] In the Cappella Ammanati of the Campo Santo of Pisa six other parts are likewise preserved. One, representing a group of angels, is the finest of the collection, but is less like a Giotto than a Taddeo or Agnolo Gaddi. The outlines are very inferior to those of the great master, and the muscular development, the weighty character of the forms, a certain slovenly ease in the handling, would tend to confirm the opinion that a later artist worked here. Another piece representing a harp-player seems to have belonged to the dance of the daughter of Herodias; but the difference between this and the figure of the player in the Peruzzi chapel is very marked. Other fragments of John the Baptist, St. Anna, and a youth, painted evidently with a coarse vehicle, reveal a far weaker hand than that of Giotto.

Had Giotto executed but a part of the works which have been noticed, it would still be evident that his residence in Florence was a long one. In the will of Riccuccio he is described as living in the parish of Santa Maria Novella, and this is confirmed by a lease, of which an extract is given by Baldinucci.[2] In the earliest years of the century Giotto married Ciuta di Lapo di Pelo, and by her had no less than seven children, some of whom were already growing up in 1306 when Dante visited the painter at Padua. The poet, indeed, was so struck with their peculiar ugliness that he asked Giotto how it was that he, who could paint such beautiful figures, should be the father of such very plain children. Giotto, in reply, repeated a jest from the *Saturnalia* of Macrobius,[3] which it would seem created some surprise in the poet. But Giotto's readiness at repartee, his humour, were quite as remarkable as his artistic talent; and

[1] Liverpool, Walker Art Gallery, Roscoe collection, No. 5, 1 foot 9 inches high by 1 foot 9 inches wide ; and No. 6, 1 foot 3 inches high by 1 foot 1 inch.

[2] *Notizie*, etc., di FILIPPO BALDINUCCI (8vo, Milan, 1811), iv., p. 170.

[3] BENVENUTO DA IMOLA, Com. in MURATORI, *Antiq. It.*, i., p. 1185.

Boccaccio's anecdote in the fifth Novella and sixth day of the *Decamerone* illustrates it amusingly.[1]

A lawyer noted for his plainness of face rode out and met Giotto, who was celebrated as the ugliest man of his time. They joined company, and were both caught in a shower, which drove them for shelter into the house of a farmer. The rain continued, and the travellers being both anxious to return home, borrowed two old cloaks and hats and proceeded on their journey. In this guise they rode, wet and stained with splashes, until the weather began to clear, when Forese, after listening for some time to Giotto, who could always tell a good story, began to look at him from head to foot, and, not heeding his own disordered condition, burst into a fit of laughter, and said, "Do you think that a stranger who should meet you in your present state for the first time would believe that you are the best painter in the world?" Giotto, without hesitation, replied, "I think that he would believe it if, looking at you, he should also conclude that you knew the abc."

Giotto had inherited property from his father at Vespignano. His son Francesco,[2] who took orders in 1319, was his father's agent when the latter was absent from Florence, and shared this responsibility at various times with Nicholas, his brother. Bice, one of Giotto's daughters, was a lay sister of the Dominicans of Santa Maria Novella, and married Piero di Maestro Franco in Mugello a year after Giotto's death. Chiara, her sister, married Zuccherino di Coppino di Pilerciano. Catherine, her sister, was the wife of Ricco di Lapo, a painter at Florence. Lucia, another sister, married Lesso or Alesso di Martinocco, of Vespignano. A third son of Giotto, Bondone,[3] was also called Donato.

Giotto's profession kept him no doubt either confined to his shop in Santa Maria Novella, or obliged him to journey wherever important commissions might lead him. His family lived much in the Mugello, which Giotto could only visit on holidays or Sundays. He was proud of his superiority in a profession in which he had no rival at least in Florence, and though Boccaccio pretends that he was too humble ever to assume the title of

[1] BOCCACCIO, *Decamerone*, Giornata VI., Novella V., *ed. cit.*, ii., p. 298.

[2] See the genealogy of Giotto in VASARI, ed. Sansoni, prepared by G. Milanesi, p. 411. [3] BALDINUCCI, *u.s.*, iv. p. 167.

master,[1] a story told by Sacchetti would prove that he sometimes considered himself at liberty to chastise what he thought presumption in others.[2] When a man whom he took for a common soldier brought him a scutcheon, and ordered him peremptorily to paint his arms upon it, he returned the shield with a helm, a gorget, and other military emblems upon it, jeering at the soldier the while, and asking what his forefathers had been, and whether he had omitted any of "his arms."

Giotto's mother-wit is clear from the quickness with which he practically punned on the soldier's words. His humour is shown in another of Sacchetti's tales, in which the novelist tells how the painter, being out with a party on the way to San Gallo, was tripped up by a pig, and laughingly rose with the remark that the brute had done right, seeing that pigs' bristles were one source of his daily earnings, yet he had never done anything for a pig in return.

Looking in at the church of the Servi after the accident, one of the party, looking at a picture of the Nativity, cried out, "How is it that Joseph is always represented with such a melancholy face?" upon which Giotto replied, "Is it not natural . . .?"

The excessive lightness of the last jest has been considered by Rumohr as exhibiting some frivolity combined with a certain coolness of spirit widely different from that which might be expected from one who should so enthusiastically and unreservedly acquiesce in the religious teaching of his time. But Giotto no doubt was far from yielding implicit faith to the claims of monks to sanctity. He may have had occasion to observe their weaknesses. The immorality of many amongst the clergy was probably quite as well known to him as to his contemporaries, and he could jest where jesting was permitted; but that he had a sense of the greatness of Christian truth is shown in his works, and no one can fail to perceive that, without a profound conviction and a deep sense of the truth of his subjects, Giotto could not have produced the noble works which afford to posterity the means of admiring his genius and his talent.

[1] Novella V., *u.s.*, p. 299. Yet in the altarpieces of the Baroncelli chapel and of the Brera his work is OPUS MAGISTRI JOCTI. The inscription of the former is perhaps modern. In the picture of the Louvre we have OPUS JOCTI FLORENTINI.

* The inscription existed in Vasari's day, but is probably not of the same date as the picture. [2] SACCHETTI, *u.s.*, Novella LXIII., i., p. 203.

CHAPTER V

GIOTTO AT NAPLES

EARLY in the year 1326 Charles, Duke of Calabria, who had been sent by his father to take the Lordship of Florence, asked Giotto to paint his likeness, and the great Florentine represented the Duke kneeling in prayer before the Virgin and Child in one of the upper rooms of the palace of the Signoria.[1] Long after the days of Charles the portrait was shown in that part of the public palace which was known as the "Depository," where it was seen and described by Vasari before it finally disappeared under whitewash.

King Robert of Naples had been busy about the time of his son's stay in Tuscany with the rebuilding of Neapolitan convents and palaces, and, having finished Santa Chiara and the Castel Nuovo, looked round for an artist to decorate the walls of those edifices. It is said that he consulted the Duke at Florence, and that Giotto, on Charles' recommendation, was induced to visit Naples.[2]

It is less material to inquire how Giotto was pressed into the service of King Robert than to determine when he made the journey to Naples. Charles, it is well ascertained, left Florence

[1] Vasari says that Giotto had previously visited Lucca to paint in St. Martin, for Castruccio, a Virgin and Saints adored by a Pope and an Emperor (VASARI, ed. Sansoni, i., p. 389). The altarpiece at all events exists no longer, though ROSINI (*Storico*, ii., p. 64) pretends to have seen it. "Many believed," Vasari adds, "that the pontiff and Emperor were Frederic of Bavaria and Nicolas V." Louis, not Frederic of Bavaria, was crowned in Italy when Nicolas V. ascended the papal throne, and the date of this is 1328, not 1322. But in 1328 Giotto was about to leave Florence for Naples.

* [2] VASARI, ed. Sansoni, i., p. 389. See DE BLASIIS, *Le case dei Principi Angoini* in the *Arch. Stor. per le Prov. Nap.*, vol. xi. ; BENEDETTO SPILA, *op. cit.*

at the close of 1327. Robert promoted Giotto to the rank of
"familiar" on the 20th of January, 1330. It was a dignity of
which we cannot now measure the importance, but which was
given under the Royal Seal as a reward for good work done.[1]
Giotto thus, it is evident, came to Naples in the interval between
1328 and 1330. There is evidence that he was still residing
there in 1332–3.[2]

According to Ghiberti,[3] Giotto's occupation at Naples consisted
in painting the Castel dell' Uovo and adorning a hall in the palace
of King Robert with figures of men of renown.[4] Vasari describes
how the King first asked the master to decorate Santa Chiara,
which was a nunnery and a royal church; and Giotto painted
several chapels in the new building with scenes from the Old
and New Testament and one with scenes from the Apocalypse,
for which suggestions had once been given by Dante. Then it

[1] "1330. January 20. Neapoli. Robertus rex Joctum (vulgo dic. Giotto), &c.
Reg. Rob. 1329 A, p. 20." In SCHULZ, *Denkmäler, u.s.*, iv., p. 163.

[2] It appears from extracts made by Dr. Matteo Camera of Amalfi from a pandect
of excerpts noted in the Neapolitan Archives before the fire which destroyed the
originals in the seventeenth century that the following record once existed:
"1332–3. Joannes de Putheolo litigat cum notario Amico et Magistro Jotto pictore
de Florentia."

* [3] GHIBERTI, MS. Comm. In the Biblioteca Magliabecchiana. "In Napoli
dipinse nel Castello dell' Uovo."

* [4] The point to be emphasised is that Ghiberti, and after him Vasari, wrote the
Castel dell' Uovo for Castel Nuovo. The Castello dell' Ovo is at the south end of
Pizzofalcone. The Castel Nuovo, the royal residence of Robert and seat of the
Court, was near the *portus manufactus* of Petrarch, and, as the poet's words in the
Itinerarium Syriacum prove, contained the royal chapel of Robert. Vasari
confused the two places, and put the "Cappella del re" in the Castello dell' Ovo,
where it never was. Robert of Anjou added to the palace of Castel Nuovo, built by
his grandfather, Charles I., and it was here that Giotto worked. See DE BLASIIS,
Le case dei principi Angoini, in the *Arch. Stor. per le prov. Nap.*, vol. xi., p. 455.
MINIERI RICCIO, *Saggio Storico intorno alla chiesa dell' Incoronata di Napoli e suoi
affreschi* (Naples, 1845), and VASARI, ed. Sansoni, pp. 422–5.

Amongst the documents relating to the palace of Castel Nuovo in the Naples
Archives we find the following: "Pro pretio calcis gissi suctilis coriorum asinorum
colle certe quantitatus auri fini eris plumbi zinnoneri panni linei petiorum argenti
et stagni deaurati otree olei lini carbonum et certarum aliarum rerum emptarum et
receptarum per eum a diversis personis ac conversarum in opere picture dicte magne
Cappelle . . . dicti Castri nec non pictura unius cone depicte de mandato nostro in
domo Magistri Zotti Prothomagistri operis dicte picture, nec non salario sue mercede
diversorum magistrorum tam pictorum quam manualium et manipulorum."—*Reg.
Ang.*, 1331, x. u. 235, fol. 213.

appears he worked at many other pieces in the Castel dell' Uovo and the Incoronata, and filled a hall with portraits of famous persons, including himself, which were afterwards destroyed by order of King Alphonso I.[1]

It is little short of a marvel that so much activity should have been shown, as we must infer from this narrative. Pietro Summonte, a poet and friend of Sanazzaro, writing from Naples to Marcantoni Michiel at Venice on the 20th of March, 1520, told him that the chapel of the Castel Nuovo had been once painted all round with scenes from the Old and New Testament by Giotto, but that in the days of Ferdinand I., and by advice of a councillor of little judgment, the frescoes were whitewashed, to the great distress of all those who knew their value. But, Summonte adds, there still exist in the church of the Incoronata, near the Castel Nuovo, paintings by Giotto's disciples which illustrate the dress and manners of the time of Boccaccio and Petrarch.[2] A striking coincidence of date may be noticed in the different accounts of the destruction of the gallery of celebrities taken down by Alphonso I., and the obliteration of the frescoes of the chapel of the Castel Nuovo by Ferdinand I. These two princes succeeded each other on the Neapolitan throne in the middle of the fifteenth century, and it seems quite clear that none of the frescoes which perished during their reigns could have been seen by Vasari, though Ghiberti might have been acquainted with them. It is of the utmost interest to find that Summonte was aware as early as 1520 that the frescoes of

[1] On his way to Naples, says VASARI (ed. Sansoni, i., pp. 433-4), Giotto stopped at Orvieto to see the sculptures of the Duomo, and recommended to Pier Saccone of Pietramala Agnolo and Agostino, two Sienese sculptors, as best fitted to execute his (Giotto's) design for the tomb of Guido Tarlati d'Arezzo. Agnolo is known by records to have lived between 1312 and 1348. Of Agostino there are notices from 1310 to his death in 1350. Agnolo's real name is Angelo Ventura. Agostino went under the name of Agostino di maestro Giovanni. He may thus be the pupil of Giovanni Pisano. MILANESI, *Doc. Sen.*, i., pp. 203-6; VASARI, ed. Sansoni, i., pp. 429-45. REYMOND, *La Sculture Florentine*, Florence, 1897, i., pp. 104-5, and DOUGLAS, *History of Siena*, pp. 311, 312.

* Agostino was best known in Siena as an architect. He acted as *capo-maestro* of the works of the cathedral, built, in part, the Mangia tower, and helped to make the aqueducts that brought the water to Fonte Gaja.

[2] The letter is given in Cicogna's "Essay on the Life of M. A. Michiel" in the *Memorie dell' Istituto Veneto* (1861), ix., p. 55.

the Incoronata were not by Giotto, but works of Giotto's disciples. The only wall paintings which Vasari could have admired when he visited Naples are those of Santa Chiara, of which some remnants are still in existence, though most of them were white-washed by a vandal named Borrionuovo a century and a half ago.[1]

Approaching the old convent of Santa Chiara in the direction of the gate which opens towards the new church del Gesù, might have been found some years ago at No. 23 a furniture shop, under the name of Francesco Tittipaldi.[2] This is part of a vast hall appertaining of old to the convent. At its extremity is a great fresco filling a square space circumscribed by a lozenge striped with the arms of Robert and Sancia.

The composition is Giottesque, and symbolises the charity of the Franciscans by the miracle of the loaves and fishes. The Saviour, youthful, majestic, and pre-eminent in size, sits in benediction on an elevated seat between two palms. At his feet, baskets of loaves have been brought by the apostles, who are grouped beneath him on each side. One of these, on the left, carries a basket which is to be added to those already destined for the poor. Another carries a couple of fish on a plate. To the right, an apostle is in the act of throwing a loaf to the crowd; and in front of him St. Peter, recognisable by his well-known type, distributes bread to a group of men, women, and children kneeling in a circle in front of him. In the foreground at that side St. Clara kneels in prayer with a chaplet between her fingers. In the foreground, to the left, St. Francis kneels in prayer with a bag containing bread slung over his shoulders.[3]

The fresco has been greatly injured, but is still remarkable for skilful arrangement as well as breadth of handling and well-blended tone.[4] The figure of the Saviour is majestic in its

[1] They were not merely whitewashed, but covered with stucco by Borrionuovo. See VASARI, ed. Sansoni, i., p. 390, and P. BENEDETTO SPILA, *Un Monumento di Sancia in Napoli*, Naples, 1901, p. 95. P. Benedetto Spila pleads that the attacks on P. Borrionuovo are exaggerated.

[2] These buildings are now used as the printing-office of the *Corriere di Napoli*.

[3] The heads of the group of apostles on the right are almost obliterated.

[4] The blues, being painted in tempera, have been altered by time. The verde tones in the dresses have become dark, especially in the figure of the apostle holding the fishes, and in the green mantle of the female taking the bread from St. Peter. When it is stated that this fresco, when first observed, was concealed by chairs and

regularity—the eye is correct in form, the face open. There is not a single example in Naples that is more in the character and spirit of Giotto than this. It is either the work of the great Tuscan himself or that of a disciple painting under his superintendence, with Giotto's composition and design before him.

The most careful search will not enable us to discover any frescoes of Giotto in the present monastery of Santa Chiara; and, with the exception of feeble productions assigned to Simone Napoletano, there is not even a Giottesque picture there.[1] Of the church appertaining to the monastery, the walls have long been whitewashed; and the portable altarpiece, called the Madonna delle Grazie, assigned to Giotto, is a poor specimen of fourteenth-century art.[2] That he also painted pictures on panel may be inferred from the remains of two figures of saints preserved by Count Gaetani at Naples. One of these is a bishop of the Franciscan Order, with the arms of Robert and Sancia embroidered on his dress, and holding a crozier; the other is a saint carrying a book. The nimbus in both is refreshed, the rest ruined by time; still the panels preserve enough original character to justify their being assigned to Giotto.

The influence of this great master is shown not only in the decoration of the chapel of the Incoronata, which we shall presently examine, but in the chapter house of the monastery of Donna Regina at Naples, where several artists of the fourteenth century appear to have laboured.

On one of the walls between two windows the Last Judgment is represented with the archangel Michael, the Virgin and the Baptist, Christ sitting in majesty with the prophets and angels, and saints and doctors of the Church. The elect are led to Paradise by the Virgin

other articles of furniture hung upon nails to the wall, it will be easier to conceive the ruin of some parts than to understand how any portion was preserved. The fresco adorned the lower part of a wall, the upper part is however gone, as is likewise every vestige of painting in other parts of the hall.

* [1] There is a Giottesque fresco in the *Refettorio dei Frati*. In it the Christ is represented seated on a Gothic throne. In front kneel on the one side King Robert and the Duke of Calabria, on the other Queen Sancia and an Angevin princess. To the right of the Saviour stand three saints, the Virgin, St. Louis of Toulouse, and St. Chiara. To the left are St. John, St. Francis, and another saint of his order.

[2] LANZI mentions this picture as by Giotto (see *History of Painting*, ii., p. 3).

Mary, the lost souls driven to eternal fire by angels. On side walls in the same edifice are scenes from the legend of St. Ursula and the Passion, ending with the death and resurrection of Christ.

Though much worn and blackened, the Judgment may be seen to partake of the double character of the old art of the twelfth century, which is particularly displayed in the violent action of the angels, and a technical treatment or selection of forms and faces, modified by the influence of the Florentines. The scenes of the Passion display even more acquaintance with the types and methods of Giotto.[1]

In the chapel of the Incoronata a painter, whose education was evidently influenced by the teaching or the maxims of Giotto, painted the seven sacraments of baptism, confirmation, communion, confession, ordination, marriage, and extreme unction, and subordinate scenes from the Old Testament. These frescoes were long assigned to Giotto,[2] although, in the sacrament of marriage, the ceremony represented is that of the nuptials of

* [1] E. Bertaux, in a long and closely reasoned argument, supported by adequate evidence, has shown that the frescoes of Santa Maria di Donna Regina are by Sienese masters. He demonstrates that, both in their technique and in their types, these works are Sienese, comparing them with the works of Simone Martini and Pietro Lorenzetti at Assisi. The artists of Santa Maria di Donna Regina, like Pietro Lorenzetti and other great masters of their own school, were not uninfluenced by Giotto, but they did not lose their Sienese characteristics, and in some cases reproduced with but little alteration the representations of saints to be found in Simone's altarpieces. BERTAUX, *Santa Maria di Donna Regina e l'arte senese a Napoli nel secolo,* xiv. Naples, Giannini, 1899. See also a review of M. Bertaux's book by C. von Fabriczy, in the *Repertorium für Kunstwissenschaft,* Band xxii., Heft 5.

* [2] The frescoes of the Incoronata are very similar in style to the works of Simone, and were probably painted by a follower of his. Sienese painters and sculptors were much patronised by the Angevin rulers of Naples; and these frescoes seem to us to be thoroughly Sienese in style. It is difficult, however, for anyone who knows well Paolo di Maestro Neri's authentic works at Lecceto to agree with Schubring that the Incoronata frescoes are by that master (see the *Repertorium für Kunstwissenschaft,* 1900, Band xxiii., Heft 4 and Heft 6). The frescoes at the Incoronata have been the subject of a long controversy which is not yet ended. It was Signor Camillo Minieri Riccio who first showed conclusively that these frescoes were not by Giotto (MINIERI RICCIO, *Saggio Storico intorno alla chiesa dell' Incoronata di Napoli e suoi affreschi.* Napoli, 1845). A quotation from his monograph is given by Milanesi in his edition of Vasari, vol. i., pp. 422–5.

Louis of Tarentum with Giovanna, queen of Naples,[1] which occurred in 1347, eleven years after the death of Giotto. More than this, the church of the Incoronata was only commenced after the coronation of Louis and Giovanna, which took place with much pomp in 1352 in the Palace of the Princes of Tarentum, near the Castel Nuovo.[2] Petrarch, in a passage of the *Itinerarium Syriacum*, has been the innocent cause of subsequent errors as to these frescoes. Addressing his friend John de Mandello he says:—

"Here stands Naples, a city that has seldom had its like amongst those seated on coasts. Here is an artificial haven, and by it the royal palace, where, if you land, you will not fail to enter the chapel of the king, in which a painter, late my contemporary and the chief of our age, has left great monuments of his genius and his hand."[3]

For a long time it was generally believed that the Incoronata was the chapel of the king here alluded to by Petrarch, and for this reason: On the site of the Incoronata was of old a chapel called the Cappella di Giustizia, which, according to several authors, was built by King Robert.[4] It was incorporated afterwards with the Incoronata, and hence topographers assumed somewhat hastily that this chapel was that to which Petrarch alluded. The Cappella di Giustizia, however, was built, not by Robert, but by Charles II.,[5] and never was called Cappella del Re. On the other hand, the royal chapel is proved by documents to have been an appendage of the Castel Nuovo, founded by Charles I. in 1279,[6] and still unfinished in 1309, when Charles II. died.[7] It was in this chapel that Montano d'Arezzo painted for King Robert previous to the arrival of Giotto. That the Castel Nuovo was close to the palace on the

[1] Historians who wish to preserve these works to Giotto say the nuptials are those of Andrew of Hungary with Giovanna.

[2] See Regist. Arch. R. Siclae, an. 1302, 17, 32, 47, etc., in GIUSEPPE ANGELUCCI's *Lettere sulla chiesa dell' Incoronata* (8vo, Naples, 1846), pp. 6, 7, 8. MATTEO VILLANI, lib. iii., cap. 8.

[3] TIRABOSCHI, *Storia della Letteratura*, v. lib. i. (8vo, Naples, 1777), p. 101.

[4] ALOE, VENTIMIGLIA and GALLO's *Annals*.

[5] GIUSEPPE ANGELUCCI, *u.s.*, pp. 6, 7, 8.

[6] CAMERA, *Annali di Napoli*, an. 1279, i. p. 322.

[7] GIUSEPPE ANGELUCCI, *u.s.*, pp. 10, 11.

Naples harbour is certain from the records in the Sicilian archives.[1] That Giotto should have painted in the Castel Nuovo may thus be inferred from the words of Petrarch. That he painted in the palace is affirmed, as we saw, by Ghiberti. It is possible that he also worked in Castel dell' Uovo, seeing that Montano d'Arezzo had already laboured there. It is not possible that he should have executed the frescoes of the Incoronata; for as works of art they but too evidently bear the impress of another hand.

These paintings cover the groined vaulting of the choir of the chapel, and are of irregular shape. The artist represents the rite of baptism in the centre of an octagon temple, where a naked infant is held by a nurse over a font, and receives the holy water from a cup in the hands of a priest. Behind the latter an assistant holds the salt box, whilst the second godfather and the godmother look on at the opposite side. A youth, on the steps of the baptistery, holds a lighted taper, whilst, in the foreground, three women look at the infant as two females deposit him in a basket. An angel flying down hovers over the scene with a torch in his left, giving a blessing with his right hand.[2] In the Confirmation a princess, wearing a diadem, stands with an infant in her arms, which a bishop in front of her confirms. Behind are a female and a girl holding a child, whilst in the foreground another child is led up the steps of the church by a dame. An angel hovers over the building.[3] A group of kneeling Christians preparing for the Communion is ably placed inside a temple by the artist. To the foremost of them a bishop, with a chalice in one hand, gives the host, whilst the attendant clergy stand behind, and two figures in rear look on. In the air two angels wave censers.[4] The sacrament of confession is given in an open

[1] "Joanellus Pacca et Julianus de Angelo de Napoli magistri tarsienerii, Tarsienatus Neapolis inventarium faciunt bonorum omnium existentium in ipso ; et dictus Tarsienatus situs est juxta hospitium ammiratæ plateæ portus civitatis Neapolis, et juxta molum parvum juxta regium Castrum Novum, juxta turrectam moli magni et ecclesiam Sti Nicolai." Ex Regest. Arch. R. Siclae, part ii., an. 1382, Arc. F., moz. 6, No. 1a, in ANGELUCCI, u.s., pp. 13, 14.

[2] The group of women putting the child into a basket is almost obliterated. The figure leaning over is likewise almost gone, and the heads of the two remaining figures are repainted. The whole of the upper part of the baptistery and the figure of the angel are new, and the figure, most to the left in the building, is also modern, with the exception of the head.

[3] Here again the figures of the princess and infant, and part of the figure, with the child behind her, are all of this painting that has not been retouched or renewed.

[4] This fresco is better preserved than the two others ; but the profiles are low, and the drawing of the figures broken and angular.

portico outside a church. A dame at the feet of a listening priest unburdens her conscience; and three penitents, holding scourges, retire with their faces concealed in their hoods to perform penance. In the air three devils fly away, as if exorcised by the blessing of the priest.[1] A pope, in the Sacrament of Ordination, is seen under a daïs, placing his hands in the palms of the candidate, whilst churchmen of various degrees stand around. In this fresco more than usual individuality and variety of attitude are conveyed.[2] The ceremony of marriage is represented in a church hung with rich tapestry. A monk unites the hands of a princely pair beneath a daïs, held by four attendant courtiers, and in presence of a crowd of churchmen and friends of both sexes. Two figures may be seen sounding a long brazen trumpet, whilst in the foreground a troupe of dancers moves to the sound of a viol and a pipe. In this group a certain beauty may be noted in the heads, with some grace of motion and costume;[3] and, in general, the distribution of the scene is better conceived than in the remaining frescoes. In the Sacrament of Extreme Unction the gaunt figure of a sick man may be observed, raised on a bed by a female, whilst the priest anoints the lips with the holy oil, and another ecclesiastic looks on, holding a taper. The wailing relatives stand or kneel around. Outside angels chastise devils.[4] Modern criticism has assigned to each of these subjects its meaning. In the first Charles, the son of the Duke of Calabria, receives the rite of baptism; in the second the three children of Giovanna— Charles Martel, Catherine, and Francesca—are confirmed; in the third Giovanna takes the Communion; in the fourth she confesses; in the fifth Louis of Anjou is consecrated Bishop of Toulouse by Pope Boniface VIII.; in the sixth Giovanna is married to Louis of Tarentum; and in the last Philip of Tarentum receives the final consolations of religion. In the lunettes of the chapel vestiges of scenes from the life of Joseph may still be seen: Joseph appears in prison; he resists the temptation of Potiphar's wife, and here the figure of Joseph hiding his face with his hand is not without character; and

[1] The lower part of this fresco is gone, and the figure of the first penitent restored.

[2] The greater part of the eight foreground figures is almost obliterated. An angel here also flies downward.

[3] The head of the queen and two nearest attendants, the upper part of the officiating monk, are repainted anew.

[4] An eighth fresco, now almost totally obliterated, seems to have represented the Saviour in Glory, in front of whom stands a figure of Religion holding a chalice, whilst on each side saints are grouped, who hold flags.

Jacob is told of the death of Joseph. In other parts of the chapel the Finding of Moses and the Burning Bush can be traced.[1]

Historical evidence having been satisfactorily adduced to prove that these frescoes could not have been executed by Giotto, they are now decried as much as they were before praised.[2] They are, in truth, but a development of the Giottesque manner by a painter of the middle of the fourteenth century who enjoyed a flicker of the flame which lighted the path of Italian art in Giotto's time, and who sought to carry out the master's grand maxims without his genius or energy. The legacy of Giotto to his pupils and followers was so great that, divided amongst a number of mediocre men, it still maintained a certain pre-eminence. Composition and distribution did not again materially decline. Giotto's pupils followed their master's example. They perpetuated certain compositions and preserved certain typical forms; but the difference between him and them was great. He improved, they degraded, the bequest of an older art. In the ratio of their talent they approached or receded from the models which he created. The test of their ability was no longer to be found in the distribution or arrangement of incidents which, being the same, required no new effort. The real touchstone was design and execution. The painter of the Incoronata frescoes, judged by this standard, is a fair imitator of the Giottesque manner; yet he must be placed in the second rank of Giotto's followers.

If a Neapolitan in name, he was a Tuscan in style. If Giotto made a long stay in the south, there is no reason why Neapolitans should not have adopted his manner with partial success. Giotto could not take with him in his travels all the pupils or apprentices who worked in his *bottega* at Florence. He might naturally trust to chance to find amongst local artists one more capable than the rest to help him. At Rome Pietro Cavallini was evidently a good assistant.[3] At Naples the most competent

[1] These vestiges of painting are altered in tone by mastic varnish.

[2] KUGLER, in his handbook, finds in them the portrait qualities of Giotto. Yet what a difference between these and the portraits of the chapel of the Podestà!

* [3] As we have already seen, there is no proof that Cavallini ever assisted Giotto at Rome. The probability is that the younger master assisted, and was influenced by the older. See *antea*, Vol. I., p. 94 note, p. 88, and p. 93 note.

seems to have been one respecting whom historians have been hitherto silent, and this is Robertus di Oderisio. A Crucifixion by this artist may be seen in the church of San Francesco d'Assisi at Eboli.[1] The figure of the Saviour is Giottesque, though it lacks the pure simplicity of form which characterised Giotto. Six angels in vehement action hover about the horizontal limb of the cross, tearing their dresses or gathering the blood from the wounds. The Magdalen grasping the base, St. John and the Virgin in the arms of the Marys, and the usual crowd at each side complete the picture. A monk kneels in prayer on the foreground, and a scroll near him is inscribed with his name.[2]

Here is a Neapolitan painter who had evidently been in the school of Giotto, possessing a certain dramatic power, a fair talent for expression, and as much knowledge of proportion and design as might fit him to hold a place amongst the good, if not amongst the best, pupils of the master. Robertus is, above all, a conscientious draughtsman. He carries out the clear system of colouring of Giotto, and in the production of drapery is master of a broad and simple style. In the portrait of the kneeling monk and in some profiles no mean power of imitating nature is exhibited. And in these qualities, as in others, he is not too distant from the painter of the Incoronata frescoes to exclude his possible claim to their authorship. In the whole of the Neapolitan school, such as it is presented to us by Dominici, it would be vain to seek a single painter whose works would entitle him to a place by the side of Robertus.[3]

There is a tradition that the church of Galatina, in the province of Lecce, was covered with frescoes at the close of the fourteenth

[1] Signor Giuseppe Angelucci, whose diligent research has been thankfully made use of in these pages, was the first to call attention to this work of Robertus di Oderisio.　　　[2] HOC OPUS PINSIT ROBERTUS DE ODERISIO DE NEAPOLI.

* [3] The Incoronata frescoes may be by Roberto Oderisio, as the authors contend, but considering the quantity and condition of that artist's existing achievement, it is scarcely possible to arrive at a decided conclusion. Whether the master of the Incoronata was a Tuscan or not, he was primarily a follower of Simone Martini, although not influenced by Giotto. Roberto Oderisio, as far as we know him, was Sienese rather than Florentine; but upon the evidence before us it is not safe to assert dogmatically that he was the author of the frescoes Giovanna caused to be painted. Throughout the fourteenth century Sienese artists were at work in Siena, and these works may have been executed by a Tuscan master.

century. The remains of pictorial decoration which are found in that edifice cover almost the whole of the walls and vaultings, those of the central aisle representing scenes from the Old and New Testaments, and including the four Evangelists, the doctors of the Church, and the seven Sacraments. The painter, whose name is unknown, is very feeble, but betrays some acquaintance with the wall paintings of the Incoronata at Naples, which we saw were by a follower of the school of Giotto. The subjects on other parts of the walls are of later date, one of them representing St. Anthony with a patron in prayer at his feet, being inscribed with the name of Francesco da Arecio and the year 1435.[1]

Atri, in the province of Teramo, in the Abruzzi, well known for work which Vasari[2] assigns to Cola dell' Amatrice, preserves remains of very old paintings in its cathedral, where the scaling of the wall in various places has laid bare frescoes of elementary execution underneath layers of plaster covered with work more modern, but equally defective. Amongst the older and better fragments of the fourteenth century is a half length of the Saviour on a wall to the left of the main ingress. The qualities which distinguish this nameless painting are regular proportions, delicate form, careful outline, and a fair amount of expression. The artist might be Luca di Penna, noted in local histories as painter of the choir of the Duomo of Atri about 1382. But if Luca decorated the choir, his work must have been replaced by a more modern decoration in the fifteenth century,[3] and the author or authors were men of no school, but local provincials of moderate skill.

At Aquila there lived early in the fourteenth century an artist named Bartolommeo di Aquila, who undertook paintings on a large scale in Santa Chiara of Naples in 1328.[4] What skill he

[1] FRANCISCVS DE ARECIO. FECIT A.D. MCCCCXXXV.

* [2] Vasari does not assign any works at Atri to Cola. He says that many works in the province in which Ascoli was situated were executed by Cola. It is writers like Orsini and the Marchese Riccio who assert that the Duomo of Atri was designed by Cola.

[3] Consult N. Topii, *De Origine* (Naples, 1655), i., lib. 3, chap. 13, p. 128.

[4] See Schulz, *Denkmäler, u.s.*, iv., p. 153.

* There is some evidence to show that this Bartolommeo was a pupil of Giotto. It is possible that he was the artist who painted the Christ and Saints in the Refettorio dei Frati at S. Chiara.

may have had it is not for us now to say. We cannot trace any specific work to his hand, and Aquila, at all events, has no paintings of the fourteenth century that display any talent, though we still see a fresco of the Virgin and Child between two saints of this period below the portal of Santa Maria di Collemaggio and other work of an inferior class in Santa Maria Paganica and Sant' Agnese.

The style which the Neapolitans formed upon the models of the Giottesques may be seen to more advantage in the apsis of San Giovanni del Toro at Ravello, where Christ is depicted sitting on a throne with the Lamb and the symbols of the Evangelists above him, and angels at his sides, whilst lower down are numerous saints of both sexes. In other parts of the church are the "Noli me Tangere," and near the pulpit Christ between the Virgin and Evangelist and the Annunciation. But these are not Giottesques imbued with the true spirit of Giotto, and the compositions are still those of the olden time which the Neapolitans treated with traditional reverence.

Feebler again are St. Louis of France and his brother, a Trinity, a Crucifixion with the Virgin, the Evangelist and Magdalen, and other injured frescoes of extremely poor execution in the abbey and abbey church of La Trinità della Cava dei Tirreni.

Amongst the artists of the fourteenth century who are supposed to have been the pupils of Simone Napoletano are Gennaro di Cola and Stefanone, Francesco di Simone, and Colantonio del Fiore. The first of these, who is said to have been a contemporary of the second, was born, according to present chronology, in 1320. A series of frescoes in San Giovanni in Carbonara of Naples, long considered to have been their joint production, has recently been surrendered to its real author, Leonardo di Bisuccio of Milan.[1] The frescoes in the chapel del Crocifisso at the Incoronata of Naples would prove Gennaro di Cola to have been a very feeble painter of the close of the fourteenth century, untaught in the art of composition and unable to depict the nude;[2] and this is true in so far as a part of these paintings

[1] These adorn the octagonal chapel of Ser Giovanni Carraciolo, and are inscribed. See *postea*.

[2] Representing a combat, a procession, portraits of bishops and saints, and

is concerned, one of them (a combat) being by a later and still poorer hand. No different opinion will be derived from three panels which stand under the name of Gennaro in the Naples Museum. These formerly belonged to the church of the Incoronata—are in the form usually called in Italy the " Conception," [1] between characteristic figures of St. Peter and St. Paul, and are coloured in warm tones with the precision and care of a miniaturist. A certain relation may, indeed, be traced between these pictures and the frescoes in the chapel del Crocifisso. The painter is of the close of the fourteenth century, with local Neapolitan peculiarities and not particularly Giottesque.[2] Were Stefanone to be judged by a much-damaged fresco of the Root of Jesse in the chapel de' Preti Missionari of the cathedral at Naples, he would be, as stated by Dominici, a painter of the rise of the fourteenth century. If, on the other hand, we consider a Virgin and Child in the Piccolomini chapel of the church of Monte Oliveto,[3] he will appear as a painter of the fifteenth century, influenced by the manner of the early Flemings; and this may be inferred as much from the character of the landscape distances as from the disproportionate size of the heads, the vulgar features of the Virgin, the coarseness of the anatomy, the angularity of the draperies, and the darkness of the high surface shadows.[4] But the uncertainty which exists as to the works of Stefanone is proved to absurdity by the attribution to him of a picture of the sixteenth century in San Domenico

St. Martin dividing his cloak. The ceiling, cut by diagonals, contains three scenes out of the life of the Virgin. The fourth, with a subject of a different class, is more modern. These frescoes are, however, partly obliterated, partly renewed, and the rest much damaged by damp. The nude of the beggar to whom St. Martin gives his cloak is bad and ill drawn.

[1] Namely, the Virgin on the lap of St. Anna, the Saviour on the lap of the Virgin. [These pictures are assigned erroneously to Neri di Bicci.]

[2] One may note the tendency to represent hands with pointed fingers. The three panels are much damaged.

[3] Enthroned under a canopy between St. Jerome and another saint, and adored by a miniature donor. [This picture has been removed and disappeared since the above lines were written.]

[4] A picture in the Naples Museum assigned to Stefanone, and representing St. James reading in a glory of angels, is in the style of the picture of Monte Oliveto, but of inferior workmanship, and dimmed by time, dirt, and restoring.

Maggiore,[1] finished, according to the Guida dei Scienziati, by Franco d'Agnolo, a painter of the close of the fourteenth!

Francesco, according to tradition the son and pupil of the mythical Simone Napolitano, has been considered the author of a Madonna in a recess of the tomb raised at Santa Chiara in honour of Antonio di Penna, secretary to Ladislaus, King of Naples (1386–1414). Antonio and his brother Onofrio kneel at the Virgin's feet and adore the infant Saviour, who holds a flower; but the lower part of the fresco is obliterated. The remains may have been executed by the son of one who lived in the fourteenth century, but the style in which they are painted is different from any displayed in the various frescoes assigned to Simone, and have nothing in common even with the works of Francesco's alleged contemporary and fellow-pupil Colantonio del Fiore. Dominici declares that this painter was born in 1352 and that he died in 1444; but there is every reason to believe that these dates are those of paintings classed under a conventional name. Pietro Summonte the architect, who, as we saw, wrote letters upon art in the sixteenth century, pretends that del Fiore abandoned the old method of tempera for the Flemish method of oils, which he learnt from Réné of Anjou.[2] It may be supposed that Summonte, when speaking of Colantonio, intended to speak of Antonello of Messina, who certainly began to paint in oil about the close of Réné of Anjou's reign.

The proofs which Dominici, Tutini, Celano, Eugenio Carraciolo, and all subsequent writers, set forth to establish the existence of Colantonio in 1375, is a triptych in the choir of the church of Sant' Antonio Abate at Naples, representing St. Anthony enthroned and in the act of benediction amongst angels and saints.[3]

[1] This picture at San Domenico Maggiore is in the Cappella Brancaccio. In the centre of the decoration is the Madonna delle Grazie (fresco), assigned to Franco d'Agnolo—a Giottesque production all but obliterated by repainting. At the sides are two panels on gold ground, one of them, the Magdalen assigned to Stefanone, an ugly piece of sixteenth-century work; the other a St. Dominic, assigned to Franco d'Agnolo, but in the manner of Andrea da Salerno. It is probable that both the Magdalen and St. Dominic are by Andrea da Salerno, the latter, however, being almost unrecognisable as his work on account of repainting.

[2] See Summonte's letter, u.s., p. 319.

[3] SS. John Evangelist, Louis of Toulouse, Peter, and Francis.

Tuscan in composition, style, drawing, colour and draperies, this picture, which bears the date of 1371, is by Nicholas Tomasi, a Florentine whose name is on the list of the first artists who joined Jacopo di Casentino in founding the guild of St. Luke at Florence. As a proof that Colantonio still lived and laboured in 1436, the authors above quoted trust to the evidence of a picture in two parts, of which the upper represents St. Francis surrounded by a choir of angels and saints, the lower is devoted to the subject of St. Jerome extracting a thorn from a lion's paw. The first of these pictures, separated from its companion, hangs in the church of San Lorenzo at Naples under the name of Zingaro, and is remarkable for a close resemblance to the manner of Roger Van der Weyden. The second, in the Naples Museum, is essentially in the Flemish style also. Both are utterly different from other pictures assigned to Colantonio. The date of 1436 is not now to be found in either of the panels under notice.[1] As to a damaged fresco of Giottesque character assigned to Colantonio, which still remains in the lunette above the portal of Sant' Angelo a Nilo at Naples,[2] it is not easy to speak with any certainty. The four works, however, assigned to Colantonio, represent him variously as a Tuscan or a feeble Giottesque of the close of the fourteenth, or a Fleming of the fifteenth century, and it may be fairly assumed that no such painter ever existed.

That Giotto exercised a certain influence in the kingdom of Naples is evident, but in this, as in other parts of Italy, he bequeathed the art of which he was the sole master to inferior men, who followed the letter more than the spirit of their master. His intercourse with Robert of Naples, as Vasari describes it, illustrates anew the powers of retort and the readiness of Giotto, whilst it places the King in the light of a condescending and considerate patron. Robert often visited the painter to hear him tell stories, or see him work, and seemed so pleased with his company that on one occasion he went so far as to say he would make Giotto the greatest man in his kingdom. The painter's answer was

[1] Angelo Criscuolo, indeed, affirms that it never existed. See a quotation from his MSS. in LUIGI CATALANI'S *Discorso, u.s.*, p. 13.

[2] Virgin enthroned between kneeling figures of St. Michael and Cardinal Rainaldo.

no doubt clever, but cannot be understood in our day. Clearer to modern ears was his reply when Robert advised him to suspend his labour, on account of the great heat. " I should certainly suspend it," said Giotto, " were I King Robert." Again the King having expressed a wish that he should paint a picture comprising a miniature view of the kingdom of Naples, Giotto drew a saddled donkey pawing a new saddle at his feet. On both the royal arms, the crown and sceptre were emblazoned. The King could not understand the joke till Giotto explained that the kingdom and its subjects were here allegorically depicted, they being ever anxious to find new masters.[1]

On his return from the south, Giotto passed through Gaeta, where he painted, in the Nunziata, scenes from the New Testament,[2] and Rimini, where he produced frescoes which have perished.[3]

On his return home he was appointed on April 12th, 1334, master of the works of the cathedral of Santa Maria del Fiore, then called Santa Reparata, and architect of Florence and Florentine edifices and fortifications.[4]

Founded in 1298, and unfinished when Arnolfo died, Santa Maria del Fiore had received but few and slight ornaments in accordance with the original design, preserved in the time of Baldinucci amongst the curiosities of the Scarlatti family.[5] It

[1] VASARI, ed. Sansoni, i., p. 391.

[2] These pictures perished during the modern alteration of the church. They were already seriously damaged in Vasari's time (VASARI, ed. Sansoni, i., p. 391).

[3] VASARI, *ed. cit.*, i., p. 392. St. Thomas Aquinas, reading to his brethren in St. Cataldo of Rimini, no longer exists. The painting was known to Riccobaldo Ferrarese (in MURATORI, *vide infra*). Those in S. Francesco representing, as Vasari says, the miracles of the Beata Michelina, cannot have been by Giotto, for Michelina only died in 1356.

[4] The document printed in BALDINUCCI, *u.s.*, iv., pp. 30, 31, and GAYE, *Carteggio*, i., pp. 481, 482, is now in the Archivio at Florence in *Libro de' Provisioni*, an. 1334, p. 84. Richa states that in the records of the Arte della Lana at Florence Giotto is appointed, in 1332, to continue the works of the Florentine cathedral, and is forbidden in the meanwhile to leave the city. Richa, however, does not give a copy of the alleged record. See *Chiese*, vi., pp. 23, 24.

[5] We shall see (*postea*) that Giotto, who is said to have designed the façade of Santa Maria del Fiore, never did anything of the kind. A view of it in its early state is represented in the great fresco of the Cappellone dei Spagnuoli at Santa

was a mere fragment of a cathedral without façade or cupola,
without a bell tower. Giotto was appointed to design the cam-
panile ; and a public decree expressed the confidence of his fellow-
citizens in his ability to do so :—

> "The Florentine republic desired that an edifice should be con-
> structed so magnificent in its height and quality that it should surpass
> anything of the kind produced in the time of their greatest power by
> the Greeks and Romans."

Posterity has acknowledged that the lofty purpose set forth in
the Florentine decree was completely realized.

The foundations were sunk to a depth of 38 feet, and on the
18th of July, 1334, the first stone was laid by the Bishop of
Florence in the presence of the clergy, the *priori*, and all the
officials of the city.[1] It is recorded of Charles V. that when he
visited the Florentine cathedral he expressed his regret that a
tower of such splendid materials could not be put under glass.
But age has only added to the loveliness of a structure which has
never ceased to be admired since it was first raised, and decorated
after the design of Giotto, with the carved work of Andrea
Pisano.[2]

It was once affirmed that Giotto was the designer of the façade
of Santa Maria del Fiore, and that he planned the decorations
which were already at the height of the gateways when copied by
Domenico Ghirlandaio for the fresco of S. Zanobi in the Public
Palace at Florence. But Giotto did not even live to see the
campanile finished ; and Pucci, in the *Centiloquio*, which is one of

Maria Novella in Florence. A drawing of the front, from Arnolfo's design, in
possession of the Scarlatti, may be seen in RICHA, *Chiese*, vi., p. 51.

* The supposition that in this fresco was represented the actual façade of Santa
Maria del Fiore is erroneous. On this whole question see NARDINI, *Il Sistema
tricuspidole e la facciata del Duomo di Firenze*, Leghorn, 1871 ; and NARDINI, *Il
Campanile di Santa Maria del Fiore*, Florence, 1855. Dr. Nardini asserts that in one
of Poccetti's frescoes in the Convent of San Marco is to be found the truest represen-
tation of Arnolfo's façade. But a yet earlier view of the façade is to be found in a
fine Florentine cassone of the middle of the *quattrocento*, which is in the possession
of Mr. A. E. Street, of London.

[1] VASARI, ed. Sansoni, i., p. 398, who assigns to the laying of the first stone the
date of July 9th. VILLANI (GIO.), *Cronaca*, xi., p. 12.

[2] VASARI, ii., p. 38 ; iii., p. 106.

the most trustworthy sources for local Florentine history in the fourteenth century, informs his readers that the tower was only brought up to the level of the first relief by Giotto; that it was then confided to Andrea Pisano, and finally entrusted to Francesco Talenti.[1] That Ghiberti should have thought that the first reliefs were carved as well as designed by Giotto is due to the fact that he saw Giotto's design,[2] from which we can discern that Pisano worked.[3]

During the progress of the campanile, Giotto was not idle. He furnished an altarpiece, of which all trace has been lost, to the nuns of San Georgio of Florence, and he painted a great fresco, which subsequently perished in the Palazzo del Podestà, representing allegories very similar to those with which Ambrogio Lorenzetti, about the same period, adorned the public palace of Siena, viz. the government of Florence, under the form of a judge, with the even balance resting on his head, and Justice, Temperance, Fortitude, and Prudence in attendance. In the Badia, where his firstling work was executed, he also painted a series of half lengths above the arching inside the portal,[4] and then he went, with permission of the governor of the city, to Milan for the service of Azzo Visconti.

It is somewhat unfortunate that historians should have neglected to describe the purpose for which the Lombard princes required Giotto's services. It is not to be credited that he undertook any works of great importance. Whatever they may have been they were not preserved;[5] and the solitary relic of Giotto's art which Milan can now boast of is a Virgin and Child in the gallery of Brera,[6] the centre of an altarpiece which once belonged to Santa Maria degli Angeli outside Bologna, of which the predella and sides are in the gallery of Bologna.

The Virgin at the Brera is enthroned. The infant Christ in her arms clings with his left hand to his mother's dress, and smiles as he

[1] Pucci, *u.s.*, canto lxxxv.

* [2] In the Opera del Duomo at Siena is a drawing which, according to Dr. Nardini, represents the master's original design for the tower.

[3] Ghiberti. In Vasari, ed. Le Monnier, i., p. xix.

[4] Vasari, ed. Sansoni, i., p. 399. [5] *Ibid.*; Villani, xi., p. 12.

* [6] The whole of this altarpiece is now in the gallery at Bologna.

endeavours with his right hand to caress her chin. Mary is veiled, and the muslin under the blue mantle, which covers her head, is gathered round her face and neck. The smile of the Child is hard and unnatural, the look of the Virgin severe and grave. The Infant is in a white tunic, edged with gold. In a medallion in the cusp of the panel is the Eternal, with the sword of the Apocalypse.

The sides at Bologna contain figures of the archangels Michael and Gabriel, St. Peter, and St. Paul. Five medallions, in a predella, comprise half lengths of the Ecce Homo, between Mary and John Evangelist, and John the Baptist and Mary Magdalen.

It is, perhaps, unfair to judge of the merit of this altarpiece from what remains of it, if the draperies of the Madonna have been refreshed, as their brightness inclines us to suspect. If the panels at Bologna have suffered from overcleaning, it may not be quite just to say what may otherwise be correct, that the altarpiece was originally one of the minor works of the master, and that parts of it betray, by minuteness of finish, the hand of assistants, and that the figures of the predella are of inferior make.[1]

Old guide-books pretend that the altarpiece was ordered by Gero Pepoli, who founded the monastery of Santa Maria degli Angeli, in 1330, and one in particular ventures to affirm that Giotto painted it during a stay at Bologna. But for this the authority is scant, and frescoes, assigned to Giotto by very old annalists, fail to convince us of the presence of the master in that city.[2]

[1] The Virgin's dress is repainted at the place where the infant Christ clutches it. On the edge of the throne footstool on the Brera panel we read: OP. MAGISTRI JOCTI DI FLORĀ.

[2] ZANOTTI's *Guida Anon. di Bologna*, 1792, p. 398, states that Giotto painted the walls of the convent church of Santa Maria degli Angeli, and was lodged and boarded in the convent for eight months. But there are no authentic records of these facts, and the 6th edition of MALVASIA's *Pitture . . . di Bologna* (12mo, Bologna, 1776), p. 318, merely states that the altarpiece above described is in the sacristy of Santa Maria degli Angeli, and "may have been ordered of Giotto by Gero Pepoli." ZAMO's *Graticola di Bologna*, a manuscript of 1554, reprinted in Bologna in 1844, assigns to Giotto four figures, painted on the Galliera Gate of Bologna. But we can hardly credit an author who also assigns to Giotto a part of the feeble frescoes of the church of Mezzarata (see LAMBI, pp. 16, 27).

Several pictures of Giotto are dispersed in the cities of the Continent, and of these we may notice the St. Francis, which bears the master's name, and, after having been preserved for centuries in San Francesco of Pisa, came, by fortune of war, into the collection of the Louvre. Notwithstanding copious and irreparable accidents and injuries, it is impossible not to recognise in this picture the genuine stamp of the master.

The kneeling saint and the figure of Christ, in the shape of a seraph in the sky, sending downwards the rays of the stigmata, are identical with those which we find in the upper church of Assisi, or the chapter house of S. Antonio at Padua. In the predella, St. Francis, in presence of Honorius III., supporting the fallen church, St. Francis receiving the rules of his order, and St. Francis with the birds are mere miniatures of the same subjects in the Upper Church of Assisi.[1]

It may be doubted whether Giotto painted this picture at Pisa, whether, indeed, he ever made any stay in that city. His authorship of the fresco of the patient Job, in the Campo Santo, may be contested on safe grounds, as we shall see later on, when speaking of the painter Francesco da Volterra.

Amongst the pictures which adorn private collections we may note the Entombment of the Virgin, which once belonged to Cardinal Fesch and Mr. Bromley Davenport, a genuine work of Giotto, with figures of small dimensions, representing two angels and an apostle lowering the body into the tomb, whilst other angels wave censers or hold tapers. Christ, in the centre of the picture, takes to his arms the soul of the departed which, under the semblance of a child, stretches its hands towards him. At the sides of the tomb the remaining apostles stand in various attitudes—one reading the service and another with an *aspersorio*. Much injury has been done to this small picture by abrasion and cleaning, which has deprived the surface of its original harmonies. It may originally have been fine enough to deserve the praise bestowed upon it by Ghiberti and Vasari, if it be, as

[1] Louvre, No. 1,312, wood, tempera, 3 m. 14 h. by 1·62. Inscribed in the lower border : OPVS IOCTI FLORENTINI. Originally in San Francesco, it was afterwards in St. Nicola, then in the chapel of the Campo Santo at Pisa. The surfaces are much injured by cleaning and restoring.

we may believe, the picture which they described in the church of Ognissanti at Florence.[1]

Another little piece of the same class, once in possession of Princess Orloff at Florence, represents the Last Supper, and is painted very much in Giotto's manner. On the left the Saviour sits in profile at the head of a table, with the fainting form of John leaning over him, upon whose head he rests his hand. All the apostles sit in a row by each other at one side of the board. St. Peter, with a knife, looks threateningly round as if to discover who of the twelve is to be the traitor. Though not free from retouching, this is a carefully finished little piece[2] of pale transparent tone.[3]

Under Giotto's name the following pictures pass in public and private collections without being really genuine:—

Florence, Uffizi. No. 4, the Sermon on the Mount, the Capture, and the Crucifixion, in the style of Lorenzo Monaco.[4]

Parma Gallery. Nos. 7 and 8, the Death of the Virgin and the Virgin giving the girdle to St. Thomas. This picture is in the manner of Niccolo or Lorenzo di Pietro Gerini.

Turin Museum. No. 91, Virgin and Child attended by angels. A feeble imitation of the Giottesque style.

Munich Gallery. No. 981, the Crucifixion.[5] No. 983, the Last Supper. These pictures are in the style of those which were originally in Santa Croce, and now form a series in the Academy of Arts at Florence. The painter of them seems to have been Taddeo Gaddi.

[1] VASARI, ed. Sansoni, i., pp. 396, 397, and GHIBERTI. In VASARI, ed. Le Monnier, p. xix. The same subject, in a somewhat different form, once formed part of the collection of Mr. Reiset, in Paris, and seemed a clever adaptation by a Giottesque of the type of Giottino.

[2] Inscribed: HOC OPUS FECIT FIERI DOMINA GIOVANNA UXOR OLIM GIANNI DE BARDIS PRO REMEDIO ANIMÆ IPSIUS GIANNI. MAGISTER IOCTI DE FLORENTIA.

* [3] In Mrs. J. L. Gardner's collection at Boston there is a small *Presentation*, which was formerly in the Willett collection, and afterwards in the possession of Dr. Richter, which many modern critics regard as a work of Giotto. In Sir Hubert Parry's collection at Highnam, near Gloucester, is a Coronation of the Virgin attributed to Giotto. It is by Andrea Orcagna.

* [4] The only picture in the gallery which now bears the name of Giotto is No. 8. The subject of this picture is Christ in the Garden. In the predella are two small pictures representing the Betrayal and the Stripping of Christ.

* [5] No. 982, Christ in Hades is also attributed to Giotto. It is a work by some pupil of Taddeo Gaddi. We regard 981 and 983 as works of the school of Taddeo, and not as paintings by the master's own hand.

Berlin Museum. No. 1040, Virgin and Child, in the manner of Agnolo Gaddi.[1] No. 1074A, Crucifixion; a school piece.

Formerly in the Dudley collection, from the Bisenzio collection at Rome. The Last Supper. This also is in the manner of Agnolo Gaddi.

Laci Nouhurik collection. The Death of the Madonna, by Bartolommeo Vivarini. The Crucifixion, a small picture with numerous figures, of the Sienese school.

The Duke of Northumberland's collection at Alnwick Castle, from the Commuccini collection and Sciarra collection at Rome. Scenes from the Passion and other episodes; four pieces in one frame under the name of Giotto. These small panels are in the manner of Giuliano and Pietro da Rimini. Amongst the subjects represented are the Sposalizio, St. Francis receiving the Stigmata, the Sermon of John the Baptist, St. Catherine preaching before the King Maxentius, all on gold ground. The compositions are Giottesque, and the details worked out with animated figures of graceful and slender make. The colour, too, is light and the gold ornament delicate.

Oxford, Christ Church. A Virgin and Child, with St. Lawrence, St. Catherine, and a false inscription.[2]

Formerly in the Maitland collection. A small panel on gold ground representing the Entombment, the Virgin fainting to the left, and four angels in the golden sky. A coarse but powerful Giottesque little picture.

Giotto died at Florence on the 8th of January, 1337 (new style). He was buried with great honour in Santa Maria Reparata, of which he had not been able to complete the bell tower.

* [1] This picture is now attributed to Agnolo Gaddi in the official catalogue.
* [2] This picture is scarcely worthy of serious mention.

CHAPTER VI

ANDREA PISANO AND ITALIAN SCULPTURE

THE art which Niccola Pisano bequeathed to his son had been gradually improved, as we have seen, after Giovanni Pisano introduced new elements into the practice of his craft. The life which had been thus infused into statuary was due to Giovanni Pisano's gradual abandonment of the antique as it had come to be understood in the thirteenth century, and his adoption of a realistic study and reproduction of nature. When Giotto acquired the wide repute which gave him an absolute lead in Italian painting, his example was speedily followed by sculptors; and Andrea Pisano, amongst others, succeeded in combining classic form with conscientious imitation of realistic form, and giving to his productions the grave feeling and religious fervour, and the admirable design of the greatest master of the revival.

We have no precise knowledge of the intercourse which took place between Giotto and Andrea Pisano; but it is well known that the bas-reliefs with which the door of the Florentine baptistery was first adorned were designed by the first, and chased by the second.[1] Under what circumstances this exchange of services

* [1] VASARI, ed. Sansoni, i., p. 489. It requires more than the statement of Vasari, and other Florentines of later times, to prove that this door was designed by Giotto.

There is no early documentary evidence whatsoever that confirms the Aretine biographer's assertions in regard to Giotto's collaboration in the masterpiece of Andrea. To the editors it seems that these statements are but another manifestation of Florentinism. The writer wishes to give to an artist trained in Florence most of the credit of Andrea's achievement. This suspicion an examination of the sculptor's works confirms. In the reliefs of the Baptistery door we can find nothing to establish the theory of Giotto's co-operation with Andrea. These graceful compositions reveal a harmonious, homogeneous style, a pronouncedly personal style :

occurred, and how, during the progress of Florentine sculpture, it became the habit of carvers to work from sketch cartoons instead of from clay models and casts, it is now difficult to guess, though it is not the less a fact.

The darkness which covers the practice extends to the early life of Andrea Pisano. If it should be confirmed that he was apprenticed to Giovanni Pisano in 1305, as records tend to prove, there is a blank in his life for many years. Records of comparatively recent discovery tell us that he was born in Tuscany, and was the son of Ugolino Nini, of Pontedera.[1]

It is by his own signature that we learn that he finished the bronze gate of the Florentine baptistery in 1330.[2] But whilst we try, somewhat vainly, to pierce the obscurity of Andrea's first labours, the flood of light which we now get is a marvellous

they show scarcely any trace of the influence of Giotto. Andrea had a sense of form which, while scarcely less powerful, was more subtilely sensitive than that of the great painter. His compositions have the marvellous plasticity of his master Giovanni without his violence. The Pontederan, too, was a master of design. His figures are admirably placed in their decorative framework. In none of his work do we find (as we do in several of Giotto's earlier frescoes) fumbling, tentative composition, and uncertainty as to scale. But the chief quality of Andrea's achievements, a quality that at once sharply differentiates his style from that of his master on the one hand and of Giotto on the other, is his gracefulness, his charm. Andrea is one of the most lovable of artists. In Florence only one sculptor, a weaker master, possessed this quality in anything like the same measure, and that was Andrea della Robbia.

[1] See BONAINI, *Memorie, u.s.*, pp. 60, 61, 127–9 ; and GIO. VILLANI, lib. vii., c. 86 ; and compare CIAMPI and MORRONA, who state that "Andreuccius Pisanus Magistri Johannis," whose existence is confirmed in a Pisan record of 1305, is Andrea da Pontedera (MORRONA'S *Pisa*, ii., pp. 357, 358).

* [2] In the *Spogli* of the *Libri dell' Arte di Calimala* made by Carlo di Tommaso Strozzi, books which are now lost, are to be found certain particulars as to the history of this door. The Consuls of the Art decided on November 6th, 1329, that the door should be "as beautiful as possible," and sent a certain Piero d' Jacopo to Pisa to make a sketch of the bronze doors there. After visiting Pisa, the same Pietro went to Venice to find a master competent to do the work. Either he was not successful in his quest, or he found a Tuscan artist, Andrea of Pontedera, at Venice, for on January 9th, 1330, the commission to execute the doors was given to Andrea. On January 22nd Andrea began work. On April 2nd of the same year the models of the "histories" were completed. The door was cast by a Venetian bell-caster in 1332, but so badly that Andrea had to recast it himself. On July 24th, 1333, Andrea agreed to make the twenty-four heads of lions which adorn the door. The whole work was finished and in its place in the year 1336. The inscription on the door refers to the date when the artist modelled it.

compensation, and the bronze gate of the baptistery is admittedly as great a masterpiece in its way as are the frescoes of Giotto at the arena of Padua.[1]

Without going into minute descriptions of this remarkable production, it may suffice to say in this place that the style, though obviously derived from the early Pisan, is chastened by the influence of Giotto, who, by means which are still unexplained, enabled his younger colleague to acquire the scientific rules of composition, and the power to express artistic ideas in a skilful manner. We may sum up the qualities which Andrea displays in eight reliefs of the Virtues by saying that they are so far Giottesque that the nude is always simply but powerfully rendered, and with due regard to harmonious proportion, grace of line, and beauty of modelling. The draperies fitly cover the nude, and action and expression leave nothing to be desired, the emblematic character of each figure being in every case judiciously conveyed. Descending to particulars we shall find in an allegory of Hope that the emotion which Hope embodies had not as yet been more ably rendered by Giotto himself than it was by Andrea in the sitting figure of a youthful and beautifully clad female, raising her head and arms with longing to the crown which she awaits.[2] Nerve and force could not have been better rendered than they are in the muscular arm and frame of a Fortitude, holding a mace and shield, and clad in the spoils of the lion. In the upper subjects from the life of St. John the Baptist thought predominates over form; but strength, tenderness, and every feeling which gives life to action are appropriately displayed.

If Vasari is correct in saying that Andrea spent a whole year at Venice, during which he designed the plan of the arsenal, and carved some figures on the front of the cathedral of St. Mark, we might account for the way in which he obtained the assistance of

[1] A. Pisano's early sculpture at Santa Maria a Ponte and the Scarperia, of which VASARI speaks (ed. Sansoni, i., 483), no longer exists.

* [2] As a master of allegorical composition Giotto was very fitful. His allegories at Assisi have great decorative qualities, but the symbolism is crudely, obviously, and even vulgarly expressed. His allegorical scenes at Padua stand on a very different plane. Symbolically as well as artistically his *Injustice* is one of the most remarkable achievements of its kind that the world has seen. But even Giotto at his best does not surpass Andrea in his treatment of allegorical subjects.

Leonardo Avanzi, a Venetian, to cast the bronzes of the Florentine baptistery.[1]

Vasari assigns to Andrea Pisano the statues of Boniface VIII., of St. Peter and St. Paul, the prophets, the four doctors of the church, St. Lawrence and St. Stephen, which all formed part of the ornament to the front of Santa Maria del Fiore, and were removed in 1588. The mutilated remains of the first of these figures may be seen in the garden called Orti Oricellari, near Florence, together with those of St. Peter and St. Paul, and two other statues. The four doctors are in the garden walk leading to Poggio Imperiale, and remnants of other parts of the monumental front are to be seen in the amphitheatre of the Boboli, but the fashion of these pieces is not that of Pisano.[2] If, however, Andrea did not contribute to the decoration of the front of Santa Maria del Fiore, he took an important part in the erection of the Campanile, of which he superintended the building, in succession to Giotto in 1337,[3] and the bas-reliefs with which he adorned the tower after Giotto's designs still exist to show his great ability.[4]

[1] The inscription on the gate is: ANDREAS. UGOLINI. NINI. DE PISIS ME FECIT A.D. MCCCXXX. See RICHA, *Chiese Fiorentine;* VASARI, ed. Sansoni, i., 489; *ibid.*, Sansoni ed., i., note to p. 487; MORRONA, ii., p. 367. The aid of Lippo di Dino, Piero di Jacopo and Piero di Donato, goldsmiths, was also secured to Andrea, probably for polishing and gilding the bronze (see G. VILLANI, x., p. 176). There is no record in the archives to confirm Vasari's account of Andrea Pisano's stay at Venice.

* There are grounds for supposing that Andrea actually did work in Venice. In the *Abbecedario pittorico* Orlandi quotes a document which confirms Vasari's assertion, and Cicognara produced some additional evidence for it. But we cannot give to Andrea the statues on the façade of San Marco, which the latter writer assigns to him.

* [2] Consult VASARI, ed. Sansoni, i., 484. Milanesi states that in the books of the *Opera* no mention is made of decoration for the façade until the year 1357. Many of the statues were not executed until the last decade of the century.

[3] See the *Centiloquio* of PUCCI, *u.s.*, canto 85.

* [4] These reliefs have been the subject of a great deal of controversy. Ghiberti, Varchi, and Vasari held that Giotto not only designed the reliefs of the "Beginnings of the Arts," but also executed models of them. Vasari tells us, too, in his life of Luca della Robbia, that Giotto actually executed two of the reliefs on the side of the tower which faces the church. Ghiberti says that he had himself seen the models made by Giotto.

Notwithstanding Ghiberti's testimony, it is difficult to believe that the models he saw were executed by Giotto, and yet more difficult to believe Vasari's assertion

On the west side nearest the Duomo, a series of hexagons forms the lowest range of ornament, and contains: The creation of man; the creation of woman; Man's first labours; Jabal, the father of those that dwell in tents and have cattle; Jubal, the father of all such as handle the harp and organ; Tubal Cain; Noah's discovery of wine. On the south side: Early Sabianism; house-building; Woman constructs earthenware; Man trains horses; Woman weaves at the loom; Man makes laws; he migrates and explores. On the east side: Man invents ships and navigates them; he destroys the wild beasts; he ploughs; he invents the chariot. On the north side are the seven liberal arts and sciences: Phidias represents sculpture; Apelles painting. But here the work of Andrea, on the designs of Giotto, ceased; and Grammar, Poetry, Philosophy, Astrology, and Music are

that Giotto actually chiselled the first two on the north side of the campanile. It is scarcely conceivable that an old man overburdened with several vast undertakings and holding important public offices could have found time to apply himself to an art which hitherto he had not practised at all, or had at most practised but little. Not even Vasari—who gives to Giotto as many works as he can reasonably attribute to him as well as some which cannot possibly be by the master—ventures to assign to Giotto any share in the execution of any other sculptured work.

Again, it is difficult to believe that a distinguished master of his art, well advanced in years, and rejoicing in the fame he had just won by the execution of a great masterpiece, should, in the very city in which that masterpiece had been executed, consent to copy the models of another artist, and that artist a master in another branch of art. Yet this is what those who hold that Giotto made the models of these reliefs ask us to believe. They claim that Andrea, then the greatest living sculptor, was content to copy models made by a painter.

Nor does style-criticism confirm the opinion that the models or even the designs of these reliefs were executed by Giotto. We can find in them, it is true, traces of the influence of Giotto; but in the best of them the characteristics of Andrea's own style are abundantly manifest, and the worst of them encourage the conviction that they were executed by Andrea's pupils from Andrea's designs, and not from designs furnished by Giotto.

In Giotto's design for the campanile in the Opera del Duomo at Siena reliefs, it is true, are indicated. Giotto, as *capo-maestro* of the works of the Duomo and chief architect of the tower, may have suggested the subjects of these reliefs, and have roughly sketched in suggestions for them in his plans of the campanile. We do not believe that his responsibility for them extends farther than this. The attribution of the best part of the credit of them to Giotto himself was probably an early manifestation of Florentinism. We agree with Schlosser that the reliefs on the east and west sides of the tower were executed for the most part by pupils of Andrea, whilst those on the south side were all the work of Andrea himself. But we do not hold with the German writer that Giotto designed the greater part of these reliefs. See SCHLOSSER, *Der Encyklopädische Bilderkreis;* in the *Jahrbuch der Kunsthistorichen Sammlungen des allerhöchsten kaiserhauses*, Vienna, 1896.

later works assigned to Luca della Robbia. Above the gate of the tower is the Redeemer between Moses and Elias, also by Andrea. In the next higher course of ornament, in starlike spaces, are: west, the seven cardinal virtues; south, the seven works of mercy; east, the seven beatitudes; north, six of the seven sacraments, the seventh being replaced by a relief of the Madonna. Amongst the statues in the niches, above the second course, four prophets, on the south front, are by Andrea, the rest by later hands; and though some of these reveal the genius of Donatello, they suit the character of the edifice less than those which the great Florentine conceived, and the Pisan carried out.

Florentine statuary here is in all its vigour, with a purely Giottesque character, and free from the mannerisms or deficiencies of Niccola or Giovanni Pisano. It is not possible to cite anything finer in this fourteenth century than the Eternal softly approaching the recumbent Adam, extending his hand and issuing the fiat, in obedience to which the man seems to live. As a composition of two figures, assisted by the judicious placing of two or three trees, this is a masterpiece of artful simplicity. Again, in the creation of woman, the repose of man, naked and bare on earth, but dreaming of heaven, is admirably contrasted with the dawn of consciousness in Eve, who floats forward into life aided by the hand of the Eternal to inhale the vivifying breath, with great elegance of action and of shape.

Nothing can be more poetic than the rendering of this subject. It seems like a return to Greek art. It is living flesh, modelled in admirable proportions, draped in the simplest vestments.

Taking others of these reliefs, we see in man's training of the horse elegance of outlines and truth of action. We mark how will is expressed in the rowers who symbolise navigation. The hand is that of Andrea Pisano; it is stamped with the genius of Giotto, and carries out his commands. One sees in these compositions, as in those of the bronze gates, his versatility, his fancy and vigour. Giotto had already painted the virtues at Assisi and at Padua, he conceived them again for Andrea in a different form. He is inexhaustible, and never repeats himself.

The finest delineation of the nude in the fourteenth century is that of the Saviour in the Baptism of the bronze gates; the most

pleasing composition in the same series is the Salutation, the former a figure which, for perfection of modelling, breadth of drapery, and beauty of shape, rivals the Redeemer of the baptistery of Ravenna. The art of Giotto, pre-eminent in painting and in architecture, thus appears equally so in sculpture, which is vivified by his spirit, though carried out by other hands.

According to Vasari, Andrea, about 1343, took numerous commissions at Florence for the Duke of Athens.[1] In 1345 he was invited by the canons of Orvieto to direct the labourers at the mosaics, and to complete the numerous works of sculpture which still remained unfinished at that place.[2] He laboured, therefore, several years with his son Nino, and no doubt many of the reliefs of more modern times were his. He finished and coloured the Virgin and Child above the central portal, of which something has been said in the notice of earlier Orvietan works; and he died about 1349, leaving his office to his eldest son.[3] Of the sculptures assigned to Andrea, in addition to those already mentioned, some have disappeared and others are spurious; and, without alluding further to these, we may trace in a rapid sketch the progress of his sons, Nino and Tommaso, the first of whom, having assisted his father in the bronzes of the baptistery, and in the works at Orvieto, inherited the maxims of Giotto's art, whilst the latter fell to the rank of a very inferior sculptor. It will thus appear that the Pisan school, having first extended its influence over Giotto, and afterwards received its last embellish-

[1] VASARI, ed. Sansoni, i., p. 491. A provision of October 6, 1342, refers to the works of the new palace erected by the Duke of Athens (GAYE, *Carteggio*, i., p. 493). According to Vasari, Andrea gave the plans for the Porta a S. Friano, which was rebuilt in 1332. We know from GAYE (*Carteggio*, i., p. 491) that the gates of SS. Giorgio, Miniato, Niccolo, Camaldoli, and Ponte alla Carraja, were renewed in 1340.

* [2] DELLA VALLE, *Storia del Duomo d'Orvieto*, p. 113, notices this fact, but assumes that the Andrea mentioned in the records is a painter and not the celebrated sculptor of that name. But the documents published by Signor Fumi (*op. cit.*) show that both Andrea Pisano and his son Nino worked at Orvieto. Andrea completed the reliefs of the façade begun by Lorenzo del Maitano and his Sienese assistants, who, like Andrea, were followers of Giovanni Pisano. See DOUGLAS, *The Duomo of Orvieto*, in the *Architectural Review*, June, 1903.

[3] Before July, 1349 (TAV. ALFAB., *u.s.*, *ut lit.*, Annals.) VASARI therefore errs (*ed. cit.*, i., 495) in stating that he died in 1345, just as GHIBERTI errs in assigning to him works at Santa Maria della Spina in Pisa (VASARI, ed. Le Monnier, p. xxvii).

ment from him,[1] subsequently shared the decline of the city which gave it life.

Nino Pisano seems, after his father's death, to have become *capo-maestro* of the Duomo at Orvieto, but to have held the appointment for a few months only,[2] after which he returned to Pisa. In Florence he had executed, probably in his early time, for the Minerbetti chapel in Santa Maria Novella at Florence, a Virgin and Child left unfinished by Andrea, and above the door leading to the canonry of Santa Maria del Fiore, a Madonna between two angels, with bronze wings.[3] Six or seven of his works remain in Pisa.

A half figure of the Virgin giving the breast to the infant Saviour, placed between the two doors of the western front of Santa Maria della Spina, discloses first in Nino a modification of Giottesque feeling and a tendency to naturalism. Nothing can be truer than the movements of Mother and Child. The former bends her head down with an expression of maternal affection, apparently struggling to suppress the sense of suffering caused by the draught of the Child at her breast. The eyes are partially closed, and mixed pleasure and pain are cleverly combined. The Infant scratches one foot with the toe of the other, and drinks evidently with supreme contentment. Here are the elegant forms, the fine draperies, but not the essentially religious feeling of the Giottesque period. Another example of this peculiarity in Nino is the standing Virgin and Child between St. John and St. Peter, in three niches by the high altar of La Spina. The head of St. Peter holding the book and keys is said to be a portrait of Andrea Pisano.[4] It is somewhat disproportioned, and remarkable for the shortness of the arms. The Virgin is, or should be, in the act of presenting a rose to the Saviour, who expresses in his face and action a desire to take hold of it. Here, Nino again admirably expresses maternal affection; and the face, figure, and draperies are so admirably carved that the sculptor deserves the praise of having "deprived marble of its hardness and infused into it the life of flesh."[5] Yet the figure, with all its grace, is

[1] "Essendo poi migliorato il disegno per Giotto, molti migliorarono ancora le figure de' marmi e delle pietre; come fece Andrea Pisano e Nino" (VASARI, ed. Le Monnier, iii., p. 10).

[2] TAV. ALFAB., *u.s.* See FUMI, *Il Duomo d'Orvieto*, pp. 71, 170.

[3] This Madonna Vasari assigns to Giovanni. See *antea* and VASARI, ed. Sansoni, i., p. 317. [4] VASARI, ed. Sansoni, i., p. 494.

[5] The rose and part of the hand are broken off (VASARI, ed. Sansoni, i., p. 494).

slender, and affects a bend similar to that which in Parri Spinelli's painting became a ludicrous exaggeration. Nature and grace, without the grave dignity of Andrea and Giotto, are the characteristics of Nino, who grafts a mixture of realism and affectation on the more solemn and grander forms of his teachers. Yet in this realism there was as yet no trace of vulgarity. For polish and fine workmanship Nino surpassed all his predecessors. One of the Virgins on the pinnacles of S. Maria della Spina, as well as the angel and Virgin Annunciate[1] at each side of a picture by Fra Bartolommeo in the church of Santa Catarina of Pisa are also by him or some of his pupils.[2] Animation and cheerfulness are in the face of the angel, but the length, slenderness, and affected bend of the frame are particularly characteristic of the sculptor. In the hair and vestments the old gilding and tinting may still be seen. The Annunciation, carved in wood and rotting in a storeroom[3] of the same church, is also very probably by Nino,[4] who, according to a funeral inscription quoted by Vasari, was an ivory worker, and is proved by documents to have been a goldsmith.[5]

The only remaining monument produced by Nino, and one in which he preserved, with most fidelity, the Giottesque feeling, is a tomb to the left of the entrance of Santa Caterina of Pisa, erected in honour of the Dominican, Simone Saltarelli, who died archbishop of Pisa in 1342.[6]

In 1364 Pisa found itself suddenly deprived of republican

* [1] These figures are in the Cappella del Rosario at S. Caterina. Originally made for the church of S. Zenone, an old abbey of the Camaldolesi, they were bought by the Società dei Battuti, and subsequently passed into the hands of the Dominicans of S. Caterina. See BONAINI, *Notizie inedite di disegno*, p. 66.

[2] These figures which, according to VASARI (ed. Sansoni, i., p. 495), were inscribed: A DÌ PRIMO FEBBRAIO 1370 · QUESTE FIGURE FECE NINO FIGLUOLO D'ANDREA PISANO, can hardly have been executed at the time stated, since it is proved that Nino was dead in 1368.

* [3] These figures ultimately found their way to the Convent of S. Francesco, and are now in the same group of buildings in the Museo Civico of Pisa. They are undoubtedly by Nino Pisano.

[4] These figures were, of old, in front of the pilasters of the choir (MORRONA, *u.s.*, iii., p. 102). They are long, affected in movement, and coloured. The hands and arms are broken.

[5] See the document in BONAINI, *Notizie ined.*, pp. 126, 127.

* [6] This monument suffered considerable injury in a fire that burnt a great part of the church in 1651. It has been thrice moved. See SUPINO, *Nino e Tommaso Pisano;* in the *Archivio Storico dell' Arte*, 1895, fasc. v., pp. 350, 351.

institutions, and subject to a doge named Giovanni dell' Agnello de' Conti. Mindful of the instability of human affairs, and desirous of securing to his family a final resting-place worthy of his high station, the new prince commissioned Nino to erect a sumptuous tomb outside the front of the church of San Francesco; but in spite of his wealth he neglected the discharge of the debt, and it was not till after his death, in 1368, that the money was claimed by Nino's heir, Andrea, and paid to his tutor and uncle Tommaso. The document in which this proceeding is recorded shows that Nino was free of the guild of Pisan goldsmiths, and that he died between 1364 and 1368.[1] Another record of 1358 proves that Nino worked in silver for the cathedral of Pisa.[2] Giovanni dell' Agnello, however, employed not only Nino, but Tommaso the second son of Andrea, likewise a goldsmith, an architect, and a sculptor. Having caused the palace of Pietro Gambacorta to be destroyed, the doge commissioned Tommaso to furnish a plan for a new one, of which the foundations were laid before his fall, and further entrusted to him the making of the model of a ducal helmet, the design of a regal chair, to stand in the choir of the cathedral, and a tomb for the remains of the doghessa Margherita.[3] This tomb was executed in due time by the artist, but perished afterwards in a fire. For none of these works was Tommaso remunerated; and it was not till popular rage put an end to the government and the life of Giovanni dell' Agnello that the debt was paid. The remains of Tommaso's works do no honour to the family. A tabernacle erected by him in the church of San Francesco, and now in the Campo Santo,[4] represents the Virgin standing with the Infant between St. Peter, St. Paul, and another saint in a niche, the curtain of which is drawn back by two angels. Seven reliefs, representing scenes from the Passion, cover the base of

* [1] In the buildings which once formed a part of the Convent of S. Francesco in Oristano, in Sardinia, is a figure, half life-size, of a bishop, a signed work by Nino Pisano. It bears the inscription, NINUS MAGISTRI ANDREE DE PISIS ME FECIT. In the Simon collection at Berlin is a small statue attributed to Nino.

[2] See the record in BONAINI, *u.s.*, pp. 126–9.

[3] BONAINI, *u.s.*, pp. 61, 127–9.

[4] Inscribed : TOMASO FIGLUOLO ... STRO ANDREA F ... ESTO LAVORO ET FU PISANO.

the tabernacle.[1] In these works the tendency to slenderness and affectation of bend is exaggerated beyond measure. A superabundance of drapery clothes figures remarkable for feeble movement and deformity of extremities. In one of the lateral chapels of the Campo Santo, two stone monuments disclose the manner of Nino and Tommaso.[2] More of their works might be noticed; but they need not be alluded to further, the object of the foregoing sketch being only to trace the general course of Pisan sculpture, its rise under Andrea to a level with the progress of Giotto, and its subsequent fall.

* [1] By Tommaso Pisano are the following works: (1) the altar of S. Francesco, now in the Campo Santo at Pisa ; (2) the relief which commemorates the alliance between the families of Gherardeschi and Upezinghi, now also in the Campo Santo.

* [2] We can find no monuments that we can assign to Tommaso in the two chapels in the Campo Santo.

CHAPTER VII

TADDEO GADDI

WHILST Giotto was thus leaving his mark upon the sculpture of the Italian revival, he was founding at the same time a school of painters which carried his precepts and, it must be owned, his manner to almost all parts of the Italian peninsula. Between the date of his death and the close of the fourteenth century, generations of artists succeeded each other at Florence which hardly did more than transmit from master to disciples the traditions of the Giottesque painting-room. The current appeared at first to be irresistible. It brought to the front the Gaddi, descendants of Gaddo, who had worked with Giotto at Assisi; the Giottinos, or little Giottos, whose very name indicated the origin of their style; and a still humbler host of apostles who propagated the same faith. Time sped on before the impulse of the movement slackened, or men of genius equal to Giotto brought art into a new path of progress. We shall devote some space at first to the Gaddi, who were Giotto's journeymen before they obtained an independent practice of their own.

It is rare to find notices of a very old painter of repute so full as those which have been preserved concerning Taddeo Gaddi. For twenty-four years before he qualified for the status of an independent master Taddeo served under Giotto, who had been at his christening.

At Santa Croce, about the year 1327, he decorated the monument commemorative of the Baroncelli family, whose chapel he subsequently adorned with frescoes. Records tell that the Baroncelli chapel was painted between the close of December, 1332, and the first days of August, 1338, and Vasari is right in assigning the frescoes to Taddeo Gaddi.[1]

[1] See the proofs in the notes to VASARI, ed. Sansoni, i., p. 573.

Till 1327 Giotto had been chiefly employed by the Franciscans. On the eve of starting for the south of Italy he probably recommended his ablest assistant to the chiefs of the mendicant order, and this patronage contributed greatly to Taddeo Gaddi's fortune. If from 1327 we subtract the twenty-four years of Taddeo's service under Giotto, we find that he must have been apprenticed as early as 1304, and that his birth may consequently be placed at a date near the close of the thirteenth century.[1]

Taddeo stood in the same relation to Giotto as Giulio Romano stood in a subsequent age to Raphael. He took what he could of Giotto's manner, adapted it in a quick and faithful way, and gained a name without developing an original idea. To no one more thoroughly than to him do Leonardo's words apply when he says that art retrograded under Giotto's disciples because of their unceasing imitation of Giotto.[2] It was the master's fault as well as the fault of his disciples that this occurred. During a long and busy life Giotto had gathered about him all the artistic forces of Central Italy;[3] he had trained them in a discipline which they liked, and afterwards found themselves unable to break through. Taddeo was the oldest and steadiest champion of the Giottesque style. He clung to it during his whole life, transmitted it to his son Agnolo, and laid the foundations of his family's repute by stopping the current of artistic progress in Tuscany.[4]

But this retarding process, which is very visible now, was probably not apparent to many of Taddeo's contemporaries, and it seems clear that the Franciscans who employed him, did so because they were entirely convinced of his ability when he was not in active rivalry with Giotto.

[1] VASARI, ed. Le Monnier, ii., p. 158, and CENNINI'S *Libro dell' Arte* (Florence ed., 1859), p. 2. [2] HEATON'S *Da Vinci, u.s.*, p. 124.

* [3] Our respect for the learned authors does not blind us to the fact that this statement savours of Florentinism. Simone Martini had an individual style. His aims as an artist were entirely different from those of Giotto. The Sienese of the Trecento and most of the Sienese painters of the Quattrocento were faithful to Simone's decorative ideals, and shunned the ideal of Giotto, an ideal which was revived and developed by Masaccio. The schools of Pisa, of Naples, and of Umbria were largely under Sienese influence.

[4] He said himself that "art fell very low after the death of Giotto." But did he not except himself? See SACCHETTI, *u.s.*, Nov. cxxxvi., ii., p. 221.

A simple enumeration will show what a splendid practice he acquired in Tuscany[1] from his connection with the order of St. Francis.

At Santa Croce, the church of the Franciscans at Florence, he painted: (1) the story of the Virgin in the Baroncelli chapel; (2) Christ and the Doctors above the door of the Sacristy; (3) the Bellaci chapel; (4) Scenes from the lives of St. Peter and St. Andrew in the chapel of Sant' Andrea; (5) the Pietà, as a pendant to Giotto's Crucifixion, at the sides of the door leading out of the right aisle beneath the monument of Carlo Marzuppini; (6) the miracles of the Resurrection of the boy of the Spini family, with portraits of himself and Giotto and Dante, on the screen which of old separated the nave from the choir, and besides these, as Vasari tells us, and we shall presently observe, a number of other pieces known to artists by their style.

In the course of years Taddeo's paintings were whitewashed or destroyed; and little remains at Santa Croce to furnish an adequate idea of his art but the frescoes of the Baroncelli chapel. Yet there are some earlier fragments which deserve attention, and are worthy of description.

* [1] In the Archivio del Subeconomato at Pistoia are the *Libri di Entrata e Uscita* of S. Giovanni Fuorcivitas. In one of these (D. 294, 1320–76) is to be found the following entry :—

"Questi sono li migliori maestri di dipingere che siano in firenze per la tavola dellopera di sancto Giovanni e quelli che meglio la farebono.

"Maestro Tadeo a sancto piero magiore.

"Maestro Stefano in chasa de frati predicatori (*i.e.*, at S. Maria Novella).

"Maestro Orchagia e Maestro Nardo in balla (*i.e.*, at the Porta di Balla).

"Maestro Puccio [Capanna] in viâ Larga.

"Maestro franciescho loquale istae in bottega dellandrea."

There follows a list of the chief masters in Siena.

Dr. Alberto Chiapelli, writing in the *Bullettino Storico pistoiese* (anno ii., fasc. i.), argues that this entry is of the year 1347, and that it was in that year that the *operai* of San Giovanni set out to find a new painter. It is certainly not of an earlier date than 1347, and may not have been written until two or three years later. See also ZDEKAUER, *Opere d'Arte Senese a Pistoia ;* in the *Bullettino Senese di Storia Patria*, 1901, anno viii., fasc. i.

The document proves in what esteem Taddeo was held. The *operai* evidently made diligent search in Florence, Siena, and Lucca to ascertain who were held by connoisseurs to be the best painters of the time, and Taddeo's name was placed at the head of the list of Florentine painters.

The monument of the Baroncelli, to which some allusion has been made, is let into the wall of this chapel in such a manner that one face of it is visible from the outside, and the other from inside. Under a lancet arch in the apex of the outer side are the arms of the Baroncelli, and on the cover of the tomb the date of 1327. On the outer face is a half length of the Virgin and Child between four prophets, which shows what Taddeo's art was when he left the service of his master.[1] The figures are slender as well as graceful, but they are specially interesting because they prove that Taddeo's earlier labours were more careful, if less bold, than those which he subsequently painted.

The subjects in the Baroncelli chapel are derived from the New Testament and proto-evangelion.

On the lunette of the side, to the left of the entrance, is Joachim expelled from the Temple, and in four compartments below the lunette,[2] are the meeting of Anna and Joachim, the Birth, the Betrothal, and Marriage of the Virgin. On the wall facing the entrance, at the sides and above the window, are the Annunciation, the Salutation, the Angel appearing to the Shepherds, the Nativity, the Magi journeying to Bethlehem, and the Epiphany.

The first of these scenes, which Giotto had already designed for the Arena of Padua, is distributed with truly Giottesque perfection, and illustrated by a very animated, often vehement action.

With anger in their faces the priests pursue Joachim, and one of them pushes him out by the shoulder. The startled Jews kneel or stand to the right and left, holding the lamb offerings. Joachim having retired reappears outside, where he may be seen comforted by an angel.[3]

Equally fine as a composition is the meeting, at the gates of the town, of Joachim, followed by a servant, carrying his rejected offering, and Anna with a suite of three graceful females.

* [1] The structure of this chapel was completed in 1338. Taddeo probably did not begin to paint these frescoes until after that year.

[2] The compartments are divided by painted twisted columns and cornices of feigned architecture.

[3] A fine figure in a glory, the rays of which are all repainted. Joachim sits on a rock. His green dress in great part touched in yellow. In a distant landscape three shepherds.

The Birth of the Virgin is not essentially different from the typical one of Giotto and his predecessors.[1] The Presentation of the Virgin in the Temple, of which a beautiful small design on grey paper exists in the gallery of drawings at the Louvre,[2] is a crowded composition, to present which would have required a knowledge of perspective not to be demanded of one living in the fourteenth century. The Virgin ascends the steps of the temple accompanied by Joachim, Anna, and an infant, to meet the high priest standing at the head of the flight, accompanied by his suite and surrounded by spectators.[3] On each side of the foreground are kneeling groups, and behind, to the right, two beautifully drawn females; a man in profile with a long beard holding his dress, and looking with eagerness at the Virgin, discloses the features of Gaddo Gaddi, the painter's father such as Vasari engraved him, and at his side another, also bearded, in a cap, and of fierce aspect for so timid a man, revealing the face of Andrea Tafi.[4]

In the Sposalizio the bridal couple and their parents are surrounded by a crowd, some of them to the left, behind Joseph, contemptuous in look,[5] others, such as the youth breaking the bough, ugly in form and expression.[6] To the left front of these, two musicians are blowing pipes. Confused as the scene undoubtedly is, a certain individuality and some character in a few heads retrieve its principal defect. The profile of the bridegroom is fine, that of the high priest, uniting the pair, equally so. A group of females to the right is elegant, especially so the female with the diadem, next but one to the Virgin.

Compared with that of Giotto, Taddeo's art is conventional. His ideas of proportion are different from those of his master, and his partiality for slender shapes might identify him as the assistant of Giotto in the southern transept of the lower church

[1] The figure of Anna, on the bed, has been obliterated. The nurses have washed the Babe, with whom one of them plays.

* [2] No. 216.

[3] The whole of the figure of the Virgin, part of that of Joachim and St. Anna, and the steps are repainted on a new intonaco. The dress of a kneeling man to the left is repainted. The figures in the middle distance are short and ill-proportioned.

[4] Some critics find these portraits in the next compartment of the Sposalizio.

* Statements of this kind drawn from Vasari in regard to early Giottesque works are really of little value.

[5] Near these, according to the commentators of Vasari, are (i., p. 207), the portraits of Gaddo and Tafi.

[6] The blue dress of this figure is repainted. In the centre of the foreground another figure breaks a stick under its foot. To the right, a group of females seems to have accompanied the Virgin.

at Assisi. But he was not even true to a fixed standard in this, though perhaps better than other pupils of Giotto. Without fancy, he seldom expressed action without an exaggeration of vehemence. The affected air of the heads is increased by neglect in defining the forms of eyes, which are usually long in the lids, half closed, and unfinished at the corners. He draws with a pernicious facility which often precludes correctness. His outlines of heads are long and narrow. A peculiar obliquity is given to the face by the false line of the cheek and chin, which instead of contrasting with that of the nose, generally follows it in an aquiline course. The neck is always inordinately long, the hands and feet are short, coarse, and neglected in drawing, the nude stiff and hard, the draperies studiously arranged. Without the sobriety of Giotto, he paints the vestments in gay contrasts and changing hues. His colour is laid on with an ease and consistency of texture that betray facility and haste, and he seldom takes the trouble to blend his tones. His shadows are dark and patchy.[1] The idea of relief by light and shade is imperfect, and the surface generally flat. Taddeo's execution is, in fact, superficial and decorative, yet to a distant observer effective and sometimes imposing. Lower than Giotto in the scale of art Taddeo is inferior to him in character and expression, and lacks at once his softness and gravity, his elegance and severe simplicity.

The absence of religious feeling, peculiar to Taddeo, is evident in the Annunciation, where the Virgin sits and quietly awaits the angel who flies down from heaven. In the Salutation he makes Elizabeth kneel before Mary. In the Apparition to the Shepherds, he paints a graceful angel; to the shepherds he gives true and energetic action. In the Adoration, St. Joseph sits with his knees between his hands. In the Progress of the Magi, it is no longer a star but the figure of the infant Saviour in the sky that guides them.[2] One who looks up under the hand which he raises to protect his eyes discloses a very common type in Taddeo Gaddi,

[1] Dark verde, and the lights stippled in a somewhat purple tone, the outlines of a claret-red.

[2] All the figures here are repainted except the head noticed in the text. The Adoration of the Magi is likewise repainted.

II.—K

a long nose and chin, and a forehead and head that suggest
absence of brains. In the pilasters at the sides of these scenes
St. Joseph with the blooming rod is a figure of some beauty;
David below, trampling on Goliath, is fine. But greyish lights
painted over red semitones and red shadows and changing hues
in flesh tints have a disagreeable effect. In the sections of the
ceiling Faith, Hope, Charity, Prudence, Justice, Temperance,
Fortitude, and Humility are painted in monochrome without the
fancy of Giotto. One example may be cited to show how little
the pupil inherited this quality. Giotto, at the Arena of Padua,
represents Temperance with a bit in her mouth, holding a sword
bound to its scabbard; Taddeo merely represents a female holding
a sickle.

It has never been doubted that these frescoes, which Vasari
assigns to Taddeo, were really designed by him. But if tried by
a sure test, that is by comparison with works which bear a name
and a date, it will be seen that Vasari's biography is, in this
instance, correct. One of these works is an altarpiece in the
Museum of Berlin, inscribed on the central panel[1] with the
painter's name and the date of 1334.

The infant Saviour, characterised by a broad head and cheeks, sits on
the Virgin's knee, and faintly attempts a smile as he caresses her face.
The slender, narrow-faced Virgin, in a simple attitude, shows a strange
exaggeration of tenderness in the half-closed eyes. Some nature is
observable in the portraits of the patron and his wife, kneeling at the
foot of the throne; stern gravity and minute finish in the saints on the
border of the antique frame at each side.

Taddeo succeeds in rendering maternal tenderness with some
show of affectation. Religious feeling he clearly does not possess.
A certain seriousness and steadiness of gravity may be noted in
the figures of apostles; the drawing is precise and more than
usually careful, especially in the extremities. The colour is
bright and so rich in vehicle as to appear moistened with oil,
yet it is a little flat in general tone. The draperies have gay and
varied hues. In the left wing the Birth of the Saviour is all

*[1] Berlin Museum, No. 1079-81. The inscription is: ✠ ANNO DNI. M.CCC.XXXIIII.
MENSIS SECTENBRIS TADEUS ME FECIT.

but a repetition of the same subject by Giotto in the lower church of Assisi.[1] Above this scene is one from the life of St. Nicolas of Bari, dramatic and truly Giottesque in character,[2] whilst in the right wing, beneath two prophets in the angles, is the crucified Saviour, a long slender nude, as yet not colossal, as Gaddi afterwards conceived it. The Magdalen grasps the foot of the cross, and the Virgin and St. John Evangelist stand at each side. Above this also a scene from the life of St. Nicolas of Bari is depicted, in which,[3] as in its counterpart on the other side, individuality and animation are conspicuous. None, indeed, but a pupil of Giotto could have followed with such certainty his laws of composition. The saints on the outer face of the altarpiece are feeble,[4] and recall more than the rest the least finished manner of the frescoes in the Baroncelli chapel. But doubtless much of this bad effect is caused by abrasion.[5] Another and, if possible, still more important example is an altarpiece originally

[1] As usual the line of the cheek follows that of the nose and mouth. SS. John Baptist, Louis of Toulouse, and twelve apostles. The group of women washing the Child is absent. In the distance the Adoration of the Shepherds.

[2] Where Taddeo represents the saint returning the child to its parents. The affection of the latter is well shown by the action. A natural incident, too, is that of the dog recognising in the child an old friend. In the upper angles two prophets.

[3] The saint presents the child with the cup to its surprised parents, who sit at a table.

[4] SS. Margaret, Catherine, and Christopher carrying the Saviour. Christ between the Virgin and Evangelist. The three panels, forming originally an altarpiece, were in the gallery of Mr. Solly.

[5] In the Bigallo at Florence, in the room of the 'Commissario,' is a small triptych which, with slight exception, corresponds with the picture at Berlin (some saints here and there being different). The subjects, the composition are similar. The painting, too, has the same character and beauty as that of Berlin, and is by the same hand. The painter's name is absent, but on the border of the central pinnacle are the words: ANNO DOMINI MCCCXXXIII. This is a very pretty and well-preserved piece, showing how the painters of this period repeated themselves.

Another very pretty picture in the same character was preserved till quite lately in the convent of the Angeli at Florence. It represents the Crucifixion and saints —a triptych with gables. Yet another in the Guardaroba of the Duomo at Florence represents the Virgin in half length with an open book in her hand; with the other hand she points to one of two figures kneeling below her, these being represented right and left by St. Zenobius and St. Catherine. In the cusp of the picture Christ appears in benediction. Below are the words: ANO DÑI MCCC.XXXIII DIE. XV FEBRVARI. In the well-preserved panel there is much of the character of Giotto in the male saint, and more of Taddeo in the St. Catherine.

in the sacristy of San Pietro a Megognano, near Poggibonsi, now in the Academy of Arts at Siena, inscribed with the date of 1355 and the master's name.[1]

The Virgin enthroned holds the Infant on her lap. He has a bird in his right hand. With the left he grasps one of the Virgin's fingers. Left and right, an angel erect, holding an offering of unguents and of a crown. Lower down the sides the four angels kneel—two offering flowers, two with the incense and censer.

This picture[2] confirms all that has been said as to the characteristics of the painter's manner, and shows what Giottesque art was twenty years after the death of Giotto.

Guided by these examples we turn to the small panels in the gallery of Berlin, which represent the Miracle of the Fallen Child of the Spini family and the Descent of the Holy Spirit.[3]

Both of them form part of a series which once adorned the presses of the sacristy in Santa Croce at Florence. They were assigned by Rumohr, on the authority of Vasari, to Giotto.[4] Taking the first of these panels in connection with the rest of the series, ten in number, which are now in the Academy of Arts at Florence,[5] it is evident that the compositions are by Giotto, and carried out according to his maxims;

[1] On the step of the throne and the lower edge of the picture: TADDEUS GADDI D̄ FLORĒTIA ME PĪXIT. M.CCC.LV. QUESTA TAVOLA FECE FARE GIOVANNI DI SER SEGNIA P̄ REMEDIO DEL ANIMA SUA E DE' SUOI PASSATI. The arms of the donor are above the signature—three roses and bar on field azure, probably arms of the Segni.

* They are certainly the arms of the Segni. The picture was painted for the Segni chapel at S. Lucchese, Poggibonsi.

[2] Gold ground. Well preserved, with exception of abrasion on the left lower corner; the picture is a simple arched rectangle.

*[3] No. 1074, once assigned to Giotto, and No. 1073, Berlin catalogue.

[4] VASARI, ed. Sansoni, i., p. 375, and RUMOHR, Forschungen, ii., pp. 63, 64.

[5] Florence Academy. No. 117, St. Francis abandons his heritage. No. 118, Innocent sees St. Francis in a dream supporting the falling church. No. 119, Innocent approves the Order of St. Francis. No. 120, St. Francis appears in a flaming car to some of his disciples. No. 121, Martyrdom of seven Franciscans at Ceuta. No. 122, Honorius III. confirms the rules of the Order of St. Francis. No. 123, St. Francis holding the infant Christ at the Christmas Mass. No. 124, St. Francis appearing to St. Anthony at Arles. No. 125, St. Francis receiving the Stigmata. No. 127, the Funeral of St. Francis. No. 118 is so different from the same composition at Assisi that the head of the Pope is turned in the opposite direction, and St. Peter is introduced near the Pope. No. 125 is an exact counterpart of the fresco at Assisi, and so is No. 122.

that the attitudes and the action are likewise his; that the subjects are, in fact, more or less, repetitions of the frescoes of the Upper Church of Assisi, but that the execution is sketchy, conventional, and decorative; that the feeling of the great master is absent, whilst the heads, features, and extremities are executed in the false forms peculiar to Taddeo in the Madonnas of 1334 and 1355, and the frescoes of the Baroncelli chapel. At the same time, Taddeo's peculiarities—gaudy colour, solid impasto, and bold rapidity of handling—are as well marked as in the certain examples of his hand. The panel at Berlin is undoubtedly the best preserved of the series, and exhibits most clearly the style of Taddeo.

The composition of the Descent of the Holy Spirit at Berlin belongs to the second series preserved in the Academy of Arts at Florence, and is, like its companion representing the miracle of the fallen child, in good preservation; but of the twelve panels at Florence the finest is the Transfiguration, which is as admirable as the compositions of Giotto carried out by Andrea Pisano in the bronze gates of the baptistery of Florence. The Saviour is represented ascending from Mount Tabor with Moses and Elias at his sides, whilst three apostles are prostrate on the ground in terror at the extraordinary light that shines in the heavens. It is a fine composition, with defects of execution common to Taddeo Gaddi.[1]

Santa Croce, as we saw, could boast in the fourteenth century of more frescoes by Gaddi than by Giotto himself. These have all perished, except those we have already described in the Baroncelli chapel, those which we shall presently examine in the great refectory, and those which once covered the wall and its archings forming the outer side of the Baroncelli chapel.

In the curve of the arch there were rescued from whitewash, in 1869, half lengths of saints; on the wall to the right, two mutilated

[1] The rest of the series at the Academy at Florence comprises: No. 104, the Salutation. No. 105, the Adoration of the Shepherds. No. 106, the Adoration of the Magi. No. 107, the Presentation in the Temple. No. 108, Christ amongst the Doctors. No. 109, the Baptism of the Saviour. No. 110, the Transfiguration. No. 111, the Last Supper. No. 112, the Crucifixion. Here the form of the Saviour is less perfect, shorter, and of worse proportions than in the pictures of Giotto. No. 113, the Resurrection. No. 114, Noli me Tangere. No. 115, the Incredulity of St. Thomas. Akin to these in style, but long attributed to Giotto, are a Crucifixion and a Last Supper in the gallery of Munich, Nos. 981–983.

prophets and remains of another fresco. On the wall to the left, Christ
on a seat, with two figures near him, may be remnants of the Dispute
in the Temple to which Vasari alludes.[1] Near these fragments are
remains of two other figures.

In the great refectory the Last Supper is depicted beneath a
vast Crucifixion and Tree of Jesse, and four side scenes from the
life of St. Francis and St. Louis by some unknown Giottesque.

The Saviour sits behind a long table in the midst of his disciples,
and St. John falls fainting on his bosom. Judas alone is seated in
front of the table, and places his hand in the dish; St. Peter, from his
place at the side of St. John, looks sternly at the traitor; whilst the
apostles generally are distinguished by animated movement. Amongst
the episodes depicted at the sides of the Crucifixion are St. Francis
receiving the Stigmata and the Noli me Tangere.[2]

The wall so adorned has a fine and imposing aspect, though
much of the background is damaged or repainted. The grandeur
of the composition in the Last Supper is marred by the somewhat
weighty character of the figures and the large size of the heads.
The eyes are drawn with close horizontal lines, and without
corners as was usual with Taddeo Gaddi; the foreheads are low,
the necks broad, the hands short and coarse. Abruptness in the
passage of light to shade, abuse of opaque red in the shadows, a
bold neglectful ease of hand in the drawing and colouring of the
parts, artificial draperies, and gaudy tones of vestments are all
peculiarities of Taddeo. The Crucifixion, on the other hand, is
composed of figures remarkable for length and incorrect pro-
portions. Some of those in the foreground are very feeble. This
subject, with its attendant figures in the Tree of Jesse and side
frescoes, is laid in, however, with a certain ease, and reveals an
artist of the middle of the fourteenth century, confident in some-
what slender powers, and sacrificing the great principles of art to

[1] VASARI, ii., p. 573.

[2] In the Crucifixion St. Francis grasps the foot of the cross. To the left is
a kneeling figure, behind which the group of the fainting Virgin is placed. To the
right a bishop sits, with three saints at his side. The backgrounds, originally blue,
are now red. Near St. Peter, in the Last Supper, the intonaco has fallen, and other
parts threaten to drop. The corner of the table to the right and parts of single
figures are repainted.

* This fresco has been recently restored. The great refectory is now the Museo
dell' Opera di S. Croce.

boldness and rapidity of handling. Should his name ever become known, it may appear that he is also the author of a Crucifixion in the sacristy of Santa Croce, surrounded by smaller frescoes assigned to Taddeo Gaddi, but which must be restored to their real author, Niccola di Pietro Gerini.[1] The same artist produced a Crucifixion, with four angels in various attitudes hovering in the air, the Magdalen at the foot, the Virgin, St. John, and two monks at the sides of the cross, in the sacristy of Ognissanti;[2] better perhaps in the proportion of the figures than those of Santa Croce, but especially interesting as showing that the author of them must have been the teacher or forerunner of the artist who painted the frescoes of the patient Job at the Campo Santo at Pisa. It will not be necessary to revert to the works of Taddeo Gaddi at Santa Croce further than to state that frescoes assigned to him by Vasari in the Rinuccini chapel are obviously of a later date, by Giovanni da Milano.[3] It is, indeed, remarkable that Vasari, who should have recognised the master's work by his style, was in too much haste to distinguish the works of Taddeo from those of his pupils—or inferior men, like the painter of the Crucifixions in the sacristy and great refectory—or those of Niccola di Pietro Gerini, who is evidently the author of the Entombment assigned to Gaddi in the Academy of Fine Arts at Florence.[4] Gerini was an artist who lived till late in the fifteenth century, the painter of several frescoes at Pisa and Prato, and one whose position amongst the followers of the declining Giottesque manner will require future consideration.

Amongst the pictures of Taddeo Gaddi, one was recently in the

[1] See *postea*, p. 266, Gerini. At the sides of the cross, the Virgin, St. John Evangelist, the Magdalen, St. Francis, St. Louis, and St. Helen; in the air about it, six angels complete a fresco exactly similar in character to the Crucifixion and Tree of Jesse in the great refectory.

[2] These paintings have suffered much from damp.

[3] Above the false ceiling of the Cappella de' Bonsi in the Carmine, remains of paintings, particularly a profile of an apostle, perhaps St. Peter, were recently discovered. The character of this painting—Giottesque, of the last half of the fourteenth century—is fine, the colour warm, and the handling bold. This head, removed by one of the monks, much altered by retouching of the outlines, and made opaque in colour, was lately in possession of Sir H. Layard.

[4] VASARI, ed. Sansoni, i., p. 574. This picture was in the church of Orsan-michele, and is now No. 116 in the Academy of Arts at Florence. See *postea*, pp. 267–8.

church of Santa Felicità at Florence, on an altar beneath and to
the right of the organ loft; another, reminiscent of his style, is in
the antechamber of the sacristy of San Giovanni Fuorcivitas at
Pistoia; and a third in the Museum of Naples.

The first, an altarpiece in the form of a five-niched tabernacle, repre-
sents the Virgin and Child enthroned amongst saints and angels, with
Hope, Faith, Humility, and Charity symbolically depicted on the
pinnacles of the throne.[1] It has quite the character of the Baroncelli
frescoes and the altarpiece of 1355. The second picture,[2] similar in
subject to the last,[3] but with the Annunciation in the upper spaces, may
be noted for heads of a lower type than was usual with Taddeo.

The third of the pictures is dated 1336, and is a triptych of hard
but transparent surface-colour, painted without the usual preparation,
but with rapidity, on a white ground, in warm tones tending to yellow,
high in surface in the lights. In bold handling it rivals the panels of
the Santa Croce presses. The figures are square and short, but not
inelegant.[4]

These and other pictures—evidently proceeding directly from
the school of Giotto, but bearing no names and authenticated by
no records—would alone prove to what conventionalism art had
already fallen.[5]

[1] This altarpiece has been restored. SS. John the Baptist, James the Elder,
Luke, and Philip. The Infant holds a bird, and four angels kneel singing and with
offerings of flowers at each side of the throne. Little prophets, in pairs, are in the
spandrels of the arches, under which the chief saints are painted.

* [2] In the year 1353 Taddeo Gaddi executed a Madonna for S. Giovanni Fuor-
civitas. In the Archivio del Subeconomato at Pistoia, in one of the *Libri di
Entrata e uscita* of the Opera di S. Giovanni (Libro, D. 295, c. 9) is an entry of the
year 1353 recording a payment to the master: "A maestro tadeo per resto della
tavola di nostra donna fiorini V d'oro."

[3] Virgin and Child between SS. John Evangelist, James the Elder, Peter, and
John the Baptist.

[4] Naples Museum, Sala IV., Upper Floor, No. 47. In the centre is the Madonna
enthroned between four saints (SS. Paul, Peter, Anthony, and a bishop; the head of
St. Paul damaged) ; on the wings, the Baptism of the Saviour and the Deposition
from the Cross ; with the Annunciation in the upper spaces.

* This picture is attributed to Andrea Velletrano in the official catalogue.

[5] Three parts of a predella (No. 1302) in the Louvre—the Dance of Salomè,
Crucifixion, and Christ surrendering the Soul of Judas to Demons—have much of
Taddeo Gaddi's style. A Virgin and Child in a mandorla, with six saints kneeling
in the lower part of the picture, is falsely assigned to Taddeo Gaddi in the Palace of
Meiningen. It is a Giottesque panel of Gaddi's school. Two pictures in the

Taddeo is said to have been an architect as well as a painter. During Giotto's absence at Milan he is reported to have furnished the plans of the Ponte Vecchio and Ponte Santa Trinita. According to Vasari he was one of those employed in the works of Orsanmichele, and he is described, though not correctly, as having conducted those of the campanile after Giotto's death.[1] It is very doubtful whether he ever practised as an architect at all. It is not till 1366 that we find him in the painter's guild at Florence.[2] In that year, too, we note him on the council which met to discuss the progress of the front of Santa Maria del Fiore, a model having been executed for this purpose in 1357 by Lapo Ghini, in the joint design of Taddeo Gaddi, Orcagna, and others.[3] Numerous paintings in various churches and edifices of Florence might testify to Taddeo's untiring industry, had they not been destroyed more completely than those of Giotto. The frescoes of the tabernacle of the Company of the Temple, at the corner of the Via del Crocifisso,[4] fell with the tabernacle itself. The frescoes in the cloisters and convent of San Spirito, the altarpieces in San Stefano del Ponte Vecchio,[5] the wall-paintings and pictures in the church of the Servi,[6] all perished.

National Gallery (Nos. 215, 216) will be found in the notices of Don Lorenzo Monaco. The Baptism of Christ (No. 579 in the same gallery) has the character of the close of the fourteenth century. It is a feeble picture, of which the partially obliterated signature must, we believe, read not 1337 but 1387. The figures in the cusps are by another hand, and have the character of Giovanni da Milano. A Virgin and Child, with saints and angels (No. 67 in the Gallery of Perugia), assigned to Taddeo, must be placed amongst the more modern works of the school of Agnolo Gaddi. The Birth of the Virgin, in the University Gallery at Oxford, is by Gerini, though assigned to Taddeo.

[1] VASARI, i., pp. 577 and 586. But PUCCI (*Centiloquio*, canto 85) states that the successor of Giotto as architect of the campanile was first Andrea Pisano and then Francesco Talenti.

[2] GUALANDI's "Register of the Guild," in *Memorie di Belle Arti*, serie 6 (8vo, Bologna, 1845), p. 188.

[3] RUMOHR, *u.s.*, ii., pp. 116, 117–66; and GUASTI, *Archiv. Stor. Nuova Ser.*, tom. 17, pp. 138–41. Taddeo was of the council in 1359, 1363, and 1366. Del Migliore found notices of Taddeo as a purchaser of property at Florence in 1352 and 1365; as umpire in 1355. Annot. VASARI, i., p. 583 n.

[4] VASARI, ed. Sansoni, i., p. 574.

[5] In 1755 an altarpiece by Taddeo still existed in S. Stefano. In 1728 it had been divided, and scattered in the cells of the friars. *Vide* RICHA, *Chiese*, ii., p. 77.

[6] VASARI, ed. Sansoni, i., pp. 574, 575. Fra Prospero Bernardi, in an apology for the miraculous Virgin Annunciate of the Servi, alludes to Taddeo Gaddi's frescoes,

At Pisa, in 1342, Taddeo painted an altarpiece and frescoes, of
which an authentic record is preserved in a letter written by the
artist himself to Tommaso di Marco Strozzi.[1] Of the altarpiece,
unhappily, we have no trace ; but the frescoes still in part exist
in the choir of San Francesco of Pisa, where they were executed
for Gherardo and Bonaccorso Gambacorti.

What remains of the latter is the ceiling, divided by diagonals, and
the Twelve Apostles in the curve of the arch leading into the chapel.
The apostles are either repainted or in a great measure obliterated.
The rest is much damaged.[2] In one compartment, where St. Francis,
in ecstasy, between Faith and Hope, shows the stigmata, the allegorical
figures hovering in the air are elegant in form and movement, of good
proportions, and admirably draped. Of two figures in the angles, one
has escaped the fate of its counterpart on the opposite side, and repre-
sents Obedience wearing the yoke. In the next compartment, saints
are placed in couples fronting each other—St. Dominic with St.
Augustine, St. Francis[3] with St. Louis of Toulouse, St. Benedict with
St. Basil. In the same order in the angles are the allegorical figures of
Temperance, Wisdom, Humility, Chastity, Fortitude, and Penitence.[4]
The signature and date, preserved in Vasari,[5] have disappeared with
the frescoes of the walls, a portion of which, representing a youthful
and an aged saint, were quite lately whitewashed. The distribution of
the space in the ceilings is well carried out according to the maxims of
Giotto. Of the frescoes executed in the cloisters of San Francesco
of Pisa nothing remains ; but if the gigantic head of the Virgin and
part of the Saviour preserved in the Cappella Ammanati of the Campo

and says the documents respecting them were in the records of the convent when
he wrote at the close of the last century. See RICHA, *Chiese*, viii., p. 89 and fol.

[1] See Taddeo's letter, dated September 7 (?1341), in *La scrittura di Artisti
Italiani riprodotta con la fotografia*, Firenze, Carlo Pini, 1871.

[2] The saints represented are SS. Basil, Benedict, Augustine, Dominic, Anthony
of Padua, Louis Bishop, and Francis.

* [3] St. Francis holds in his hand a book bearing the words, TRES ORDINES HIC
ORDINAT.

[4] Faith, with a draped head, carries a cross and is veiled. Wisdom carries
books ; Chastity bears a lily and vial ; Fortitude a pillar and shield ; Penitence an
instrument of flagellation. The blue ground is gone.

[5] VASARI, ed. Sansoni, i., p. 575. "Magister Taddeus Gaddus de Florentia pinxit
hanc historiam Sancti Francisci et Sancti Andreæ et Sancti Nicolai, A.D. MCCCXLII.
de mense Augusti." The side walls were whitewashed in 1613. *Vide* MORRONA,
u.s., iii., p. 56.

Santo be a fragment of them, they cannot have been by Taddeo Gaddi, whose forms were not of the character peculiar to these remains.[1]

On his return to Florence from Pisa Taddeo painted allegories in the tribunal of the Mercanzia, which have perished. He was afterwards called to Arezzo and Casentino, where he executed numerous works with the assistance of Giovanni da Milano and Jacopo del Casentino.[2] His death, erroneously referred by Vasari to 1350, only occurred in 1366.[3] He was buried in the cloister of Santa Croce.[4]

[1] This fragment is colourless, and the subject is only visible in outline. The surface has been altered by varnish.

[2] He is said to have painted at the Sasso della Vernia, where he first met Jacopo (VASARI, ed. Sansoni, i., p. 669). RICHA (*Chiese*, iii., p. 31) speaks of certain frescoes in the chapel of the Palagio family, church of the SS. Annunziata, at Florence, painted in 1353, and removed to make place for others by Matteo Rosselli.

[3] ALBERTINI (F.), *Memoriale di molte statue*, etc., *della citta di Firenze; ripubblicato nel* 1863 (8vo, Florence), p. 15. The same author mentions a standard by Taddeo in San Lorenzo at Florence, p. 11, and six panels in the sacristy of San Spirito, p. 16.

* Dr. Ugo Nomi holds that Taddeo did not die until after 1371, and in his *Della vita e delle opere di Cennino Cennini* (Siena, 1892) he gives substantial grounds for this belief.

*[4] In the Musée Fol at Geneva is a small Madonna of the school of Taddeo Gaddi, which has hitherto passed unnoticed.

Two small pictures, a Last Supper and a Crucifixion, in the Munich Gallery (Nos. 981 and 983), which were formerly attributed to Giotto, are of the school of Taddeo Gaddi.

According to Alessandro Segni, a distinguished scholar of the seventeenth century, librarian to Cosimo III., a chapel appertaining to his family in the church of S. Lucchese in Poggibonsi, was painted by Taddeo Gaddi (Arch. di Stato, Florence, Cod., 1882). He says that in his day (1633-97) an inscription still existed in the chapel showing that Taddeo Gaddi painted it.

Father Jacopo da Radda, who lived at Colle in the closing years of the sixteenth century, and in the early years of the seventeenth, and who was one of the witnesses to an inventory still existing of the things appertaining to the Segni family at S. Lucchese, in the year 1604, gave in his deposition of that year the text of three inscriptions then to be seen in the chapel. These are the inscriptions as quoted by him:—(1) QUESTA CHAPELLA A FATTO DIPINGERE LE VEDE DI GIOVANNI DI S. SENGNIA PE REMEDIO DELL ANIMA SUA ET DE' SUOI DISCENDENTI:

(2) QUESTA CAPPELLA È DI GIOVANNI DI SER SEGNA FATTA A LAUDE ET RE-VERENZA DEL N. S. GIESU XTO, PER REMEDIO DELL' ANIMA SUA E DI TUTTI I SUOI MORTI : (3) JAM CHRISTI PROLES MILLENUM DUXERAT ANNUM
 HIC TERCENTENUM QUATER BIS CUM DECIES OCTO,
 DEMONIUSQUE CHIRON PHEBEOS LIQUERAT EQUOS
 COLLENSIS PATRIA, CUM TU EXTREMUM DEDISTI
 HUIC OPERI FINEM INCOLUMEM QUOD NUMINA SERVENT.

The last inscription states that the work was finished in 1388 by an artist from

Amongst pictures attributed to Taddeo in British collections we should notice the following :—

Ex collection of Captain Stirling, of Glentyan. Cusped altarpiece, with the Eternal in benediction in a medallion at the top. Below, the Virgin enthroned, the Child on her knee playing with a bird which is perched on the palm branch held by one of four female saints who stand in couples to the right and left. On the foreground, before the steps of the throne, left, St. Francis and St. John the Baptist; right, St. Paul and St. Peter. This is a genuine work of Taddeo Gaddi, distinguished in some parts by retouches.

Ex Maitland collection. A cusped altarpiece with wings. In the centre, the Eternal in benediction in a medallion; beneath, Christ on the cross, with the usual gathering of soldiers and horsemen, the Magdalen grasping the foot of the instrument of death, the Virgin fainting on the left. In the half cusp to the left is the crucifixion of St. Peter; below, the Nativity. In the half cusp to the right, St. Nicholas throwing the coins into the room occupied by the maidens, beneath which is the Virgin and Child enthroned between St. John Evangelist and St. Peter (left) and St. Augustine and St. Paul (right). On the lower border of the triptych, the following fragment of an inscription: ANNO DN̄I MCCCXXXVIII FLORENTIA. PERM̄GRE. . . . The figures are designed with great animation; the panels are much in the character of those assigned to Taddeo Gaddi and Giottino, and are fine productions of the Giottesque school.

Colle. It is difficult to reconcile it with Alessandro Segni's statement that Taddeo Gaddi frescoed the interior of the chapel, and that he had seen an inscription in the chapel itself recording that fact. It has, however, been conjectured that the greater part of the interior of the chapel was decorated with frescoes by Gaddi, and that the work was finished by some artist of the school of the Gaddi from Colle, perhaps by Cennino Cennini after Taddeo's death. The position of this inscription on the outer face of the pilaster at the right of the entrance to the chapel lends colour to this theory. The external decorations of the chapel still remain. They are works of the Gaddi school, and may be by the author of the *Trattato*.

Taddeo certainly painted one picture at the order of the Segni, the Madonna in the Siena Gallery already referred to, which was formerly in this church of S. Lucchese. An altarpiece by an imitator of Taddeo still remains in the church. It is a triptych, and has a Gothic frame. In the central compartment is a Coronation. Both Christ and the Virgin are seated. The throne is supported by two angels, and four angels kneel below. The sides are sub-arcuated, and in each of the two sub-arches is a saint. St. Augustine and St. John Baptist are on the right, St. Francis and a female saint on the left. In the decorative framework of the triptych above are God the Father and two doctors of the church.

Serious doubts have been very justly expressed as to the authorship of the frescoes in the Cappellone dei Spagnuoli in Santa Maria Novella at Florence, which Vasari assigns to Simone of Siena and Taddeo Gaddi. This chapel was built between 1320 and 1350 by one of the numerous architects of the Dominicans, at the expense of Buonamico di Lapo Guidalotti, a rich Florentine merchant,[1] who died in 1355, before the paintings of the walls were completed. Vasari states that Taddeo Gaddi received the subjects from the prior, and executed the subjects between 1339 and 1346.[2] The frescoes of Simone created such a sensation in the city "that the prior determined to ask the Sienese to join in Taddeo's labours. The paintings of the Cappellone were then half finished, but Taddeo, a friend of Simone, who had been his fellow-pupil under Giotto, far from objecting to the appointment, expressed great pleasure at the prospect of dividing his work with such a friend. Taddeo therefore painted the ceiling and one side, whilst Simone completed the remainder." It is untrue that Simone was a pupil of Giotto. If Taddeo had half finished the painting of the ceiling and left side when the frescoes in San Spirito were exhibited, we should date the incident previous to Simone's journey to Avignon in 1339. If the work had been completed previous to 1339, it could not have been left unfinished in 1355 at the time of Guidalotti's death. But the doubts suggested by the record of a few facts acquire consistency from a consideration of the frescoes themselves, which we now proceed to describe.

The ceiling of the chapel is divided by diagonals into four parts, in which the rescue of Peter from the waves, the resurrection of Christ, the descent of the Holy Spirit, and the Ascension are represented. Of these compositions, the finest is the Rescue of Peter, which completely embodies the great laws of Giottesque composition. It may be said, indeed, to compensate for the destruction of the mosaic of the Navicella in San Pietro at Rome. As the subject stands in the Cappellone dei Spagnuoli, so Giotto may have originally composed his. The apostles are visible in a tempest-tossed vessel, with a balloon sail puffed out

[1] See the authorities in MARCHESE, u.s., i., p. 124. MECATTI (*Notizie*) says 1320, and Marchese follows him. Fineschi and Borghigiani say 1350.

[2] VASARI, u.s., ii., p. 117.

by the wind blown through the horns of two allegorical figures flying
at its mouth. The painter here avoids the mistake prominent in the
mosaic of Rome, where the symbolical figures of the winds are at
opposite sides of the compass. This is a truthful representation of
a bark tossed by the winds; the figures on board express varied
feelings; some are calm, others alarmed; some haul at the ropes. At
the helm is a more confident figure. One holds on to the sides of the
bark with great force and looks towards the Saviour, who treads
securely on the waves; a second sheds tears; a third prays with
joined hands. The composition is fine, and the action is vigorously
and truthfully expressed. To the right the Saviour rescues Peter; to
the left a figure angles in the water.[1]

The Saviour, in the next compartment, ascends from the tomb,
bearing the cross and banner, in a flood of light; whilst the two angels
sit on the sepulchre, at whose base the guard lies sleeping. The three
Marys approach to the left, and to the right Christ appears to the
Magdalen. Grace marks the figures of the Marys, but the glance and
action of the Magdalen are cold compared with those of Giotto.[2]

In the third scene the apostles are on the terrace of a house around
the Virgin. Prominent amongst them, St. Peter stands in the back-
ground with the keys. The dove of the Holy Ghost sheds its rays
on the group, and the flame of the Spirit rests on the heads of the
elect. In front of the house, which has a porch supported on pillars, a
crowd of figures is grouped. One is about to enter, others look up
surprised. The subject is well arranged.[3]

The Saviour, in the fourth fresco, ascends to heaven in an elliptical
halo and a glory of angels. Beneath him, the Virgin stands in the
midst of the apostles, and the group is guarded by an angel at each
extremity. These are very feebly executed, and, as a whole, the
Ascension is the weakest composition of the four.[4]

The west side of the chapel, assigned by Vasari to Taddeo, represents
St. Thomas Aquinas in majesty between the prophets, foremost amongst
them Daniel, St. Paul, Moses, and St. John Evangelist, sitting on
a long bench at each side of the throne. At the saints' feet lie the

[1] The foreground and sky are repainted, and throughout the flesh tints are
damaged by damp.

[2] This fresco is in many parts damaged, and the figure of the Magdalen is
repainted.

[3] The yellow ground of the upper scene is new, and the blues of some dresses
are obliterated.

[4] Many of the dresses have lost their colour, and some are repainted.

heretics Arius, Sabellius, and Averrhoes; whilst the seven virtues, with their symbols, fly over the scene. Beneath these figures fourteen females are seated personifying sciences and virtues, in which those have excelled who are seated at their feet; whilst the action peculiar to each science or virtue is demonstrated in single figures or groups in the pinnacles of the throne devoted to each of them. Grammar is enthroned with a globe in her hand, teaching three children; whilst at her feet Donatus, who excelled in that science, sits writing; and in the pinnacle a female looks at the water gushing out of a fountain. Rhetoric, holding a scroll, is the symbol of the excellence of Cicero; and so, as we proceed, we find Logic and Zeno, Music and Tubal Cain, Astronomy and Ptolemy, Geometry and Euclid, Arithmetic and Pythagoras, Charity and St. Augustin, Hope and John of Damascus, Faith and Dionysius the Areopagite, Practical Theology and Boethius, Speculative Theology and Peter Lombard, Canon Law and Pope Clement V., Civil Law and Justinian.[1] No talent of composition is

[1] The dress of the figure of Grammar is new, and half the face and right hand gone. The dress of Donatus is repainted.

Rhetoric holds a scroll inscribed: MULCEO DUM LOQUOR, VARIOS INDUTA COLORES. The figure is entirely repainted. Cicero has been restored so that he has three hands instead of two—one holding a book, another pointing to heaven, and a third holding his chin. This last is old, the two others new. The head has been altered in form by the repainting of the allegorical figure above it. In the pinnacle a female looks into a mirror.

Logic has a twig in its right hand, a scorpion—not a serpent, as Vasari says—in its left. Part of the dress is repainted, as well as the hat on the head of Zeno. In the pinnacle is a figure writing.

Music plays an organ. Part of its green dress is damaged. Tubal Cain, below, strikes with hammers on an anvil. Above, Time is marked by one with an hourglass.

Astronomy holds a hemisphere and an arm raised, of which the hand is gone. The draperies, which are here preserved, are fine and broadly treated. The head of Ptolemy, below, in profile, is in a good original state. In the pinnacle is a figure with a sickle and a bow.

Geometry carries a set square. The compass in its right hand is gone, and the whole figure is much damaged by restoring. Euclid holds a book, and in the pinnacle a warrior with helmet and shield carries a sword.

Arithmetic has a multiplication table, yet counts on its fingers. Below, Pythagoras, with a book and a hand raised, is well preserved as regards the head, but the dress is repainted. In the pinnacle a king sits with the orb and sceptre.

Next follow the theological virtues and four allegories:—

Charity holds a bow and arrow, and is a much-damaged figure—the head only in part preserved, the dress repainted. In the pinnacle is a soldier, with his hand on the hilt of his sword.

Hope, much damaged, carries a falcon on his fist, of which only the claw

shown in a work evidently dictated in its arrangement and distribution by bookworms, but the vastness of the fresco makes it imposing, and some of the figures of the lower course are not without character.

The figures in the ceilings are marked by expressive features, and length and slenderness of shape, a peculiarly close fit of costume, and an affected bend of body. They show none of the masculine force, the broad and decisive mass of light and shade which characterise the certain works of Taddeo Gaddi; whilst in the study of extremities, and in details of outline, more care is apparent than is common in the works of Giotto's first pupil. Boldness of hand is less marked than a soft, clear, and careful manipulation of pigments. The compositions, which are Giottesque, are evidently not by Taddeo Gaddi. Antonio Veneziano probably painted the Navicella, the Resurrection, and the Descent of the Holy Spirit; another pupil the Ascension, which is the lowest of the series in merit.[1] Between the figure of the

remains. John of Damascus, beneath, mends a pen, and is a fine figure. In the pinnacle a female is about to grasp a head in front of her.

Faith points to heaven ; whilst Dionysius, below, looks at his pen and holds an ink-bottle. This is a well-preserved figure. In the pinnacle stands a figure with her hand on her breast. Boethius, pensive, leans his head on his hand and his arm on his knee. In the pinnacle a child is held up by a female.

Speculative Theology holds a disk, in which a figure with two heads is depicted. Peter Lombard, beneath, rests his two hands on the edge of a book. In both figures the heads are preserved and the dress repainted. In the pinnacle a female gives alms to an aged man.

Canon Law holds in one hand a model of a church, in the other a wand; the background is repainted. In the pinnacle a man points with one hand to money which lies in the palm of the other. The Pope gives the benediction, and holds the keys of St. Peter in his left hand.

Civil Law is a fine figure, with the terrestrial globe in its left hand and a drawn sword held horizontally in its right. The head is preserved and the dress repainted. Justinian, with a book and staff, in profile, is all repainted. In the pinnacle a woman, of grievous aspect, wrings her hands.

Most of the nimbuses are removed by the repainting of the background. According to RICHA (*Chiese*, iii., p. 88) these frescoes were restored by Agostini Veracini about the middle of the eighteenth century ; but they had been retouched before, as the three hands of Cicero puzzled the ingenuity of the Abate Mecatti, who wrote in 1737.

* The ornamental framework of these figures has been repainted, and badly repainted. All the figures, too, have suffered from successive restorations.

[1] See further on the life of Antonio Veneziano.

Redeemer in the Ascension, and that of the Saviour in the limbus in the Crucifixion on the north wall of the chapel, assigned by Vasari to Simone Martini, some resemblance may be traced. In the west face, assigned to Gaddi, the slender frames and close-fitting dresses are again remarkable, together with a careful and precise execution, and a character more Sienese than Florentine. The three remaining frescoes of the Cappellone may also be proved to have a Sienese rather than a Florentine character. But it can also be shown that they are not by Simone Martini. But on this point it is sufficient here to remark that, if it could be clearly proved that Andrea di Florentia painted the frescoes of the Campo Santo assigned to Simone, he also painted the four walls of the Cappellone dei Spagnuoli at Santa Maria Novella of Florence, the two works being evidently by the same hand. These productions of the art of the fourteenth century are, indeed, second-class works, by pupils of the Sienese and Florentine school, and unworthy of the high praise which has been given to them.

CHAPTER VIII

PUCCIO CAPANNA AND OTHER GIOTTESQUES

TIME, which dealt but roughly with the pictorial remains of Taddeo Gaddi, has dealt more roughly still with those of less important persons, and we seek in vain to reconstruct the lives of Puccio Capanna, Guglielmo di Forlì, Ottaviano, and Pace di Faenza. Puccio is not a mere phantasm, since his name is on the register of the Florentine painter's guild in 1350 (old style).[1] Earlier still is a record in the ledgers of the Opera of San Giovanni Fuorcivitas at Pistoia,[2] which notes him amongst the best masters of Florence between 1310 and 1349, together with Taddeo Gaddi, Stefano, Andrea Orcagna and his brother Nardo, Puccio Capanna, and Maestro Francesco, a journeyman in Orcagna's service.[3] Vasari asserts that friendly relations united Puccio to Giotto, but amongst the numerous frescoes which he mentions as Puccio's work the majority differ from each other in style, and all are beneath the standard of a direct disciple of Giotto.[4] We fail to discern in the crucifix at Santa Maria Novella of Florence, which Puccio is supposed to have executed in Giotto's company, either the form or the character of the great Florentine.[5] Santa Trinita[6] and the Badia[7] at Florence, San Cataldo of

[1] GUALANDI, *u.s.*, vi., p. 187. BALDINUCCI, *u.s.*, iv., p. 358, gives the date of registry as 1349.

* [2] See *antea*, p. 126.

* [3] VASARI, ed. Sansoni, note to i., p. 613 n. There is no foundation for Milanesi's assumption that this Francesco was Francesco Traini. Between the years 1340 and 1380 there were no less than fourteen painters who bore the name Francesco enrolled in the Florentine guild. See *postea*, p. 227.

[4] *Ibid.*, ed. Sansoni, i., pp. 402, 403. [5] *Ibid.*, p. 394.

[6] In S. Trinita he painted in a chapel of the Strozzi, the Coronation of the Virgin, much in Giotto's manner, and scenes from the life of St. Lucy (*ibid.*, p. 403).

[7] Puccio painted the chapel of the Covoni near the sacristy (*ibid.*, p. 403). An altarpiece in that chapel is mentioned by Cinelli in RICHA, *u.s* i., p. 199.

Rimini,[1] Bologna,[2] no longer yield any clue to Puccio's style.
Scenes illustrative of the Passion in the Lower Church of Assisi
would do him honour, were it possible to forget that Giotto is
the author of them.[3] We might be forced to fall back at once
upon the frescoes attributed to Puccio at Pistoia were it not for
the wall paintings of the Maddalena chapel in the Lower Church
of Assisi, which it is clear none but a pupil of Giotto could have
laid out with the varied scenes from the lives of the Magdalen
and St. Mary of Egypt which we find there. The chapel was
devoted to the remains of Pontano, Bishop of Assisi, whose days
were finally numbered in 1329. His arms certify that it is he
who is represented receiving consecration from St. Rufinus in the
spandrels of one of the painted arches.

In a triple course of frescoes, six scenes from the life of the
Magdalen and St. Mary of Egypt are depicted. In three lunettes,
the Communion, where three figures look on and four angels
carry the saint to heaven; the gift of his garments to Mary by
Zosimus in the cave; the Magdalen carried to heaven in a mantle
by four angels. In the lower courses, Christ anointed by the
Magdalen, the Resurrection of Lazarus, the "Noli me Tangere,"
and Lazarus miraculously reaching the port of Marseilles. In the
spandrels of painted arches, imitating recesses in the side walls
of the chapel, the consecration of Bishop Pontano, the figure of a
female saint, another female saint raising a kneeling monk, and
a half-figure of Lazarus; twelve figures of saints, male and female,
in the entrance vaulting, amongst them St. Peter, St. Matthew,
St. Clara. In the diagonals of the ceiling are the Saviour,
Magdalen, St. Mary of Egypt, and Lazarus in a medallion.

Amongst the compositions of a series clearly due to a pupil
of Giotto, though assigned, on no conceivable grounds, to Buffal-
macco,[4] the finest is one in which the Magdalen lies prostrate at
the Saviour's feet whilst he addresses his host and the apostles in
attendance. A Raising of Lazarus and a "Noli me Tangere"
are counterparts of the compositions at the Scrovegni in Padua.

[1] Here he painted a wreck in which his own likeness was introduced (VASARI,
ed. Sansoni, i., p. 403). [2] *Ibid.*, p. 404.

[3] Assigned to Puccio by VASARI (ed. Sansoni, i., p. 403).

[4] Note to VASARI, ed. Sansoni, i , p. 507.

The technical execution and colouring of the series remind us of the allegorical ceiling and the scenes of the Passion in the south transept of the Lower Church of Assisi. Giotto's designs are copied, his forms imitated in clear, bright keys of colour. None but a painter who actually assisted Giotto could have done this, and we may discern in the painter the helpmate who worked as a subordinate at the ceilings who was not ambitious of daring more than to reproduce his master's creations without alteration, and whose secondary talent would suit the characteristics under which Puccio is presented to his readers by Vasari.[1] Yet it may be admitted that the frescoes of the Maddalena chapel are not like the solitary remnant of those in San Francesco of Pistoia.

This fragment in the altarplate press represents St. Mary of Egypt taking the Communion from Zosimus, rudely executed in the Giottesque manner by an artist of little refinement.[2]

That Puccio at one time resided in Pistoia is affirmed by Ciampi and Tolomei,[3] who give the authority, without quoting the text, of conventual records in San Francesco. We have it on the authority of Vasari, also, that Puccio painted scenes from the life of St. Francis in the choir of San Francesco of Pistoia.[4] The recent recovery of these frescoes by the removal of an old coat of whitewash enables us to recognise a series of subjects similar to those illustrating the life of St. Francis in the Upper Church of San Francesco at Assisi. The surface thus laid bare is fragmentary, but the remains display outlines of bold freedom, colour of some force, and flesh of warm brown tone. Amongst the subjects are: St. Francis receiving the stigmata, St. Francis undergoing the ordeal of fire before the Soldan, the saints casting out devils at Arezzo, supporting the falling edifice of the church, receiving the confirmation of his order, Christ com-

[1] These frescoes are damaged by time, dust, and partial dropping of the plaster.

[2] The walls are whitewashed with the exception of the part inclosed by the press. St. Mary of Egypt kneels with her arms crossed on her breast. Part of the head, arms, and breast of the saint remain. The flesh tints damaged by rubbing are somewhat purple in shadow.

[3] Tolomei, *u.s.*, p. 138. Ciampi adds that, according to records in San Francesco, Puccio began to labour there, but the work was interrupted by his death (*Notiz. Ined.*, *u.s.*, p. 103). [4] Vasari, ed. Sansoni, i., pp. 402, 403.

manding him to restore the church, Lazarus, the Magdalen, and
other saints. Injured as these fragments have been by the
treatment which they have undergone, they reveal the hand of
a disciple of a school of Giottesques. The period in which he
practised is indicated by remnants of an inscription on the
pilaster to the left of the ingress to the choir. The chapel is
described as having been decorated by order of Bandino Conti
of the family of the Ciantori of Pistoia in 1343, *i.e.* six years
previous to the date of Puccio's registry in the guild of Floren-
tine painters. But these are not the only works recovered from
whitewash in San Francesco of Pistoia. There are fragments of
scenes from the life of St. Anthony brought to light in the chapel
of Sant' Antonio, which are evidently by the artist who worked
in the choirs. Episodes of similar appearance have been found
in the chapel of San Jacopo, and a Marriage of the Virgin, her
Death and her Ascension in yet another chapel. But it may be
that the frescoes of San Jacopo, and those representing scenes
from the legend of Mary, are by Giovanni di Bartolommeo
Cristiani or Antonio Vite. That a crucifix by Puccio once
existed in San Domenico of Pistoia is affirmed by Vasari, who
quotes the inscription which certified its origin.[1] In addition to
the fragment in the choir, the frescoes in the chapel of San
Lodovico at San Francesco are assigned to the master, but these
are also not unlike the productions of Giovanni di Bartolommeo
Cristiano[2]; whilst in the chapter-house of the same convent a

[1] VASARI, ed. Sansoni, i., p. 403.

[2] These frescoes, lately rescued from whitewash, represent the Crucifixion with the
usual attendant groups, and, in front, a lady kneeling, supposed to be Donna Lippa
di Lapo. This lady died in 1386, leaving a will in which she ordered the chapter-
house of San Francesco to be painted and the ceiling of the sacristy to be "intona-
cata." The communication of this will, which mentions the name of no artist, is
due to the kindness of Padre Bernardino del Torto. It is Vasari who states that
the chapel of San Lodovico was painted by Puccio with subjects drawn from the
life of St. Louis. No such subjects exist, and it is obvious that if Donna Lippa be
really portrayed in the Crucifixion, she can hardly have been limned by Puccio,
who was registered at Florence as early as 1349. The subjects in San Lodovico
(chapel in San Francesco) are, besides the Crucifixion, two scenes at its sides—the
Nativity and Deposition from the Cross. On an opposite wall, traces of St. Francis
receiving the stigmata. In the ceiling, more modern and rude, are figures of SS.
Peter, Louis, and Lawrence, the two first restored; scenes from the life of St. Louis
may be under whitewash.

Crucifixion and Root of Jesse, to which Puccio's name also clings, recall the same subjects in the great refectory of Santa Croce at Florence.[1] Other works alluded to by Vasari may be dismissed without comment.[2]

As regards Guglielmo di Forlì and the two artists of Faenza, Ottaviano and Pace, the frescoes of the first in San Domenico of Forlì have disappeared,[3] and other Giottesque remains are insignificant.[4] Yet we may except a fragment in the Ginnasio Comunale at Forlì, part of the series once adorning the church di Schiavonia.

We may, indeed, regret that nothing remains of these series except a life-size Adoration of the Magi, St. Peter, St. Jerome, St. Paul, St. Augustin, three figures and two horses, creations that do more honour to the school of Giotto in these parts than any assigned to the

[1] In the chapter-house the fainting Virgin, the Evangelist. Yet a bishop writing and other saints, a kneeling man and a nun in the foreground supposed to be Donna Lippa, form part of the Crucifixion. In two side compartments the Transfiguration and another sacred incident seem the product of a painter of the close of the fourteenth century. The ceiling represents the Nativity reproduced at Greccio by St. Francis, the burial and ascension of St. Francis, the resurrection of Christ, and another subject, rude and in part repainted works of the fourteenth or fifteenth centuries.

[2] VASARI mentions paintings above the door of Santa Maria Nuova at Pistoia (three half-figures). The Virgin and Child between St. Peter and St. Francis in San Francesco of Pistoia both absent (ed. Sansoni, i., p. 403). The chapel of St. Martin in the Lower Church of Assisi is by Simone Martini, as may be seen hereafter (VASARI, i., p. 403). In Santa Maria degli Angeli, near Assisi, no paintings exist which can be assigned to a pupil of Giotto (*ibid.*, same page). The Virgin and Child between SS. Clara, Mary Magdalen, Catherine, Francis, Lawrence, Anthony the Abbot, Stephen, and another female, engraved by D'Agincourt as by Puccio, and now at the Museo Cristiano at the Vatican, is a common product by a follower of Taddeo Gaddi. The Saviour at the column mentioned by VASARI (i., p. 403) at "Portica," is not to be found; nor indeed do any pictures or frescoes exist in or about Assisi that are worthy of attention. Above the portal of San Crispino at Assisi a fresco of the Virgin between SS. Roch, Blasius, Francis, and other saints, partly damaged, is a rude production of the close of the fourteenth century. Another remnant of the same time, reminiscent of the lowest class of Sienese pictures, the Madonna between angels and mutilated remains of saints, is in the ex-church of San Bernardino at Assisi. Similar feeble paintings may likewise be seen in San Damiano outside that town.

[3] VASARI, ed. Sansoni, i., p. 404.

[4] A repainted fresco, Virgin and Child, in the sacristy of the Servi, a Virgin and Child and crucifix in the old chapter-house, and a Madonna delle Grazie under glass in the cathedral of Forlì are assigned to Guglielmo degli Organi, otherwise Guglielmo da Forlì.

artists named by Vasari. A certain nobleness distinguishes the slender
figures and heads, the finely-drawn hands and broad draperies.[1] No
name has yet been attached to this work, but history records that of
Baldassare, a painter of 1354, who is said to have laboured long at
Forlì, and this date would apply to the paintings now before us.[2]

In the absence of all traces of Ottaviano,[3] an altarpiece in the
Academy of Faenza is still assigned without sufficient warrant to
Pace,[4] who is thus unwittingly classed amongst the followers of
a low Giottesque style, the principal illustration of which is due
to a hitherto unknown artist called Peter of Rimini.

Living in the early part of the fourteenth century, this local
painter left his name on a crucifix at Urbania, near Urbino,[5] the
peculiarities of which we find reproduced in frescoes still preserved
in the chapter-house of Pomposa, and in Santa Maria Portofuori
of Ravenna. Of these the reader, if patient enough, may take
the following summary.

[1] A head in the same manner is in the upper story of the same gymnasium.

[2] Bonoli, *Storia di Forlì* (4to, Forlì, 1661), p. 154, in Giov. Casali's *Guida per
la Citta di Forlì* (12mo, Forlì, 1838), p. 71.

[3] Vasari mentions works at San Giorgio of Ferrara by Ottaviano without giving
the subject (ed. Sansoni, i., p. 404), a Virgin between St. Peter and St. Paul in San
Francesco of Faenza. Both have perished.

[4] To Pace Vasari assigns frescoes in San Giovanni Decollato at Bologna—a Tree
of Jesse and an altarpiece with scenes from the life of the Saviour and of the Virgin
at San Francesco of Forlì—gone; scenes from the life of St. Anthony in the chapel
of that name in the Lower Church at Assisi, now whitewashed. Another chapel of
St. Antonio, of Padua, is decorated at Assisi with frescoes of the legend of St. Laurence
rudely executed and assigned by modern critics to Pace, perhaps because of some
resemblance between them and the so-called Pace in the Academy of Faenza.
These frescoes, and those of the chapel of St. Catherine, assigned to Buffalmacco,
have also a family likeness. The picture of Faenza is a Virgin and Child between
SS. John Baptist, Peter, Mary Magdalen, and Paul, with the Angel and Virgin
annunciate in the upper spaces. According to Lanzi (*u.s.*, iii., p. 31), this is the
picture by Pace formerly in San Sigismondo fuori di Porta Montanara. Yet it is a
work of the beginning of the fifteenth century, raw and violently contrasted in
tone, unrelieved by light and shade, and marked by figures short and defective in
the extremities.

[5] In the fraternity of San Giovanni Decollato, inscribed: PETRUS DE ARIMINO
FECIT HOC . . . Passavant, *Raphael* (8vo, Leipzig, 1839), i., p. 425, mentions this
crucifix as signed: JULIANUS PICTOR DE ARIMINO FECIT, ANNO MCCCVII.

* But perhaps the writer erred, and was, as Signor Cavalcaselle suggests, thinking
of another picture, a picture in the cathedral at Urbania, of which we shall
presently speak. See *postea*, p. 154.

The Saviour shows a thin and bony frame, with somewhat overhanging hip in the old style, but the form is drawn with nicety and care. The hands and feet are thin, but fairly accurate. The Virgin, on one side clasping her hands in grief, is of a Giottesque type, and not without dramatic power. St. John, also full of force, is a little more vulgar in features. The Saviour blessing at the top of the cross is noble in face and soft in expression. A fair definition of light and shade, and warm yellowish colour, add to the value of the work. Petrus no doubt lived in the early part of the fourteenth century.

Between Ravenna and Ferrara, near Commachio, lies the abbey of Pomposa, of which the second consecration took place in 1027.[1] The apsis and tribune, and the whole of the spaces above the arches of the nave were probably filled with mosaics in early times. These, however, apparently shared the fate of many others in Italy, and were replaced by paintings.

We may still remark in the apsis a figure of the Redeemer, and on the arch of the tribune an angel holding a scroll, with the four doctors of the Church, and the four Evangelists round him. In the courses of the nave stories from the Old Testament, commencing with the Creation, and almost obliterated; scenes of the New Testament, beginning with the Annunciation; and, in the spandrels of the arches, illustrations of the Revelation of St. John. In the tribune incidents from the life of St. Eustace seem not to have been copies like the rest from older works; but on the wall above the chief portal the Saviour is first represented in glory, attended by angels, then as the Judge distributing blessings and curses. These feeble paintings may have been executed by Chegus (Cecco or Francesco) of Florence, whose name was found in the records of the Abbey by Federici, and who laboured at Pomposa in 1316.[2]

Contiguous to the abbey is the chapter-house of Pomposa, the property of Guiccioli, in which numerous frescoes are still preserved.

On one of the walls of the old refectory three large and fairly composed subjects remain. In the central one, of which the figures are all marked by dignity, fair proportion, and natural attitudes, the Saviour sits in benediction between the Virgin, St. Benedict, St. John

[1] As is proved by an inscription in the body of the building.
[2] PLACIDO FEDERICI, *Rerum Pomposiensium Historia* (fol. 1781), p. 279.

the Baptist, and St. Guy,[1] while the others, parted from each other by feigned columns supporting a painted entablature, display similar qualities. The heads in the Last Supper are deficient in drawing. The staring eyes, broken draperies, and feeble red shadows[2] are disagreeable, but the style is that of Petrus of Rimini, which, though far below the perfection of Giotto, is evidently that of a student, perhaps that of an assistant, of the Florentine master.[3] Of the same period and manner, but almost obliterated, are a Crucifixion, with attendant figures of St. Benedict, St. Guy, and other saints, in monochrome in feigned niches on the walls of the old chapter-house. Petrus of Rimini did not labour in Urbania and Pomposa only, but in Ravenna also, in the choir and lateral chapels of the church of Santa Maria Portofuori.[4] In a niche in the choir the Communion is represented, and the Redeemer has a type and character which seem derived from the painters of the Pomposa refectory. In the chapel to the right of the choir a fresco of the ascent of a saint to heaven in a cloth held by an angel is in the same manner, but side by side with these are frescoes by an inferior hand. On the left wall of the choir the Expulsion of Joachim, the Birth of Mary, and the Presentation in the Temple are composed of long lean figures in exaggerated movement. On the right wall the Massacre of the Innocents, the Death, Assumption, and Coronation of the Virgin; in the ceiling the four doctors of the Church and the four Evangelists. Various frescoes in the lateral chapels, on the arches leading into the tribune, are painted in the feebler style of another follower of Petrus, whose manner seems moulded on that of Julian of Rimini.

Of this painter, who reduced the second-rate manner of Petrus to a third-rate manner of his own, a very fair example may be

[1] The youthful and slightly bearded Saviour is reminiscent of that in the medallion of the crucifix of Petrus of Rimini. Similar qualities are to be found in the Last Supper on one side, and in a scene, on the other, representing Guido, abbot, and S. Gebeardo, Bishop of Ravenna, sitting behind a table in presence of six other persons. On the opposite walls are remains of a Christ on the Mount, and on the third a headless figure of a monk seated, the mutilated part showing an under intonaco, already covered with older paintings.

[2] The shadows are of a purple-red.

* [3] FEDERICI does not hesitate to assign these paintings to Giotto himself. See *Rerum Pomposiensium Historia, u.s.*, p. 286; and BUSMANTI, *Cenni Storici di Pomposa.*

[4] All these paintings are strangely enough assigned by ROSINI (*Storia della Pittura*, ii., p. 63) to Giotto.

seen in a Virgin and Child, angels, and saints, dated 1307, in the sacristy of the cathedral of Urbania, near Urbino.

This is a picture not essentially different in appearance from most Italian productions of the same period at Tolentino, Fabriano, Gualdo, or Camerino.[1] The male figures are not without character and animation, the females not without grace in costume and head-dress. The forms of the hands are regular, the drawing of the whole conscientious, and the draperies not ill lined. The light and transparent colour, though soft, is flat and unrelieved. It is obvious from this example alone that Julian of Rimini had his own peculiar style, which may be traced with certainty in the picture of the Academy of Faenza attributed to Pace,[2] a tabernacled and pinnacled altarpiece, of a shape common in the Umbrian school, inclosing no less than twelve subjects or figures, and six medallion half-figures of saints or prophets. The centre represents the Virgin enthroned, above which the Crucifixion is depicted, and here the Saviour is of a long, attenuated form, and some heads are remarkable for absence of all beauty. The saints in the side niches are in character like those of Urbania, the best of them a St. Clara.[3] As far away to the south as Bologna there are traces of this phase of art in the ex-convent of San Francesco, where the Giottesque style of Pomposa is apparent in a Crucifixion, Resurrection, and scenes from the legend of St. Francis, which cover the extensive walls of the refectory.

[1] Inscribed:—

ANNO DÑI MILLE CCC. SETTIMO.
JULIANUS, PICTOR DE ARIMINO FECIT
HOC OPUS, TEMPORE DÑI CLEMENTIS
P. P. QUINTI.

The Virgin, a feeble and defective figure, both as regards form and type, sits enthroned with the infant Saviour between four angels waving censers and holding up the drapery of the throne. In front eight figures kneel to the right and left, and in eight panels, in a double course at the sides, are an equal number of male and female saints, in the following order, beginning from the top to the left: St. Francis receiving the stigmata, St. John the Baptist, St. John Evangelist, St. Mary Magdalen, St. Clara, St. Catherine, another female, and St. Lucy.

＊ On the right are St. Francis, St. John, St. Clare, and St. Catherine ; on the left St. John the Evangelist, St. Mary Magdalen, St. Agnes, and St. Lucy.

[2] In PUNGILEONI, *Elogio Storico di Giovanni Santi* (8vo, Urbino, 1822), the reader finds record (p. 47) of one "Giuliano dipintore" at Urbino in 1366 and 1367. But he cannot be the same as the author of the crucifix of 1307.

[3] The niches at each side of the centre are six in all, containing St. Christopher, St. Clara, St. John the Baptist, St. Elizabeth, St. Francis, and St. Louis of France. In the pinnacles, at each side of the Crucifixion, are Christ on the Mount, the Kiss of Judas, the Deposition from the Cross, and another subject.

Inferior to these pictures, perhaps because of extensive restoring, but in
the local style of the period, are the frescoes in a chapel to the left of
the choir in the convent of Sant' Antonio Abate of Ferrara,[1] representing
in a series of feeble compositions, coloured with flat rosy tones, scenes
from the Passion of the Saviour. The date of 1407 may be seen
beneath a figure of the Redeemer on one of the walls; but this date
seems to have been placed there after the frescoes had been some time
completed.

In the gallery of old pictures at Urbino we find an altarpiece
in several parts, not long since transferred from a church at Macerata,
and certified with an inscription of which fragments only are preserved,
but which clearly sets forth the name of Johannes, coupled with the
words "de Arimino" and the date of 1345. There seems to be some
ground for thinking that the picture at Urbino is that which once
hung in the refectory of San Francesco of Macerata, and hence that
we have an authentic specimen of art from the hand of a Riminese,
whose name was Barontius. In the centre is the Virgin and Child, with
Christ crucified in a pinnacle. At the sides, in three courses: left, an
angel and St. Francis, beneath which are the Last Supper and the
Capture; right, an angel and a bishop, beneath which are the Epiphany
and the Presentation in the Temple. The style of this piece is that of
the painters of Rimini, and is closely allied to that of Giuliano.[2]
According to the latest authorities, records in the archives of Rimini
contain the names of numerous artists of the thirteenth and fourteenth
centuries who cannot be connected by any means with any extant works
of art. But in the title-deeds of property owned at San Lorenzo in
Correggiano in 1346, Domina Catalinà, the freeholder of the land, is
described as the widow of the painter Julian, who is probably the artist
to whom we owe the pictures above described. But records also establish
the existence of another craftsman of this period, who executed an
altarpiece in San Francesco of Macerata,[3] whose name is Johannes

[1] A chapel not usually open to visitors.

[2] The inscription as it now remains is this: ANNO. DNI MILLE CCCXL . . . IOANES
. . . DE ARIMINO. As preserved in local annals the inscription ran: ANNO D.
MCCCXL. QUÌTO TPE DÑO CLEMENTIS P. P. OC OPUS FECIT JOANNES BARONTIUS DE
ARIMINO (see TONINI, u.s.). But Clement VI. was Pope in 1352, and not before.

[3] Amongst the sepulchral inscriptions of the church of San Francesco of Rimini
handed down to us by LINGI TONINI, in his Rimini nella Signoria di Malatesta
(8vo, Rimini, 1880), is one of JOHIS BARONTII ET DEUTA COMANDI BARONTII,
ET COMANDI FILII QUONDAM MAGISTRI JOHANNIS BARONTII PICTORIS DI CONT.
S. AGNETIS.

Barontius of Rimini. There is evidence that Barontius lived till the middle of the fourteenth century, and an inscription is preserved from which it appears that the altarpiece of Macerata was painted by him in 1345. The gradual decline of this manner may be traced in a colossal crucifix in the church of San Paolo at Montefiore, near Urbino; in a crucifix in the chapel to the right, inside the portal of the cathedral of Rimini; and in a third relic of the same kind in the deadhouse of the hospital of Urbino. Generally in character with these works are some old paintings at Verrucchio, not far from Rimini. Interesting amongst them is a crucifix with figure, over life-size, of Christ on the cross, and busts of the Virgin and Evangelist at the ends near Christ's hands, and at the foot of the cross the Magdalen. Similar in style, in the church of Santa Croce of Villa, the Crucifixion with all the episodes attending it, a Giottesque composition which seems to have been part of an old series of frescoes representing scenes from the Passion. It might be easy to give a long catalogue of similar works, differing only from those which preceded Giotto's time in this, that, whereas before him an uniform model was derived from past ages, painters now sought to imitate that of which the type had been created by the great Florentine; and there is evidence enough in the stories of Sacchetti to prove that crucifixes were manufactured, so to say, by the gross.[1]

Thus, whilst we seek in vain for the works of men like Guglielmo di Forlì, Ottaviano, and Pace da Faenza, we stumble,

[1] An ex-chapel of Santa Chiara at Ravenna (abandoned and close to a riding-school) is covered with frescoes in which a style related to that of Petrus and Julianus of Rimini may be found. Christ on a rough-hewn cross in convulsive movement is bewailed by angels in vehement action (four fly about in grief, three gather the blood from the wounds, one tears its dress from its breast). The Virgin and St. John are at the sides, and St. Mary Magdalen at the foot stretches out her arms to heaven. Beneath this Crucifixion is the Baptism of Christ, with an ugly and partly repainted nude of the Redeemer. On other walls the Annunciation, St. Francis, St. Clara, St. Anthony the Abbot, St. Louis, and the Adoration, and in the ceiling the four doctors of the Church, are all frescoes, of which the principal figures display the defects noticed at Pomposa and Santa Maria Portofuori (note the long thick necks, protruding chins, massive hair, and heads without cranium), and repeated in other parts of Italy in pictures and frescoes assigned to Simone (No. 159 of the Academy of Arts at Bologna, Nos. 161 and 231 of the same gallery), or Jacopo at Bologna.

* As we have already stated, the convent of S. Chiara at Ravenna is now the Ricovero di Mendicità. The apse of the church is properly preserved. The entrance is in the garden of the Ricovero.

even in the nineteenth century, on painters hitherto scarcely noticed, and evidently forming a second-rate school, the chief of which may have known Giotto, and assisted him in his works at Rimini and Ravenna.

In other places where Giotto laboured it is difficult to find traces of the influence which his example may have produced. At Rome, where we shall find the Florentine Giottesques employed till the close of the fourteenth century, little is to be discovered, except some feeble frescoes in San Sisto, of which something may be said hereafter. As to pictures, a fair specimen may be noted in an altarpiece in the ex-convent of the Filippini, where the Trinity is represented in the old form, and the figure of a male patron is introduced at foot. Everything in this piece indicates contact with Giovanni da Milano, Giottino, and Agnolo Gaddi, whose extensive decorations at the Vatican, in 1369, have unfortunately perished.[1]

In the fourteenth, as in the thirteenth century, painting was cultivated and patronised in the vicinity of Rome, and notably at Subiaco, where an entire chapel, dedicated to St. Bede, in Santa Scolastica, is filled with wall paintings.

On the walls are the Nativity, the Flight into Egypt, the Baptism, the Sermon on the Mount, and the Crucifixion, with the figures of the Virgin and Evangelist, St. Benedict, and another saint in the foreground. In the lunettes are episodes out of the legend of St. Michael the archangel, and in the vaulting the Eternal in benediction, with the thrones, dominations, virtues, and angels. But the painter, who was perhaps a Benedictine clinging to the traditions of old art, as exemplified in violent action, ill-studied form, and ugly faces, seems to have been more familiar with the practice of miniature than with that of fresco.[2]

In Sant' Andrea of Tivoli remnants of a decoration in fresco point to a remote time, but are too rough to deserve serious attention.

[1] See *postea*, in notices of Giovanni da Milano, Agnolo Gaddi, and Matteo Pacini. The altarpiece of the Filippini bears illegible remnants of an inscription. It is shaded or covered with figures and the crust of age.

[2] Subiaco. These paintings have been recently restored, and so deprived of some of their original character.

At Verona the remnants of old Christian art are only less numerous than those of the pagan time. In Santi Nazzaro e Celso, a Baptism of the Saviour seems produced in the earliest Christian period, and till very lately there were old examples in the crypt of San Fermo, amongst which were parts of twelfth-century figures, which had some local value. A fresco, too, of Christ about to be removed from the cross, showed the feet separately nailed to the cross, according to the fashion of the thirteenth century.[1] In a garden belonging to the Casa Smania, near Santi Nazzaro e Celso, a chapel still exists which was originally cut out of the solid rock. There some figures of angels in niches are visible, which may be considered of some antiquity. There, too, we see a lion on one of the under strata of intonaco, and, on a more modern stratum, a Baptism of Christ, saints in niches, and the Saviour in Glory in the ceiling. The latest of these frescoes can scarcely be of more recent date than the eleventh century. In Santi Siro e Libera, a figure on a stone seems as old as the tenth, and an effigy in San Zeno Maggiore is said to date from the eleventh, and to represent Pepin. A Crucifixion in San Zeno, with the Eternal in benediction above it, and the Virgin and Evangelists at its sides, with other saints and a kneeling friar at the base, may be work as late as the middle of the fourteenth century.[2]

In Treviso, which was distinguished in early times by encouragement to art, we find, even now, copious evidence of the industry and skill of painters of the thirteenth and fourteenth centuries. At San Niccolò, where Tommaso of Modena laboured, he was preceded by numerous guildsmen whose names are not attached to works, whilst works are extant of which we do not know the authors.[3]

We may notice in San Niccolò of Treviso, between the windows at the back of the high altar, a Crucifixion, painted on the wall, with the

[1] The frescoes in the crypt of San Fermo disappeared when the place was turned into a canteen.

[2] San Zeno Maggiore. Inside and to the left of the main entrance. Besides the friar there is another kneeling figure at the foot of the cross.

[3] See, for some of these, viz. Uberto, Gabriele di Villa (1280–1315), Perenzuolo, and Marco and Paolo, FEDERICI, *Mem.*, *u.s.*, i., pp. 4, 160, 169–84.

usual flight of angels, the Virgin and Evangelists in the foreground to the right and left, and, in niches at the sides, St. Peter and St. Paul. On the border beneath the cornice of the church, and between the brackets which support the cornice, a head of Christ, and busts of prophets and angels.[1] These are wall paintings, apparently executed in the early part of the thirteenth century.

At Modena we find, in the first half of the thirteenth century, Armaninus, a painter of whom a fresco remains in the church of the Madonna of Castignana, near Solmona in the Abruzzi, representing Christ in Glory between the Virgin and the Evangelist. The painter's name, and the ciphers of 1237, seem to vouch for the antiquity of this work.[2] A Virgin and Child, with a bishop, a miraculous image in an altarpiece, on the Altar of the Relics, in the cathedral of Modena, is attributed to this age because of the date upon it of 1269. But the painting is of the fourteenth century, and looks like work by Seraphino de' Seraphini, of whom a word later. Other paintings—as, for instance, a bishop half length in fresco in San Spirito, and a Virgin giving the breast to the infant Christ in San Domenico—are poor productions of the fourteenth century.

The far north of Italy is not without examples of early pictorial activity. At Cividale the cathedral contains wall paintings of the eleventh and twelfth centuries.

On the wall, to the left as you enter, figures of the Magdalen, St. Sofia, and the three cardinal virtues; above the arching of the nave on that side, the Creation of Adam and Eve, beneath which Eve presents the apple to Adam, God the Father reproves Adam and Eve, and the expulsion from Paradise.

These are all frescoes of one period, the oldest if not the rudest in the province of Friuli. Of a later date, yet still old, are half lengths of Christ in benediction, between two angels; mutilated and discoloured figures, above and inside the portal, to which other fragments may be added, viz. :—

On side walls four martyr-saints, also St. Benedict between St. Placidus,

[1] Some of these are all but obliterated.

[2] Inscribed : A.M. DVCENTESIMO XXXVII. MAGISTER ARMANNINVS FECIT HOC OPVS (not seen by the authors).

St. Mark, St. Scolastica, and another female, traces of two episodes from the life of St. Benedict, the Coronation of the Virgin, the Baptist, St. Andrew, and two women. In the choir, near a window, fragments of an Annunciation. In the vaulting, Christ in Benediction, the Epiphany, the Baptist, St. Benedict, St. Anthony, the Magdalen, and another saint. About the window of a neighbouring chapel are fragments of painting, beneath which are a Crucifixion, with the Virgin and St. John the Evangelist.

The earliest of these are as old as the eleventh, the rest are of the twelfth and thirteenth, and some possibly of the fourteenth century.

CHAPTER IX

BUFFALMACCO AND FRANCESCO DA VOLTERRA

IT is usual to find amongst men who work in common, and who
form a company in any given society, one or two who are the
merry-andrews of the community, and one who is the butt of all
the rest. Such, amongst the painters of the fourteenth century
at Florence, were Buonamico Christofani, called Buffalmacco,[1]
Bruno Giovanni,[2] and Nozzo, called Calandrino.[3] Calandrino, the
butt, was an older man than his tormentors, a bad husband,
avaricious, credulous, and a fool. It is impossible not to laugh
at the practical jokes successfully played off upon him. He is
led to believe in and then to search for a stone which has the
property of making its possessor invisible. Buffalmacco and
Bruno encourage him to load his dress with gravel and pebbles
picked up on a road outside Florence, and induce him to think
that he has found the treasure of which he was in search by pre-
tending to lose sight of him. Then, cursing his luck, they pelt him
mercilessly home. It is amusing to read the narrative of Buffal-
macco's success in forcing Andrea Tafi to rise late instead of
early ; his rivalry with the monkey of Guido, Bishop of Arezzo,[4]
who repainted in the evening the frescoes which had been com-

[1] The existence of Buffalmacco has been denied. See *Forschungen*, ii., note to
p. 14. But his name appears in the form given in the text in the register of the
Florentine company of painters in 1351 (GUALANDI, *u.s.*, vi., p. 178).

[2] This painter is inscribed on the register of Florentine painters as " Bruno
Giovanni pop. S. Simone dipintore, MCCCL." (GUALANDI, *u.s.*, p. 177), and is
found mentioned by Baldinucci in a contract of 1301 (*Op.*, *u.s.*, iv., p. 296).

[3] His name appears in Florentine records : " 1301. Nozzus vocatus Calandrinus
pictor quondam Perini pop. S. Laurentii testis." See BALDINUCCI, *u.s.*, p. 200.

* [4] Guido Tarlati, the ambitious Bishop of Arezzo, died in 1327.

pleted during the day; the trick which he played on the very
same bishop, a fierce and haughty Ghibelline, by painting for
him, instead of an eagle humbling the Florentine lion, a lion
devouring the Imperial eagle; and the revenge he took on the
impatient people of Perugia by painting their patron saint with
a diadem of fishes. Equally pleasant is the trick perpetrated on
a peasant, who, having ordered a St. Christopher of twelve braccia
to be painted in a chapel that had only nine braccia in height,
was obliged to content himself with a figure on the floor, of which
the legs passed out of the entrance. No wonder that such a man
should die in a hospital, or that the fame of his adventures
should have survived his pictures. It may be doubted, indeed,
whether even Vasari, who gives a vast catalogue of his works,
did not group together under his name a mass of inferior pro-
ductions by various hands. Yet Ghiberti affirms that Bonamico,
or Buffalmacco, was an excellent master, and that when he set
his mind to a task he surpassed every one of his contemporaries.
Vasari, who copies Ghiberti, repeats after him that—

"Buffalmacco painted many pictures for the town and Campo Santo
at Pisa, and executed important works for the Badia of San Paolo a
Ripa d'Arno at Pisa and at Bologna.[1] On his own responsibility he
adds that, at Florence, Buffalmacco worked in the Badia di Settimo,
in the Certosa, in the Badia di S. Benedetto, at Ognissanti, and San
Giovanni fra l'Arcore; that at Bologna he painted the chapel of the
Bolognini in San Petronio; at Assisi, in 1302, the chapel of
St. Catherine and the chapel of Cardinal Egidio Alvaro;[2] at Arezzo,
the chapel of the Battesimo in the episcopal palace and part of the
church of San Giustino; at Pisa, the four frescoes of the Genesis in
the Campo Santo; at Cortona, a chapel and an altarpiece in the
episcopal palace; and at Perugia, the Cappella Buontempi in the church
of San Domenico."

Not one of the pictures at Florence, Arezzo, or Cortona remain.
As for the frescoes—

[1] Ghiberti's second commentary in VASARI, ed. Le Monnier, i., p. xxi.
[2] In 1304, according to Vasari, he arranged, on the Arno, a theatrical representa-
tion of the infernal regions which had fatal consequences. The bridge was burnt
and many people perished. Buffalmacco, however, escaped (VASARI, ed. Sansoni,
i., p. 510–11).

The Bolognini chapel in San Petronio of Bologna was painted after 1408.[1] The chapel of Santa Caterina, in the Lower Church of Assisi, is the chapel of Cardinal Alvaro, or more properly Albornoz, and was erected after Albornoz obtained the purple hat in 1350. That chapel is covered, as Vasari truly says, with frescoes representing incidents from the life of St. Catherine. One of the paintings, in the vaulting of the entrance arch, is the Cardinal's consecration by a Pope, attended by St. Francis. The counterpart, on the vaulting at the other side, represents St. Louis between two bishops. The compositions are third-rate and of the close of the fourteenth century, injured by time, but ill-arranged, rude, and patchy in colour. Some figures, taken separately, are fair in movement; but they are of defective proportions and coarse outlines. We may bear in mind that the chapel of the Maddalena in San Francesco of Assisi is by one of Giotto's disciples, and cannot for that reason be assigned to Buffalmacco.[2] The chapels of Santa Caterina and of the Maddalena are by two different painters, one of whom was Giottesque, and flourished in the first half of the fourteenth century; the other not Giottesque, who lived at the close of the same century.

The frescoes of the Cappella Buontempi at Perugia are of another order altogether. The subjects are taken from the life of St. Catherine of Siena, a holy personage, whose life cannot have become a subject for pictorial delineation before the close of the fourteenth century.[3] Very few of the figures now remain; but traces of a female in a white and black dress, of an elegant and well-proportioned form, surmounted by a fine oval head of aquiline features, may still be seen. A natural and easy attitude, a broad style of drapery, remind us of the fine figures

[1] See GUALANDI, *Memorie* (8vo, Bologna, 1842), series iii., p. 93. It appears from the will of Bartolommeo della Seta, executed in 1408, that he ordered the paintings in the Bolognini chapel, with subjects given by him, and carried out as they may now be seen, to be produced at his expense. See note to VASARI, ed. Sansoni, i., p. 507, and the *Graticola* of LAMO, *u.s.*, notes to p. 39. A picture in the Bologna Gallery (No. 229), assigned to Buffalmacco because it is a copy of a part of the frescoes in San Petronio, cannot be by him. The latter can be assigned, indeed, with some certainty to Antonio da Ferrara, who may be worthy of special mention in a notice of the early Ferrarese school.

[2] See notes to VASARI, ed. Sansoni, i., p. 517. Father FRANCESCO D'ANGELI, in his *Collis Paradisi amœnitas* (Montefalco, 1704), says that the chapel of San Lodovico at Assisi, once painted by Buffalmacco, was repainted in 1490 by Andrea Albizzi, commonly known as "the Ingegno." This may be true, though the sibyls which he assigns to Ingegno are by Dono Doni.

[3] Yet ROSINI (ii., p. 52) does not hesitate to give these figures to Buffalmacco, presenting them engraved as a specimen of the painter's art.

painted by Orcagna in Santa Maria Novella at Florence. Near this figure, which no doubt is that of St. Catherine of Siena, is a fine life-size head of St. Dominic, of regular shape, finely drawn, well modelled, and painted in warm light flesh tones. Vestiges may be found also of a head of St. Bartholomew, of the Saviour in glory, of armed soldiers. Vasari, however, not content with assigning the frescoes to Buffalmacco, attributes them in another place to Stefano Fiorentino.[1]

At Florence a picture in the Academy of Arts,[2] assigned to Buffal-macco, represents St. Humility of Faenza, and scenes from her life. But the style is that of the Sienese school.

We have already noted some early painters at Pisa.[3] Pictorial records of the Campo Santo are dated as far back as 1299, 1300, and 1301, at which time a certain number of masters were employed there. We observe the name of Datus,[4] assumed by many to be identical with Deodati Orlandi of Lucca;[5] Vincinus Vanni of Pistoia,[6] and Johannes Apparecchiati, nicknamed Nucchulus or Nuccarus,[7] who painted a Virgin and Child between the Baptist and Evangelist, and a Madonna above one of the gateways of the Campo Santo, are artists whom we have seen in partnership with Cimabue. Later records comprise other names of even less repute.[8] Pisa, during the fourteenth century,

[1] Hardly visible without a lantern, on account of the darkness of the chapel (VASARI, ed. Sansoni, i., p. 453).

[2] No. 3. * This picture is by Pietro Lorenzetti. Under the figure of the saint is the inscription : A. M. CCC. XVI., and the words, HEC TENT. MIRACULA. BEATA. HUMILITATIS. PRIME. ABBATISSE. ET. FUNDATRICIS HUIUS VENERABILIS MONASTERII. ET IN ISTO ALTARI EST CORPUS EIUS. [3] Antea, vol. i., pp. 143–156.

* [4] There is no proof that Dato and Deodati Orlandi were identical. Dato was also a mosaist, and worked on the mosaic in the Tribune of the Duomo. See TANFANO-CENTOFANTI, Notizie di Artisti tratte dai Documenti Pisani, Pisa, 1897, pp. 134, 135.

[5] See FÖRSTER in Kunstblatt, 1833, No. 68.

* [6] See TANFANI-CENTOFANTI, op. cit., pp. 492–4.

* [7] See TANFANI-CENTOFANTI, op. cit., pp. 120, 121. Johannes Nucchulus was the son of Apparechiato.

[8] See Arch. di Stato, Pisa, Libr. Entr. e Uscita dell' Opera del Duomo di Pisa of 1299, 1300, in FÖRSTER, Kuntsblatt, 1833, No. 68 ; CIAMPI, Notizie, Doc. xxiii., u.s., p. 143 ; and Libro F. del Duomo di Pisa, 1301, 1302, in CIAMPI, u.s., p. 145.

* The following list of painters—which is that which Professor Giuseppe Fontana compiled for Signor Cavalcaselle, with our own additions—shows that artists were numerous enough in Pisa in the fourteenth century. Only one of these, however,

did not give employ to any painter above the most ordinary level. Those who practised in the fourteenth century formed themselves more or less upon the models of Siena, but at so humble a distance that the directors of the great Pisan works employed strangers from Siena, rather than entrust their commissions to natives. Thus, in the early part of the fourteenth century, the Lorenzetti illustrated hermit life on the walls of the Campo Santo; though Vasari affirms that Orcagna took a great part in the production of that series. Towards the close of the century, the want of competent artists at Pisa was still sensibly felt, and many from distant parts of Italy were sent for in succession. In 1370 the frescoes of the trials of Job were produced, as it is now believed, by Francesco of Volterra, who had settled at Pisa in 1346, had already furnished an altarpiece for the cathedral,[1] and in 1358, had been elected to the great

Francesco Traini, a follower of Simone Martini, who was also influenced by the Lorenzetti, can be regarded as a master even of the second rank :—

Bonturo, 1301 ; Francesco, 1301 ; Michele or Ghele da Santa Margherita, 1301 ; Tano, 1301 ; Upezzino, 1301 ; Vanni di Bono, 1301 ; Vittorio di Francesco, 1301 ; Tura or Torello, 1301–1303 ; Pucchiarello di Maestro Ciolo, 1301–1349 ; Piastra (?), 1304 ; Bonaccorso detto Coscio, del Gese, 1315–1365 ; Matteo, 1315 ; Feuccio di Paolo, 1315 ; Peruccio di Bindo, 1315 ; Vanne (? Vanni), 1315 ; Sardo, 1315 ; Piero, 1315 ; Bindo di Giucco, 1317–1347 ; Luzzo di Cagnazzo, 1318 ; Francesco Traini, 1322–1341 ; Nino di Piero, 1330–1339 ; Michele di Geppo ; Tomeo di Betto di Vanni, 1337–1345 ; Lupo di Puccio, 1344 ; Betto di Vanni, 1344–1345 ; Giucco di Bindo di Giucco, 1347 ; Simone di Lapo, 1348 ; Matteo di Niccoluccio, 1349 ; Benedetto di Michele, 1349–1371 ; Nino di Michele, 1356 ; Rombolo, 1357 ; Giovanni di Bonaccorso, or Giovanni del Gese, 1357–1387 ; Neruccio di Federico, 1357–1389 ; Francesco da Volterra, 1346(?)–1371 ; Giovanni di Giovanni, 1365 ; Giuntino di Bonagiunta, 1365 ; Jacopo di Simonetto, 1365 ; Piero di Puccino, 1365 ; Jacopo di Benincasa, 1367–1383 ; Giovanni del Mosca, 1368 ; Nino, 1368 ; Paolo di Giunta, 1368 ; Piero di Nardo, 1368 ; Giambello di Barone, 1368–1377 ; Borghese di Pasquino, 1368–1390; Berto da Volterra, 1369–1385 ; Jacopo di Francesco da Roma, 1370–1371 ; Jacopo di Ghele, 1370 ; Cecco di Piero, 1370–1402 ; Jacopo di Michele, 1371–1389 ; Benedetto di Michele, 1371 ; Giovanni di Cristiano, 1381–1388 ; Benincasa di Jacopo, 1384 ; Betto, 1384 ; Turino di Vanni da Rigoli, 1392–1438 ; Borghese di Piero, 1397–1461 ; Antonio di Pucciarello, 1397 ; Piero di Borghese, 1398.

These painters, as Signor Cavalcaselle has said, followed for the most part, but at a great distance, the great Sienese masters of the Trecento. It would be difficult to find a more undistinguished succession of artists in the history of Italian painting.

[1] "Memoriale" of the Opera of the Duomo. The value of the altarpiece is given at sixty-seven florins eight den.

council of the people.[1] Had the records of the Campo Santo
been searched with care previous to the destruction of their old
bindings in 1802, more certainty might exist as to the authorship
of these frescoes, which were long assigned to Giotto. Some of
the bindings contained entries of payments for work in the Campo
Santo, and one, amongst others, to the effect that, "the story of
Job in the Campo Santo was commenced on the fourth of August,
1371."[2] A search in the books resulted in the discovery of records
stating that Francesco da Volterra had received important pay-
ment in 1372, for material used in painting and restoring
paintings at Pisa;[3] and other records proved that the same artist
had been employed at the Campo Santo, in company of one
Neruccio and one Berto.[4] Cecco or Francesco di Pietro, a Pisan
painter who has left behind him some interesting works, also
remains in notices of 1372, and of Neruccio alone it is known
that, in 1370, he furnished designs for the glass windows of the
"opera."[5] But the paintings of Job are said to have been
commenced in 1371, and the payments to Francesco da Volterra
appear to have been made as early as 1370; it is either an error
to assign them to Francesco,[6] or the transcript from the book

[1] BONAINI, *Memorie, u.s.*, p. 94.

[2] This record has been given fully by E. FÖRSTER in *Beiträge, u.s.*, p. 114, and
for some time belonged to Signor Ciappei at Pisa.

[3] FÖRSTER, *Beiträge, u.s.*, p. 115.

* [4] For further information relating to Francesco da Volterra consult TANFANI-
CENTOFANTI, *op. cit.*, pp. 97, 107, 189–93, 387.

[5] See the records once belonging to Signor Ciappei, also CIAMPI, *Notizie, u.s.*,
p. 96, and FÖRSTER, *Beiträge, u.s.*, p. 114.

* Neruccio, Piero di Puccino, and Bonaccorso del Gese went in company with
other Pisan painters to Milan in 1365 to work at the Court of Galeazzo Visconti.
The Pisan school of the fourteenth century, as we know it in the works of Traini
and Cecco di Pietro, was little more than an offshoot of the Sienese. Its masters
were followers of Simone Martini and Pietro Lorenzetti. Through their Pisan
followers the school of Siena influenced the early Milanese school. This important
influx of West-Tuscan influence into Lombardy in the Trecento has been overlooked
by art-historians. See in the Archivio, Pisa, *Arch. del com. Provv. degli Anziani*,
1366 (cap. pis.), c. 20. Tanfani-Centofanti gives some information in regard to this
visit of Pisan artists to Milan. See TANFANI-CENTOFANTI, *op. cit.*, pp. 101, 107.

* [6] It is very doubtful whether those frescoes in the Campo Santo are by
Francesco da Volterra. The words of the entries in the *Libri di Entrata e
Uscita* of the Duomo tend to prove that the work with which Francesco da Volterra
and his comrades were entrusted was that of restoring some existing fresco. There

covers errs in the use of the word "commenced." The style is doubtless Giottesque, but so many painters went by the name of Francesco at Florence, that it is not possible to determine which of them is Francesco da Volterra.[1]

Vasari mentions amongst the artists enrolled in the old company of Florentine painters, Francesco di Maestro Giotto, of whom he is unable to give any information.[2] We learn from the books of the guild that this Francesco was registered as early as 1341.[3] The first notices of Francesco da Volterra at Pisa only date back, as we saw, to 1346. Possibly Francesco di Maestro Giotto and he are one person.

The frescoes of Job, in a double course at the western end of the south wall at the Campo Santo, are divided into six great compartments. Beginning from the top near the western gate, with the subject of the feast,[4] the series continues with Satan pleading before the Redeemer, the battle of the Sabeans, the destruction of Job's house, an obliterated subject, Job on the dunghill, the rebuke of Job's friends, and Job's return to prosperity. In the first composition there are traces of Job feeding the poor, and feasting with his friends at a table, whilst a musician plays the viol, and herds, tended by shepherds, are scattered around. In the second, the Saviour, in an elliptical glory supported

is an authentic painting by Francesco da Volterra in the church of Pugnano, near Regoli, which shows what an inferior painter he was. For our part we believe that the question of the authorship of these frescoes of Job is by no means settled. See Archivio, Pisa, *Archivio dell Opera, Libro di Entrata e Uscita*, 17 turch. c. 56, 56ᵗ, 58ᵗ and 111, and *Libro di Entrata e Uscita*, 19 turch., c. 135.

[1] As proof, we need but to consult the following list, extracted from the books of the Florentine painters' guild in GUALANDI, *u.s.*, vi. pp. 180, 181.

Years.	Names.	Surnames.	Years.	Names.	Surnames.
1340	Francesco	Pardi.	1344	Francesco	Cialli.
—	—	Consigli.	1348	—	Bondanza.
—	—	Bertini.	—	—	del Maestro Niccola.
—	—	Carsellini.	1365	—	Bartoli.
—	—	Vannini.	1368	—	Neri.
1341	—	di Maestro Giotto.	1371	—	Boni.
1342	—	Cennamella.	1387	—	Pucci.

[2] VASARI, ed. Sansoni, i., p. 405.

[3] BALDINUCCI assumes (*u.s.*, i., p. 167) that this Francesco is Giotto's son, but without any proof.

[4] This fresco was restored in 1623 by Stefano Maruscelli (MORRONA, *u.s.*, ii., p. 205).

above the horizon of a landscape varied with seas and mountains, sits and listens to the pleading of Satan, represented as a horned monster with bat's wings and the legs of an ox. Separated from this incident by a high and bare rock is a massacre, over which a flying demon hovers; and, in the distance, the dispersion of the flocks and the burning of Job's house. In the third compartment Job kneels in front of two other kneeling figures and raises his arms to heaven. He is attended by a group of friends, and seems to have descended from a throne beneath an arched building, to humble himself before God.[1]

With the assistance of the engravings of Lasinio we may observe that the composer did not deviate much from the great maxims which Giotto carried out so perfectly. We shall find animation and action in many groups—an advanced study of the detail of form and a certain amount of pictorial feeling. The colours, if we can judge of them in their present state, are handled with ease. The artist, whoever he may be, doubtless executed many works besides these of the Campo Santo. A common style connects them with the four frescoes representing scenes from the life of St. Francis by the side of the crucifix and Tree of Jesse in the great refectory of Santa Croce at Florence; nor is it improbable, from the resemblance between the latter works and the Crucifixion in the sacristy of the church of Ognissanti, that these are early works from the hand of the painter of the Job of the Campo Santo.[2]

In 1377[3] Andrea da Firenze commenced the series of frescoes illustrating scenes from the life of S. Raineri, assigned by Vasari

[1] This fresco was completed, says Cav. Totti, by Nello di Vanni of Pisa (a pupil of Orcagna); but, adds Morrona, he only repaired damage which had been caused by rain. *Vide* MORRONA, *u.s.*, ii., p. 205. Yet ROSINI (*Storia della Pittura*, ii., p. 7) and the annot. of Le Monnier's edition of VASARI (ii., p. 135) affirm that Nello was "the author" of this fresco, which differs in no respect from the rest of the series.

[2] The frescoes of the Ognissanti sacristy are more Giottesque and less modern in style than the Job of the Campo Santo, and may have been produced about 1350; but see *antea*, p. 135.

* [3] It was on October 13th, 1377, that Andrea received the final payment for the frescoes illustrating the life of S. Ranieri. See BONAINI, *Memorie inedite del disegno*. Andrea, though a Florentine, was very much under the influence of the school of Siena.

to Simone of Siena; and Antonio Veneziano continued it in 1386,[1] after Barnaba of Modena had been called (1380) to Pisa. In 1391 Spinello Aretino[2] laboured at the series illustrating the life of St. Ephesus and St. Potitus. At the same time the frescoes of the Genesis, assigned by Vasari to Buffalmacco, were designed by a painter and mosaist of Orvieto named Pietro di Puccio, who had been employed under Ugolino di Prete Ilario[3] in the choir of the cathedral of Orvieto in 1370,[4] and in 1387 executed the mosaics of the front. Invited, in 1390, by a special letter from Parasone Grassi, who then directed the works of the Campo Santo, to visit Pisa, he came, and after an interval of sickness[5] painted the frescoes of the Genesis at the western end of the northern side and the Coronation of the Virgin above the entrance of the Aulla chapel.[6] Pietro, in the former, seems not without merit; but he was evidently a second or third-rate artist of the Sienese rather than of the Florentine school,[7] so much so,

[1] Antonio Veneziano painted in the Campo Santo at Pisa in the years 1384–86. The first entry which refers to him is of December 7th, 1884. All the entries are given in full in TANFANI-CENTOFANTI, *Notizie di Artisti tratte dai Documenti pisani.* Pisa, 1897.

[2] Spinello Aretino was painting in the Campo Santo as early as February 1st, 1390. See Arch. di Stato, Pisa, *Memorie dell' operaio* (Parasone Grassi), *ad annum*, c. 52 v. and 47 v. All the documents relating to Spinello Aretino's work at Pisa are given in TANFANI-CENTOFANTI, *op. cit.*

[3] The author of feeble frescoes which Vasari erroneously assigns to Pietro Cavallini.

[4] DELLA VALLE, *Stor. del Duomo d'Orvieto*, pp. 117 and 285. Puccio's pay was eighteen soldi per diem. See the curious error of DELLA VALLE, *u.s.*, p. 288, who makes the painter and mosaist of the same name two different artists.

[5] His apothecary's bills, paid by the superintendent of the Campo Santo, have been preserved. See CIAMPI, Doc. xxxi., p. 150.

[6] CIAMPI, *u.s.*, p. 151. In the first, Puccio represents the Eternal holding the sphere of the universe with the earth in the centre, surrounded by the remaining planetary spheres, as explained by the cosmographers of the Middle Ages. In the lower corners, to the right, St. Thomas Aquinas; to the left, St. Augustin; next, the Creation of Man and of Woman, the Temptation, the Expulsion from Paradise, the Death of Abel and of Cain, the Ark of Noah, the Deluge, and the Sacrifice of Abraham.

[7] There was recently in the Casa Oddi, at Perugia, an altarpiece in three parts representing the Virgin and Child enthroned between St. Jerome and St. Paul, with the Eternal between the angel and Virgin annunciate in the pinnacles. It bore the inscription: PETRI DE URBIS OPUS. On the predella the Ecce Homo is depicted between two incidents from the lives of Paul and Jerome. It is a small third-rate work, possibly by Pietro di Puccio.

that the Coronation was assigned by Vasari to Taddeo Bartoli.[1] On the eastern wall of the Campo Santo Buffalmacco is said to have painted scenes from the Passion,[2] the Crucifixion, the Resurrection, the appearance of the Saviour to the apostles, and the Ascension.

The Crucifixion, a most common production of the close of the fourteenth century, is remarkable for figures of a long and exaggerated shape, ugly in character and features, and the Saviour on the cross is repulsive. The Resurrection, Apparition, and Ascension, though much damaged, display, in short and stout figures, another hand and third-rate talent, but seem likewise to have been executed at the close of the fourteenth century.

The life of Buffalmacco thus necessarily leads us to the comparison of pictures varying in style and in period, and precludes all chronological sequence. But we shall be satisfied if we have succeeded in proving that the frescoes assigned to Buffalmacco all differ from each other, and that the life of this artist, as written by Vasari, is utterly untrustworthy.

In so far as Bruno di Giovanni is concerned, we may observe—

The frescoes which he is said to have executed in company with Buffalmacco in the abbey of Ripa d'Arno are obliterated; but the altarpiece of St. Ursula, produced for the same church, is described by Vasari[3] in terms almost completely applicable to a picture formerly in the Casa di Commenda,[4] and now in the Academy of Pisa. In this picture St. Ursula and her virgin companions are represented in a rough distemper panel split in four places, in great part repainted, and of a very feeble character.[5]

[1] VASARI, ed. Sansoni, ii., p. 37. The greater part of the intonaco of this fresco is gone.

[2] Others assign these scenes to Antonio Vite of Pistoia.

[*] Supino seeks to show that these frescoes are by Pisan artists, and much exaggerate their merits. They may be by local masters, but the evidence Signor Supino produces is far from adequate. See SUPINO, *Il Campo Santo di Pisa.* Florence, 1896, pp. 48, 49.

[3] VASARI, ed. Sansoni, i., p. 512.

[4] Near the canonry of the church of San Paolo a Ripa d'Arno.

[5] The picture has been engraved in ROSINI, *u.s.*

CHAPTER X

STEFANO FIORENTINO

STEFANO FIORENTINO shares with Taddeo Gaddi the praises of Vasari,[1] yet to affirm anything positive respecting him at the present time would be all the more presumptuous because none of his works have been preserved.[2] Baldinucci would lead us to believe that Stefano was not merely a pupil, but a grandson of Giotto, because, according to the records of the monastery of Cestello at Florence, Catherine, Giotto's daughter and the wife of an artist named Ricco di Lapo, had in 1333 a son called Stefano, who was a painter. That a person of this name and profession did exist at Florence in the first half of the century is proved by Sacchetti,[3] who mentions him as a contemporary of Orcagna and Taddeo Gaddi. Stefano, too, is registered in 1369 as pupil of one Giotto, which would give some force to the assumption of Baldinucci.[4] As to pictures, the difficulty of making any deductions from Vasari's or Ghiberti's statements is very great. Vasari says: "Stefano painted in fresco the Madonna of the Campo Santo of Pisa, which is better designed

[1] He is called by ALBERTINI (*Opusculum de Mirabilibus Nove et Veteris Roma*, 4to, Rome, 1510, p. 56), the precursor of Vasari, who used his books, Stefano "symia." Vasari, enlarging upon this, says Stefano was the ape of nature (VASARI, ii., p. 15 and fol.). Vasari wrote the lives of Stefano and Ugolino together, and says they were intimate friends. The truth of the latter statement may be doubted.

* [2] Stefano Fiorentino's name stands second in the list of the best Florentine masters compiled by the Operai of S. Giovanni Fuorcivitas at Pistoia in or about the year 1347. The names are given in order of merit, and there are grounds for believing that the Operai made careful investigations before preparing their list. See *antea*, p. 126.

[3] SACCHETTI, *u.s.*, Nov. cxxxvi., ii., p. 221.

[4] BALDINUCCI, *u.s.*, iv., pp. 171, 316.

and coloured than the work of Giotto."[1] If he meant to allude
to the Assumption on the inner lunette of the chief gate of the
Campo Santo, he assigns it in another place to Simone Martini.[2]

Ghiberti, in his commentary,[3] distinguishes amongst the works of
Stefano a St. Thomas Aquinas, at the side of a door in Santa Maria
Novella, leading to the cemetery, "which seems to stand out from
the wall in relief." Vasari adds "that the figure was painted at
the side of a door in the *primo chiostro*," where Stefano also
drew a crucified Saviour. In the first cloister of Santa Maria
Novella, a crucified Saviour with the root of Jesse, and remnants
of a head of St. Thomas, may now be seen at the side of a door
leading to the cemetery. In the same cloister a Christ crucified,
between St. Dominic and St. Thomas Aquinas, decorates the
lunette of the door leading into the Chiostro Grande. The latter
has been so completely renewed as to defy all criticism. The
former is injured, but may still be studied. It has the appearance
of being a work of the close of the fourteenth century. In
design and execution it bears some resemblance to another fresco
in Santa Maria Novella, a half length of St. Thomas Aquinas
with a pen in his right, and an open book in his left hand in
a lunette *above* a door which led of old to the chapel of San
Tommaso;[4] but this is work such as a painter of Giotto might have
painted in the latter half of the fourteenth century, fair as
regards movement, natural and regular as regards attitude and
form, yet without the quality of relief which Ghiberti so de-
liberately dwells on. None of these wall paintings, indeed, is
such as to contrast in a favourable sense with those of Giotto.
Vasari attributes to Stefano the frescoes of the chapel of San
Jacopo, in the cathedral of Pistoia, which Ciampi proves to have
been completed by Alessio d'Andrea and Bonaccorso di Maestro
Cino in 1347.[5] Ciampi, however, adds that Stefano did, indeed,
paint in the Duomo of Pistoia, but in the chapel of the Bellucci,
not in the chapel of San Jacopo. Yet even this fact is immaterial,

[1] VASARI, ed. Sansoni, i., p. 447. [2] *Ibid.*, pp. 552, 553.
[3] GHIBERTI, in VASARI, ed. Le Monnier, i., p. xx.
[4] A chapel now suppressed.
[5] See CIAMPI, pp. 93, 145–7. These took the places of earlier ones by Coppo di
Marcovaldo.

as both chapels are whitewashed.[1] There are old paintings in the Palazzo del Comune at Pistoia which reveal the presence of Florentine artists, amongst others, a second-rate Madonna between St. James and St. Zeno, in the Salone, dated 1360; but though this fresco makes some approach to those already noted in Santa Maria Novella at Florence, they are still insufficient to entitle the author to the name of a great artist.

The frescoes of the Buontempi chapel in San Domenico of Perugia have been noticed as uncertified works of Buffalmacco. Were they by Stefano he would be a painter of the fifteenth century, and therefore not a pupil of Giotto.[2] At Rome, at Milan, at Assisi, Stefano is said to have painted, but the alleged fruits of his labour have all disappeared.[3]

We shall have occasion to observe that Taddeo Gaddi, on his death-bed, asked Giovanni da Milano to direct his son Agnolo in the practice of art, and recommended him to the friendship of Jacopo del Casentino for advice "in all things relating to conduct."

Jacopo del Casentino was a painter with whom Taddeo Gaddi became acquainted when employed on certain frescoes in the church of Sasso della Vernia. He followed Taddeo to Florence, where, thanks to the master's influence, he found employment.[4]

At first a journeyman, then an independent artist, he soon obtained a number of orders in the Tuscan capital. Three tabernacles—in the Mercato Vecchio, the Piazza San Niccolò, and the garden of the Tintori—were entrusted to him to decorate

[1] CIAMPI, *u.s.*, p. 95; also TOLOMEI, pp. 16, 17, and TIGRI, p. 123.

[2] ROSINI has fallen into this error (see *Storia*, *u.s.*, ii., p. 127); he gives, p. 125, an engraving of a picture at the Brera, which is signed Stefanus, but dated 1435. Rosini also gives an engraving of a picture now in the Lindenau Museum at Altenburg, representing the Virgin with the Infant sitting near her, having brought in a bird. This piece is exactly suited to the description of a lost fresco by Stefano in a tabernacle of old near the Ponte alla Carraja at Florence.

[3] VASARI (ed. Sansoni, i., pp. 450, 451), describing the subjects of frescoes in San Spirito at Florence, repeats what GHIBERTI (ed. Le Monnier, i., p. xix.) says of frescoes at Sant' Agostino of Florence. San Spirito and Sant' Agostino are one and the same church, in which, however, the frescoes in question no longer exist. At Assisi a painting by Sermei covers the niche of the choir in the Lower Church originally painted by Stefano. At San Pietro and Araceli, Rome, there is nothing.

[4] VASARI, ii., pp. 178, 179.

with altarpiece or frescoes. At Orsanmichele he painted sixteen figures of patriarchs and prophets in the ceilings, and scenes from the legends of the Virgin and saints on walls and pilasters. Unfortunately the walls of Orsanmichele are now as bare of frescoes as the tabernacles. What remains in the pilasters and skirting beneath them is a set of life-size saints in niches, with a scene from the legend of each saint, or a gospel subject in the framing below. In some of these compartments a Trinity and an Annunciation are discernible, whilst in the vaulting of the edifice there are also remnants of four figures of saints. Amidst the ruins it is still possible to trace the incorrect drawing, sharp red flesh tint and rude drapery, with opaque shading peculiar to a feeble follower of the methods of Giotto.[1] If Jacopo is entitled to little attention as a painter, he deserves credit for a spirit of organisation, and for the business-like assiduity with which he founded the guild of St. Luke at Florence, of which he was one of the first councillors.

According to Vasari this corporation was established in 1350, in order that artists might acquire a better status than they had held till then in the larger guild of surgeon apothecaries. Baldinucci, who first published the charter of its incorporation, gave an earlier date by more than ten years than that of Vasari, and Gaye, in his *Carteggio*, followed Baldinucci's example. An attentive examination of the register of artists appended to the charters will show that 1339 must be the correct time, as many painters were entered in the lists in 1341.[2] Four captains, four councillors, and two clerks were appointed to the company, the majority of which, excepting Jacopo and Bernardo Daddi, have left not a single work behind. The captains or councillors did not think it necessary to draw up extensive regulations for the administration of their craft, such as had been embodied in the earlier statute of Siena, but they made provision for the election of officers, for monthly meetings in the church of Santa Maria Nuova, and for the entrance and other fees to which the corporation might consider itself entitled.

[1] Four saints in the vaultings have been recently rescued from whitewash.

[2] Compare VASARI, ed. Sansoni, i., p. 674; BALDINUCCI, iv., p. 363; and GAYE, *Carteggio*, ii., pp 32, 39.

The statute and organisation of the company of painters was
registered before a notary in 1354, up to which time it is evident
that Jacopo del Casentino remained in Florence. According to
Vasari, it was he who painted the obligatory picture of St. Luke
taking the likeness of the Virgin, with all the members of the guild
and their wives in the predella, a painting which was in the painters'
chapel at Santa Maria Nuova, in the sixteenth century.[1] How
much longer after this he resided there is uncertain. But if
Arezzo owed to him, as Vasari states, the regulation of the water-
works of the Fonte Guinizelli,[2] the date of his return to that city
was 1354. Here he seems to have executed a vast number of
frescoes, the majority of which have perished—part in the
bishop's palace, part in the church of San Bartolommeo, and part
in the Duomo Vecchio, which had been thrown down in Vasari's
time.[3] In a recess, in the right-hand corner of the side facing
the portal of San Bartolommeo, we observe a dead Saviour lying
as in a coffin, naked, with his arms crossed over his breast,
bewailed by the Virgin and St. John Evangelist.[4] Much injured
by time and other causes, this work is coloured in glaring tones of
a coarse substance, and exhibits rude Giottesque types and drapery.
It is the work of a man anxious to master the details of form and
not unacquainted with proportion, but a feeble draughtsman,
destitute of feeling or elevation, and powerless in rendering
expression.[5] It is, technically speaking, the exact counterpart
of a fresco in the Pieve representing St. Francis and St. Dominic,
which the partiality of Vasari assigned to Giotto.[6] Taking these

[1] VASARI, ed. Sansoni, i., pp. 674, 675. But it is well to note that the books of
the hospital of St. Luke describe this picture as a work of Niccolò Gerini, executed
in 1383.

[2] Ibid., ed. cit., i., p. 672. It is affirmed in a note that in the year 1354 the
old Roman aqueduct was restored.

[3] Ibid., ed. cit., i., p. 671. In the Vescovado he painted, according to Vasari,
a story of St. Martin.

[4] Half-figures. St. John rests his head on his right hand. In the vaulting, the
Lamb between St. Bartholomew and St. Donato, the latter miscalled by Vasari
St. Paul.

[5] Besides this fresco in San Bartolommeo he painted the panel for the high altar
(VASARI, ed. cit., i., p. 671).

[6] VASARI, ed. Sansoni, i., pp. 376, 377. See antea in Giotto. St. Francis holds
a book, St. Dominic a lily.

works as a guide, we may assign to Jacopo further a Pietà in a
lunette above the gate of the old Fraternità di Santa Maria della
Misericordia, now a library and museum at Arezzo, hitherto
attributed to Spinello, a composition with half length in which
the Redeemer is represented naked and erect between the Virgin
and Evangelist.[1]

Better than these is an altarpiece painted for the church of
San Giovanni Evangelista in Prato Vecchio, and now in the
National Gallery, where Jacopo illustrates scenes from the life of
St. John Evangelist with a certain vehemence of hand and
exaggeration of expression or movement.[2] More interesting still
is a predella at the Uffizi[3] in which a religious ceremony, at the
centre, is flanked by two scenes from the life of St. Peter and
eight figures of saints, the value of which lies chiefly in a lively
colour and flowing drapery. A more modern altarpiece of the
same class in the passage of the Uffizi represents the Coronation
of the Virgin,[4] a subject which is repeated in the same style in a
panel in the magazines of the Louvre. In the old Bromley
collection, sold in 1863, there stood a series of five half lengths of
the Saviour between St. Peter, St. Paul, St. Bartholomew, and
St. Francis assigned to Giotto, but executed in the style of
Jacopo's fresco in San Bartolommeo at Arezzo.[5]

The period of Jacopo's death has not been ascertained, but he
died at eighty years of age and was buried in Sant' Agnolo, an
abbey of the Camaldoles at Pratovecchio.[6]

[1] The head of the Saviour is damaged, and that of a St. John obliterated, but
the style, forms, and colour are the same as those of Jacopo at San Bartolommeo.
According to VASARI, he also painted at Poppi in the Casentino (*ed. cit.*, i., p. 671).

[2] National Gallery, No. 580 and 580A. This piece is of a dry tempera with verde
shadows. It came from the Ugo Baldi collection. The subjects are : upper course,
centre, the Resurrection, the limbus, the donor and family under the protection of
the two SS. Johns. Above this upper course : the Trinity, the Virgin, and angel
annunciate. Predella : scenes from the life of the Evangelist. Pilasters : saints.

* [3] No. 1292. This predella is a work of the early Quattrocento.

* [4] Uffizi, No. 31. In the first corridor. A triptych.

* [5] In the Arezzo Gallery (Sala I., 20) is a genuine work of Jacopo, a Madonna.

[6] VASARI (*ed. cit.*, i., p. 675), who further mentions the following works which
have perished : frescoes at Arezzo in the Cappella di S. Cristofano in San Domenico,
in the Compagnia Vecchia of S. Giovanni di Peducci, in the Cappella Nardi of Sant'
Agostino (*ibid.*, p. 110) in the palace of the citadel, and beneath the organ in the
Pieve (*Ibid.* p. 111). The annotators of the latest edition of VASARI, ed. Sansoni,

His contemporary and colleague in the council of the company of St. Luke was Bernardo di Daddo di Simone, who was born late in the thirteenth century and matriculated with the guild of surgeon apothecaries in 1320.[1] Records and inscriptions of 1333, 1335, 1338, 1346, and 1347, determine Daddi's presence at Florence in those years, the latest date being that of his election to the consulship of the surgeon apothecaries' guild as well as that of the execution of an altarpiece, now unfortunately lost, commissioned in 1346–7 for the Company of Orsanmichele.[2] According to Vasari,[3] Daddi was a pupil of Spinello Aretino, which is manifestly incorrect, as it is but reversing the order of nature to make Spinello the master of an artist who must have been in his manhood when Spinello was born. Daddi matriculated seventeen years before the death of Giotto; his art is that of a Giottesque of the time of Taddeo Gaddi, and there may be some truth in the statement of an anonymous annalist, that he studied under Giotto.[4] The earliest period to which we can reliably trace his connection with any work of art is 1335, at which time he completed a Madonna for a chapel in the Palazzo della Signoria

i., p. 675, add to this list a fresco of St. Martin, executed about 1347, for the Compagnia di Gesù of Santa Maria Novella.

[1] In a report entitled "Del Ritratto di Dante Alighieri," drawn up by Messrs. Luigi Passerini and Gaetano Milanesi in 1865, the date of Daddi's matriculation with the surgeon apothecaries is given (p. 302) as 1312. In a second edition of this report, embodied in Signor MILANESI's book, *Sulla Storia dell' Arte Toscana* (8vo, Siena, 1873), p. 117, the figures are given as 1320, and we assume the revised date to be the correct one.

[2] Villani's Chronicle tells how a Madonna on a pilaster of Orsanmichele became celebrated in 1292 for its miracles. In 1304 the Loggia and, we may suppose, its contents were destroyed by fire. It was restored on the old model in 1308: taken down and rebuilt after 1336. There hangs at the present moment in Orsanmichele a Madonna, which by some is attributed to Ugolino (see *postea*), by others to Bernardo Daddi. With the latter opinion we have now to deal. Signor GAETANO MILANESI has written a most interesting paper, "Della tavola di Nostra Donna nel tabernacolo di Or San Michele," in the work *Sulla Storia dell' Arte Toscana*, in which he quotes records to show that Bernardo Daddi painted a picture of our Lady for the Compagnia di Orsanmichele, in the years 1346–7. He thinks that the picture thus commissioned is that which now hangs in Orsanmichele. It is only necessary in this note to observe that the style of the Madonna reveals a painter of much later date than Daddi (see *postea*).

[3] VASARI, i., p. 464. * This is another curious manifestation of the spirit of local patriotism. Vasari wishes to prove that Daddi owed his merits to an Aretine.

[4] MS. in MILANESI, *Sulla Storia, u.s.*, p. 339.

II.—N

at Florence.[1] It has also been discovered that he painted an altarpiece, in 1338, for a Dominican friar, who placed it in the screen of Santa Maria Novella. It represented three saints of the Dominican Order, and was inscribed with the name of Bernardus.[2] But there are frescoes also attributed to Daddi of which vestiges remain on the Porta a Pinti, Porta a San Niccolò, and Porta a San Giorgio at Florence, and the latter, which are less injured than the rest and bear the date of 1330, only tell, what the date of itself would prove, that the painter was of an early Giottesque school.[3] We are less in doubt as regards the frescoes already noted as existing in the San Stefano chapel of the church of Santa Croce at Florence; for here, though time, abrasion, and retouching have to some extent changed the character of the decoration, we still see that the Martyrdoms of St. Stephen and St. Lawrence are composed and executed in the Giottesque form, with figures of fair proportion and motion, but drawn and painted in the cold, stiff manner which naturally reveals an artist of inferior power.[4] In the absence of any other specimens of wall paintings we turn of necessity to portable pictures; and here it seems appropriate to consider such works as bear if not the name

[1] This chapel was dedicated to St. Bernard; and Signor G. Milanesi thinks that the altarpiece which Daddi painted for it is the Vision of St. Bernard between S. Galgano and St. Quintin on the right, and St. Benedict and St. John Evangelist on the left, now in the Florence Academy, No. 138 in the Sale dei Maestri Toscani, Sala Prima. Yet we shall see (postea, note to p. 214) that the altarpiece is more in the manner of a follower of Orcagna than in that of an older Giottesque. The commission to Daddi for the altarpiece of the chapel in the Palazzo della Signoria is not preserved, but it is mentioned in an inventory of 1432. Consult MILANESI, *Sulla Storia dell' Arte Toscana, u.s.*, p. 118.

[2] Inscribed: PRO ANIMABUS PARENTUM FRATRIS GUIDONIS SALVI ET PRO ANIMA DOMINE DIANE DE CASINIS. ANNO MCCCXXXVIII. BERNARDUS ME PINXIT. See VASARI, ed. Sansoni, i., p. 673.

[3] VASARI, ed. Sansoni, i., pp. 464-5. The fresco on the San Giorgio Gate represents the Virgin and Child between S. Leonardo and S. George, and Signor G. MILANESI (*Sulla Storia dell' Arte Toscana*, p. 117) affirms that the date is MCCCXXX.

[4] Santa Croce, Florence, chapels of San Lorenzo and San Stefano de' Pulci e Berardi (VASARI, *ed. cit.*, i., p. 673). The frescoes of the vaulting are gone; on a wall to the left, St. Stephen before the high priest, and on that to the right, the Martyrdom of St. Lawrence, who lies on the gridiron, whilst the executioners feed the fire. On the third wall, at the sides of the chapel window, a saint per side, and medallions with the grieving Virgin and the dead Saviour. All this is much abraded and in part obliterated. The figures are all of life size.

of Daddi, at least that of Bernard, with which he was christened. Several pictures in Italy and elsewhere bear this name ; one was formerly exhibited in the Florentine Academy, another in the church of Ognissanti at Florence; a third, originally in San Giorgio of Ruballa, was subsequently in the Bromley collection in London. The first is a fragment of a triptych executed about 1332, representing the Virgin enthroned amidst adoring angels, and between St. Peter and St. Paul, inscribed with the master's name and a mutilated date.[1] It is the work of a Giottesque of the first half of the fourteenth century, an artist more remarkable for gentleness of feeling than for power, who may possibly be Daddi. The second is an altar dossal of 1328, with half lengths of the Virgin and Child between St. Matthew and St. Nicholas, and a similar inscription, in the church of Ognissanti. It has, perhaps, more of the stern severity of the earlier Giottesques than the other example.[2] The third, of 1347, is a Crucifixion with eight saints authenticated with name and date: a picture containing the usual dramatic composition of this period with the Redeemer of Giottesque type, coloured in clear, light tones, revealing a comrade of Taddeo Gaddi.[3] Two companion pieces, apparently by the same hand, a Madonna enthroned with six angels and Christ crucified, are still preserved in the church of Ruballa, and a Crucifixion of the same class long adorned the collection of the late Sir Charles Eastlake.[4] In the same style we may notice two

[1] NOMINE BERNARDVS DE FLORĒTIA PINXIT OP . . .
ANNO D̄N̄I MCCCXXXII. . . .
　＊ This picture is not included in the present catalogue of the Academy, but it is in the Gallery. It is in the Sala Seconda di Beato Angelico, No. 271.

[2] Inscribed :—　　　　　AÑO D̄N̄I MCCC . . . XXVIII
FR. NICHOLAVS DE MAZINGHIS.
DE CANPI ME FIERI FECIT P. REMEDIO ANIME MATRIS ET FRAT̄VM
And lower down :—BERNARDVS DE FLORENTIA ME PINXIT.
This picture used to be in a dark corner above a door leading into the choir of Ognissanti church. It was kept later in a room in the cloisters of the convent, and is now in the Uffizi (No. 26. In the First Corridor).

[3] Inscribed :—
AÑO D̄N̄I MCCCXLVII BERNARDVS PINXIT ME QVEM FLORENTIA PINXIT.
The saints are SS. Lawrence, Andrew, Paul, Peter, Bartholomew, George, James, and Stephen.

[4] Altarpiece in a framing of pilasters in which there are figures of saints. This piece was once in the Ottley collection, and has been assigned (see WAAGEN, *Treasures*, ii., p. 264) to Spinello Aretino.
　＊ This picture is now in the National Gallery, No. 1468. See *postea*, p. 264.

small triptychs in the Academy of Siena, one of which represents
the Virgin and Child with saints and angels, with the Nativity,
Crucifixion, and two legendary episodes on the wings, dated 1336;
the other a Virgin and Child between St. John the Baptist and
St. Nicholas, with Christ between the Virgin and the Angel
Annunciate in the cusps.[1] With these examples before us we
become acquainted with a painter who was a contemporary of
Taddeo Gaddi, and Jacopo del Casentino, and helped to keep alive
the traditions of the Giottesque school; but this merit, if it be a
merit, will not entitle Daddi to a position in art annals equal to
that of Giotto's greater pupils. He can no more be the painter
of the chapel of the Podestà,[2] for which some authorities plead,
than of frescoes which have been assigned to him in the Strozzi
chapel at Santa Maria Novella, or the Campo Santo of Pisa, the
first, as we shall observe, being Florentine, but of the latter half
of the fourteenth century; the second altogether of a Sienese
type.[3]

It may also be borne in mind that Bernardo Daddi, if he be,
as we are told he is, the painter of the frescoes at Santa Croce,
and of the altarpieces inscribed with the names of Bernardus, is
cleverer as an artist in panel than as a mural decorator.

Bernardo Daddi died in the summer of 1348, and on the
18th of August of that year the Court of Wards (Pupille) of
Florence chose trustees for his two infant children, Daddo and
Francesco.[4]

* [1] The first is in Stanza II. (No. 4), signed ANNO DOMINI M. CCC. XXX. VI. ; the
other is No. 18 in the same room.

[2] Signor GAETANO MILANESI, in "Del Ritratto di Dante Alighieri" (*Sulla Storia
dell' Arte Toscana*, pp. 116-20), assigns these frescoes to Daddi.

[3] Assigned by Vasari to Bernardo Orcagna, by Signor GAETANO MILANESI (*Sulla
Storia, u.s.*, 339, 340), to Bernardo Daddi.

[4] These facts alone will show that Bernardo Daddi could not have been councillor
of a guild of St. Luke founded as late as 1349. Still less could he have been a
registered member in 1350 or 1355 (see GUALANDI, vi., p. 177 ; VASARI, ed. Sansoni,
i., p. 464). We owe the date of Daddi's death to the communication of records found
by Signor G. Milanesi.

CHAPTER XI

GIOVANNI DA MILANO

AS late in the fourteenth century as the year 1369 Agnolo, the son of Taddeo Gaddi, was practising as an assistant to Giovanni Gaddi and Giottino, who at that time were employed in decorating the chapels of the Vatican under orders from Pope Urban V.[1] According to one of the anecdotes which Vasari has preserved, Taddeo Gaddi on his death-bed appointed Giovanni da Milano to act as his son's guide in all matters pertaining to art, Taddeo having perhaps observed Agnolo's liking for quick and superficial painting;[2] but as Agnolo must have been of age when his father died he had probably even then formed a style which no efforts of Giovanni da Milano were likely to modify.

Giovanni da Milano moulded his style to a certain extent on that of Taddeo Gaddi, with whom he lived for many years in the position of a journeyman. But Giovanni had been bred in the north of Italy; he had never quite acquired the Tuscan manner, and his constant aim had evidently been to correct the conventionalism of the rigidly Giottesque school by a more careful appeal to nature, a more finished contour, and a more conscientious shaping of form. It is not too much to say that the stress which he laid upon these material parts of painting contributed to the marked expansion which characterised Florentine art under Orcagna. That Giovanni da Milano was not a Florentine is evident from his pictures, in which traces of Sienese influence are apparent. He acquired some of the affected grace and daintiness and some of the warmth of tone which are peculiar to the paintings of Siena as contradistinguished from the expanded figures and pale-coloured flesh of the Florentines of the same age.

[1] See *postea* in "Giottino." [2] VASARI, ed. Sansoni, i., p. 484.

Various circumstances combine to prove that Giovanni da Milano was born and bred in the north of Italy[1]—first his name, next his private history.

About 1350 he was a journeyman painter at Florence, but he was registered amongst the strangers of the city as Johannes Jacobi da Como.[2] Under that name he was entered in the register of the surgeon apothecaries of Florence in 1363, though he signed his return to the income tax at the same period as Giovanni, pittore da Milano.[3]

Later on, having entered into a contract with the Franciscans of Santa Croce to paint the Rinuccini chapel, or Chapel of the Sacristy, and having failed to complete his work on the terms of the original contract, he appealed to the Capitani of Orsan-michele to obtain an extension of time, and in the document in which his prayer is granted he is called Johannes *pictor de Kaverzaro*, showing that the place of his birth was a small hamlet in the district of Como,[4] from whence no doubt he had originally wandered to Milan on his way to a final residence at Florence.[5]

As Taddeo Gaddi's assistant, Giovanni's practice was sufficiently lucrative or his thrift sufficiently great to enable him to save money and invest it in the purchase of land at Tizzano. In this way his lot was cast in with the Florentines, who gave him the freedom of the city in 1366.[6]

Whilst Giovanni was begging for leave to postpone the delivery of the frescoes which he had promised to complete in the Rinuccini chapel at Santa Croce, he succeeded in finishing and despatching an altarpiece for the Florentine church of San Girolamo sulla Costa, on which we still find his name and the date of 1365, and it is from this earliest example of his manner

*[1] We have already spoken of the early connection that existed between the school of Milan and the school of Siena, the Siena-inspired school of Pisa being the intervening link between the Milanese and the Sienese schools. We know that in 1365 Pisan masters were summoned to the court of Galeazzo Visconti. The evidence of style-criticism leads us to believe that they had been preceded by earlier masters from Siena or Pisa.

[2] VASARI, ed. Sansoni, i., pp. 572, 573. [3] *Ibid.*

*[4] The name of this hamlet is Caverzajo. [5] *Ibid.*

[6] *Ibid.*, and certificate of citizenship of April 22, 1366, in the Florentine Archives, printed in the *Giornale Storico degli archivi Toscani* (8vo, Florence, 1858), ii., p. 65.

that we judge of his style, since the frescoes which he executed in Taddeo Gaddi's company perished at Arezzo.

The picture of San Girolamo sulla Costa, which is now in the Academy of Arts at Florence, represents the dead Saviour supported by the Virgin, the Magdalen, and St. John Evangelist.[1] A long rigid frame, regular in its anatomy, with face and hands contracted by suffering, a head with well-proportioned features betray the realistic tendencies of the artist. In the aged features of the grieving Virgin extreme naturalism is apparent. The Magdalen, wailing as she holds the Redeemer's left arm, is youthful but vulgar in expression. The careful drawing defines every part with accuracy, and reveals a habit of excessive conscientious- ness. There is a tendency to define varieties of stuffs in drapery and embroidery, and much study of detail of folds. The art of Giovanni is realistic, a step towards the more correct definition of natural forms, but seldom ennobled by selection. As a colourist he is now no longer to be judged.

More vast and important is an altarpiece, now in the Municipal Gallery of Prato.

It represents the Virgin enthroned[2] between St. Bernard, St. Catherine, St. Bartholomew, and St. Barnabas, with a scene from the life and martyrdom of each saint in a predella, and prophets in medallions in the spandrels. Divided from these, but forming the base of the altar- piece, are six compartments, representing the Nativity,[3] the Adoration of the Shepherds, the Presentation in the Temple, Christ on the Mount, the Kiss of Judas, and the Procession to Calvary.[4] Long and slender

[1] Florence Academy, Sale dei Maestri Toscani, Sala Prima, No. 131. Inscribed: IO GOVANI DA MELANO DEPINSI QUESTA TAVOLA M.CCCLXV.

[2] This picture, of which the upper parts have received serious damage, is inscribed at the base of the enthroned Virgin : EGO JOHANNES DE MEDIOLANO PINXIT HOC OPUS. And beneath the Annunciation : FRATE FRANCESCO FECIT DEPINGERE QUESTA TAVOLA. Not long since (1857) it was exposed to every vicissitude of weather in the hospital of that city. Half of the Virgin's face, part of the right hand are gone; the red dress is damaged, and the blue mantle repainted. The head of the infant Saviour is new, and the nimbuses are regilt. The white dress of St. Bernard is repainted, as well as those of the three other saints.

* The altarpiece has been restored.

[3] Parts of this scene are obliterated. St. Joseph, as usual, sits pensive on the foreground.

[4] In the Kiss of Judas and the Calvary the paint has in parts fallen out.

shape, an affected bend, and somewhat forced tenderness of expression, with eyes of the small closed kind which become familiar in the school of Siena, mark the principal figures. There is vigour and bold action in some, elegance in others[1]—in all, breadth of drapery. A graceful angel in the Annunciation is somewhat affected in action. The head of the Virgin, with its prim bend and small eyes, is reminiscent of those designed by Simone Martini. Very clever are the small scenes of the pediment, in which certain groups combine the dramatic action of a Giottesque with the soft expression of a Sienese. The Saviour, carrying his cross and looking round at the Virgin in grief, is a reminiscence of a similar scene in the chapel of the Arena at Padua, but the wail of Mary is rendered with some vulgarity.

The painting as a whole may have been produced later than the Pietà at the Florentine Academy, the nude, generally, being more natural and precise. The artist betrays an evident wish to define and diversify the thin slender hands of a female and the coarse working joints of males. In the heads of men great realism is apparent. The drawing is everywhere most conscientious. But the principal charm of the picture is the warmth and richness of the colour in flesh tints and in vestments.

Another work, evidently by Giovanni, and formerly in the church of Ognissanti, is now in the Uffizi at Florence, having been damaged and subjected to a necessary restoring.

It consists of two fragments representing ten saints in couples, with medallions containing scenes from the Creation, partly effaced or damaged; whilst below are choirs of martyred saints and virgins, apostles, patriarchs, and prophets.[2] The upper five represent the couples St. Catherine and St. Lucy, St. Stephen and St. Lawrence, St. John the Baptist and St. Luke, St. Peter and St. Bernard, and St. James and St. Gregory. The lower five contains a choir of virgins, one of martyrs, one of apostles, one of patriarchs, and one of prophets.

Fine as these undoubtedly are for colour, character, and individuality, as well as for carefulness of modelling and breadth of draperies, they are too realistic for the state of Florentine art

[1] The executioners in the three martyrdoms are all in bold and natural action, whilst in that of St. Catherine the bending form of the saint is very graceful. The head of St. Bernard before the Virgin is fine.

[2] Uffizi, No. 32. In the first corridor. The figures are one third of life size.

at that time, so that we notice a want of subordination of parts to the whole, which is a fault unknown to Giotto.

But these defects are most conspicuous in the Rinuccini chapel at Santa Croce, which has been erroneously assigned by Vasari to Taddeo Gaddi and his assistants, but was evidently done by Giovanni da Milano.[1]

The ceiling, as well as the two sides, and the vaulted entrance of this chapel are covered with frescoes. The Saviour, in a central medallion of the groined vaulting, gives the blessing, whilst the four Evangelists with scrolls stand in the spaces around him. On the walls there are three courses of subjects: to the left, the Expulsion of Joachim in a lunette, beneath which are the Meeting of Joachim and Anna and the Birth of Mary, the Presentation and Marriage of the Virgin; to the right, the Magdalen in the house of the Pharisee, the Resurrection of Lazarus and Christ in the house of Martha, the Miracle of the Merchant of Marseilles, and the Noli me Tangere; in the soffit of the entrance, half lengths of the twelve apostles, St. Anthony, St. Francis, St. Andrew, and St. Louis.[2]

The Saviour in benediction is the genuine type of Giovanni da Milano, with a round head and common working hands. Joachim's Expulsion from the Temple is a lively composition divided into sections by twisted pillars. In the centre, the high priest pushing out the childless votary; to the right and left, a congregation partly prostrate in prayer, partly kneeling, or standing with lamb offerings. Equally well arranged is the Meeting of Joachim with Anna, the composition being made up and completed by a servant leading a dog and a

[1] At the time when the above lines were originally penned style alone enabled us to form an opinion. Records, as we have seen, now prove the opinion to have been correct.

* In this case, as in many others, the conclusions of the authors, based upon considerations of style, were subsequently confirmed by documentary evidence. The document which proves these frescoes to be by Giovanni da Milano is in the Archivio di Stato at Florence (*Arch. de' Capitani della Compagnia di Santa Maria in Or San Michele*). In this document Giovanni is spoken of as a native of Caverzajo, a small place near Como. CALVI (*Notizie sulla vita e sulle opere de' principali archi-tetti scultori e pittori che fiorirono in Milano durante il governo de' Visconti e degli Sforza.* Milan, 1859, p. 85) seeks to prove that Giovanni da Milano is identical with Giovanni de' Grassi, a Milanese painter of the Trecento. We agree with Milanesi in thinking that he does not prove his case.

[2] All these frescoes—framed, as usual, in painted ornament, with cornices supported on pillars—have been damaged by time and restorers. Of the latter, Agostino Veracini and G. F. Giarré are known to have worked in 1736.

subordinate episode of the angel's appearance. There are some very good groups in the Nativity: St. Anna, on her couch, holds her hands over an ewer whilst a maid pours water upon them; three nurses are about to bathe the Child, and a dame receives linen from a female on the left. There is less to be said of the Presentation or of the Marriage, both of which are much injured. The Magdalen, on the opposite wall, is recumbent, anointing one of Christ's feet. He sits at the table addressing the Pharisee, whilst the two apostles listen and servants carry the dishes. The manner in which the host and apostles suspend their meal is very naturally displayed, and there is much realism in the figure of a man going down steps to the left. Christ in the house of Martha is seated, with Mary crouching on the floor at his feet. Martha, with excited movement, complains that "she is cumbered with much serving." Here intentness and scolding are cleverly contrasted. Equally realistic is the cook busy in the kitchen. Still more so, and out of keeping with the dignity of religious painting even in this age, is the Raising of Lazarus, where the dead man is hoisted out of the grave by the apostles, and some of the bystanders hold their noses.

In every one of these wall paintings we detect a mixture of Sienese and Florentine character peculiar to Giovanni da Milano, and we observe his extreme carefulness of drawing, searching imitation of un-ideal models, and excessive minuteness in details. His Expulsion of Joachim is full of action, and treated with a breadth that foreshadows Masolino and Masaccio. The figures are grand and well draped, relief is appropriately given by light and shade, and the outlines are made out with remarkable precision. The style is altogether more chastened and more truly within the limits of nature than that of Taddeo Gaddi; but there is an excess of realism in the marking of minutiæ both of form and face. In the grouping of the Nativity there is feeling and truth, as well as homeliness and simplicity; in the Magdalen before the Saviour much quietness; whereas the Christ in the house of Martha and the Resurrection of Lazarus more or less display coarseness and want of artistic tact. Throughout the series the colour, in its original condition, is warm, transparent, and cleverly blended, and shows what progress Giovanni da Milano had made in advance of his time

by judiciously combining the precepts of the two great schools of that age.[1]

An altarpiece which still remains in the Rinuccini chapel is by an unknown painter. The date of 1379 which it bears is of no importance as evidence in the life of Giovanni da Milano. There is no proof, indeed, that he did not practise beyond that date. Records[2] tell us that he was one of many artists employed

[1] The background of the Meeting of Joachim and Anna is repainted; that of the Nativity is damaged, and there is some retouching in the yellow dress of the nurse, the basin, and the draperies of the two females on the left. The Presentation and Marriage are much repainted, especially in the distances. The dress of the Saviour is new and the background abraded. The vestments are all new in the Saviour in the house of Martha. The Noli me Tangere and Miracle of the Merchant are totally repainted.

*[2] We give the records in full as they were communicated to Crowe and Cavalcaselle by M. Müntz:—

1. "A die xix. mensis julii (1369) usque ad diem ultimum dicti mensis servierunt infrascripti magistri pictores in palatio. Imprimis magister Johannes de Mediolano servivit diebus xi. pro pretio s. x. per diem, summa lib. v., s. x.

Guarnerius de Venitiis servivit, pro eodem pretio.
Nicolaus de Urbe, pro eodem pretio.
Stephanus de Perusio servivit, pro eodem pretio.
Nicolaus Theotonicus servivit, pro eodem pretio.
Antonius de Monterano servivit, pro pretio s. viii. per diem.
Antonius Ipoliti, pro idem pretio.
Iacobellus Jacchetti, idem.
Reynaldus de Cesano, idem.
Iohannes de Cesano, idem.
Iulianus magri Iohannis, idem.
Dominicus di Mirandie, idem.
Magister Laurentius de Urbe, idem."

The greater part of these masters continued to work at the Vatican until October, with which month the register closes. In September is to be found the name of Paulus da Verona.

We give in full the following important excerpt from the register:—

2. "Item dedi Jocto pro salario Iohannis Auri de Florentia et Iohannis de Montepulciano infra pluribus vicibus lib. xiv., s. ii. die dominica iii. mensis Augusti.

Porta mirra (sic) cum suo operario servivit v. diebus pro pretio s. xxiiii. per diem inter ambos; summa eorum lib. vi.

Item dedi Iohanni magistri Thadie de Florentia pro parte salarii Angeli fratris sui lib. vii. s. i.

Domenica die iii. mensis Augusti.

Item Iannuctius de Florentia incepit servire die xxiii. mensis Iulii pro pretio s. xvi. per diem, et servivit a dicto die usque ad ultimum diem mensis Augusti;

in 1369 at Rome during the short stay of Pope Urban V. at the
Vatican. But although Giovanni evidently holds an honourable
place amongst the masters of his age, he stood second at Rome to
Giottino, Giovanni Gaddi, and even to one arch-presbyter John,
of whom we have found no trace hitherto in the history of
painting. It is unfortunate that the frescoes of the fourteenth
century at Rome should have perished, and that no relics of

diebus quibus ipse laboravit infra dictum tempore sunt dies xxiiii. summa lib. xix.
s. iiii.

Item dedi magistri (*sic*) Iohanni Arcipresbytero infra duobus vicibus flor. xv.,
summa lib. xxxv. s. v.

Iannuccius de Florentia incepit servire de prima mensis septembris pro pretio
florenorum viii. in mense.

In tertia ebdomada mensis septembris servierunt infrascripti magistri et operarii.

Porta mirra cum famulo suo laborant v. diebus pro pretio xxiiii. s. in dicta, et
sic sunt inter ambos lib. vi.

Magister Iohannes de Mediolano laboravit iiii. diebus pro pretio xii. s. in dieta
et sic sunt lib. ii., s. viii.

Angelus magistri Thadei de Florentia laboravit v. diebus pro xii. s. in dieta.

Iohannes Auri de Florentia, xii. s. in dieta.

Iohannes de Montepulciano, xii. s. idem.

Antonius Ypoliti, xii. s. idem.

Stephanus de Perusio, xii. idem.

Nicolaus Theotonicus, x. s. idem.

Antonius de Monterano, viii. s. idem.

Rayneldus de Cesano, viii. s. idem.

Iohannes de Cesano, idem.

Iulianus magistri Iohannis, idem.

Dominicus de Miranda, idem.

Iacobellus Jacchetti, idem.

Frater Petrus Theotonicus, idem.

Magister Laurentius, idem.

Salarium Iohannes Thadei et Giocti magistri Stephani de Florentia pro uno
mense incipiendo die xxviiii. mensis Augusti et terminando die xxvii. mensis
septembris flor. xxiiii. inter Ambos.

Salarium magistri Bartholomei de senis pro pretio s. xvi. in die ; laboravit a die
xxii. mensis septembris inclusive usque ad diem secundam octobris pro pretio dicto
laboravit ix. diebus, summa sua lib. vi. s. xvi.

Iacobellus Janneccie de Roma laboravit a die xxiiii. mensis septembris citra
usque ad diem xxviii. dicti mensis septembris pro pretio s. xvi. in dieta. Laboravit
iiii. diebus, lib. iii., s. iii.

Summa hujus marginis sine salario Iohannes et Jocti lib. ix., s. ix.

Summa summarum operariorum supradictorum a die decimo nono julii incipiendo
et terminando die secunda octobris eiusdem anni inclusivo, sine salario Arci-
presbyteri, Iohannes Thadei et Jocti cum tribus eorum discipulis, videlicit Angelo
Tadei, Iohanne Auri et Vanne de Montepulciano, lib. iiii., et. s. vii."

the labour of any of the late Giottesques should have been left there.

We may assign to Giovanni da Milano the recently discovered frescoes of a nun and a knight with their patron saints at each side of the Virgin in the cloister of the Carmine at Florence.[1] With some grandeur and nobleness in the figure and attitude, the Virgin's face recalls the Sienese type of Simone Martini. The kneeling nun is fine, and the saints are full of dignity. The colour, where it remains, is warm and pleasing, the draperies broad and flowing.

A pretty little picture of the Virgin, full length and one third of life size, assignable to Giovanni da Milano, was some time ago in possession of the Avvocato Bergolli at Modena. It is said that this picture once belonged to the Puccini collection at Pistoia. It is a very finished and interesting work. The infant Christ in a white undergarment is partly covered with a yellow and green drapery worked with delicate embroidery. He smiles and strokes the chin of his Mother, who looks affectionately at him. The Virgin's abundant hair is fastened by a ribband with a clasp on the forehead. The faces and shapes, as well as the colour and treatment, are those which mark Giovanni da Milano's style.[2]

Another painting which presents many of the characteristics of Giovanni da Milano is a lunette fresco above the portal of San Niccolò of Prato, representing the Virgin and Child enthroned between St. Dominic and St. Nicholas of Tolentino. The movement of the Virgin is given with masterly ease; the colour generally is bright and vigorous.[3]

[1] Subject: Virgin enthroned with the Infant, the latter extending its hand to an armed man kneeling in front and presented by St. James, near whom St. Anthony. To the right of the Virgin, a kneeling nun introduced by St. John Evangelist, near whom is a female saint with a palm and cup. The fresco is much damaged by time. On the painted cornice are the arms—according to Passerini, one of the best heraldic scholars in Italy—of the Bovarelli, a Florentine family of the fourteenth century.

[2] Wood, gold ground. The blue mantle of the Virgin unfortunately repainted in oil.

[3] See *antea*, p. 137, as to pinnacles of the altarpiece No. 579 in the National Gallery. Other fragments or relics in other places are of insufficient importance, and require no further comment.

CHAPTER XII

GIOTTINO

AMONGST the contemporaries of Taddeo Gaddi at Florence there were many whose skill enabled them to acquire considerable practice, yet whose names are not now connected with works of acknowledged importance. Fourteen masters composed the art council of the cathedral of Santa Maria del Fiore in 1366, yet we know few except Gaddi and Orcagna to whom extant productions can be assigned. The muster-roll of those who were employed to furnish models or designs contains a long series of names which represent nothing to us at the present time except mere sound. But, on the other hand, large and important creations, especially in the domain of painting, are attributed to artists who are only remembered by an alias.

One of the most important amongst these is a disciple of Giotto, called, in the fifteenth and sixteenth century, Giottino or the little Giotto, an artist who was known to Ghiberti and Vasari as Maso or Tommaso di Stefano, and is probably the Giotto di Stefano of existing records.[1]

* [1] Vasari's Giottino is a composite creature made up of three persons. The first of these artists is a certain Maso. This Maso is mentioned by Filippo Villani, by the Anonimo Magliabecchiano, and by Ghiberti. Villani speaks of him as a disciple of Giotto, Ghiberti adds that he was a very noble painter. The Anonimo and Ghiberti give to Maso a tabernacle at the Piazza of San Spirito, the frescoes of St. Sylvester at S. Croce, the picture of the Duke of Athens and his associates on the façade of the Palazzo of the Podestà. This Maso has been identified with Maso di Banco, an artist who matriculated in the guild of painters in 1343 and in the Company of St. Luke in 1350.

The second artist Vasari included under the name Giottino was a certain Giotto di Maestro Stefano, who is perhaps identical with the Giotto employed at Pisa, of whom there is a record quoted by Bonaini (*Memorie Inedite*, p. 63). This artist,

Ghiberti and Vasari both attribute to Maso, alias Giottino, a series of frescoes in Santa Croce and Sant' Agostino (now San Spirito) at Florence. According to the first, the decoration of a whole chapel by this master at Sant' Agostino was an excellent piece of workmanship, equalled only by a Descent of the Holy Spirit above the high portal, and a Virgin and Child in a neighbouring tabernacle. At Santa Croce the legend of St. Sylvester and Constantine was copiously illustrated by the same hand.[1]

The wall paintings which were thought so admirable at San Spirito no longer exist. The frescoes of the chapel of San Silvestro at Santa Croce are still extant, and, as they are undoubtedly one of the best contributions to the knowledge of the art of Giotto's disciples that can now be found, an exhaustive description of them will not be out of place before we attempt to determine whether the painter is identical with Maso or Giotto, of whom we know that they were both called Giottino.

The frescoes represent the miracles of St. Sylvester. They cover the whole of the lunettes and the remaining wall spaces of the chapel. In one compartment of a lunette Constantine is represented sitting in a chariot receiving the wailing mothers whose children had been selected to furnish a bath of blood for him. He declares himself ready to die rather than be restored to health by such means. In another compartment Constantine sees St. Peter and St. Paul in a vision, who tell him that his leprosy will be cured if he succeeds in being baptised by Sylvester, Bishop of Rome. The vision oppresses the Emperor, who cries in his sleep, attracts a watcher, who looks in at a door and awakens two attendants (now nearly obliterated) at his bedside.

according to the Anonimo, painted a picture at the Canto alle Macine, a tabernacle at the Piazza of S. Spirito, some pictures in the same convent, some works at Ognissanti, and a Pietà in the monastery of San Gallo, all of which have perished.

The third artist who went to compose Vasari's Giottino was Tommaso di Stefano, who was matriculated in the Art of the Maestri di Pietra on December 20th, 1385. It was probably he who carved the statue of the campanile of Florence attributed by Ghiberti to Maso and by Vasari to his Giottino.

The existing works attributed to Giottino are for the most part the work of Giotto di Maestro Stefano. In the important record discovered by Müntz in the Vatican Registers, quoted in the notes to the last chapter, this Giotto di Maestro Stefano is ranked amongst the most important masters employed at the Vatican. Like Giovanni Gaddi and the archpresbyter Giovanni, he is paid at a higher rate than Giovanni da Milano, Agnolo Gaddi, and the other artists.

[1] Ghiberti, Com. 2, *u.s.*, in VASARI, ed. Le Monnier, i., p. xxi.

In the opposite lunette Sylvester appears before Constantine, who sits on his throne, shows him the likeness of Peter and Paul, and convinces him that the apostles really appeared to him in his sleep. In the right compartment of the same space the Pope, attended by a cardinal and two guards, puts his hand on the head of Constantine, who is up to his middle in a baptismal font.

The Empress Helen having expressed her disappointment that Constantine should have been converted, the Emperor called a council, in the midst of which he appears, immediately below the Baptism, enthroned with cardinals and courtiers around him. Zambri, a Jew, has killed a bull with a whisper, and Sylvester, in the picture, restores the bull to life before Constantine with a blessing.

A dragon having killed many people, and amongst them two holy clerks, by the poison of his breath, Sylvester braves the monster in the ruins which he inhabits. He then restores the two holy men to life in the presence of the Emperor.

Beneath the Vision of Constantine a niche contains the painted effigy of Christ in his tomb. Two saints fill the curved vaulting of the recess, and two medallions with prophets are in the spandrels.

Below the fresco of the wailing mothers a stone monument is let into the wall, above which the kneeling figure of Bettino de' Bardi is painted looking up at the Saviour, who ascends to heaven in a glory of angels—a fresco much injured by damp. The vaulting of the recess in which the tomb lies contains two prophets and medallions of saints, and two medallions with half lengths in the spandrels.

At the sides of the chapel window there are saints in couples, St. Zenobio and a bishop to the right, St. Romolus and a bishop to the left.

Amongst the pictures on the walls of the chapel, that in which Sylvester seals the lips of the monster is the finest. The compositions are telling and skilfully arranged. The movements are lively, and the heads fairly individualised. In the final miracle the groups and incidents are carefully arranged. The distance of houses and ruins displays that freedom from conventionalism or artifice which is so pleasing a feature in the latest of Giotto's frescoes. Nothing can be more forcibly rendered than the action of Sylvester. The expression in the eyes of the friar holding his nose to exclude the smell is striking. Realism is fairly allied to decorum and correct shaping; it is carried further than we find

it in Giotto or Giovanni da Milano, yet without an undue sacrifice of any of the laws of composition. The draperies are sweeping, the drawing is firm. Form and detail are studied, without detriment to the mass, and the draperies and articulations show little of the neglect common to so many Giottesques even at the end of the fourteenth century. Warmth and transparence of colour are combined with high finish and broad modelling, and Vasari was justified in asserting that the painter inherited the spirit of Giotto.[1]

Similar style, technical execution, drawing, and tone are to be found in a Crucifixion and other frescoes in the crypt chapel beneath the Cappellone dei Spagnuoli at Santa Maria Novella,[2] where an inscription carved on a slab records the proprietorship of the family of Strozzi.

The Saviour in the Crucifixion[3]—a counterpart as regards the head of the Redeemer—at San Silvestro shows an effort at greater research in the rendering of nude forms than was usual with Giotto. Amongst the principal figures, one of venerable aspect behind the Virgin is full of character. On the wall to the left of the entrance a powerful composition represents the Virgin in adoration before the infant Saviour, where a curious realism may be noticed in the action of one of the shepherds who holds back a barking dog.[4] The painter might, indeed, for this deserve the epithet—"ape of nature"—which Vasari applies to Stefano Fiorentino. This is not a Giottesque composition, yet it is well distributed. The features of the Virgin are tender and full of feeling. A pensive gravity marks St. Joseph, whose head is

[1] The intonaco has in many places fallen out.

[2] This crypt chapel is not to be confounded with the chapel of the Strozzi in the same church, decorated by Orcagna.

[3] Lunette fresco, facing the entrance. As usual, the Magdalen grasps the foot of the cross, the Virgin faints in the arms of the Marys, soldiers and priests stand around, and angels wail about the principal figure. Where the colour has fallen the original grey preparation of the angels appears. In the four sections of the ceiling are four prophets; in the vaulting of entrance, the four Evangelists between St. Benedict and another saint.

[4] The Virgin's dress has scaled away. In the shed St. Joseph sits to the right, the ox and the ass in a corner, and a choir of angels about. Three celestial messengers fly above the shed, one of whom announces to the shepherds in the distance to the left.

Giottesque in type. The angels, though graceful and slender, have still something more than usually masculine about them, and some of them are impressed with the stamp of Taddeo Gaddi's manner. Here, as at San Silvestro, we see an artist combining Giottesque qualities with a technical advance equal to that which marked the work of Giovanni da Milano, and therefore a man apparently living in the second half of the fourteenth century.[1] Yet even this cannot be affirmed with too much certainty, because it is possible to point out yet another work with the same characteristics, the subject of which would lead us to believe that it was produced before 1350. This is a fresco on the staircase of the present Accademia Filarmonica in the Via Ghibellina[2] at Florence, a building called in olden times the Stinche Vecchie, where the expulsion of Walter of Brienne, Duke of Athens, on the day of the feast of St. Anna is allegorically represented.

The Duke's empty throne stands on the right side of the picture. He has just been expelled from it by a figure holding a column, hovering in the air, and threatening him with a dart. He flies away, treading on the symbols of justice and law, figured by a pair of scales, a book, a broken banner, and a sword; and he holds tenderly in his arms a monster emblematic of treason, with a human head hoary with age, and a tail like that of a lobster. In the centre of the fresco, St. Anna, enthroned under the guardianship of two angels, points to, or rather touches with her left, the towers of the old palace of the tyrant, and presents to the kneeling guardians of Florence the banner of the city.[3]

It may be that this damaged wall painting was executed later than 1343, the date of Walter de Brienne's expulsion. It is not to be confounded with that which, according to Vasari, was commissioned of Giottino for the palace of the Podestà, where shapeless vestiges still remain of portraits of the Duke of Athens,

[1] Amongst the painters of the time whose names present themselves as capable of having executed the frescoes of this chapel, we may mention Bernardo of Florence, respecting whom see *postea*. * [2] No. 83.

[3] The monster in the Duke's arms may be seen repeated in the figure of treason in a fresco by Ambrogio Lorenzetti in the Palazzo of Siena. The fresco is highly interesting for its exact representation of the Palazzo Vecchio as it stood in the middle of the fourteenth century.

and his minions, Cerettieri Visdomini, Meliadusse, and Ranieri di San Gimignano, with the mitres of justice on their heads.[1] It is not easy to conceive how these portraits or the fresco at the Stinche could have been produced in 1343 by one who at that time, if Vasari's chronology be correct, was but nineteen years of age.[2] But, setting aside again for a time the question of authorship, the same hand as that which seems to have produced the frescoes at the Cappella San Silvestro in Santa Croce, and the Cappella Strozzi in the crypt of Santa Maria Novella, executed the Pietà, formerly in San Roméo, and now in the Uffizi at Florence.[3]

Here the Saviour lies on his winding sheet on the ground. In rear of the body the Virgin raises the head, whilst one of the Marys kisses the right hand, the Evangelist leans over her and looks on in grief. A female saint, in pensive attitude, sits on the right foreground near the Saviour's head, and another of the Marys kisses his left hand. At the Redeemer's feet, the Magdalen kneels, with two females to her left, the first of whom is protected by the hand of St. Benedict placed on her head, the second by St. Zenobius with his crozier in similar action. On the gold ground is the cross.

This is a truly Giottesque composition, with great feeling and not a little realism in the expression of passion, yet simple in its mode of rendering. The manner in which the patronesses and their guardian saints are introduced is a clever solution of a difficult problem. The forms are well modelled and drawn, and show an advanced study of nature, and an effort to reproduce minute details in flesh and in draperies. The colour is still warm and powerful, and laid on with a profusion of vehicle. These are qualities peculiar to Giovanni da Milano, allied to greater force of expression than he possessed, and more talent in composition.[4]

[1] VASARI, ed. Sansoni, i., pp. 625, 626.

[2] Being born, according to VASARI, in 1324 (ed. cit., i., p. 621).

* Little reliance is to be placed upon Vasari's chronology in regard to Giottino.

[3] No. 27. See VASARI, ed. Sansoni, i., pp. 627, 628. This picture was in the sacristy of San Romeo in the time of Richa (Chiese Fior., i., p. 258).

[4] RUMOHR assigns this picture to Piero Chelini, a painter of the fifteenth century (Forschungen, ii. p. 172). A picture with figures and heads in the style above inscribed is a Deposition from the Cross with a Virgin and angel annunciate in medallions, once the property of Signor Lombardi at Florence. Of a similar character is a picture in the Florence Academy, Sale dei Maestri Toscani, Sala Prima, No. 135. * But it is very inferior to Giottino's picture at the Uffizi.

The question is how to reconcile the fact that all these works at
Santa Croce, Santa Maria Novella, the Stinche, and the Uffizi are
of the latter half of the century, with Vasari's statement, that
Tommaso detto di Stefano, called Giottino, was born in 1324 and
died in 1357.[1] Ghiberti, we saw, calls the painter of the Silvestro
chapel Maso, and gives no clue to his birth. Del Migliore, in his
comments to Vasari, notes the year 1344 as that in which there
lived "Tomas pictor, filius Dominici, populi Sancte Marie Novelle,"
who was afterwards in the guild of painters.[2] But Thomas,
the son of Dominic, is a different person from Tommaso the son
of Stefano, whose name is not to be found in any record. The
Florentine guild, in 1368, registered Giotto di Maestro Stefano
amongst its members,[3] who would be much better entitled to the
by-name of Giottino than Tommaso. Bonaini very reasonably
thinks he has found a trace of this Giotto in a document of 1369,
which tells how "that painter received seventy livres for two
caskets that were presented to Margaret, the wife of the Doge
Giovanni dell' Agnello de' Conti at Pisa."[4] It has been very fairly
assumed that Giottino's real name was Giotto di Maestro Stefano;
and as this painter lived in the latter half of the century he may
be the author of the frescoes described in the foregoing pages.
It is all the more probable that this should be correct because
records of recent discovery have proved that Giotto di Stefano
was a painter of real flesh and blood, and a man of good repute
amongst the masters of the second half of the fourteenth century
at Florence and Rome.

Since the days of Boniface VIII. and Clement V., Rome had
almost ceased to attract painters. The popes who had settled at
Avignon, and no longer cared for the Vatican, took no measures
for the preservation of Roman buildings. The Lateran and
Vatican suffered much from fire and neglect, and when at last
Urban V. was persuaded to visit Italy in 1367 he found the old
papal capital in a bad condition. It has been said that Urban

[1] VASARI, ed. Sansoni, i., pp. 628, 629.
[2] Note to VASARI, ed. Sansoni, i., p. 622, and GUALANDI, *u.s.*, Ser. vi., p. 188.
 * The statement in the document runs as follows : *Tomas pictor filius Dominici
populi Sancte Marie Novelle emit bona . . . anno* 1334.
[3] GUALANDI, *u.s.*, p. 182. [4] BONAINI, *u.s.*, *Memorie inedite*, p. 63.

undertook to restore all the Roman churches. Records of papal expenditure sanctioned in 1369 for the restoration of a large and a small chapel in the Vatican have brought the names of twenty-four painters to light who were employed together to effect what perhaps, under less extraordinary circumstances, would probably have been confided to one master.[1] The three principal artists who directed the works were Florentine, viz. Giotto di Stefano, Giovanni Gaddi, and "Archpresbyter" John. Under them laboured Agnolo Gaddi, Giovanni Auri, Giovanni of Montepulciano, and Bartolommeo of Siena. We have already seen that Giovanni da Milano was one of Giottino's colleagues. There were seventeen other painters besides, whose names we find noticed for the first time. The wages were twelve florins a month, equivalent to sixteen pence a day, for Giotto di Stefano and his colleagues, eight, ten, and twelve pence or soldi per diem for the rest. Even Giovanni da Milano did not at first receive more than ten soldi; and it was not till a certain time had elapsed that he earned the twelve pence of which Agnolo Gaddi had been thought worthy. We are now without means of ascertaining what chapels Giotto di Stefano painted. No work of any of the artists named has been preserved at the Vatican or in any other part of Rome, though Vasari says that Giottino painted frescoes in San Giovanni Laterano, and a hall full of celebrities in one of the Orsini palaces.

The difficulty which attends the history of Giottino does not end here. Amongst the works assigned by common consent to him, are the frescoes of the Cappella del Sacramento at the end of the south transept in the Lower Church of Assisi, respecting which Vasari is silent, and frescoes painted on an arch above the pulpit, in the same church, representing the coronation of the Virgin in the midst of a choir of angels, and scenes from the life of St. Nicholas.[2] The coronation of the Virgin is in the

* [1] Long extracts from these records have been given in the notes to the last chapter. See pp. 187, 188.

[2] VASARI, ed. Sansoni, i., p. 627. In the old ex-chapter, as one issues from the church, where a door leads to the room, celebrated as being that in which S. Giuseppe da Copertino died, are, on a wall, frescoes, now restored, of a Crucifixion with figures of St. Paul, St. Peter, St. Louis, and St. Anthony of Padua, and at the foot of the cross St. Francis. Six angels hover about the cross. In the arch traces of saints appear. These paintings, much damaged by restoring, are like those above the pulpit in the body of the Lower Church of Assisi.

place mentioned by Vasari. It is partly obliterated and partly damaged, and might have been executed in the first half of the fourteenth century, but at the spring of the arch, instead of scenes from the life of St. Nicholas we have the crucified Saviour with the Virgin in grief and St. John in a violent attitude at the sides of the cross, the Redeemer a coarse figure, but still Giottesque in type and form. Two remaining scenes are taken from the martyrdom of St. Stanislas of Cracow; but they are of a different period from the Florentine works assigned to Giottino, and by a different hand. Moreover they are vastly inferior to the frescoes of the Cappella del Sacramento, which is decorated with scenes from the legend of St. Nicholas—scenes which may be sought in vain where Vasari describes them.

St. Nicholas, hearing that a consul had been bribed to put three innocent youths to death, appears on the place of execution and arrests the hand of the executioner. Constantine causes three generals—Nepotian, Ursus, and Apilio—to be arrested for treason. But St. Nicholas appears in a dream before Constantine, who sleeps by the side of his prisoners, inclosed in a cage, and calls upon him to release them. These are the first frescoes on the left wall, in the lunette of which a posthumous miracle of the saint is depicted.

A Jew hearing that no thieves ever robbed houses under the protection of St. Nicholas, ordered a statue of him to be placed in his room, and was nevertheless plundered of everything he possessed. In his rage he beat the useless image with a stick. St. Nicholas appeared to the thieves and induced them to restore what they had stolen. The painter represents the Jew beating the figure of St. Nicholas with a whip. St. Nicholas is also the protector of maiden virtue; and one of the first acts that brought him into notice was his secretly throwing gold into the room of a neighbour whose poverty would have induced him to sacrifice the honour of his three daughters. He is depicted on the wall of the chapel, to the right of the entrance, standing on the threshold of a room where three females and their father all lie in sleep, a curious and probably real picture of humble life in the fourteenth century. Lower down, on the same wall, St. Nicholas may be seen pardoning the consul at the intercession of the three youths whose lives he had ordered to be taken. In the next lunette the saint restores to life a child enticed from home and killed by an evil spirit. Beneath this, again, St. Nicholas snatches away from before a king a captive youth, and restores him to

his parents. The saint flies downwards and catches the youth by the head. The latter is in the act of handing a cup to the king, seated on a throne. To the left, the child stands before two persons, seated at a table. Beneath this, again, a youth who had been drowned as he drew water in a cup originally intended as a present to the altar of St. Nicholas, is restored to his parents by the saint. In the side pierced by the arch of the entrance, above the lowest course in which nine out of twelve standing apostles are still visible,[1] St. Mary Magdalen appears erect, yet in prayer, to the left; and St. John the Baptist, to the right, points to a figure of the Saviour in a niche in the lunette. At his sides St. Francis gives his hand to a kneeling cardinal in episcopal dress, beneath whom the arms of the Orsini are depicted, and St. Nicholas holds by the hand a monk in a white dress upon which the arms of the Orsini are embroidered. Beneath the first of these groups is the word CARDINALIS, and below the second DÑS. JOÑS GAETANUS FRATER EJUS.[2]

Vasari declares[3] that Agnolo of Siena erected a chapel and a tomb at Assisi to Cardinal Gaetano, the brother of Cardinal Napoleone Orsini, who died there. The latest record which has been preserved of Agnolo of Siena is dated 1349.[4] Napoleone Orsini was one of Nicolas IV's. cardinals, and died in 1342 at Avignon. Gian Gaetano Orsini received the hat in 1321 from John XXII., and died at Avignon in 1339.[5] The Chapel of the Sacrament was built for the mortal remains of members of the Orsini family; and it is obvious that the frescoes which now adorn it were painted for, or in commemoration of, Napoleon and Gaetano. There is no certainty as to the date of the paintings of the chapel, but the style points to the middle of the century.[6] They

[1] Three on the wall to the left are obliterated.

[2] All that remains of two long inscriptions.

[3] VASARI, ed. Sansoni, i., p. 439.

[4] *Documenti per la Storia dell' Arte Senese*, by GAETANO MILANESI, *u.s.*, i., p. 206.

[5] See EGGS, *Purpura Docta*, i., pp. 248, 317. Eggs corrects Ciacchoni, who affirmed that Gaetano Orsini died at Avignon in 1355. RICHA relates of the latter that he caused the steeple of the Badia of the Benedictines of Florence to be rebuilt in 1330 (*Chiese*, i., p. 195). He founded the convent of the Minorites of Siena in 1326.

* [6] The whole question of the date and authorship of these frescoes bristles with difficulties. Some modern critics assert (1) that these paintings must have been painted before 1316, because in that year Giovanni Orsini received the cardinal's hat, and in the fresco he is represented in the dress of an inferior order of the clergy; (2) that Giottino was born in 1324, and that therefore (3) Giottino could not have been the author of these frescoes. To this it is sufficient to reply that

are lively, well-arranged compositions, showing considerable power
in the rendering of movement and action. Artists of the earlier
part of the fourteenth century seldom imparted more life to their
incidents than may be observed in the groups formed by the saint
presenting the drowned child to its parents. Affection overflows
in the figure and face of the father who embraces his son. The
mother with outstretched arms longs to press him to her heart;
the dog barks and capers with joy, and the saint himself is
admirable as he presents the boy. St. Nicholas, in easy motion,
flies down to rescue the young captive, and stops the arm of the
executioner with great energy. Variety of expression marks the
faces of the youths interceding for the consul. The apostles of
the lower course are, after those of Giotto in the altarpiece of
Rome, the most admirable that were produced in the early times
of the revival for gravity and individuality of character. In the
vaulting of the arches are figures of male and female saints with
fresh and attractive faces, noble in shape and stature, and finely
and broadly draped. Great feeling is shown in contrasting light
and shade. Hands and feet are carefully drawn in the Giottesque
fashion; but there is a tendency to display the human features
in comparatively small proportions, and to lavish minute care on
embroideries. The colour is light and clear, rosy, well blended,
and transparent in shadow.[1] No painter, Taddeo Gaddi not
excepted, ever showed himself at once a better or a closer
imitator of Giotto. No frescoes do more honour to the chief of
the Tuscan school. But the pictures inside the chapel are not
more remarkable than those which decorate the outer face of the
entrance wall. These are close to the frescoes of Giotto, and

Giovanni Orsini did not receive the cardinal's hat in 1316, and there is no proof
that Giottino was born in 1324. It rests only on Vasari's statement, and Vasari's
life of Giottino is absolutely untrustworthy. Moreover, it is doubtful whether these
frescoes were painted for, or in commemoration of, Napoleone and Gian Gaetano
Orsini. Nevertheless, whilst disclaiming these familiar but erroneous arguments,
the editor confesses his inability to definitely accept the attribution of any of the
frescoes in the Lower Church to Giottino. The question of the authorship of the
frescoes in the Cappella del Sacramento he regards as an unsolved problem. At
the same time he would draw the attention of critics who are tempted to dogma-
tise on the subject to the first paragraph of this chapter.

[1] The figure of the Saviour before St. John is grand in the regularity of its
form. The lights of some draperies are touched in gold.

differ slightly from them; but they also differ from those illustrating the life of St. Nicholas, so that it is difficult to say whether they are by the same hand. They are, however, of a later period than the age of Giotto, and are finished in a style not dissimilar from those inside the Chapel of the Sacrament. They represent on one side of the arch the death of a child through the fall of a house, and his resurrection at the intercession of St. Francis.[1] On the opposite side of the arch is the resurrection of the child,[2] a very fine composition, in part damaged and discoloured, but very animated. The medallion prophets in the painted ornament are different from those of the other frescoes in the transept. Above these two figures is a splendid Annunciation, with a majestic figure of Gabriel, and a matronly Virgin shrinking back in surprise, and well draped in her blue mantle. Puccio Capanna is, according to some writers, the painter of the Annunciation. A Madonna amongst saints,[3] in style much resembling these frescoes, though perhaps feebler, adorns the Medici chapel in Santa Croce at Florence. Of the saints Bartholomew is especially fine.

In Santa Chiara of Assisi, an edifice of which Vasari says

[1] In the first of these scenes the ruins of a house may be seen in the distance to the left, and in the foreground a man, almost turning his back to the spectator, holds the corpse of the child which the mother in an agony of grief stoops to kiss. Behind her a female wrings her hands, another tears her hair, a third lacerates her cheeks with her nails, and more to the right are other female spectators. On the extreme left a man stands in profile, to whom tradition gives the name of Giotto, Vasari having stated in a general way that in the sides of this portion of the church a portrait of Giotto existed (VASARI, i., p. 317).

[2] St. Francis in flight appears in the upper story of a house where he lay, and may be observed to rise in bed. A youth runs down a flight of outer steps to make the miracle known, whilst in front of the house a trestle lies ready for the body. The clergy has arrived, and a crowd waits to follow the funeral.

[3] St. Louis, St. John the Baptist, St. Bartholomew, St. Peter, and other saints. In the medallions of the niches are prophets. In the Cappella Medici, again, we find an altarpiece which has received much damage in the course of ages, but recalls, though on a feebler scale, the paintings of the Orsini chapel at Assisi. It represents the Virgin and Child enthroned with five female saints at her sides. In the upper part of the altarpiece there are half lengths of prophets, in the lower half lengths of saints.

Of the same class, but in style more like works of Julian and Peter of Rimini, are the four panels in the collection at Alnwick, and other parts of the same altarpiece in the Sciarra palace at Rome, already noticed in the life of Giotto.

that it owed much of its internal decoration to Giottino,[1] some
vestiges of the art of the fourteenth century are preserved. The
figures in the ceiling of the transept[2] seem, however, to have
been designed by an artist of the fourteenth century, but of
much lower powers than the painter of the Chapel of the Sacra-
ment. Vasari affirms that Giottino painted scenes from the life
of S. Chiara in the church of that name. Traces of these
subjects have lately been recovered from whitewash, together
with remains of incidents from the life of the Saviour in the
sides of the right transept;[3] but the remnant so recovered seems
to have been originally of very small value. Besides these frescoes
or fragments of frescoes in Santa Chiara a Crucifixion (altarpiece)
of the fourteenth century is also preserved, which, if like some
third-rate paintings at Pistoia, we still hesitate to ascribe even
to Puccio Capanna. In the private church of the convent of
Santa Chiara, the frescoes of which have that species of renown
which generally attaches to carefully guarded relics, the scenes of
the Passion which cover some of the walls are of a low order,
the least defective of them a Deposition from the Cross,[4] being
painted with some tenderness of colour.[5] A diligent search
throughout the convents of Assisi reveals nothing but carefully
whitewashed spaces.[6]

[1] VASARI, ed. Sansoni, i., p. 627.
[2] St. Agnes, St. Monica, St. Catherine, St. Mary, St. Clara, St. Cecilia, St. Lucy,
guarded by angels in the space diagonally divided.
[3] The Flight into Egypt and Massacre of the Innocents, for instance, which had
not been whitewashed when Rumohr wrote at the beginning of this century. He
notices them for the purpose of showing that in the fourteenth century no one
objected to seeing the acts of S. Chiara compared to those of the Virgin. This is
truer than the artistic opinion which assigns these frescoes to Giottino. *Forschungen*,
ii., note to p. 213.
[4] Above which are S. Chiara, a monk, the Virgin and Child, St. Francis, and
another saint.
[5] In the same chapel a miraculous crucifix is preserved, which certainly dates as
far back as the tenth century.
[6] The following is a list of the churches in which were works, now perished,
which were attributed to Giottino by Vasari:—San Stefano al Ponte Vecchio, the
church of the Frati Ermini, S. Spirito, S. Pancrazio, S. Gallo, Santa Maria Novella,
Ognissanti, Convent alle Campora, Ponte a' Romiti in Valdarno, all in and about
Florence. At Assisi, above the gate leading to the Duomo, was another work by
Giottino which has perished. Vasari also assigns to Giottino a marble statue on
the campanile of Santa Maria del Fiore, which still exists, and has the Giottesque
character of a follower of Andrea Pisano. *Vide* VASARI, *ed. cit.*, i., pp. 623-627.

That the works of two or more painters may be concealed under the name of Giottino is not impossible ; our present knowledge only enables us to classify the frescoes and paintings according to style and technical execution. Time may bring some further records to light, which shall facilitate the studies of later historians. The clue which might be given by the works of Giottino's pupils is wanting; of Giovanni dal Ponte and Lippo, whose lives are written by Vasari, not a single picture or fresco remains. Of Giovanni Tossicani[1] d'Arezzo nothing has been preserved ;[2] but it is characteristic of Vasari that he makes that artist—a pupil of Giottino, born in 1324—the author of an Annunciation executed at Arezzo for the Countess Giovanna Tarlati about the year 1335.[3] If, however, Giovanni Tossicani, mentioned by Vasari, be the man whose name appears in the register of Florentine painters as Giovanni di Francesco Toschani, Vasari errs to the amount of a century in his dates. The painter of that name was born in 1372, registered in the corporation in 1424, and in 1427-30 made the usual returns of his income to the Catasto of Florence. We learn from the returns that Toschani contracted to complete the painting of the Ardinghelli chapel in Santa Trinità of Florence, which had been begun by a friar of the name of Domenico, and which Vasari assigns to Don Lorenzo Monaco. From the same source we ascertain that Toschani painted a picture for the Lord of Urbano, and began an Annunciation for Simone Buondelmonte, which was finished after his death by Giuliano d'Arrigo Pesello. Toschani died May 2nd, 1430, and was buried in Santa Maria del Fiore.[4] As for Michelino, it is not possible to say to which of the painters of that name Vasari specially alludes.

* [1] Milanesi corrects this to Toscani.

* [2] In records Giovanni Toscani is always spoken of as a Florentine. Vasari's statement that he was an Aretine is probably a manifestation of Aretinism, which, with Vasari, was only stronger than his Florentinism. He wished to believe that the work he himself had restored at Arezzo was by a native of that city.

[3] VASARI, ii., p. 145. The subject was the Annunciation with St. James and St. Philip (now lost), the two latter figures repainted by Vasari himself (see *ibid.*) still exist.

[4] *Giornale Storico degli Archivi Toscani, u.s.*, 1860, p. 15; and GUALANDI, *u.s.*, Ser. vi., p. 182, and VASARI, ed. Sansoni, ix., p. 267.

CHAPTER XIII

ANDREA ORCAGNA

THREE artists of the fourteenth century, registered in the guilds of the surgeons and painters of Florence, are called, after their father, Nardo, Andrea, and Jacopo Cione. Matteo, the fourth son of Cione, is entered in another guild as a sculptor. Vasari mentions a goldsmith called Cione in one of his biographies, and assigns to him the silver altar dossal of the baptistery and the silver chased head of St. Zenobius in the cathedral of Florence. Historians of the present century have jumped—very unreasonably, it may now be admitted—to the conclusion that Cione, whom Vasari describes as a goldsmith, is the same person as Cione, the father of Nardo, Andrea, Jacopo, and Matteo. But since proofs have been adduced that the dossal of the baptistery and the head of St. Zenobius are not by anyone of the name of Cione, Florentine writers have come to the conclusion that the goldsmith of that name was a mere creature of Vasari's fancy. Be this as it may, Andrea Cione is a celebrated painter, who is perhaps best known by his nickname of Arcagnolo or Orcagna.[1]

Orcagna was probably born in 1308. He entered the guild of stone-cutters in 1352 on the recommendation of Neri Fioravanti, a well-known sculptor of that period at Florence. He was afterwards registered in the guild of painters. According to Vasari, he died, aged sixty, in 1389. But on August 25th, 1368, he was pronounced to be so ill that the consuls of the Cambio gave

[1] See VASARI, ed. Sansoni, i., p. 593, note, and fol.; GUALANDI, *u.s.*, vi., p. 186; JACOPO CAVALUCCI, on the dossal of the baptistery of Florence, in *La Nazione* of Florence, June 23rd, 1869; G. MILANESI's and PASSERINI's *Del Ritratto di Dante* (8vo, Florence, 1865), p. 19; VASARI, ed. Sansoni, i., note to p. 593; and RUMOHR, *Forsch*, ii., p. 114.

a picture of St. Matthew which he had begun to his brother Jacopo to finish, and it is probable that he then died.

Nardo Cione, whom Vasari calls Bernardo, though his real name is now said to have been Leonardo, is registered in the guild of surgeon apothecaries in 1343 and in the guild of painters in 1365; and on May 21st, 1365, he made his will, being then in a dangerous state of health, leaving all he possessed to his brothers Andrea, Matteo, and Jacopo.[1]

There can be no doubt that the only eminent son of Cione was Andrea Orcagna, who lived early enough to do honour to the teaching of both Giotto and Andrea Pisano. No one more surely than Orcagna acquired the true maxims of Giotto in art. He was a painter, a sculptor, and an architect, and a master in every branch of the arts. He not only understood and grasped the great laws of Giotto, but, like him, combined all the essentials which unite to make art progress. He lived at a time when the Gaddi and others had lowered the pictorial standard. Placing himself on the vantage ground which Giotto had occupied, and keeping within the necessary limits of truth and of nature, he corrected the errors into which so many of his contemporaries had fallen and gathered into his grasp the scattered reins which they had come to hold so loosely.

Nature had evidently marked him out for a universal genius, and had he lived at the time when perspective became a science, he might have been numbered amongst the greatest artists of his country. Vasari pretends, but fails to prove, that Stefano Fiorentino and Giottino surpassed Giotto in the production of perspective effect and in the foreshortening of figures. Orcagna was well deserving of this praise; and in so far as one accustomed to scrutinise nature can fathom the difficulties of imitation, so far he penetrated with success. Figures may be found in his frescoes foreshortened with a certain daring, and his wall paintings generally are more strongly stamped with the characteristic features of his genius than his easel pictures. It is to be

[1] For these dates respecting Andrea and Nardo the authorities are VASARI (ed. Sansoni), i., pp. 594, 608, and BONAINI, *Mem. Ined., u.s.*, pp. 105, 106. Vasari's date of 1389 may, perhaps, be due to the printer, who should have set 68 for 89, the figures being only turned upside down.

deplored that his frescoes should have shared the fate of most
artistic works of the fourteenth century. But enough remains
for the satisfaction of a searching criticism, though too little may
be left to charm superficial observers.

If we reconstruct, mentally, the whole of that which is in
a great measure altered by the effect of time, and then compare
Orcagna with Giotto, the only painter that can stand comparison
with him, we find that he introduces a yielding and sensitive
religious feeling into art and a tenderness which foreshadows the
coming of an Angelico. He is a link in the chain that unites
Giotto to Masolino and Masaccio. From the Florentines he
derives his greatest qualities, from the Sienese, Simone, and the
Lorenzetti the lesser ones. He tempers the sternness of the first
with the mildness of the second, combining grace in his figures
with severity of form and nobleness of deportment. A Florentine
by education, he takes from his rivals at Siena only that which
suits his purpose, and he never sinks to meaningless affectation.
Vasari is evidently right when he says that Andrea Pisano was
Orcagna's first teacher.[1] Orsanmichele still exists to confirm the
statement; nor could anyone be more fitted to give grandeur
and severity to Orcagna's style than he, who had so successfully
and conscientiously carried out the conceptions of Giotto. It is
less obvious who taught him to paint—perhaps his brother
Nardo, as Vasari states; but evidently he combined Florentine
and Sienese qualities, and at Santa Maria Novella he unites the
dramatic force of Florentine composition with Sienese softness
and colour. It was admitted in Orcagna's own time[2] that he
was the greatest painter who had lived since Giotto; and though
Taddeo Gaddi was inclined to believe that painting declined after
the death of his master, this was true only of himself and of
those who, like him, were servile imitators. Sacchetti has
recorded the meeting of several artists at San Miniato, in which,
after a pleasant dinner and much drinking of wine, Orcagna,
being at that time *capo-maestro* of Orsanmichele, suggested as a
subject for debate "who, after Giotto, had been the greatest
master in painting?" No one appears to have hinted that

[1] VASARI, ed. Sansoni, i., p. 593.
[2] SACCHETTI, *u.s.*, Nov. cxxxvi., ii., p. 220.

Orcagna was himself the person best entitled to election. Yet his name was no doubt at that time well known. He had painted the whole of the choir of Santa Maria Novella for the family of the Ricci, a chapel and altarpiece in the same church for the Strozzi; he had furnished, in 1357, the model of the pillars for Santa Maria del Fiore; he had been called to Orvieto in 1358 to superintend the mosaics of the cathedral, and had already commenced the statues and reliefs which were to complete the tabernacle of Orsanmichele.

The records of Santa Maria Novella are silent as to the period when Orcagna decorated the choir of that edifice,[1] but Baldinucci authorises us to believe that his frescoes were damaged by a storm in 1358.[2] Their disfigured remains were preserved for upwards of a century, until Ghirlandaio was appointed to replace them by others. In doing so, he used many of the incidents which had already been set forth by his great predecessor.

Equal uncertainty exists as to the date of the Last Judgment in the Strozzi chapel, which may, however, have been executed before the altarpiece which was finished in 1357.

The Last Judgment decorates the wall facing the entrance, and is distributed so as to suit the spaces above and about the sides of the lancet window of the chapel. Instead of appearing in the usual glory, held up by angels, the Saviour soars in heaven, majestically wafted onward and half visible in the clouds, distributing blessings and curses, wearing a diadem, announcing his coming by two heavenly heralds, whose horns sound the last call, and accompanied by four angels, bearing the symbols of the Passion. Below him, to the left, kneels the Virgin clad in white, with reverence and inspiration in her glance, and her arms folded on her bosom. She heads a double kneeling row of six apostles, whilst a similar number, on the right side of the window, is presided over by the kneeling Baptist, raising his arms and face in ecstasy to the Saviour. Beneath these tenants of the clouds there are patriarchs, prophets and prophetesses, Noah holding the ark, Moses, Abraham, saints and martyrs of the early Church, a cardinal, kings and princes, whose joys are symbolised still lower in the space by a group of female dancers, by whom stands a woman in prayer. In the corner of the

[1] BALDINUCCI says this occurred in 1350, but supports his assertion with no proofs (iv., p. 395). [2] BALDINUCCI, *u.s.*, p. 396.

foreground, an angel assists one of the elect to rise from the grave. The guilty and accursed tear their clothes, gnash their teeth, and exhibit the most various effects of despair, on the side beneath the Baptist. Females, though in agony and torture, bear their suffering with feminine composure. In contrast with the dancers on the left, a group of women on the right contemplates in silent grief the Paradise they have lost, whilst in the corner of the foreground, a demon drags one of the accursed with a cord towards Hades.

Youth combined with dignity are characteristic in the Saviour.[1] Repose and contemplation are well rendered in the face of the Virgin, the ecstasy of a dweller of the desert in the wild features of the Baptist. Grandeur and force mark the apostles as they sit upon the clouds majestically enveloped in their draperies, and holding their several symbols, as St. Peter with the keys behind the Virgin. The groups of crowned princes and dignitaries are much damaged, as well as that of the dancers beneath it, by restoring; but in the elegant form of the latter is evidently the original conception of the dances which charm us in the pictures of the Dominican of Fiesole. In the distribution of this subject, Orcagna perfectly observed the laws of composition, and symmetrically divided the space he had to fill. He gave an additional charm to the picture by making it, as it were, a moving vision. Nature and individuality mark the select type of the faces. The angels, forcible in motion, are graceful and well proportioned. Remarkable, however, above everything else is their foreshortened attitude, unscientifically rendered indeed, but as nearly correct as the knowledge of the age allowed. Nor is it possible to conceive that more should have been, at this time, attained by Stefano or Giottino, even if we admit with Vasari that these painters were to some extent masters of perspective. In the choice of human proportion, Orcagna had a clear idea of selection, and a delicate sense of the beautiful. Life, action, grace, slenderness, and elasticity mark his figures, and they stand on the plane with the necessary firmness of tread. In this, and in the positive relation of his creations to nature, he was clearly Giottesque;

[1] The colour of the Saviour's dress and all the lower part of the fresco are injured, and one can only speak of outlines and general movement of figures.

but he displayed the progress of his time by defining and more fully rendering form, without sacrifice of detail to mass. Hands, feet, articulations are in fit relation to the general parts, as in Giotto, and are yet more studied. Drapery preserves its old simplicity and breadth, and clothes the frame beneath it judiciously. The lines are simple, but firm and decisive, and display the inner parts. In colour, brilliancy is combined with softness, vigour of light and shade with transparence. By a massive distribution of chiaroscuro, relief and rotundity are attained in a measure unknown to Giotto. The flesh tint is natural and well fused, the harmonies true and pleasing. Atmosphere is not wanting, nor is modelling or relief. Having thus prepared the way for the perfection of aerial, as intuitively he had divined the results of linear perspective, Orcagna was the great representative of artistic progress in his time.

To the right and left of the fresco which has given occasion to these observations are the Paradise and Infernal Regions, the first of which has suffered much from damp and from restoring.

High up in the centre of the space, to the left of the entrance, the Saviour and the Virgin sit enthroned, the former, young, crowned, and wielding the seeptre,[1] the latter, in calm repose with her arms crossed upon her bosom.[2] About and beneath them, in rows, and tinged with the red and azure hues of the zones of celestial light, are red warrior seraphs and blue warrior cherubs, in prayer, turned towards the presence of the Redeemer, parted on each side of the central heaven, on the clouds of which the throne reposes.[3] Lower down, and at each side of two central angels playing music,[4] are the orders of the heavenly hierarchy, likewise in rows, and comprising the apostles, prophets, saints and martyrs, the latter with their emblems, and each accompanied by his guardian angel, playing instruments, singing or praying. Yet lower, a dance of males and females, on a ground of clouds, separates rows of female saints, whose emblems are accurately given. In the corner of the foreground, to the right, an angel introduces a female into Paradise.

[1] Dressed in the blue mantle, which is much altered in colour.
[2] The Virgin is in white.
[3] The rows to the right have been seriously damaged.
[4] Both of these angels have repainted mantles.

What remains of this great work deserves the same praise as
the Last Judgment.[1]

The Inferno is completely repainted,[2] and we can only guess
from the Dantesque arrangement of "bolge," or compartments,
what Orcagna intended to represent.[3]

. These works were probably produced previous to 1354, when
Tommaso di Rossello Strozzi ordered of Orcagna the altarpiece of
the chapel, on condition that it should be finished in a year and
eight months, a fact corroborated by a record of the family, in
which it is declared that Orcagna failed to complete his contract
in the given time.[4] In truth, the altarpiece, as it now stands,
bears the date of 1357.

It consists of five niches resting on a predella in three divisions.
The Saviour is enthroned under a red and blue prism filled with
seraphim and cherubim, giving with his right hand the gospel to

[1] The spectator must carefully study what time and restorers have left untouched
before he can come to this conclusion. The upper parts of the rows of cherubs, to
the right, have been best preserved. The rows of saints immediately beneath these
have been damaged by retouching of the most sweeping kind. On the right-hand
foreground not a dress of the numerous saints standing on the clouds has remained
unrepainted. On the left side, many heads are discoloured, some retouched and
others new. The central foreground group has been so completely changed that,
where of old possibly interesting contemporary likenesses were to be found, nothing
remains but the outlines of some heads.

[2] According to GHIBERTI (Second Comment. in VASARI, ed. Le Monnier, i.,
p. xxiii.), this Inferno is by Nardo.

[3] The ceiling, divided, as usual, by diagonals, is adorned in the centre with the
arms of the Strozzi, around which the symbols of the four Evangelists are dis-
tributed. In the ornaments are emblematical figures of virtues, and in four
medallions in the centres of the triangles are Dominican monks, amongst which
St. Thomas Aquinas stands pre-eminent, with figures near them of Faith, Hope,
Charity, Fortitude, Justice. The head of St. Thomas, the all but obliterated
figure of St. Augustine above him, St. Jerome and St. Dominic (much damaged
by restoring), a fine St. Ambrose, and St. Gregory decorate the pilasters of the
entrance arch, in the key of which is a painted root of the Strozzi family. The
three principal frescoes rest on a painted cornice imitating white marble, supported
by feigned pilasters inclosing rectangular slabs, in the centre of which are mono-
chrome heads in medallions. In the painted glass of the window is St. Thomas
Aquinas holding a head, from which rays are projected on a model of a church in
his hand. Time has deprived this figure of its colour; but the design is worthy of
Orcagna, and was doubtless his. Above the figure and the arms of the Strozzi is a
representation, on the glass, of the Virgin and Child, likewise probably by Orcagna.

[4] See the doc. in BALDINUCCI, u.s., iv., pp. 392, 393.

St. Thomas Aquinas, with his left, the keys to St. Peter. Both these saints kneel at his sides with two angels sounding instruments. The first is presented by the Virgin, at whose right stand St. Catherine and St. Michael; the second by St. John the Baptist, on whose left are St. Lawrence and St. Paul. In the predella are two scenes from the life of a saint at each side of one representing St. Peter saved from the waters by the Saviour. To the left is the celebration of the Mass; to the right, a king dying amidst the wails of a crowd surrounding his bed, with a monk kneeling at one side of the foreground and an angel at the other weighing the soul of the departed in a balance.[1]

Here Orcagna represents the Saviour youthful and not without majesty, with fine features of Giottesque type. In the figure of St. Thomas the noble head shows an advanced study of form. The draperies are grand. In the predella scenes much vivacity of action may be noted. The colour is clear, light, and powerful, yet the execution is not, on the whole, so good as that of the best-preserved parts in the frescoes of the surrounding walls, where Orcagna, like most of his countrymen, displayed all the skill of which he was possessed.

Another altarpiece, combining all his qualities, hangs on the first pilaster to the left inside the northern front portal of Santa Maria del Fiore at Florence.

It represents St. Zenobius, the patron saint of the city, majestically sitting *in cathedrâ* with St. Crescenzius and St. Eugenius kneeling at his sides.[2] His feet rest in scorn upon the two allegorical vices of Pride and Cruelty.[3] In a medallion on the pinnacle of the throne the

[1] The following inscription is on the picture: AÑI DÑI MCCCLVII. ANDREAS CIONIS DE FLORENTIA ME PINXIT. At the bottom of the Saviour's dress is a hole. The blue mantle is retouched at the knees. The black portion of St. Thomas's dress is retouched and the white part new. The colour and part of the ground and the breast of St. Paul are gone. In the central predella compartments some of the colour in the head of St. Peter is gone, and a few of the apostles in the vessel are repainted.

[2] The figures are of life size. St. Crescenzius bears a censer, St. Eugenius a book ; Charity and Humility, as allegorical figures, support a damask cloth behind St. Zenobius. The head of Charity is much damaged. St. Zenobius, in episcopals, holds a crozier.

[3] The first remarkable by the golden horns on his head, the second sucking the blood of an infant.

Saviour gives the blessing, and in the predella are two episodes from the life of St. Zenobius.[1] Here, in spite of partial restoring, the colour is clear and bright. The figure of the Florentine saint is imposing and majestic, of well-chosen type, and lined with severely simple contours.

A picture in the Medici chapel at Santa Croce, inscribed 1363, is of the same class, and represents, in four lancet niches, St. Ambrose, St. Jerome, St. Gregory, and St. Augustine. Above the pinnacles are the four symbols of the Evangelists.[2]

Of less marked resemblance with the undoubted Orcagnas, but in the same chapel, is a picture in three parts—a glory, St. John Gualbertus, and four episodes from his legend.

The saint in the garb of a monk, holding a staff and book, fills the central space, above which the Saviour is represented in benediction. In one of the compartments is the ordeal of fire. On the pediment six lozenges are filled with figures of males and females. Many of the characteristic features of Orcagna's style mark this piece.

In the same chapel, to the right of the door, is a Virgin and Child between Pope Gregory and Job,[3] executed in 1365.

Three scenes in the pediment are almost obliterated. This picture has much the character of the San Giovanni Gualberto, but is slightly inferior to it. The Virgin and Child are not ungraceful, and the forms of the draperies are fine.

Very majestic, likewise, and much in the style of Orcagna, is a life-size St. Matthew, erect with the pen and book, the central figure of an altarpiece which, till 1860, hung high up in the church of Santa Maria Nuova at Florence, and is now in the refectory of the hospital of San Matteo.[4]

[1] In one a youth is restored to life, in the other the withered elm blooms anew.

* [2] These four representations of saints now form a part of the altarpiece of S. Croce.

* [3] Numbered 36. Inscribed : ANNO DOM. MCCCLXV. TELLINUS DINI FECIT FIERI HOC OPUS PRO ANIMA SUA. This picture is now in the sacristy of S. Croce.

[4] Falsely assigned by some to Lorenzo di Bicci, this altarpiece is noted by RICHA (vii., p. 92), as in San Matteo and in the manner of Giotto. Signor Gaetano Milanesi informs us, from records in the convent, that Mariotto di Nardo Cione laboured there. The saint wears a blue tunic and red mantle. Beneath the saint's feet is the inscription : S. MATHÆUS APOSTOLUS ET EVANGELISTA.

* In the year 1415 Mariotto di Nardo di Cione was commissioned to paint a

Grandly posed and grave in expression, the saint occupies a pointed niche, the companions to which on each side are divided into compartments, in which four scenes from the legend of St. Matthew are depicted.[1] One of these—an encounter with two dragons—is a grand composition of four figures of tall proportions, full of life and character, and in the pure Giottesque style; whilst another, in which the son of Egippus is restored, presents to us in the reviving youth a form of the finest kind as to beauty and character. In these scenes, indeed, we find the same power and animation as in the predella of the altarpiece signed by Orcagna at the Strozzi chapel.[2]

As regards execution, this picture, with the exception of its predella, is finished with a bold rapidity of hand and warmly tinged with vigorous colour. In the second chapel belonging

picture of S. Matteo for the hospital of S. Matteo. This picture Milanesi held to be identical with the picture of S. Matteo formerly in the gallery at the hospital of S. Maria Nuova, and now in the Uffizi, which Crowe and Cavalcaselle give to a follower of Orcagna. Signor Cavalcaselle, however, regards this San Matteo as identical with a picture Orcagna was commissioned to paint for Orsanmichele by the consuls of the Arte del Cambio, and which was finished by Jacopo Orcagna. He points out that it bears the device of the Arte del Cambio: in each of the wings of the altarpiece are two *tondi*, in which are coins on a red ground. The form of the picture, he argues, renders it more suitable to be placed on a pilaster than over an altar.

This picture is in one of the new rooms at the Uffizi. It is still given to Mariotto di Nardo in the official catalogue (No. 20).

[1] In the first and lowest, to the left, Christ with four apostles calls Matthew from his bank. An inscription has the following words: QUOMODO SANCTUS MATHÆUS RECESSIT DE TELONEO, ET SECUTUS EST CRISTUM. In the second, the taming of the dragons sent by the soothsayer to worry St. Matthew. Here again: QUANDO MISERUNT SUPER EUM SANCTUM MATHÆUM DRACONES. In the third St. Matthew restores to life the son of Egippus, King of Ethiopia. In the last St. Matthew is decapitated by a soldier. The inscription on these two last are: QUOMODO SANCTUS MATHÆUS RESUSCITAVIT UNUM MORTUUM, QUANDO S. MATEUS FUIT OCCISUS.

[2] In two medallions, at each side of the central pinnacle, are angels holding severally a crown and a palm; on the medallions of the sides, golden coins. The predella, representing a Crucifixion and two scenes from the life of St. Nicolas of Bari, are by a feebler painter and in a more modern frame than the rest of the altarpiece. Since this work was first published a record has been discovered which proves that this altarpiece was the last work on which Orcagna was engaged. On August 13th, 1368, the master being reported sick, the consuls of the Arte del Cambio ordered Jacopo Orcagna to finish the St. Matthew which had been commenced by Andrea on September 15th, 1367, for a pilaster at Orsanmichele. See TAV. ALFAB., *ad lit.*, Orcagna.

to the company of the Misericordia, in the cloister of the Badia of Florence, an altarpiece in three parts may be seen, representing the descent of the Holy Spirit.

The Virgin occupies the middle of the space, and stands, with her arms crossed on her bosom, in the midst of the apostles. Above her are the dove and two angels. This picture, inclosed in a modern frame, has been in part restored,[1] but still reveals the hand of Orcagna. The colour has become a little brown, but the same hand may be traced in it as in the altarpiece at San Matteo, and both resemble in style the Orcagna of the Strozzi chapel.[2]

The altarpiece which once adorned San Piero Maggiore[3] at Florence, and is now the property of the National Gallery,[4] is much altered by restoring. The lightness of the tempera has been destroyed, and the beauty of the master's style cannot therefore be judged from it.

Vasari says that Orcagna painted the choir of Santa Maria Novella and the Strozzi chapel in company with his brother.

[1] The names of the apostles on the frame are new. The red mantle of St. Simon is damaged, and likewise the red dress of St. Philip. The restoration is of the eighteenth century, as may be gathered from the following inscription : TABULAM HANC, VETUSTATE FERE DELETAM PROPRIÂ MANÛ HANC IN FORMAM REDEGIT CAN. BONSUS PIUS BONSI HUJUS SACELLI PATRONUS A.R.S. MDCCLXXI.

[2] We may add to the list a Vision of St. Bernard in the Academy of Arts at Florence (Sala Prima, No. 138), a feeble example, but soft in colour.

* In Sir Hubert Parry's collection at Highnam is a Coronation of the Virgin attributed to Giotto, which is by Andrea Orcagna.

* Milanesi thinks that this picture was painted by Bernardo Daddi for the Cappella dell' Udienza of the Palazzo della Signoria. In an Inventory of the year 1432 is to be found the following statement : ANCORA E SOPRADETTI FECIONO NETTARE E RIPULIRE LA TAVOLA, PREDELLA E CAPPELLA DELL' ALTARE DI SAN BERNARDO LA QUALE ERA TULLA AFFUMICATA E NERA PER LO FUMMO DEGL' INCENSI E DELL' ESSERE STATA GRANDISSIMO TEMPO NON PROCURATA : LA QUALE TROVANO FU DIPINTO NEL 1335 PER MAESTRO BERNARDO DIPINTORE, IL QUALE FU DISCEPOLO DI GIOTTO. See VASARI, ed. cit., i., p. 467.

[3] Nos. 569 to 578 inclusive, National Gallery, represent the Coronation of the Virgin and choirs of saints, with nine small subjects attached. The No. 581 in the National Gallery, representing three figures of saints assigned to Spinello, has some features of the school of Orcagna. We may notice here an altarpiece assigned to Orcagna, in the palace of Meiningen, representing the Virgin and Child adored by a kneeling bishop and St. Francis. On one side are St. Peter and St. Paul ; on the other, the Annunciation and the Crucifixion. This is no doubt a picture of the Giottesque school, but not by Orcagna. VASARI, ed. Sansoni, i., p. 595.

There is no trace of two hands in the chapel, and as to the period when the decoration was completed, it has been proved to date as far back as 1354. Orcagna must at that time have been an artist of acknowledged merit. As early as 1355 he had received the appointment of *capo-maestro* to the oratory of Orsanmichele, one of the great examples of mixed architecture, sculpture, and mosaics of the time, the tabernacle of which was executed from his designs.[1] Without entering into a minute description of this monument, which has been admired not more than it deserves by the very best authorities in matters of art and of taste in most countries, it may be sufficient to remark that in the bas-reliefs of the basement the composition and the figures are characterised by the same severe style, the same grandeur, united to softness and elegance, which are peculiar to Orcagna's painted Virgins and angels. In the handling of the chisel Orcagna perhaps exhibited more force and energy, and was more imbued with the necessity of breadth than when handling the brush; yet nothing can be more careful than the polish of his marble. These sculptures surpass those of Orcagna's contemporaries quite as much as the frescoes cast in the shade all that were produced by his rivals, and they are, without any doubt, the finest that were produced by an independent artist in the fourteenth century. Amongst the bas-reliefs the best, and that which is certainly entitled to the highest praise, is one representing the transit of the Virgin. Nothing can be better than the group in which she is carried to heaven by the angels. The lower scene, in which the mother of the Saviour lies dead in presence of the apostles, is less perfect, because a certain stiffness and naturalism mar the chief figure; still, the passion, the fire of Orcagna are here, and the noble breadth of his drapery is conspicuous, as in his frescoes. One may ask, after contemplating these masterpieces, from whence Orcagna could have derived the vigour and character of his style unless from Giotto through Andrea Pisano. Were it even proved that Orcagna had another

[1] See the records in GAYE, *Carteggio*, i., p. 52 and fol., which prove that Andrea was *capo-maestro* of Orsanmichele from February, 1355, till as late as 1359, at the salary of eight florins a month. See Sacchetti's poem describing Orsanmichele in GUALANDI, *u.s.*, Ser. 3, p. 133 and fol.

master, it might still be affirmed with certainty that he owed
much to the great Pisan Giottesque, and that from the reliefs
of the bronze gates and campanile at Florence he took the
lessons which yielded fruits of surpassing value in the tabernacle
of Orsanmichele. Orcagna's genius is proved by his painting and
sculpture. His acquirements and taste in architecture may be
judged from the elegant and light proportions of the stonework
which surrounds the great monument of his skill. Even the iron
rail which incloses the whole is a part of a grand unity. It is
a pity that the oratory should be closed, as it thus loses much
of its beauty, particularly from want of light.[1] This great work
was completed, as is shown by the inscription, in 1359.[2] We
may remark an affectation of the form in the inscription, in
which Orcagna, though perfect as a sculptor, calls himself
"pictor." Vasari tells us that in his pictures he called himself
"sculptor," a statement not corroborated by the only inscribed
picture that is known.[3]

The course of this narrative now leads us to Orvieto, where
the cathedral was at last approaching completion, though its
external mosaics were incomplete, and its internal paintings un-
finished. The Orvietans had pressed the Florentines to grant
them the services of Orcagna, and this having been unwillingly
conceded, Andrea proceeded thither early in June, 1358. On the
fourteenth of that month a contract was signed by him in
presence of two vicars of Messer Egidio Albornoz, then the
apostolic legate, the "seven" of the city, and the authorities of
the cathedral, in which he agreed to serve in the triple capacity
of a sculptor, a painter, and a mosaist for an entire year, to begin
immediately after the completion of his labours at Orsanmichele,
then computed to last fourteen months. It was also stipulated

[1] See in RICHA, op. cit., i., p. 1, a copy of the original sketch for this tabernacle
preserved amongst the records of the Strozzi family.

[2] ANDREAS CIONIS PICTOR FLORENTINUS ORATORII ARCHIMAGISTER EXTITIT
HUJUS MCCCLIX. Vasari assigns to Orcagna seven figures of virtues in the Loggia
de' Signori, which, as we shall see, were designed in part by Agnolo Gaddi and
carved in part by Jacopo di Piero and Piero di Giovanni. See BALDINUCCI, u.s.,
iv., pp. 344, 402; also the Zecca, or mint, erected in 1361, VASARI, ed. Sansoni, i.,
p. 604. See also GAYE, Carteggio, u.s., i., p. 512.

[3] VASARI, ed. Sansoni, i., p. 607.

that his contract at Orvieto might be prolonged from year to year, subject to four months' notice, if desired by the Orvietans.[1] Having exchanged signatures to this contract, Orcagna returned to Florence, where he remained till February 21st, 1359, when he spent fourteen days at Orvieto with his brother Matteo, and carefully examined and determined how the works were to be carried on in his absence.[2] At the end of two months, little remaining to be done at Orsanmichele, Orcagna reappeared (October 18th, 1359) with Matteo in Orvieto.[3] Having taken the oath of service and engaged his brother to work under him at a fixed monthly salary,[4] he diligently conducted the erection of a window in the front of the cathedral.[5] But the Florentines would not let him rest; and as early as February, 1360, they recalled him to Orsanmichele, where he might have remained but for the importunity of the Orvietans. A letter is extant[6] in which the Florentines, dispensing again with Orcagna's official duties, recommend him to the people of Orvieto, and excuse themselves for delaying his coming (August 3rd, 1360). But Orcagna soon after disagreed with the heads of the *fabbrica*, and they released him (September 12th, 1360) from his contract.[7] He remained, however, for the time in Orvieto to complete a mosaic ordered of him immediately after (September 16th, 1360), for the front of the cathedral,[8] and then withdrew, leaving Matteo to fill his

Andrea's salary to be three hundred gold florins per annum in monthly payments of twenty-five florins. See the original "condotta" in MILANESI's extracts from Orvietan records, *Giornale Storico degli Archivi Toscani*, iii., p. 100 *et seq.*, and LUZI, *u.s.*, *Il Duomo di Orvieto*.

* All these documents relating to Orcagna are to be found in full in FUMI's *Il Duomo d' Orvieto* (Rome, 1891), together with some others not given by Milanesi and Luzi. See FUMI, *op. cit.*, pp. 121–126.

[2] He was at Orvieto fourteen days, and the expense (one florin) for the parting dinner is recorded. *Vide* in DELLA VALLE, *Storico, u.s.*, pp. 115, 116, and 284, and MILANESI, *l.c.*

[3] DELLA VALLE, *u.s.*, and MILANESI. [4] Eight florins per month. *Ibid.*

* [5] MILANESI, *u.s.* It was about this time that he executed for the façade the mosaic of the Birth of the Virgin, now in the Victoria and Albert Museum. See FUMI, *op. cit.*, p. 106.

[6] Given in précis in GAYE, *Carteggio, u.s.*, i., p. 512, in full in MILANESI, *u.s.*

[7] MILANESI, *u.s.*

* This document, like those previously referred to, is given in full in FUMI's *Il Duomo d' Orvieto*. See pp. 125, 126.

[8] See the original contract in MILANESI, *u.s.*

place, which that industrious artist seems to have done till
August, 1367.[1] It had been arranged that four masters named
by the Orvietans and two chosen by Orcagna should value the
mosaic on the front of the cathedral, after its completion. Pe-
truccio di Vanni came from Rome (February 10th, 1361) to
perform this duty,[2] but his verdict is not known. Much time
elapsed before it was settled what Orcagna was to claim for his
work, and a year had already expired since its completion when,
on the part of Orcagna, Ugolino, and Jacopo di Lotto on the part
of the cathedral authorities, Matteo di Cecco of Assisi and
Maestro Paolo di Matteo, met and made a report (September 10th,
1362) to the effect that the colours of the stones and the paste
had changed, that the plane of the mosaic was not level and the
binding substance not good; hence that the mosaic (in diameter
eighty-one hands) was not likely to last.[3] In spite of this un-
favourable report the authorities of Orvieto met on September 15th,
1362, and ordered sixty florins of gold to be paid to Orcagna.[4]

An interesting notice of Orcagna is that which relates to the
façade of the cathedral of Florence. In 1356 he was appointed
one of a commission which included Neri di Fioravante, Benci di
Cione, Francesco Salvetti, Taddeo Gaddi, Andrea Bonaiuti, Niccolò
Tommasi, and Neri di Mone, to produce a design for the front
of that edifice. The design was made, adopted, and publicly
exhibited in October of 1357, Orcagna being also successful in
competing for the form of pillar to be used in the decoration of
the interior of the edifice.[5]

This is all that we find recorded of this great master except
that he was inscribed in the guild of St. Luke at Florence as a
painter in 1368-9.[6]

[1] DELLA VALLE, *Storico*, p. 284. At all events, the payments to Orcagna cease
to be recorded. The name of Matteo di Cione appears as late as 1380 in a record of
works executed at Orsanmichele. See PASSERINI (L.), *Stabilimenti di Beneficenza*
(8vo, Florence), p. 53.

[2] MILANESI, *u.s.*

[3] The statement may be seen in MILANESI, *u.s.*

[4] *Ibid.*

[5] See CESARE GUASTI in *Archiv. Storico*, Nuova Serie, tom. 17, pp. 138-41;
RUMOHR, *Forschungen*, ii., p. 113.

[6] GAYE, *Carteggio*, ii., p. 36, as follows: "Andrea Cioni Pop. S. Michele Bisdomi-

In 1376 an instrument drawn up before a public notary at Florence was made in favour of Cristofano Ristori as tutor to Tessa and Romola, daughters of Orcagna, by Francesca his widow.[1] Vasari makes Orcagna live till 1389. This is not the only error into which he fell. He asserts that Orcagna painted, in the Campo Santo of Pisa, the great frescoes of the Triumph of Death, the Last Judgment, and the Inferno.[2] It may be necessary to devote a little space to the consideration of this statement.

At the eastern extremity of the southern wall in the Campo Santo of Pisa, a painter of considerable talent depicted with surprising power the advantages of contemplative over active life, suggesting that, whereas in the pursuit of pleasure, and in the enjoyment of wealth, death invariably takes the common mortal by surprise; on the contrary, the lowly hermit welcomes its approach, and expects it without fear. Various episodes illustrate this idea:—

In the foreground of a rocky landscape forming the left side of the fresco, a party of knights, hawking with ladies and servants and dogs, have been arrested by a gruesome spectacle. Before them stands the hermit Macarius and three open coffins, the contents of which are doubtless the subject of a sermon contained in the long scroll to which he points. In the first coffin lies a body in its shroud, in the second a body evidently decomposed, in the third a skeleton. A snake glides away in the foreground. The sudden thought of death, thus presented in its most naked form before a company bent on pleasure, affects the various members of the hunt in divers ways. One of the riders sits on a horse who snorts at the sight of the coffins and looks astonished. To his right, and nearer the spectator, a second holds his nose; and his hack, stretching its neck, looks with glaring eyes before it. This, we are told, is a portrait of Andrea Uguccione della Faggiuola. Between

nis Orgagnia MCCCLXVIII." Baldinucci copies the register and gives the date as 1369, but see GUALANDI, *u.s.*, vi., p. 176, who gives it as 1368.

* The following is the entry relating to Orcagna in the *Libro della Matricola* of Florentine painters: "Andreas Cionis, vocatus Arcagnolus, pictor populi Sancti Michaelis de Vice Dominis, juravit et provisit dicte arti, pro quo fideiussit Nerius Fioravantis magister in MCCCLII. indictione sexta die XX. Ottubris." Orcagna's will, too, is to be found in the Florence Archives.

[1] See the original record in BONAINI, *Mem. Ined.*, *u.s.*, p. 106.
[2] VASARI, ed. Sansoni, i., pp. 596-99. Ghiberti says nothing of this.

these a dame looks on with timidity, whilst the knight at her side
boldly points at the objects which cause her reverie. In rear are more
riders and huntsmen. The group could hardly be more powerfully
delineated whether one considers the human or the brute creation.
The track upon which the party is riding leads up a stony path edged
with trees to a hermitage, near which a bearded and cowled inmate sits
reading, whilst another stands by, leaning on a staff, a third under a
tree to the left milks a goat, and a fourth stoops to look down. To the
right of this scene, and parted from it by a high and barren rock, a
group of players, male and female, sits in an orchard, whilst cupids fly
amongst the branches. Castruccio of Lucca sits with a falcon on his
wrist listening to a lute played by a buxom dame, and a fiddle played by
a minstrel. A female, on Castruccio's right, fondles a lapdog as she
listens to the compliment of a knight near her. But, close at hand in
the centre of the fresco, Death with a falchion comes sweeping through
the air in the shape of an aged female, with dishevelled hair and
ferocious aspect, beating space with batlike wings. In vain a troop of
beggars, tottering on crutches, call upon her to hasten the period of
their earthly sufferings. Death has mown down kings and princes who
lie pell-mell at her feet, spares the beggars, and rushes towards the groves
where love and pleasure hold their sway.

Amongst the dead, some have been of virtuous lives; an angel draws
the soul of one of them from his mouth with intent to make it partake
of heaven; whilst two devils perform their less pleasing office upon
another of the departed. In the sky, a legion of angels and devils
contend in the labour of transferring souls to heaven or the abyss.
Hades may be seen to the left in the distance, with flames issuing from
it, and demons feeding its infernal gulf. The angels all carry the cross,
the emblem of human redemption, and the groups which they and the
demons form are full of fancy and energy.

Nothing is left to be desired in all this as regards order,
symmetry, and distribution. It is, like a play, in acts and scenes,
the sequence of which is carefully regulated. The parts are
well sustained, and each figure has its meaning in the scene, as
each scene has its fit place in the drama. Extraordinary force is
sometimes pushed to a vulgar realism.[1]

[1] The dresses of the riders in the hunt are all repainted, and the same may be
said of the central episode, many of the draperies being either new or obliterated.
All but a part of the legs and wings of the figure of Death is repainted. The

By the side of this piece is the Last Judgment.

In the centre of it the Saviour, of gloomy and threatening aspect, sits enthroned in an almond-shaped glory, raising his right arm aloft, and pointing with his left to the wound in his side. On his right, the Virgin in a mandorla tempers the menace of the Saviour, and looks down with pity at the condemned. Above, at each side, are six angels bearing the symbols of the Passion; beneath these, and in a row on each side, the apostles seated on the clouds,[1] St. Peter to the left, with disdainful glance, holding the keys. Immediately beneath the Saviour and Virgin stands a group of four heavenly messengers, majestic and terrible in aspect. The first, erect and girt with a sword, holds up a scroll in each hand, and is represented with that primitive austerity and grandeur which mark the figures of the earlier mosaists and painters. At his feet, a second, seated, looks out in menace,[2] and two others at his sides, blow brazen horns. There is a striking affinity between this group of angels and that in the same situation in the Last Judgment of Sant' Angelo-in-Formis at Capua, a picture which, we saw, dates as far back as the year 1075. But the energy which the master concentrates forcibly reminds us of the age of Michael Angelo. Below, on the Saviour's right, the army of the blessed is grouped behind St. John the Baptist,[3] each of the happy souls looking up towards the Redeemer, and some in the foreground helping others to rise out of the grave. An angel points out to one in this condition, inscribed with the words "hypocrisy," the everlasting abyss to which he is consigned; whilst, more to the right, St. Michael directs a soul led out by its guardian angel to Paradise. To the Saviour's left, angels drive back the condemned, the mass of whom is huddled together in bold and varied attitude.[4]

dresses of the orchard group are all retouched, and in the sky above the trees the first and third angels are altered with modern colour. The blue sky is damaged, and the forms of angels or demons spoiled or rubbed away. The painted frame surrounding the fresco has in great part disappeared; but in the upper corner, to the left, is a half figure, in a lozenge, of Death as a skeleton with a scroll, whilst in the next lozenge another figure of a man also carries a scroll.

[1] All the dresses of the apostles are repainted.

[2] This figure bears a scroll, the inscription upon which is obliterated.

[3] This mass of figures is much damaged.

[4] This portion of the fresco is so damaged by restoring that it is no longer possible accurately to distinguish the figures issuing from the tombs. The angels are remarkable for vulgarity of features.

The Inferno is not in the least like that of the Strozzi chapel, but divided into horizontal sections, in each of which figures undergo torture, Lucifer presiding in the midst. Of the four rows which compose this portion of the Last Judgment, the upper seems most to present the character of the fourteenth century. The forms of the nude are reasonable, the intelligence of anatomy fair, and the colour is not without relief. The next lower row is ruder in execution, reddish in tone, flat in modelling, and mechanical in outlines; and these characteristics extend to two figures to the spectator's left of the Lucifer. Satan, however, and all the rest of the picture, are modern, and probably due to Salazzino, the restorer, who, according to Vasari, laboured here in 1530.

It is proved that one Cecco or Francesco di Pietro, a Pisan, of whom there are notices at Pisa in 1370, was employed, in 1379, to restore the Inferno, which had been "spoiled by the apprentices."[1] The portion due to him is probably the second circle and the two figures by Lucifer's side, already noticed as of inferior merit. The upper circle of all seems the only original one, and that which most resembles the best-preserved portion of the neighbouring frescoes. From it and from the portion of the subject which represents the hermit Macarius before the dead bodies, the primitive style of the whole must be judged. There is nothing to recall the paintings of Orcagna in the Strozzi chapel, nothing to reveal the Florentine in type, construction, or expression. In the faces of females the peculiar model which Orcagna affected is not to be traced. For the symmetrical oval of his heads a broad ellipse with swelling cheeks is substituted, for the delicate contours of his figures a coarse outline, for the finer chiselling of hand and limb a ruder workmanship, for drapery or dress a cast and fashion altogether different from his, for dignity and decorous mien, rugged but vulgar force. We need not go far to discover, in the Campo Santo itself, works of the very same character. The frescoes devoted to hermit life, painted by the Lorenzetti of Siena, and those assigned to Orcagna, are in every respect similar. Yet Vasari would have

[1] BONAINI, *u.s.*, p. 103, and MORRONA, *u.s.*, p. 243.

us believe that two masters, chiefs of great but totally different schools, laboured here. If the question of distribution and composition be set aside, for doubtless there is a difference in this respect, it will still be found that the manner in which each group is presented, each character is given, is the same in the frescoes assigned to both masters. In Lorenzetti's anchorites we shall find wild power, the austere aspect of the solitary, an excessive energy of movement. The same features exactly, the same style of drapery, the same technical execution and feeling, mark the Macarius and the hermits assigned to Orcagna. A hermit at the extreme right of Lorenzetti's fresco, bent over the dead body of a solitary, and covering it with a shroud, or two figures in similar attitudes on the extreme left of the same piece, compared with the Macarius assigned to Orcagna, are marked by the same peculiarities. Again, take the "happy" in the Paradise assigned to Orcagna; examine their profiles in contrast with those in the picture of the Lorenzetti, such as that of a woman on the extreme right tempting St. Anthony, who holds his hands in the fire; the same character appears in both. Examine critically the mode of draping, the action, the articulations; choose for a contrast the Saviour appearing to Anthony in the Lorenzetti fresco, and the Saviour and St. Peter in the so-called Orcagnas. The forms, the landscape, the rocky path, the tree, are everywhere the same. Were we to admit with Vasari that Nardo Orcagna painted the Inferno, we might be entitled to claim for him the whole of the remaining part of these wall paintings, because the only portion of that episode which has preserved its original character is exactly the same in style as the best of the Triumph of Death. Yet it is impossible to reconcile this assumption with the fact that a Sienese, not a Florentine character, prevails. Equally difficult is it to admit that Orcagna's composition was used by a Sienese subordinate, the language, spirit, and education of the artist of the Campo Santo being in every sense Sienese rather than Florentine. Who then, it may be asked, is the author of these so-called frescoes of Orcagna? In answer, it will be sufficient to recollect that, as regards composition, the Lorenzetti were capable of this effort. It may therefore be safely supposed

that the three frescoes are by the same hand, that of a Sienese.[1]
We may at the same time cast a glance at the neighbouring
pictures on the east wall, assigned to Buffalmacco or Antonio
Vite, and representing the Crucifixion, the Resurrection, and the
Ascension, and, damaged as these are, we shall find the execution
similar to that of the so-called Orcagnas, and composed evidently
in the same Sienese style.　A word, finally, as to less important
points.　The painted frames of the three frescoes assigned
severally to Orcagna and the Lorenzetti are by one person.[2]

* [1] In his *Il Camposanto di Pisa* Signor Supino, himself a Pisan, seeks to show
that these frescoes are by the Pisan master Francesco Traini and his followers.
The evidence that he adduces in support of this contention is, it must be con-
fessed, very slight.　There is nothing to show that Traini had the knowledge
of the nude and the power of painting it displayed by the painter of the Last
Judgment of the Campo Santo.　There is nothing to show that Traini was able to
achieve great monumental works.　His panel pictures in the gallery at Pisa do not
suggest the possession of such powers.　Nor do we find in them any display of
brutal realism, or any exuberant expression of intense emotion such as is to be
seen in these frescoes.　The only similarities that exist between these frescoes of
the Campo Santo and Traini's pictures are due to the fact that Traini was an
offshoot of the Sienese school, being a follower of Simone Martini.　The three
frescoes of the Campo Santo—the Triumph of Death, the Last Judgment, and the
Anchorites of the Thebaid—are entirely characteristic of Pietro Lorenzetti and his
followers.　In his love of obvious allegory, in the gross realism of his nudes, in his
violent emotionalism, the artist of these frescoes is at one with the painter of the
Crucifixion at S. Francesco at Siena, and the Passion frescoes at Assisi.　The
Triumph of Death, like the Anchorites of the Thebaid, is full of Sienese types.
Similar types of old men are to be met with in Pietro's predella pictures in the
Siena Academy and in the Arezzo altarpiece, as well as in the representation of the
Thebaid in the Uffizi.　Some of the women have their counterparts in Pietro
Lorenzetti's Birth of the Madonna in the Opera del Duomo at Siena.　The long,
thick neck to be found in most of the figures in these frescoes is characteristic of
Pietro Lorenzetti, who rarely drew well the attachments of the human form.　The
apparent rudeness of the execution of these frescoes is due in part to the intervention
of unskilled assistants—perhaps local artists trained by the Sienese—in part to the
incompetence of successive generations of restorers.

Signor Supino clearly shows that he has not learnt to differentiate between the
styles of Ambrogio and Pietro Lorenzetti.　Otherwise it is impossible to account for
his introducing into a discussion of the authorship of the frescoes of the Anchorites
a glowing description of Ambrogio's *Pace* in the Palazzo Pubblico at Siena.

[2] The frescoes are painted on an intonaco daubed over a trellis-work of canes, so
that it is impossible to save the plaster in its fall by iron clamps as has been done
in other parts.　The only means of saving these works is to detach the intonaco
and, instead of fixing it anew to the wall, place it on canvas and make the whole
portable.　The air will then pass beneath and preserve the lower surface from

Modern research has been rewarded by the discovery that, amongst the frescoes of the Campo Santo, some illustrating the legend of St. Raineri are by Andrea da Firenze. It is proved further that this Andrea was still living after the death of Andrea Orcagna at Florence. These facts are conclusive to show that Vasari, in his usual haste, having heard that one Andrea, a Florentine, had painted at Pisa, and not knowing which of the frescoes he should assign to the person whom he confounded with Orcagna, chose the series of the Triumph of Death and the Last Judgment, careless as to whether the style or execution of these works should justify him in his supposition. If it be admitted that Pisa owes nothing to Orcagna, the statement that he painted in Santa Croce frescoes which were copies of those of the Campo Santo falls to the ground.[1] The remaining works assigned to Andrea at Florence have disappeared in the progress of time.[2]

Nardo di Cione, or, as Vasari calls him, Bernardo Orgagna, occupies a large place in Andrea Orcagna's life, if we believe, with Ghiberti and Vasari, that he painted frescoes in the Ricci and Strozzi chapels at Santa Maria Novella, in the Cresci chapel at the Servi, in Sant' Appollinare, at Florence, and in the Campo Santo of Pisa. Unhappily there is nothing to distinguish what remains of all these works from those assigned, either correctly or the reverse, to Andrea Orcagna. And it may be that Nardo was never more than an assistant to his brother. We shall be confirmed in this belief by the fact that pictures bearing the name of Bernard of Florence are assignable by their style as

damp, the upper having long ceased to suffer from the effects of weather. The method of fixing the colours, raising the intonaco and placing it again to the wall, has already been successfully practised in the case of the Gozzoli frescoes.

 * At S. Francesco at Siena Pietro Lorenzetti painted on an intonaco daubed over a framework of canes.

 [1] Vasari, *ed. cit.*, p. 600.

 [2] Those in the Cappella de' Cresci at Santa Maria de' Servi are gone (Vasari, ed. Sansoni, i., p. 595), and likewise the picture of San Romeo (*ibid.*, pp. 595, 607),—it represented the Annunciation and was known to Richa (Chiese, *u.s.*, i., p. 258). Gone also are the paintings on the front of San Appollinare (*ibid.*, p. 596), the pictures said to have been sent to Avignon (*ibid.*, p. 605), and that which adorned the chapter-house of the monastery of the Angioli (*ibid.*, p. 607), as well as the frescoes noticed by Ghiberti in Santa Croce and in San Agostino, now San Spirito (Ghiberti, see Com. in Vasari, ed. Le Monnier, i., p. xxiii.).

well as by the dates, which authenticate them to an earlier
Giottesque, of whom we have treated under his true name of
Daddi. In the meanwhile we may note, as possibly by Nardo di
Cione, a certain number of pictures which bear the impress of
the style without displaying the concentrated power of Andrea
Orcagna, and of these we should single out the four doctors with
the date of 1363 in the Medici chapel at Santa Croce.[1] The
Majesty of St. John Gualbertus, the Virgin and Child between
St. Gregory and St. Job, of 1365,[2] and the Vision of St. Bernard,
in the Florentine Academy—pictures which we have noticed as
feeble Orcagnas on the one hand, and shall have to notice on the
other as being in character very like the work of another pupil of
Orcagna,[3] namely, Niccola Tommasi.

Amongst the painters on the council of Santa Maria del Fiore
in 1366 are Bernardo Pieri and Bencius Cionis.[4] The latter is
probably not one of Andrea's brothers. As for the Loggia de'
Lanzi, which has been attributed to Orcagna, it is proved clearly
that the provision for its erection was passed by the Florentine
government on the 21st of November, 1356, but that it was only
commenced in 1376,[5] under the direction of Bencius Cionis.[6]

[1] See *antea*, p. 212.　　　　[2] See *antea*, p. 212.　　　　[3] *Postea*, p. 231.

[4] See RUMOHR, *u.s.*, ii., p. 166. Benci di Cione is recorded in a Sienese document
of about 1356, where he gives an opinion as to the works of the new Duomo.
MILANESI, *Doc. dell' Art. Sen.* i., pp. 249–51. He was also extensively employed as
a sculptor at the Palazzo del Podestà of Florence, with Neri Fioravanti, Maso
Leonis, Lippo Cursi, Niccola Martelli, Rustico Cennis, Antonio Johannis, Paolo
Maj. Johannis (1345). See LUIGI PASSERINI's lecture on the *Pretorio of Florence*
(8vo, Florence, 1858), p. 21.

[5] *Vide* GAYE, *Carteggio, u.s.*, i., p. 526–8.

[6] See PASSERINI, *u.s.*

CHAPTER XIV

FRANCESCO TRAINI. NICCOLA TOMMASI

A GENEALOGY of the family of Cione, constructed by Del Migliore,[1] a Florentine antiquary, would lead us to conclude that Mariotto di Nardo was of kindred with Orcagna and the Pisan family of the Traini; and this conclusion might appear to acquire confirmation from the statement made by Vasari that Francesco Traini, an able painter of Pisa, was educated in art by Andrea Orcagna.[2] It is now pretty certain that Mariotto is not the son of Nardo di Cione;[3] and records enable us to disprove completely the statement of Vasari by showing that as early as 1322 Francesco Traini was in practice as a painter at Pisa.[4] At a period of history so remote as the beginning of the fourteenth century it is very difficult to trace the progress of a first-rate painter, whilst the fortunes of a second-rate artist become exceedingly obscure. Two altarpieces and a few dates are all that have been preserved to illustrate the life of Traini. The dates are derived from an old power of attorney drawn at Pisa, on the 3rd of September, 1322 (Pisan reckoning), which Francesco *olim* Traini, a painter and Pisan citizen, signed as a witness, and a

[1] MS. Del Migliore, *postea.* Mariotto di Nardo was registered in the guild of Florentine painters in 1408 (GUALANDI, *u.s.*, vi., p. 186). BONAINI, *u.s., Mem. Ined.*, note 5 to pp. 6 and 7, quotes the notes of Del Migliore; yet records speak of Francesco not as of the Traini but as the son of Traino.

[2] See VASARI, ed. Sansoni, i., p. 610.

* [3] Mariotto was the son of Nardo di Cione, but not of Orcagna's brother Nardo di Cione. No authenticated work by him remains. Information in regard to his career is to be found in Sansoni's edition of Vasari, i., pp. 610, 611.

* [4] The legend that Traini was a pupil of Orcagna dies hard. It is to be found in most recent accounts of the Pisan artist. Traini was a follower of Simons Martini. Artistically he was a child of Siena.

record but a few months older, dated November 3rd, repeats the
same names and qualifications.[1] Nineteen years after the first
records a document of equal importance presents Traini to us as
a party to a contract for furnishing the banner of the Brother-
hood of the Laudi in the cathedral of Pisa.[2] It is not improbable
that previous to this date Traini completed a picture representing
St. Thomas Aquinas, which is now in the church of St. Catherine
of Pisa, whilst the companion piece of St. Dominic Enthroned
in the Pisa Museum was finished later.

The St. Thomas, originally a gable altarpiece, was subsequently
enlarged to a rectangle, in which the Dominican is represented,
inspired by the Saviour, Evangelists, and Greek philosophers,
and triumphant over heretics.[3]

The whole composition is characterised by tender serenity and beati-
tude. It is like an enlarged miniature in which we see the saint
enthroned in a halo of rays with a book in his hand. High up in the
picture Christ in a mandorla sends down from his mouth to St.
Thomas's head a stream of rays of light. Thomas receives rays likewise
from frescoes and St. Paul above, and Aristotle and Plato beneath him.
On the ground at his feet is the prostrate Averrhoes. At the sides are
the symbols of the Evangelists, and lower down there are figures of
saints, amongst which one appears to have been renewed in order to
represent Urban VI. The figures are all drawn with a careful hair
outline, within which the forms are actually studied. Length and
slenderness of shape is characteristic. Softness rather than power, a
certain sharpness of features, small hands with taper fingers, reveal in
the artist a study of the Sienese rather than of the Florentine manner.
Nor is this impression weakened by the draperies which, whilst they
develop the parts they cover, are carried out with patient accuracy by
the gay harmonies of the vestments, or by the absence of well-defined
masses of light and shade. Here, indeed, is a marked defect of Traini.
His picture is flat and unrelieved, and in this he holds less to the

[1] This power and the later record, which are too long to quote, are in a book of
copies belonging to the Pisan family of Cicci, called *Origine e descendenza dell'*
antichissima famiglia di Ciccio, etc., put together on the occasion of a litigation,
and commended to us by Professor Fontana of Pisa.

[2] CIAMPI, *u.s.*, p. 117, quotes the record in question in which Francesco del q.
Traini contracts to paint (1341) the banner of the Brotherhood of the Laudi.

[3] The foreground figure, changed to represent Urban VI., bears a scroll inscribed
URBANUS SEX PISANŪ, a modern addition.

Florentine style of Andrea Orcagna than to the yielding one of the
Sienese school. Yet at the same time Traini is not deficient in the
art of distribution. His space is fairly laid out and well arranged.

No signature, no date authenticate this altarpiece, but **Vasari**
praises it highly, and finds a charm in its "capricious" arrange-
ment.[1] Nor does he fail to notice the second production of Traini,
which he describes as having been executed for a gentleman of
the Corsica family, whose remains repose in a vault of the chapel
of St. Dominic in St. Catherine of Pisa. At the base of the
sidewings we read an inscription which confirms that the picture
was painted in the days of John Cocus, one of the superintendents
of the church of Santa Maria of Pisa by Francesco Traini, for the
repose of the soul of Albizzo delle Statere.[2]

Giovanni Coco was a lawyer who filled the office of "Elder" at
Pisa five times at least, and whose will, dated 1346, is still pre-
served.[3] Albizzo delle Statere was one of those wary diplomatists
whom Pisa so frequently found herself obliged to employ at the
time when she was threatened alike by the hostility of the
Florentines and of Castruccio of Lucca. His will, dated the
25th of January, 1336, betrays a close intimacy with the ablest
Dominicans of his time, and one clause of it relates to the
erection of an altar in St. Catherine of Pisa, for which a picture
was commissioned of Traini.[4] Original records discovered and
printed by Signor Bonaini refer to this altarpiece, which, it seems,
was partly finished in April, 1345, and completed in the January
following.[5]

The central panel (in the Academy of Pisa) is exclusively devoted
to the standing figure of St. Dominic grasping the book and the lily.
The founder of the inquisition is grave in expression, with a face and
features of a certain softness, and fine regular outlines. The draperies
sweep broadly and gracefully round the form, which may be classed

[1] VASARI, ed. Sansoni, i., pp. 611, 612.

[2] HOC OPUS FACTUM FUIT TEMPORE DOMINI JOHANNIS COCI OPERARII OPERE
MAJORIS ECCLESIE SANCTE MARIE PRO COMUNI PISANO, PRO ANIMA DOMINI ALBISI
DE STATERIIS DE PE . . . SUPRADICTE, FRANCISCUS TRAINI PIN.

[3] BONAINI, u.s., p. 10.

[4] Ibid., u.s., pp. 11, 12, and 109.

* See also Archivio Storico dell' Arte, anno vii., fasc. i., Il Trionfo della Morte.

[5] For the sum of 110 livres. BONAINI, u.s., pp. 123, 124.

without hesitation amongst the fine ones of the fourteenth century. In the pinnacle is the figure of the Redeemer in the act of benediction, with a round-shaped head, broad across the cheekbone, supported on a long neck, and enwreathed with hair in waving locks. The smiling type, though noble and dignified, is less Giottesque than old Christian; and Traini, in this respect, is more of kindred to Sienese than the Florentines. The side panels of the altarpiece, now in the Seminario of Pisa, each divided into four, and having double pinnacles in which are the prophets Daniel, Isaiah, Jeremiah, and Ezekiel, are filled with scenes from the legend of St. Dominic, whose birth forms the subject of the first compartment. Giovanna Aza lies on a couch, attended by two females. On the bed a lapdog with a lighted taper symbolises the mission of the newborn babe, whose tiny frame, already dignified with a halo, is in the hands of the nurses on the foreground. One of them supports him in the basin, whilst a second has the clothes ready for him in her hand. In the next scene St. Dominic supports with both hands the falling edifice of the church, whilst to the left Innocent III. in pontificals sleeps, with his head on his hand, and two attendants repose drowsily on the step of the bed. Next St. Paul and St. Peter, at the gate of the Lateran, give to the kneeling St. Dominic the staff and the gospel; and in the fourth episode the saint, amidst a concourse of people, burns the books of heretic teachers, whilst the gospel hangs harmless in the fire. In the next series of four the death and resurrection of Napoleon, nephew of Cardinal Fossanuova, are depicted. The relatives and friends of the youth are grouped round his body, which lies stretched on the ground. At his head a female stooping, wailing, and tearing her cheeks, whilst the rest are more or less affected, and some children peep forward more in curiosity than grief. To the right the youth revives at the prayer of St. Dominic, and is restored to the cardinal, his uncle. This double composition, full of lively action and expression, is essentially Sienese in the character of the faces, in the movement and shape of the slender figures. The next scene is a reminiscence of the life of St. Dominic, who, during his stay at Toulouse, "quel nido d'albigesi," saved from drowning a boatload of pilgrims, too pious to travel by land in the country of heretics. The saint hurried with two of his brethren to the water side, and, extending his arms towards them, spiritually attracted them to his side and to the safety of land. In the pilgrims we remark that Traini successfully imitates the appearance of persons emerging with clammy hair from the water. At the same time terror in various degrees is depicted in the faces. We next notice St. Dominic extended horizontally in the fore-

ground of the picture. On his body rest two ladders, which are supported above by the Saviour and the Virgin, and two angels ascending carry between them the soul of the saint in the form of an infant to heaven. This is the dream of Guala, Prior of Brescia, a prosaic subject rendered with much simplicity by Traini. The last scene is that of St. Dominic's burial in a church, with a concourse of prelates and clergy in prayer around him.

The whole of the altarpiece, including the prophets in the pinnacles of the sides, is of the same character as that of St. Thomas Aquinas. Francesco Traini's style is, to sum up, a mixture of the Florentine and Sienese, the Sienese elements overshadowing the Florentine.[1]

Greatly to be regretted is the obscurity which surrounds the name of Niccola Tommasi, of whose painting in Sant' Antonio Abate at Naples some notes have been made in the life of Giotto. This painter is probably the same whom Sacchetti mentions in his account of the debate at San Miniato upon the question of artistic superiority in the middle of the fourteenth century. He is recorded in the list of the council of Santa Maria del Fiore, and was one of those who contributed to the design for the front of that church in 1366. He is thus proved to have been the contemporary of Andrea Orcagna.[2] More than this, he was, as has been stated, of the first batch of artists who formed the guild of painters in Florence. But, most interesting of all, his style has many of the qualities which distinguish that of Orcagna, as we know by his picture dated 1371 at Naples, to which reference has already been made. Originally a triptych, the altarpiece represents in its central part St. Anthony the abbot enthroned between saints. The style is essentially Florentine.[3] The head

* [1] Throughout these pictures, as in the St. Thomas Aquinas, Traini shows himself to be a faithful follower of Simone.

[2] See *antea* and CESARE GUASTI in *Arch. Stor.*, *Nuova Ser.*, tom. 17, pp. 138-41.

[3] Holding the gospel in his left hand, and with the right giving the blessing. A daïs above his head is supported by two angels, whilst at his feet two other celestial messengers play upon instruments, gold ground new, to the great detriment of the shape of the throne, the nimbus repainted with lake, the black cloak retouched, as well as part of outlines. In the right wing stand St. John the Evangelist and St. Louis, on the left St. Peter and St. Francis. The figures are about half life-size and in a very bad condition.

of the principal saint is fine, the form and character manly. He wears a long white beard and is well draped in flowing vestments. The head of St. John Evangelist, at the right side, recalls, like the rest, the manner of Orcagna. This work of Niccola Tommasi is indeed as nearly as possible akin to the San Giovanni Gualberto and St. Ambrose and other saints in the Medici chapel at Santa Croce in Florence.[1] It is pleasant to rescue an artist of such talent from the total obscurity in which he has remained.

Amongst the disciples of Orcagna, Bernardo Nello di Giovanni Falconi is noted by Vasari as one whose " numerous pictures were executed for the cathedral of Pisa."[2] None of these productions can now be traced; nor is the name of Nello connected with any fresco except one in the series of Job, in the Campo Santo. A single writer assigns to him the execution of the scene in which Job descends from the throne to humble himself before God;[3] but Morrona affirms that if Nello did anything at all to that fresco he only repaired some damage caused by rain.[4]

One picture, dated 1392, is said by Vasari to have illustrated Tommaso di Marco, another pupil of Orcagna;[5] but this work, originally at the side of the screen in Sant' Antonio of Pisa, has disappeared.

A faint shadow of the teaching of the son of Cione may be noticed in the feeble works of a painter of Pistoia called Giovanni di Bartolommeo Cristiani; but these may be dealt with summarily in a future notice of the artists of that city.

As regards Mariotto, long held to have been the son of Nardo Orcagna, none of the works mentioned by Vasari are preserved. What we know of him is that he was employed in Santa Reparata at Florence in 1396, 1398, and 1402. In 1398 he painted an altarpiece for the chapel of the Virgin in Santa Reparata, and in 1402

* [1] As we have already stated, the S. Giovanni Gualberto is now in the sacristy of S. Croce.

[2] VASARI, ed. Sansoni, i., p. 609.

[3] Totti. See MORRONA, ii., p. 205.

* Rosini stated that Nello di Vanni executed the last of the Job series. The authors have shown that this series was executed by Francesco da Volterra. See also SUPINO, *Il Campo Santo di Pisa*, Alinari, 1896, pp. 163, 164. Rosini's statement in regard to Bernardo is to be found in his *Storia della Pittura*, ii., pp. 7, 23, note 7.

[4] MORRONA, ii., p. 205.

[5] VASARI, ed. Sansoni, i., p. 609.

he made a design for one of the glass windows of the same edifice.[1]
Mariotto is only on the roll of Florentine painters in 1408. His
name may be found inscribed on a portion of the draperies of a
St. Catherine, part of a glass window in the choir of San Domenico
of Perugia, executed in 1411 by Fra Bartolommeo di Pietro, a
Dominican. The probabilities are that Bartolommeo worked from
one of Mariotto's cartoons. Other notices show that Mariotto
died in 1424.[2]

[1] SEMPER in ZAHN'S *Jahrbücher*, iii., p. 67.
[2] VASARI, ed. Sansoni, i., pp. 610, 611 ; and GUALANDI, *Memorie, u s.*, vi.,
p. 186.

CHAPTER XV

AGNOLO GADDI, CENNINI, AND OTHERS

TADDEO GADDI, on his death-bed, bequeathed his practice
to his two sons, who were left in partnership with some of
the master's older disciples, in the hope that Agnolo, especially,
might acquire excellence as a painter.[1] We know from Cennino
Cennini that Agnolo was first taught by his father.[2] Vasari
attributes to both artists the adornment of Tuscan churches;
but he devotes a chapter almost exclusively to Agnolo, whom he
looks upon as the elder of the pair; and he only mentions
Giovanni with an expression of regret that he should have given
so much promise yet have perished so early.[3]

Time, which spared many important works of Agnolo, swept
away all that Giovanni produced, which is the more disappointing
because Vasari's biographical account of this Gaddi is untrue, and
Agnolo, instead of being the teacher, was the disciple of Giovanni.
The evidence of this fact which has recently been acquired
deserves particular attention, because it proves that whilst
Giottino and Andrea di Cione were the moving spirits of Italian
art in the fourteenth century, they were supported by men of
almost equal attainments in the persons of Giovanni Gaddi and
John the "Archpresbyter," a man of whom, unfortunately, we
know no pictures, but who clearly got his nickname at the same
time as the "Archangel" who was better known as Orcagna.
We saw that when the archpresbyter and Giottino, in partnership
with Giovanni Gaddi, worked for Urban V. in the Vatican in the
summer of 1369, they directed the labour of Giovanni da Milano

[1] VASARI, ed. Sansoni, i., p. 636.
[2] *Il libro dell' arte*, etc., ed. MILANESI (8vo, Firenze, 1559), p. 2.
[3] *Ibid.*, p. 643.

and other contemporary masters, but each of them also com-
manded the service of one disciple, and Giovanni's subordinate
was his own brother Agnolo.[1] We know too little of the lives
of Taddeo Gaddi and his children to be able to say when
Giovanni and Agnolo were born. Vasari merely says that the
first died early, and the second at the age of sixty-three.[2] If
Agnolo was born in 1333, as our knowledge of the date of his
death enables us to assume, he would have been considerably past
thirty when he lost his father in 1366. But this can hardly be
reconciled with what we learn of Agnolo's dependence on his elder
brother and his professional status at Rome.

It is evident that he can have had no share in any direct
commissions for frescoes until his return to Florence at the close
of 1369, though he may then have painted, as history confirms,
at Santa Maria Maggiore, Santa Maria del Carmine, and Santa
Maria fra Fossi. Vasari considers the Resurrection of Lazarus
in Santa Maria fra Fossi as the earliest of Agnolo's creations,
remarkable for unusual examples of realism, such as the repre-
sentation of the dead man's face with the livid marks of disease
on it, linen stained by the corruption of death, and spectators
holding their noses to exclude foulnesses of smell. But realism
had all sorts of turns in Agnolo, who showed this versatility at
the Carmine, where he represented the Virgin Mary in her
dwelling attended by young girls in different costumes and busy
at various occupations, such as spinning, sewing, winding, and
weaving.[3] We can only suppose that he did all this and more
immediately on entering upon an independent practice. The
pictures which might reveal their age by those signs which
often enable us to distinguish the earlier from the later works of
the same artist, are no longer in existence, and this, unfortunately,
is equally true of Santa Maria Maggiore as it is of the Fossi and
Carmine.[4] But Agnolo also covered the Bardi chapel at Santa

[1] See *antea*, the note to pp. 187, 188.

* [2] Agnolo died in 1396. See Arch. di Stato, Firenze, *Registri de' Morti tenuti
dagli Ufficiali della Grascia*, 1396, *die xvi. mensis ottobr. Angelus Tadey taddi*
(Gaddi) *pictor de populo in Sancti Petri magioris* (sic) *Quarterio Santi Johannis,
seppultus in ecclesia Sante Crucis, Retulit Dopninus Fortiori becchamortus: banditus
fuit.* [3] VASARI, ed. Sansoni, i., pp. 636, 637.

[4] VASARI (i., pp. 636, 637) says that Agnolo painted a choir of angels dancing round
the throne of the Virgin, who receives the crown from Christ; and the picture was

Croce with frescoes representing the story of St. Louis, and painted single episodes in San Romeo and Orsanmichele, and these too have perished.[1] The extent of the practice which these facts reveal might prompt us to disbelieve what Vasari tells of Agnolo's employment as an architect in restoring the building and mosaics of the baptistery of Florence, the battlements of the palace of the Podestà, and the walls of San Romolo. But the dates of these restorations are known; and this knowledge enables us to curtail the list of Agnolo's operations which would otherwise be too large, and perhaps convey the impression that he was a master before he was a full-grown man.[2]

There is no reason to doubt that between 1370 and 1380 Agnolo established his reputation at Florence on such good foundations that his claim to public employment was everywhere acknowledged. Orcagna had just died. He had filled the highest place in the esteem of his countrymen—prized alike for his skill as a painter, an architect, and a sculptor; he had done master work in all the sister arts. No one now seemed able to wear his mantle, and first-rate men were wanting in every branch because of the great activity with which building, shaping, decorating, carving, and painting were carried on. The Loggia de' Lanzi and the cathedral were in progress, requiring skilled work from every sort of artistic craftsmen. Strangely enough, the sculptors of the time were not their own designers.[3] Just as Giotto furnished

in the high altar of Santa Maria Maggiore, for which it had been ordered in 1348, by Barone Cappelli. It has been found that Barone died in 1348; he could hardly have ordered a picture from Agnolo, who was a boy at the time. But his son, according to RICHA (*Chiese*, iii., p. 281), erected a monument to his memory in the church after his death, and he possibly gave Agnolo a commission.

[1] VASARI, ed. Sansoni, i., pp. 636, 637.

[2] At the baptistery the repairs were done in 1346; San Romolo was rebuilt between 1349–56; the palace of the Podestà was restored in 1340. All the dates exclude Agnolo. See VASARI, ed. Sansoni, notes on pp. 639, 640, 641, and GAYE'S *Carteggio*, i., pp. 499–502, 508; also VASARI, ed. Sansoni, i., p. 639, and BALDINUCCI, iv., p. 343.

* [3] There are reasons for believing that the works in sculpture designed by painters are much fewer than Vasari would lead us to believe. Third-rate sculptors like Piero di Giovanni may have been content merely to execute the designs of painters; but it is scarcely likely that Andrea Pisano, the most distinguished sculptor of his day, whose pre-eminence had been recognised by his contemporaries, would consent to allow his genius to be trammelled in this way.

Andrea Pisano with drawings for the reliefs of the Florentine campanile or the bronzes of the baptistery gate, so now Agnolo Gaddi, Spinello Aretino, and even Lorenzo de' Bicci, were selected to make the designs upon which the virtues of the Loggia de' Lanzi or the apostles of the front of the Florentine cathedral were carved out of marble by Jacopo di Piero and Piero di Giovanni; and when the sculptors had done their work, Agnolo, Spinello, and Bicci stepped in again and coloured the marbles which had been cut and polished from the models they had presented.

Nothing tells of Agnolo Gaddi's relation to the artistic work of his time more completely than the short entries of the accounts of the superintendents of the Loggia de' Lanzi and the cathedral of Santa Reparata :—

"1382. January 1st. Agnolo receives payment for a drawing at the Loggia.

"1383. Payment for designs of figures.

"1384. August 12th. Payment for a drawing. These are probably the drawings on which the reliefs of Faith and Hope were carved between 1383 and 1384 by Jacopo di Piero.

"1386. January. Agnolo designs figures of Prudence and Charity, which were executed in marble by Piero di Giovanni and coloured by Lorenzo di Bicci between 1388 and 1391.

"1387. September 5th. Agnolo, employed with Spinello and Lorenzo di Bicci to make designs for Santa Reparata, furnishes a drawing of an apostle to be executed by Piero di Giovanni.

"1390. March 23rd. He paints and illuminates the marble statues finished for the portal of Santa Reparata by Piero di Giovanni, representing John the Baptist and John the Evangelist."[1]

Very shortly after this form of Agnolo's practice began Cennino Cennini became his apprentice, and, as he tells us himself, remained twelve years in the workroom learning the secrets of the profession, which were subsequently consigned to his treatise on painting.[2]

[1] These records, in full, have been published in Dr. HANS SEMPER's *Vorläufer Donatello's*, in ZAHN's *Jahrbücher für Kunstwissenschaft* (Leipzig, 1870), iii., pp. 36, 43–8, 51, 66.

[2] CENNINO CENNINI, *Trattato* (ed. of 1859, 8vo, Firenze), p. 2.

In 1387 Agnolo, who probably had long been a member of the corporation of surgeon apothecaries, was admitted to the Guild of St. Luke at Florence.[1] Later on his practice extended to Prato, or rather Prato came to be one of the places in the vicinity of Florence in which he had most clients. There, in 1390, he painted frescoes for Francesco di Marco Datini, who employed him in company with Niccolò Gerini and Bartolommeo of Florence, a fact revealed in the correspondence of Gerini, who wrote to Datini in January and February, 1391 (Pisan style),[2] to press for payment.[3] In August, 1392, Gerini again writes to Datini to say that Agnolo Gaddi would be ready to come at a moment's notice to Prato to value his work.[4]

In 1393 we find Agnolo residing at Prato and receiving articles of household furniture from Datini, from which we may infer that the Florentine artist had come over to design and execute the frescoes of the Chapel of the Sacred Girdle, which are still shown in the Pieve of Prato, respecting which records of expenditure in 1394 are still preserved, and of which history tells that they were first exhibited in 1395.[5] It is here that we tread upon firm historical ground in respect of Agnolo's practice, for here we actually find his frescoes in existence.

There was a legend at Prato, which was traceable out of the gloom of the eleventh century, that the girdle of the Virgin Mary, which had been given to St. Thomas, was bequeathed by the apostle to one of the earliest ministers of the Christian religion in the Holy Land, in whose family it remained till 1096, when Michele de' Dagomari, of Prato, became possessed of it by his marriage in Palestine. On his return to Italy Dagomari was accompanied by his wife, and the chest containing the girdle lay on the deck of the ship, which, so protected, made a prosperous passage to Italy. Dagomari landed with his treasure at Prato, then, it would seem, a port, and carried the relic to his house, where it was his custom to sleep on the lid of the chest which contained the girdle. The sacred character of this treasure

[1] GUALANDI, Mem., u.s., vi., p. 176.
* [2] That is 1392 in the ordinary style.
[3] GUASTI (R.), La Cappella de' Migliorati in Prato (8vo, Prato, 1871), p. 7.
[4] Ibid. [5] Ibid.

was repeatedly affirmed by a miracle. Dagomari, who always
went to sleep on the chest, constantly found himself on the floor
in the morning. On his death-bed he gave the girdle to the
church, and it was taken in a solemn procession to the Pieve.

The legend of the girdle having thus become part of the history
of Prato, a chapel was built for its custody, and this was the build-
ing which Agnolo Gaddi painted in 1394.[1]

The frescoes fill the spaces at both ends of a long central aisle, the
central ceilings of two transepts, and the vault of the arch leading into
the building. This arch, opening at one end of the aisle, is surmounted
internally by a fresco which represents the expulsion of Joachim from
the temple. The ends of the transepts, to the spectator's left as he
enters, are divided into three courses, each of which contains an episode
of the Virgin's life. In the two lunettes, the Meeting of Joachim and
Anna and the Birth of Mary; in the next course, the Presentation in
the Temple and the Marriage of Joseph and Mary; in the lowest
course, the Annunciation and the Nativity. The end of the aisle
opposite the entrance is decorated, in the lunette, with the Coronation
of the Virgin, and below, in a double course, with the Death of Mary,
her Ascension, and the Gift of her Girdle to St. Thomas. The subjects
derived from the legend of the girdle are painted in one of the
transepts to the right of the principal entrance. In the lunette
St. Thomas delivers the girdle to one of his disciples in one division
of the space, whilst in the other the marriage of Michele dei Dagomari
and the transfer to him of the girdle are depicted. In the next course
Dagomari sails in a ship towards the Italian shore, lands with his
treasure at Prato, and having gone to sleep on the lid of the chest,
he is transferred to the floor by two angels. In the lowest course the
death of Michele and the procession of the relic are represented. In
the last remaining lunette Agnolo represented the Saviour in the act of
benediction; in the vault of the entrance, the twelve apostles in
medallions; in the triangular section of the ceiling of the first transept,
the four doctors of the Church; and in that of the second transept, the
four Evangelists.

It is perhaps unfortunate that our knowledge of Agnolo's style
should be based on one of the latest of his monumental paintings;

[1] See the records of the payments for the frescoes from the Archivi dell' Opera
del Sacro Cingolo in GUASTI (R.), u.s., p. 6.

but he seems to have been pretty equal in all the specimens
of his manner that remain to us ; and although we perceive even
at Prato that he is sometimes hasty, we cannot but admit his
strength and skill within certain lines, and throughout we shall
concede to him good judgment and pictorial tact.

In the Expulsion of Joachim, which is cleverly divided into
three episodes, the rules of composition are applied, according
to the lessons of Giotto, with a true balance of parts not always
realised even by Taddeo Gaddi. Life and nature are conveyed
in the lively movements of figures draped with appropriate
breadth.

In other scenes the simplicity of Giotto's means, his lucid
display of motive, his sobriety, are to be discerned. There is no
occasional confusion as in Taddeo, no excess of realism as in
Giovanni da Milano, none of the naturalism which Vasari's
narrative would lead us to expect.

In the Meeting of Joachim and Anna the pair fall prettily into each
other's arms, whilst in the distance Anna receives the visit of the angel.

The Birth of the Virgin is made unusually pleasing by the affectionate
play of the nurse with the new-born child. Only the background and
the nurse are injured.

There is much vivacity in the figures of the Presentation, where the
Virgin turns her face towards her mother as she ascends the slope of
the temple, and Anna holds out her hand to her daughter, Joachim
meanwhile standing by near two kneeling women, and musicians
playing and singing in the church porch. But here, too, the dresses,
particularly the green one of the Virgin and that of the attendant to
the left of the high priest, are repainted, which, together with the
retouching of the distance, throws the picture out of focus.

The Marriage of the Virgin is cleverly arranged to show the opening
of the church, under which the priest is standing on the right side of
the picture. He appears in the porch before which the pair are united,
and the bride and bridegroom are attended by appropriate groups of
friends and a procession of women, closed by a couple of trumpeters.
There are spectators, too, under the porch and in the distant houses,
and the flowering branch is carried by one of the suitors, whilst two
others break the barren ones. But here, too, there is much repainting
in the blue dress of the priest, the green and yellow of vestments
generally, and parts of the houses and sky.

The Annunciation is but a variety of a very old theme. The Virgin, in a seat, has dropped the book in which she was reading, at the approach of the angel, who bends reverently before her carrying the lily. The Eternal looks down from a glory of angels, and a ray comes to Mary with the dove. There is dignity and tenderness in the conception of this fresco, on which, however, a shadow rests in the shape of repainted distance and dresses.

The Nativity is formal and somewhat poor in its bareness. The Virgin sits, with the Child on her knee, in the middle of the hut between two angels; Joseph, pensive, is on his saddle to the left; near him, a shepherd bending as he enters with a lamb; another shepherd in a kneeling posture to the right; angels fly about and above the penthouse in which the ass and the ox are sheltered; in the distance the shepherds receive the message from heaven. But the bad impression made by this picture is doubtless due, in a great measure, to new tinting of dresses and gilding or repainting of halos and ornament.

Time and restorers have totally altered the character of the incidents depicted on the wall at the bottom of the central aisle. The Death and Ascension of the Virgin, the Gift of the Girdle, and the Coronation are almost all new. Extensively damaged likewise are the lunette frescoes illustrating the legend of Michele de' Dagomari, yet in their present state they still have some charm of nature and spontaneity in the action and expression of the figures.

There is much force in the movement of St. Thomas delivering the girdle, and good arrangement distinguishes the composition of the wedding. The landing at Prato is prettily conceived, and a most successful episode is that of the angels taking Dagomari, asleep, from the chest. But one of the best pictures is that of Dagomari giving the girdle, in a casket, to the prior of Prato, who has it taken in procession to the church. Agnolo applies the Giottesque maxims of composition in their finest form in the arrangement of the subject.

The type of the Saviour in Benediction in the lunette hard by is the favourite one adopted by Agnolo's contemporary, Spinello Aretino, a notable artist in a secondary line of Giottesques who succeeded in preserving the letter of the great master's maxims without regard for the progress of the time or the rise of a new school.

The other frescoes display some progress in boldness and
freedom of drawing, coupled with more dignity, nature, and
individuality in the figures than are to be found in the majority
of Taddeo Gaddi's works. Immoderate slenderness is avoided;
grace is carefully studied. We do not meet with habitual neglect
of detail in the drawing of parts; but there is a Giottesque
indifference to correctness in certain points, such as the parallelism
of eyelids and lips, the droop in the corners of mouths, the line
furrow in flesh. There is some coarseness, too, in the shape of
finger-joints and fingers. Where colour is not clouded by re-
painting the tones are bright, transparent, and light in scale, and
the effect of this quality is enhanced by a judicious contrast
of light and shade. On the whole, however, Agnolo Gaddi must
be allowed to rank as a painter below Orcagna, who shows more
unity of power and more depth of intellect than any of his
contemporaries.

Agnolo Gaddi has left traces of considerable labours at Prato.[1]
In the Via dei Tintori, a tabernacle with shutters, in which the
Virgin is depicted amongst saints, presents all the character of
his style. In his manner, too, is a Virgin erect, with the infant
Saviour between saints and angels,[2] in a tabernacle at the corner
of the Strada al Ceppo and Via della Pilotta. Similar tabernacles,
much damaged by time, are to be seen in the neighbourhood.
At Figline, three miles from the town, is one attached to a house,
belonging to the Pini family, where the hand of Agnolo may be
traced with certainty in a Conception between saints,[3] a Christ in
the act of benediction, and an Annunciation. The fresco of the
Conception,[4] though much damaged by exposure, has not been
retouched, and affords a favourable example of Agnolo's talent in
producing clear and bright transparent colour. The type of the

[1] Vasari says "he left works enough in churches of that land" (ed. Sansoni, i.,
p. 640).

[2] The Magdalen and another saint, with four angels above.

[3] Right and left in niches, St. John the Baptist, St. Stephen, and St. Anthony
the Abbot, partly obliterated.

* [4] The subject and arrangement of the figures may be found in a Conception
under the name of Masaccio, at the Academy of Fine Arts at Florence. It is in the
Sala Prima del Botticelli, No. 70. The picture was formerly in S. Ambrogio. It is
an early work of the master.

Virgin is peculiarly graceful, that of the angel full of softness. The heads of the saints at the sides of the tabernacle are powerfully delineated, and the style generally indicates a contact with Spinello of Arezzo.

We saw that Agnolo Gaddi and Spinello Aretino were often employed at the same duties. It is not to be supposed that they were strangers to each other. When Agnolo returned to Florence, where we have records of his presence from August, 1394, till his death, he no doubt had occasion to renew the relations which might have been broken off during his absence at Prato.[1] But the light duty of making designs for the sculptors of the Florentine cathedral was nothing to those which Agnolo now assumed.

In the choir of Santa Croce at Florence, at the request of Jacopo degli Alberti,[2] he painted in eight frescoes the well-known legend of the cross, from the moment when the archangel Michael presents to Seth a branch of the tree of knowledge to that in which the Emperor Heraclius enters Jerusalem.

In the first compartment to the right of the entrance the archangel presents to Seth a branch of the tree of knowledge;[3] whilst on the foreground Adam lies dead, and Seth, in the presence of his relatives, plants the branch upon the tomb. Next appears the Queen of Sheba kneeling with her suite by the pool, at the opposite side of which carpenters are at work, striving to fashion the wood of the tree. Further on the wood is sunk in the pool by order of Solomon. In the fourth compartment the Empress Helen kneels with two dames behind her in the midst of her guard, whilst the cross is taken up by three persons, and a sick youth rises in bed healed by its virtue. On the right, again, the cross is erected by a number of men before the Empress. On the left side of the choir the subject is continued, the angel appearing to Heraclius being represented in the third fresco. In the fourth the decapitation of Chosroes is depicted; and Heraclius enters Jerusalem carrying the cross on his shoulders.

In the right-hand corner of this fresco, near a gate, says Vasari, is a portrait of Agnolo Gaddi painted by himself, in a red hood, and with a small pointed beard, according to the fashion of the time.[4] This figure

[1] See records of Agnolo's employment at his old work of designing for Santa Reparata in SEMPER, *Jahrbücher, u.s.*, iii., 66.

[2] VASARI, ed. Sansoni, i., p. 637, and RICHA, *Chiese*, i., p. 295.

[3] The angel is newly repainted. [4] VASARI, *ed. cit.*, i., p. 646.

still exists, and may be seen near the Emperor Heraclius in the place
mentioned by Vasari. Though a little younger than the likeness given
by the Aretine in his lives, the features are the same in both, and the
appearance of Agnolo is that of a man of fifty or fifty-five. Between
the windows of the choir are figures of saints, and above them angels
and ornaments. In the painted frames of the frescoes are lozenges
containing saints. In six triangular compartments of the ceiling are
St. Francis, erect in an almond-shaped glory, St. John the Baptist erect,
with the cross in his left hand, and giving a blessing, and the four
Evangelists likewise erect with their symbols, all on a ground of blue
studded with stars. On the surface of the pilasters supporting the arch
of the choir there are figures of saints and prophets, some of them but
very recently cleared of superposed whitewash, and in poor condition
on that account.

The impression made by these decorative paintings is imposing.
Something still remains of a gay and lively colour. The composi-
tions are often overcrowded, but many figures, especially those in
the ceiling, are remarkable for grandeur, and beauty of character
and features. The draperies have a marked breadth of fold.
Agnolo shows that he was a perfect decorator, that he knew the
value of distance and of scales of harmony for the production of
effect. Breadth and certainty of hand reveal the experienced
artist. But, in the words of Vasari, " the work is that of a prac-
tised hand, but poor designer." The drawing is bad; and in these
frescoes Agnolo brings out into broad light defects which are not
seriously noticeable in those of Prato. Still less than those of
Prato will the frescoes of the Alberti chapel bear close inspection.
But, on the other hand, colour will charm by its brilliancy, and
varied costumes give interest to the figures. Neither better nor
worse than these frescoes is the Virgin and Child between St.
Augustine and St. Peter, in a lunette inside the door leading from
the church to the convent of San Spirito at Florence. Of equal
value is the altarpiece of the church of San Pancrazio, now in the
Academy of Arts at Florence,[1] in which Agnolo represents the
Virgin and Child in a glory of graceful angels, between saints of

* [1] Sale dei Maestri Toscani, Sala Prima, No, 127. The missing panel of the
Sposalizio passed into the hands of a dealer in 1813.

broad, square build.[1] The Virgin, though vulgar in face, is graceful in action. Above these figures are fourteen half saints in niches, and below, seven scenes from the life of the Madonna, or rather six, for that which occupied the space beneath the figure of the Baptist is gone. These compositions begin with the Expulsion of Joachim from the Temple, and, being small, display, as Vasari truly remarks, better qualities than usual.[2] They are bold and tastefully arranged miniatures, of soft, clear colour.[3] A Virgin and Child between saints in the Chiostro Verde of Santa Maria Novella is much in the character of that which of old hung in San Pancrazio, but less interesting, because the surface has been flayed, and the flesh tints are reduced to the primitive preparation. In the Cappella Castellani at Santa Croce a double ceiling, decorated with the four Evangelists and four doctors of the church, displays much the style of Agnolo as it may be found in the frescoes of the choir of the same church. But of this more shall be said presently, when treating of the painter Starnina. The fifteenth chapel of the church of San Spirito contains an altarpiece of four figures in the same style, and a similar one with the Virgin and Child assigned to Giotto is in the gallery of Berlin.[4] By Agnolo, also, are a Virgin and Child, with saints, in the gallery of Prato,[5] and a couple of saints with incidents from their legend, as predellas, once in the Metzger collection at Florence. Inferior to Agnolo's works in execution, but displaying evident efforts at imitation of his style, is a Coronation of the Virgin, assigned to Ugolino of Siena, formerly in Santa Maria Novella, now in the Academy of Arts at Florence.[6] One hardly understands how Vasari could attribute to the patriarch of Sienese painters a picture so evidently by an imitator of Agnolo Gaddi.

[1] The Evangelist, whose mantle has lost its colour, SS. Nereo, Pancrazio, and John the Baptist, whose red mantle is also obliterated, Archilleo and Reparata. Both the St. Johns are turned towards the Virgin, and the Baptist has the character and draperies of that by Agnolo in the ceiling of the Alberti chapel. S. Reparata in a diadem holds a banner. [2] VASARI, ed. Sansoni, i., p. 639.

[3] The tones seem to have assumed this rosy hue since the disappearance of colouring glazes.

* [4] No. 1040. This picture is now given to Agnolo in the official catalogue.

[5] The saints are SS. Francis, Bartholomew, Catherine of Alexandria, and the Evangelist. * [6] Sale del Beato Angelico, Sala II., No. 274.

About 1390 the superintendents of the cathedral of Florence
were called upon to sanction the erection of a monument to Piero
Farnese, a captain to whom the Florentines were grateful for
services done at Pisa.[1] Before they had given effect to this
resolution a similiar sanction was required by the governors
of the city for the erection of a monument to the English
condottiere, John Hawkwood.[2] On the 29th of November, 1395,
the *operai* of Santa Reparata met and resolved that the two
monuments should be erected as required, but that previous to
these being taken in hand and placed between the two portals of
the cathedral facing the Via de' Cassetai, the "sepultures" should
be designed by good men and exhibited in the church for the
judgment of the public. It is not unlikely that the exhibition
took place. The designs were entrusted by a resolution of the
2nd of December to Agnolo Gaddi and Giuliano d'Arrigo detto
Pesello. But the monuments were never carried out, for there is
no trace of that in honour of Farnese at the place mentioned,
and the monument to Hawkwood was only painted by Paolo
Uccello in 1436.[3]

One of the latest works upon which Agnolo Gaddi is known
to have been busy at Florence is an altarpiece commissioned in
1394 for the church of San Miniato al Monte. The records
which tell of payments in instalments for this picture in 1394
and 1395 also prove that Agnolo did not live to receive the full
price for it, which was paid to his then surviving brother, Zanobi
Gaddi, in 1396.[4] The subject of the picture is not mentioned in
the records, but we recognise the hand of Agnolo in a cusped
altarpiece in the tribune of San Miniato, where the patron saint
is represented in majesty and almost of life size in a central
panel, and eight small panels at the sides contain episodes from
his life.

Formerly in the possession of Dr. Garibaldi, at Genoa, were three
panels, in one of which the Virgin is depicted with the Child, and

[1] BALDINUCCI, *Opere*, v., p. 198. [2] In 1394 (GAYE, *Carteggio*, i., p. 536).

[3] See records in BALDINUCCI, *Opere*, v., p. 198 ; SEMPER, *Jahrbücher, u.s.*, iii.,
pp. 43, 66 ; and annot. to VASARI, ed. Sansoni, ii., p. 212.

[4] The records are in G. F. BERTI, *Cenni Storico-Critici di San Miniato* (8vo,
Florence, 1850), p. 155.

seated on a throne in front of a golden cloth carpet. At the Virgin's
feet are two angels a side kneeling, two with flowers, two playing
viol and cyther. Side panels, probably from the same altarpiece,
contain St. Catherine and St. John the Baptist with a cross,
and St. Helen and the Evangelist; and in rounds above, the
angel and Virgin Annunciate. All the figures are half life-size,
those of the side panels being on gold ground. At the base of
the central panel are remnants of an inscription with the date
of 1379. The style of these pieces is Giottesque, and they are
probably by Agnolo Gaddi.[1]

Agnolo was married, and his widow is known to have lived till
1404. He died at Florence on the 16th of October, 1396, and was
buried in Santa Croce.[2]

Fea, who described with more industry than critical acumen the
basilica of Assisi, pretends to have discovered in that edifice a
Crucifixion with the usual figures of Mary and the Evangelist, by
Giovanni Gaddi. Of all the frescoes or pictures of the sanctuary,
not one presents the character of the time or of the manner of
Agnolo Gaddi.[3] According to the same authority, the fresco of
the Massacre of the Innocents, in the south transept of the Lower
Church of Assisi, is by Giacomo Gaddi. We saw that this fresco,
assigned by Rumohr to Giovanni da Milano, and in these pages to
Giotto, could not possibly have been painted by any of the pupils
of Taddeo Gaddi.

In Venice, and in the states of the republic where Taddeo had
a branch of his mercantile house, and where, according to Vasari,
Agnolo spent some of his time, there are very few traces of their
art, and it would appear that they devoted themselves specially to
trade. The only painting in Venice which displays the style of
the Gaddi is a pediment now attached to an altarpiece by Antonio
and Giovanni da Murano, in the chapel of S. Terasio of San

[1] The inscription runs so: . . . NO DÑI. MCCCLXXVIIII. AVE MARIA GRATIA . . .

* This picture was at the shop of a Genoese dealer in September, 1902.
The three panels were united in one frame. The picture was in very good
condition.

[2] MILANESI (G. and C.), in their edition of Cennini's *Trattato della Pittura*, *u.s.*,
p. x.

[3] FEA, *Basilica d'Assisi*, in note to VASARI, ed. Sansoni, i., p. 643, n. 2.

Zaccaria, with a half figure of St. Stephen and three somewhat damaged scenes from his life at each side.[1]

Chief amongst Agnolo's pupils are Antonio of Ferrara and Cennino di Drea Cennini. The latter was born at Colle di Val d'Elsa, and is better known as the author of a treatise on painting than as a painter.[2]

The only fresco which Vasari could assign to him was one representing the Virgin and Saints, at one time in the portico of the hospital of San Giovanni Battista at Florence, an edifice erected after 1376 by Bonifazio Lupi, Marquis of Soragna, to whom Padua owed some of her monuments. It is said that this work of art, which was sawn away and transferred to another place in 1787, is identical with that which is now preserved on canvas in the hospital of Santa Maria Nuova at Florence. It is difficult to judge of a piece which has been reduced to a mere fragment representing the Virgin enthroned giving the breast to the infant Christ. A modern inscription containing the painter's name is not calculated to convince us of the genuineness of a fresco all but ruined by accident and repainting.[3]

That Bonifazio Lupi was a patron of Cennino seems likely from the fact that the painter spent the greater part of his life in Padua, where he married Donna Ricca della Ricca, born in the neighbouring village of Cittadella. There are records which prove the existence of Cennino and his wife in Padua in 1398, and his acquaintance with Francesco da Carrara, for whom he may have performed artistic labours. It is not improbable that he left Florence in 1396, after the death of Agnolo Gaddi, and remained in Lombardy till his death, his name being absent from the roll of Florentine painters. No pictorial creations of his are now known

[1] There is also a mosaic at S. Giovanni e Paolo at Venice, representing a doge and his wife attended by three patron saints ; the Virgin and Evangelist kneeling in front of the cross on which Christ is crucified. The style is very like that of Agnolo.

* [2] The best English edition of this book is Mrs. HERRINGHAM'S *The Book of the Art of Cennino Cennini* (London, G. Allen, 1899). Mrs. HERRINGHAM'S notes on "Mediæval Art Methods" are of great value. For the life and works o Cennino himself, students may consult UGO NOMI'S *Della vita e delle opere di Cennino Cennini* (Siena, 1892).

[3] On the base of the fragment we read : CENNINO DI DREA CENNINI DI COLLE DE VAL D'ELSA FECE A FRESCO.

in Padua; but if his style should be sought anywhere in that city, one might suggest the Salone as a place where Giottesque character is traceable.[1]

The only frescoes which might seem entitled to attention in connection with the author of the treatise on painting,[2] are a series representing scenes from the life of the Redeemer and the finding of the cross, in the Compagnia della Croce di Giorno at Volterra, a church contiguous to that of San Francesco, and built in 1315, as appears from an inscription on marble within it, by Mone Fidicigi for the repose of the soul of her brother Marcuccio. Amongst the subjects represented on the walls is the Massacre of the Innocents, beneath which an inscription may still be read to this effect, that the painting was ordered in the year 1410, of "Cienni di Francesco di Ser Cienni" of Florence, but that the four Evangelists were not his, having been executed by Jacopo da Firenze.[3]

The painter of these frescoes is a Florentine, whose manner is certainly derived from Agnolo Gaddi. The frescoes are like miniatures of those at Santa Croce. The same composition, features,

[1] See Gaetano and Carlo Milanesi's edition of CENNINI, *u.s.*, where two records of 1398 are given in full (Preface), and it is suggested that the treatise was written at Padua, not in the Stinche at Florence, inasmuch as the reference to the execution of one of the MS. of the *Trattato* in the Stinche is probably due to a copyist, and not to Cennino.

* [2] On a pilaster at the entrance to one of the chapels of S. Lucchese in Poggibonsi, a chapel decorated by Giovanni di Ser Segna in the latter half of the fourteenth century, is the following inscription in verse, already quoted in the chapter on Taddeo Gaddi :—

JAM CHRISTI PROLES MILLENUM DUXERAT ANNUM
HIC TERCENTENUM QUATER BIS CUM DECIES OCTO
DEMONIUSQUE CHIRON PHEBEOS LIQUERAT EQUOS
COLLENSIS PATRIA, CUMTU EXTREMUM DEDISTI
HUIC OPERI FINEM INCOLUMEM QUOD NUMINA SERVENT.

The inscription states that the frescoes were finished in the month of November, 1388, and seems to imply that the artist was from Colle. The frescoes on the face of the arch of the chapel are by a Giottesque painter, and may be by Cennino. It is believed that the frescoes formerly existing in this chapel were by Taddeo Gaddi. To Cennino Cennini, it is surmised, was entrusted the task of finishing the decoration of the chapel.

[3] NEL MCCCCX ALOGHERONO QUESTI DELLA COMPAGNIA TUTTE QUESTE STORIE A CIENNI DI FRANCESCO DI SER CIENNI DA FIRENZE, ECCIETO QUATRO EVANGELISTI; SONO DI JACOPO DA FIRENZA.

head-dresses, and costumes may be found repeated; but the
Volterran frescoes, though gay in colour and revealing a certain
force, are by an inferior hand, imitating the manner of the last of
the Gaddi, and they remind us of inferior work such as might
have been done by Neri di Bicci, or Parri Spinelli. As Cennino
Cennini, according to Vasari, was the son of Francesco, there is
present cause for rejecting the identity of the two artists. It may
be that Cenni di Francesco is the painter whose name appears in
the register of the Florentine guild of St. Luke, in 1415.[1] Be
the truth in this respect what it may, the Cenni of Volterra may
be traced in other Italian cities. In the ex-church of San Lorenzo
at San Gimignano,[2] a vault, now used as a cellar, contains vestiges
of paintings in the same style, and it is still possible to trace a
Last Judgment in which figures of the Redeemer, the Virgin, and
the apostles are visible. A Crucifixion in this manner with four
saints at the foot of the cross may be seen in the Oratorio di San
Lorenzo in the same city, and a Virgin and Child in the Pretorio,
falsely assigned to Lippo Memmi. The list may be further
swelled by a fresco of St. Francis with St. Clare, angels and alle-
gorical figures, in a niche within the first chapel to the right in
the church of the ex-convent of San Francesco at Castel Fioren-
tino.[3] All these pieces are evidently by the same author.

The gallery of the Uffizi recently acquired at the sale of the
Toscanelli collection a ~cture of the Virgin seated with the
infant Saviour in benediction on her knee, attended by St. John
and a female saint with a palm, on one side, and St. Peter with
the book and keys, and St. Margaret with a cross on the other.
This picture bears the name of Cenni d'Andrea, and the date of
1408. Whatever may be thought of the genuineness of the
inscription, the style is that of an imitator of the manner of
Lorenzo Monaco.[4]

The name of Cenni is suggested by a picture in the Academy of

[1] GUALANDI, *Mem.*, vi., p. 179.

[2] Now a private house, lately belonging to Signore Vittore Vecchi.

* [3] On the right of the door is a Trinity, a fine work which reveals the influence
of Orcagna.

* [4] Uffizi, No. 42. On the basement of the altarpiece are the words: A.D.
MCCCCVIII. and beneath the date: CENVS DE ANDAE CENNI ME PINXIT.

Arts at Florence bearing a mutilated date which points to the early part of the fifteenth century. The subject is the Coronation of the Virgin, with a large attendance of saints of both sexes. The figures are executed in the same manner as those in the oratory of the Croce di Giorno at Volterra, yet it may be that the Coronation instead of being by Cenni is by one of his contemporaries, an artist named Rosselli, of whom nothing was known hitherto except that he was companion to Bicci di Lorenzo in the painting of twelve apostles executed for the Florentine cathedral in 1433.[1]

The style of Rosselli may now be studied in a picture formerly in the Toscanelli collection, which bears his name and the date of 1439. It represents the same subject as the picture of the Academy of Arts above noted, viz. the Coronation of the Virgin, but without the attendance of saints. Behind the throne on which the Saviour and Mary are seated, two angels support a curtain; above, God the Father holds the cross on which the Redeemer is crucified; at the sides are two angels in prayer; on a pinnacle, the half length of a prophet. Rosselli's full name is ... us Rosselli Jacopo Franchi. His figures are slender and graceful, his drapery natural in fold, his colour a little gaudy. He seems to be a disciple of Agnolo Gaddi,[2] and is probably the painter of the Coronation of the Florentine Academy, and a Virgin and Child between St. Francis, the Baptist, the Magdalen, and St. Matthew, formerly assigned to the "school of Giotto," in the corridor of the Uffizi.[3] Rosselli's name is not on the roll of Florentine painters, from which the sheet headed " R " is missing. But it has been found in records of the fifteenth century at Florence. In 1445 he painted jointly with Ventura di Moro in the oratory of the Bigallo, and Ventura di Moro is registered in the guild of

[1] G. Milanesi in VASARI, ed. Sansoni, ii., p. 67.

Florence Academy, Sala Prima, No. 142, inscribed: AL NOME SIA YHESUS, QUESTA TAVOLA FU FATA A DĪ XXV DI GENAIO MCCCCXX E PER REMEDIO DEL ANIMA DI CHI LA FATA FARE.

[2] The Coronation of the Toscanelli collection passed into the hands of Mr. C. F. Murray. It is a small panel with diminutive figures on gold ground. One of the angels supporting the curtain is all but obliterated. There are other little blemishes due to scaling, and the Saviour's blue mantle is repainted. The inscription runs as follows: . . . VS ROSSELLI IACOPI FRANCHI A.D. XXV. DI. GIVGN. AÑO. 1439.

painters in the year 1416.[1] There are payments in favour of Ventura at the Bigallo in May, 1446, other payments to him and Rosselli for a picture of St. Peter Martyr on the façade of the Bigallo, in August of the same year. The remains of this picture, a fragment of fresco in bad condition, shows some qualities as regards composition and form. The drapery is good, the colour bright. It is, on the whole, a better work of art than the Coronation, and but for records and inscriptions we should possibly not assign the two pieces to the same hand, yet it must be so; and we can only suppose that the joint work of Rosselli and Ventura was better than that of Rosselli alone.

To these examples of the art of Agnolo Gaddi's time we may add others, in which a fair imitation of his style is displayed, and the names of inferior artists at the close of the fourteenth century in Florence are revealed.

Puccio di Simone appears on the register of the guild of St. Luke at Florence in the year 1357. His name is inscribed: PUCCIUS SIMONIS FLORENTINUS PINXIT HOC OPUS on a picture representing the Virgin and Child between St. Onophrius, St. Laurence, St. James, and St. Bartholomew, in the Academy of Florence (Sale dei Maestri Toscani, Sala Prima, No. 130). Puccio's style is that of an imitator of Agnolo Gaddi. His picture was once in San Matteo in Arcetri, near Florence, and is much injured.

Matteo Pacini is another artist of the same calibre who appears in the book of the painters' guild in 1374. But he must have been in other guilds previously, as we have a triptych by him representing the Coronation of the Virgin, with St. Peter and St. Paul on the inside of the wings, and St. John the Baptist and St. Martin on the outside, inscribed: ANNO DOMINI 1360 MATEUS PACINI ME PINXIT ADI 20 DE MARZO. This altarpiece, lately belonging to the brothers Corvisieri in Rome, is by a very humble imitator of Agnolo Gaddi; yet the style is superior still to that of the Giottesque remains of frescoes in the choir of San Sisto at Rome, in which we still distinguish the Descent of the Holy Spirit, a Presentation in the Temple, and St. Dominic, St. Anthony, St. John the Baptist, and St. Paul in pointed niches below the subject pictures.

A Coronation of the Virgin, attended by numerous saints and angels,

[1] See PASSERINI (L.), on the Bigallo, in *Curiosità storico-artistiche fiorentine*, and the Roll of Florentine Painters in GUALANDI, *u.s.*, vi.

on panel, with pinnacles containing Christ on the cross between half lengths of angels, in the oratory of San Giovanni di Valdelsa, looks as if it might have been executed by the same hand as the frescoes of San Sisto or some other close imitator of Agnolo Gaddi.

Pacino Bonaguida is also a follower of Agnolo Gaddi. He is author of a Crucifixion in the Florentine Academy (Sale dei Maestri Toscani, Sala Terza, No. 9) formerly in the church of S. Firenze, Florence, inscribed : SYMON PRESBITER S. FLOR. . . FEC. . . PINGI. H . . OP . . A PACINO BONAGUIDE. ANNO DOMINI MCCCX. . . The picture may owe some part of its feebleness to age and retouching. We may attribute to the same hand a Virgin and Child between St. Francis, St. Bartholomew, St. Catherine of Alexandria, and St. John the Baptist in the gallery of Prato.

CHAPTER XVI

SPINELLO AND HIS DISCIPLES

CONTEMPORARY with Agnolo Gaddi in the Florentine school, Spinello of Arezzo successfully held a place amongst the painters who preserved the traditions of the Giottesque art in the second half of the fourteenth century. According to Vasari, he was of an old Ghibelline family; but records prove that his father's name was Luca and his uncle a goldsmith at Arezzo. It is not known where he took lessons from Jacopo del Casentino, whom he acknowledged as his master, nor is it certain at what time he was apprenticed.[1] The date of his birth is obscure, but his style is Florentine, and shows acquaintance with the models of Jacopo del Casentino and Daddi; whilst he contrasts with both by rugged energy as a designer and varied power as a colourist and manipulator. His skill may be judged from numerous pictorial works at San Miniato, outside Florence, the Campo Santo of Pisa, and the public palace of Siena. He was less successful in altarpieces and pictures than in wall paintings; but in this he shared a peculiarity common to most Florentines. Taking his frescoes as a guide, we can see that he possessed Giotto's maxims of composition, which he enlivened with the gay tinting and occasional exaggeration of the masters of Siena. His figures are always remarkable for energy, stern character, or boldness of attitude; but though true in movement and expression, they are often defective in proportions. Details of the human frame, as well as of the extremities and articulations, are suggested rather than fully displayed.

[1] See VASARI, ed. Sansoni, i., p. 677. In the inscriptions of Spinello's pictures, and in the records respecting him, he is called Spinello Lucæ, which confirms Vasari's statement that his father's name was Luca.

The drawing is bold, sweeping, and loose; the drapery broad and flowing; the contrast of light and shadow massive; the colour is variegated and often gaudy. Spinello, in fact, is a clever decorator, inferior to Agnolo Gaddi as a draughtsman, but more spirited than other Florentines of the fourteenth century.

Were it not almost certain that the fresco in the lunette above the portal of the old Fraternity of the Misericordia at Arezzo is due to Jacopo del Casentino,[1] it should be assigned to Spinello's earliest and feeblest time. So little, however, of Spinello's works at Arezzo has been preserved, and so few dates are recorded in his life by Vasari, that it is difficult to follow his progress. We may presume that he proceeded with Jacopo del Casentino to Florence, where he painted, about 1348, the choir of Santa Maria Maggiore,[2] two chapels in the Carmine,[3] one in Santa Trinità, and three altarpieces for the church of Sant' Apostolo, the church of Santa Lucia di Bardi, and the chapel of the Peruzzi in Santa Croce.[4] Bottari notes that the frescoes in Santa Maria Maggiore, painted in dead colour, were going to ruin.[5] They are lost to the present generation, like those of the Carmine, Santa Lucia, and Santa Croce.

Recalled to Arezzo by numerous patrons, Spinello painted, in 1361, the picture of the high altar in the abbey of the Camaldoles in Casentino;[6] and between that date and 1384, when, after the sack of the town, he took refuge in Florence,[7] he completed numerous frescoes and altarpieces.[8] With success,

[1] See *antea*.

* [2] The frescoes in this chapel were not painted by Spinello, but by his son Filippo. See RICHA, *Chiese Fiorentine*, vol. iii., p. 282.

[3] At the Carmine, says VASARI, he painted the chapel of SS. Jacopo and Giovanni Evangelista, when the wife of Zebedee asks Christ to give seats in Paradise to her sons, when Zebedee, James, and John leave their nets; in another chapel, scenes from the life of the Virgin (ed. Sansoni, i., p. 679).

[4] VASARI (i., p. 680) says, with reference to the choir of Santa Maria Maggiore, that Spinello painted it for Barone Cappelli; but this is probably an error, as the patronage of the high altar was only obtained by Barone's son in 1348 (*vide* RICHA, iii., p. 282).

[5] Bottari, in notes to VASARI, ed. Le Monnier, ii., p. 186.

[6] VASARI, ed. Sansoni, i., p. 683. [7] *Ibid.*, i., p. 689.

[8] In the Duomo Vecchio and the Pieve (*ibid.*, pp. 680, 681); in S. Laurentino, the Compagnia della Nunziata, SS. Marco, Giustino, Lorenzo, and other places (*ibid.*, p. 682).

and not without grace, he designed the Annunciation on an altar
to the right inside the portal of San Francesco of Arezzo.[1] Near
this picture, which a restorer has somewhat damaged, he painted
frescoes on the wall between the chapel and the belfry, traces
of which have recently been recovered from whitewash—a figure
of a bishop and of one carrying an infant still revealing his
style.[2] In the bellroom of the same church Spinello depicted
scenes from the legend of the archangel Michael, most of which
are greatly injured. In one of the lunettes the Saviour,
enthroned amongst angels, orders St. Michael to expel from
his throne the rebel Lucifer and his angels. Beneath this the
archangel, poised on the dragon, is seen in the act of striking
him ; whilst on each side angels and demons struggle for the
mastery—a fantastic medley of celestial warriors and evil spirits
in the forms of serpents. Here we find the counterpart of the
frescoes in the Compagnia di Sant' Angelo at Arezzo, decorated
with the same subjects by Spinello, but since obliterated, with
the exception of the head of an archangel[3] and parts of the
figures of six angels transferred to canvas, which were lately
in the collection of Sir H. Layard.[4] Though in bad condition,
these frescoes still have the spirit and character of the master.

The Annunciation, in a tabernacle outside the church of the
Annunziata, rivals in feeling and grace, as well as in beauty of
composition, that of San Francesco. The calm attitude of the
Virgin is not less good than the lithesome action of the angel.[5]

[1] In the chapel of Messer Giuliano Baccio (VASARI, ed. Sansoni, i., p. 681).
The composition is arranged with taste, the angel graceful and pleasing.

[2] VASARI (i., p. 681) mentions these, and besides, paintings in the Cappella de'
Marzuppini representing Pope Honorius confirming the rules of the Order of
St. Francis.

[3] VASARI, i., p. 692. Another of the sides of the bellroom, cut in two by the
wall of a passage leading from the church to the sacristy, contains remains of a
fresco representing the vision of the archangel to Pope Gregory on the Mole of Hadrian
at Rome, which has since been called from this miracle the Castle of St. Angelo,
and scenes from the life of St. Egidius.

* It was Boniface IV. who, in 610, erected the chapel of S. Angelo inter Nubes
to commemorate Gregory's vision of the Destroying Angel sheathing his sword.
But the name of S. Angelo was not regularly applied to the castle for centuries
after this event.

* [4] The fragments of this fresco from the church of S. Maria degli Angeli were
presented to the National Gallery by Sir Henry Layard in 1886.

[5] The Virgin sits with a book, Gabriel on one knee with arms crossed on his

Spinello's bold ease of hand and lively colour, his breadth of
distribution, his power in giving ready motion to figures without
any special accuracy of drawing, his ability in casting drapery,
are illustrated in San Domenico of Arezzo, where an altar to the
left of the portal is decorated with the majestic erect forms of
St. James and St. Philip between side panels representing scenes
from the lives of these saints.[1]

Vasari justly praises another of Spinello's frescoes in Arezzo, a
tabernacle above the door leading into the Compagnia della
Misericordia. The colossal Trinity depicted there, although re-
painted in its lower half, is worthy of attention. The head of
the Eternal, of a fine and powerful type, a well-proportioned
figure of the Redeemer, of deep feeling, impart to the whole
subject a certain grandeur, whilst the general effect is heightened
by vigorous colour.[2]

A Virgin between St. James and St. Anthony, assigned to the
master in the company of the Purraciuoli at Arezzo, bears the
date of 1377, and might prove, if the fresco be authentic, that
Spinello was still at the time in his native city.[3]

According to a tradition which has survived to the present
day, his shop was situated near the Via Sacra at the corner of

breast. The Spirit of the Holy Ghost and the form of the infant Saviour descend
as if from the Eternal in the lunette above, now obliterated.

A Virgin giving the breast to the infant Saviour (half figures), known as the
Madonna del Latte and executed for the church of San Stefano fuor d'Arezzo, is
now in San Bernardo, where of old were other works by Spinello (VASARI, ed.
Sansoni, i., pp. 684, 685). On the façade of the ex-hospital of Spirito Santo he
painted the Descent of the Holy Spirit, three scenes from the legend of St. Cosmo
and St. Damian, and a Noli me Tangere, of which the remains are now all but
obliterated.

[1] VASARI, ed. Sansoni, i., p. 686. The scenes from the life of St. James on the
left, those from the life of St. Philip on the right. Some of the heads in these
have been injured by retouching. Two scenes from the life of St. Catherine are
above the rest.

[2] The frescoes have been detached from the wall and transferred to the town
gallery (Sala I., 15).

Four angels supporting the Trinity have also been injured, as well as St. Peter,
St. Cosmo, and St. Damian in the vaulting.

* This work has been much repainted.

[3] VASARI (ed. Sansoni, i., p. 686) mentions, as by Spinello, an Annunciation in
the Comp. de' Purraciuoli. He misdates the frescoes of the Virgin and saints,
which he describes as executed in 1367.

the Via della Tolletta. A room is shown on the ground floor of a house on that site, in which a half-figure of a Virgin annunciate is preserved on a wall, with a winged Saviour above and to the right of it, both figures displaying truly the style of the master.

Spinello was employed at Florence by an Aretine, Don Jacopo, general of the congregation of Monte Oliveto, to paint for the church of that name at Chiusi an altarpiece, illustrating the lives and martyrdom of various saints. The central panel was supposed to have perished, but is now said to be in the collection of Mr. Harry Quilter, in London, and to represent the Madonna enthroned.[1] A gable and wings are still in the gallery of Siena,[2] the wings having since adorned the gallery of Herr Ramboux at Cologne, and finally found their way in part into the National Gallery at Pesth.[3] On the pediment is the date of MCCCLXXX. and the names of the carver and gilder,[4] two different persons in that age—that of Spinello the painter being absent. His signature, however, may have been on the central panel, as Vasari completes the inscription, adding that the date was 1385. The fragments of predella and pinnacle at Siena have all the breadth of Spinello, and are much injured, but are not different in this from the other panels of the series. Little more than two years after this the sacristy, a lofty square chamber on the south side of the choir of San Miniato al Monte, near Florence, was completed in accordance with the last will of Nerozzo degli Alberti; and Don Jacopo d'Arezzo, for whom Spinello had already executed

[1] Exhibited at the Dudley Gallery in January, 1895. Not seen by the author.

* This picture is now in Mr. Quilter's possession. It is by Spinello.

*[2] Siena Gallery. The fragment of pediment is in the Sala Seconda, No. 70 ; that of the pinnacle is in the same Sala, No. 64. The subject of the predella is the Death and Transit, that of the pinnacle the Coronation of the Virgin.

*[3] Pesth National Gallery, No. 36, St. Nemesius and St. John the Baptist, with predella containing the Decapitation of the former and Herod's Feast, and Isaiah in the gable point. The following fragments mentioned by the authors are not now exhibited :—St. Benedict and St. Lucilla with a predella on which are the Death of St. Benedict and the Decapitation of St. Lucilla; an apostle with a book ; a saint in monkish dress.

The apostles, St. Philip holding a book and St. James with staff and book, remained at Cologne, and are in the Walraff Museum.

[4] MAGISTER · SIMON · CINI · DE · FLORENTIA · INTALIAVIT · GABRIELLUS · SARACENI · DE · SENIS · AURAVIT · MCCCLXXX. . . . "

the altarpiece of Monte Oliveto, ordered of the artist the frescoes of the walls on which he represented the legend of St. Benedict.[1]

In the delineation of these subjects Spinello showed his usual vigour and skill, and surpassed himself in the last scene of all, in which St. Benedict is seen on his couch, bewailed by brethren in various degrees of affliction, in a composition of a grand and decorous order. He was, indeed, more than usually successful in the drawing, proportion, and detail of this fresco. His draperies are broad, and in spite of the injuries of time, much of his transparent colour and peculiar dexterity of hand remain. Some of the frescoes of the series are not faultless in distribution; they betray casual neglect and carelessness; yet in general they show so much life and energy, and are so fairly sustained by general laws of composition, vigour of character, and bold facility of handling, that the total impression is grand. To Spinello's assistant, Niccolò di Pietro Gerini, the comparatively feeble evangelists in the ceiling may be assigned, as they are not unlike the works of that master and his son Lorenzo, which shall be presently noticed.

Spinello's increasing fame now attracted the notice of Parasone Grasso, who, after exhausting the illustrations of San Raineri, now bethought him of two other saints whose lives and miracles might fitly adorn the still vacant spaces of the Pisan Campo Santo. Spinello was accordingly commissioned, in 1391,[2] to paint on the south wall, by the side of the miracles of St. Raineri, those of the St. Ephesus and St. Potitus.

The legend relates that Ephesus was promoted by Diocletian to a high command; but that after he had braced on his armour, and was ready to start against the Christians, the Saviour appeared to warn him

[1] VASARI, ed. Sansoni, i., p. 683. By the will of Nerozzo, dated 1377, we have the exact period when these frescoes were commissioned of Spinello. They were still unfinished on June 11th, 1387. Vide *Cenni Storici di S. Miniato, u.s.*, p. 156.

* [2] In the month of February, 1390 (Pisan style), some part of these frescoes were already finished. In PARASONE GRASSO'S *Libro di Memorie*, already referred to, is the following entry :—" 1390. Spinello di Lucha d'Aresso dipintore lo quale dipingie in chapo santo de dare a dì primo di ferraio 1390 fiorini x d' oro li quali li prestai soprascritto dì in fiorini nuovi e in grossi—lire 35, soldi." This book is in the Archivio at Pisa. The account books for the previous year are missing.

against the enterprise. Ephesus turned accordingly against the pagans
of Sardinia, receiving as he was about to spring into the saddle a
banner of Victory blazoned with the arms of Pisa from the hands of
the archangel Michael, who rode with him in the subsequent fight with
the host of his angels, and who ensured a decisive victory. Appearing
afterwards before the prætor of Sardinia, he was sentenced to the
stake; and only escaped by prayer from the flames, to perish im-
mediately afterwards by the sword of the executioner. These incidents
are depicted in three parts of the upper courses of the wall at the
Campo Santo, whilst in three parts of the lower are scenes from the
life of St. Potitus, which have disappeared with the exception of the
Decapitation, and the carriage of the saint's body to Alexandria. In
the first compartment of the upper course nothing remains but frag-
ments of the fresco of the saint before Diocletian and the appearance
of the Saviour[1] to St. Ephesus; in the second the Lord appears to the
left, the saint kneeling in the midst of his officers. He receives on
horseback the banner from the archangel, and finally the battle is
represented. In the third the saint is brought before the prætor of
Sardinia, and taken to the stake; the flames slay the executioners, and
Ephesus is decapitated.

In such stirring scenes as these Spinello's art is effective, and
even where the form of the compositions is partly obliterated, his
power and boldness are apparent. In the battle scene, and where
the soldiers of the guard fall back from the flames which spare
the saint, there is a bold action and foreshortening worthy of
admiration. Nor has Spinello been so exclusively attentive to
expressing passion in the heads of combatants and guards but
that in the face of Ephesus he can show the influence of tenderer
feelings. The fragments of the Campo Santo are, however, most
advantageous to Spinello, as they prove that he had the Giottesque
quality of bright and transparent colour, which is indeed far
more apparent in this series than in the neighbouring one of the
sorrows of Job so long assigned to Giotto.

According to the records of the Campo Santo, Spinello received
from Parasone and his successor, Como de Calmulis, 150 florins of
gold for the three frescoes of St. Ephesus, and 120 florins for the

[1] Whose form is now obliterated.

three frescoes of St. Potitus, and the whole series was completed in March, 1392 (Pisan style).[1]

From Pisa Spinello probably proceeded to Florence, where, in 1400 and 1401, he is known to have painted altarpieces for Santa Croce and Santa Felicità; but he had resolved to spend his old age at Arezzo, and it is probable that about this time he finished the Fall of the Angels in the Compagnia di Sant' Angelo, to which we have already seen our attention drawn. But so far from dying of fright of his own picture of Lucifer, as Vasari states, he listened to the overtures of Caterino Corsino, *operaio* of Santa Maria of Siena, to come and paint there,[2] and in answer to a letter from him replied, in September, 1404, that he was ready to come.[3]

Spinello arrived on the 1st of October, engaging to serve for a year at Siena in any work of the Duomo which might be entrusted to him. His son Gasparre, better known as Parri, accompanied him. They were installed in the house of Domenico di Niccolò, and they laboured together till the end of the summer of 1405.[4] Of the works in the Duomo nothing has been preserved, yet seven months of labour at the rate of eleven and a half florins a month might have had a result worthy of remembrance.[5]

Spinello on his return to Florence painted for Leone Accaiuoli the chapel of that name in San Niccolò, and other portions of the same edifice, incorporated later into Santa Maria Novella. In the present Farmacia a room, called "Stanza delle Acque," is still decorated with Spinello's frescoes of scenes from the Passion, the greater part of which are concealed by medicine bottles and shelves[6]—work of hasty execution, inferior to that of 1407 at Siena, and betraying the extensive employment of pupils.[7] More correspondence between Spinello and the

[1] *i.e.* 1391. See the originals copied in FÖRSTER's *Beiträge, u.s.*, p. 118. Spinelli is there called "olim Luce," or the son of the late Lucas.

[2] VASARI, ed. Sansoni, i., p. 692. The "condotto" or contract of Calerino Corsino is dated the 20th of August, 1404 (MILANESI, *Doc. Sen.*, ii., p. 18).

* Vasari's story is admirably told.

[3] MILANESI, *Doc. Sen., u.s.*, ii., p. 19.

[4] See the original record in MILANESI, *Doc. Sen.*, ii., p. 19. [5] *Ibid.*

* [6] The shelves and bottles have been removed and the frescoes restored. The entrance to the Farmacia is in the Via della Scala (No. 12A).

[7] Two inscriptions in RICHA (iii., pp. 94, 95) prove that these frescoes of San Niccolò were finished in 1405, and Vasari errs in the date of 1334 because he found that in that year Dardano Accaiuoli caused the chapel to be built. The paintings were commissioned by Leone in 1405 (VASARI, ed. Sansoni, i., p. 678.)

Sienese in April, 1406, without results. In June, however (1407 old style), he signed a new contract, and in March, 1407–8, returned to his old quarters at Siena with Parri, to execute the frescoes of the Sala di Balìa in the public palace, in conjunction with Martino di Bartolommeo, who decorated the ceiling and framework with festoons and allegorical figures of little value. Here Spinello illustrated in sixteen parts the animated story of the Venetian campaign against Frederick Barbarossa, interesting to the Sienese from the share which legendary history assigns in it to Rolando Bandinelli, promoted to the pontificate under the name of Alexander III.[1] Executed with great dexterity and freedom, and more than usually successful in composition, these frescoes are the best that remain to us of Spinello. The whole of two rectangular rooms, communicating with each other by an arching, are covered with a double course of paintings, the upper stripe of which is distributed into twelve lunettes. In the lower course the space above the doorway is entirely taken up by a fresco representing the naval battle in which Otho, the son of the Emperor Barbarossa, is captured with his fleet by the Doge Ziani. On the same course, to the right of the spectator as he enters, the Doge is depicted receiving the sword, Barbarossa suing for peace before the Pope in the cathedral of San Marco, and the Pope is led in triumph at Venice, riding on a palfrey with the reins held by Barbarossa and Ziani. In the twelve lunettes beginning above the door and counting from left to right of each of the two cubes of the chapel, we have : (1) the Pope running away in the dress of a monk, (2) receiving a prince who kneels before him, (3) the Pope's coronation, (4) Barbarossa present at the coronation of the anti-pope, (5) Pope Alexander a fugitive at the Carità of Venice, and (6) the Pope receiving a messenger in the presence of the Emperor. The lunettes of the second cube comprise : (7) Pope Alexander giving his blessing to a bishop, (8) the Pope at Mass, (9) Otho kneeling before the Pope, (10) Barbarossa doing homage to the Pontiff, (11) the Pope in council with his cardinals, (12) the burning of the anti-pope. The least damaged of these frescoes is that of Ziani before Alexander, the most animated and best arranged that of the Pope on a charger led by Barbarossa ; and the figures on horseback, as well as the horses themselves, are fine and fairly in motion. Though all the scenes are not equally well distributed, and the defective form and perspective of the architecture give a certain obliquity to the horizontal planes, still the

[1] MILANESI, *Doc. Sen.*, ii., pp. 20 and 33. The subjects were traced for Spinelli by one Bettus Benedicti.

general impression is favourable, because of the excessive speed and boldness of the execution, a comparatively fair breadth of light and shade, gay, vigorous, and transparent colour, sweeping drapery, and a general aspect of life and motion. The decorative unity of the whole is effective. But there is still much to reprove in the drawing of the hands, feet, and articulations, and in that of many short and stunted figures. Colour seems to have been obtained by simple means; first of all by systematic rapidity of hand, and then by the use of white undergrounds for the high lights, warmed up by transparent glazes. The share of Parri in these labours is evidently secondary.

The latest record respecting Spinello at Siena is of the 11th of July, 1408,[1] after which perhaps he retired to Arezzo, where he died on the 14th of March, 1410,[2] leaving behind Parri to follow the profession of a painter.[3] Several pictures by Spinello have been preserved. One, a Madonna amongst saints and angels in the Academy of Arts[4] at Florence, originally painted for Sant' Andrea of Lucca, is interesting for the inscription: OPUS PINXIT SPINELLUS LUCE ARITIO. D. I. A. 1391. It is a damaged, feebly executed production.

A banner painted on both sides for the Brotherhood of San Sepolcro, lately in the collection of the Marchese Ranghiasci, at Gubbio, has all the character of the master, and is one of the best examples in private hands. On one face is the Flagellation; on the other the Magdalen, enthroned amidst a glory of eight angels playing instruments, holds in her right the ointment and in her left a crucifix. Four brothers of the fraternity kneel in pairs below; the whole inclosed in painted architecture adorned with medallions of saints.[5]

Three figures of the Baptist, the Evangelist, and St. James the elder, all but life size, originally in the hospital church of San Giovanni e Niccolò at Florence, are now in the National Gallery, and have been mentioned as illustrating the school of Orcagna.[6]

[1] MILANESI, *Doc. Sen.*, ii., p. 33.	[2] TAVOLA, *Alfab.*, *u.s.*
[3] VASARI, ed. Sansoni, i., p. 693.
[4] Sala Prima, No. 128. The Virgin enthroned, guarded by angels between St. Paulinus, St. John the Baptist, St. Andrew, and St. Matthew. The two angels to the left of the Virgin are gone, those to the right are in adoration.
[5] Of these, vestiges only remain.
[6] Purchased from the Ugo Baldi collection and now No. 581 of the National Gallery Catalogue. Wood, 6 feet 2 inches high by 5 feet. As examples of pictures which are not by Spinello the following may be registered: a Tabernacle exhibited at Manchester by G. E. H. Vernon, Esq., M.P. (No. 27 in the Catalogue of the

As a final example of Spinello, and a proof of the manner in which he allowed his assistants to share the honours of publicity with him, we may notice an altarpiece in three compartments, formerly in the monastery of Santa Felicità at Florence, and now in the Academy of Arts, of which records show that it was ordered in 1395 of Niccolò di Pietro, Spinello, and Lorenzo di Niccolò. It would seem that the centre, representing the Coronation of the Virgin, was painted by Lorenzo di Niccolò; the side to the right by Niccolò di Pietro, father of Lorenzo; and the side to the left by Spinello.[1] But for the records it would be difficult to assign to each of these men his share in the entire work. That of Spinello is undoubtedly beneath his usual powers, and in harmony with the third-rate talent exhibited by Lorenzo and Niccolò. These, however, were artists extensively employed in their time, though unknown or neglected by Vasari. Of Niccolò di Pietro we have accounts which show that he was the son of one Pietro Gerini, and settled, as early as 1380, at Florence.[2] He was engaged at Prato in company with Agnolo Gaddi in 1391 on works of an extensive kind for Francesco di Marco Datini.[3] At Pisa in 1492 he was employed to decorate the chapter-house of the Franciscans, and from Pisa we find him in the summer of that year writing to Datini to be careful of a paint-box and tools which he had left on the scaffoldings in San Francesco of Prato.[4] This very convent was subsequently the

Manchester Exhibition), by some master of the close of the fourteenth century. The Adoration of Christ and Circumcision (No. 1,102), the Last Supper (No. 1,108), and the Annunciation (No. 1,111), all assigned to the master in the Berlin Gallery.

* Of the pictures at Berlin only the Last Supper (No. 1,108) is now ascribed to Spinello. In Thorwaldsen's Museum at Copenhagen is a predella (No. 2) of the school of Spinello. The subjects are, the Crucifixion, the Betrayal, and the Resurrection. The Crucifixion attributed to Spinello at the National Gallery (No. 1,468) is given to Daddi by the authors. See *antea*, p. 179.

[1] Florence Academy, Sala Prima, No. 129. *Vide* annot. to VASARI, ii., p. 197 ; and GAYE, *Carteggio*, ii., p. 433. Side to right, St. Peter, St. John the Evangelist, St. James, and St. Benedict. Side to left, St. John the Baptist, St. Matthew, and St. Felicita. Pediment, six saints ; beneath the principal panel the words : QUESTA TAVOLA FECE FARE EL CAPITOLO COVENTO DEL MONASTERIO DI SANCTA FELICITA DE DANARI DEL DETTO MONASTERIO, AL TEMPO DELLA BADESSA LORENZA DE' MOZZI IN ANNO DOMINI M.CCCC.I.

[2] GAYE, *Carteggio*, ii., p. 433.

[3] GUASTI, *La cappella de' Migliorati in Prato* (8vo, Prato, 1871), p. 7. [4] *Ibid.*

scene of Niccolò Gerini's labours. Here he painted, after 1394, a Flagellation, an Ascension, an Annunciation, St. Francis, and God the Father, which have perished;[1] here the chapter-house, of which we shall have to speak. He lived at this time, it would seem, at Prato, and kept a workshop there with his son Lorenzo. He painted a crucifix for Francesco Datini in 1395, and adorned a chapel in the Duomo with frescoes.[2] His return to Florence is proved by the records which illustrate the altarpiece of 1401 at the Academy of Florence, and his residence there till later in the century is proved by the rolls of the painters' guild, which register his name in 1414.[3] The earliest and most important of Niccolò's works is the series of frescoes in the ex-chapter-house of San Bonaventura at San Francesco at Pisa. His name may be found on a bracket above the entrance door.[4]

On the sides of the entrance are St. Laurence and St. John the Baptist; on the entrance wall to the left, Judas selling himself; on the left side of the chapter-house, the Last Supper, the Washing of the Apostles' Feet, Christ on the Mount of Olives, and the Capture. On the side opposite the door, the Flagellation, Christ carrying his Cross, the Crucifixion, the Deposition, and the Burial; on the side to the right, the Resurrection, Noli me Tangere, and Ascension; on the wall of the door to the right, the Descent of the Holy Spirit.

There are now but fragments of Judas selling himself; and of the frescoes on the wall to the left, hardly anything remains. The Flagellation, the Carriage of the Cross, and the Crucifixion itself are in an equally bad state, and the Deposition is partly injured

[1] *Ibid.* [2] *Ibid.*

[3] GUALANDI, *Memorie*, vi., p. 186. There are further records of Niccolò's existence in the archives of Prato. He and four other Florentine painters decorated the front of the Palazzo del Ceppo about 1411. Three years before (1408) he painted a fresco of St. Francis in San Francesco of Prato. See GAETANO GUASTI'S *Memorie dell' imagine e della chiesa di M. V. del Soccorso* (Prato, 1871), pp. 45 and 55.

[4] As follows:— NICOLAUS
 TR. PITOR
 DE FLORENT.
 INS ...
 MCCCI

or as copied by LASINIO: NICOLAUS PETRI PICTOR DE FLORENTIA DEPINSIT AN. D. MCCCLXXXXII. DE MAR (Tav. II. of *Raccolta de' Pitture antiche intagliate da Paolo Lasinio designate da Giuseppe Rossi*. Pisa, 1820.)

by abrasion or the fall of the plaster; but in this last composition
enough remains to justify an opinion as to the talent of the
painter. A group of long slender figures of a weak character
represents the Marys about the Virgin and the Virgin herself.
Their long thin necks and small chins, their mouths writhing to
express grief, display defects similar to those conspicuous in
frescoes decorating the sacristy of Santa Croce at Florence, which
may for that reason be assigned to Niccolò Gerini.[1] The subject as
a whole is not ill-arranged; but being an imitation of others of
the same kind by artists of note, and therefore typical, it cannot
be accepted as a proof of original power. In the Entombment,
the naked frame of the Saviour is extended on a winding sheet,
held up at each end by two apostles. The Virgin embraces as she
raises the head of the Redeemer, and an apostle at each side kisses
the hands, whilst the Marys and others stand around in attitudes
of lamentation. With a slight change in the position of some of
the figures, the fresco is a mere repetition of a picture at the
Academy of Arts in Florence assigned to Taddeo Gaddi;[2] and in
both the same character may be noticed. We may conceive
Niccolò di Pietro Gerini to have been bred in the school of Taddeo
Gaddi; his education is in any case Florentine; and in these
frescoes of Pisa the continuation of the school of Taddeo Gaddi
may be traced. The Resurrection, like the Entombment, is a
typical composition. The Saviour sets his foot on the side of the
sepulchre, raising his right arm and grasping a banner in his left.
Clothed in his white winding sheet his movement is not without
grandeur. The type and outlines of this figure are the best in the
chapter-house. The Noli me Tangere, though less good, is hardly
less interesting, the action of the Magdalen being ready, and the
group recalling that of Giotto. A certain amount of grace,
natural movement, fair shape and drapery likewise mark the
neighbouring group of the Marys. A thoroughly Giottesque form,
again, may be noticed in the Ascension. In general, the remains of
these damaged frescoes would prove that Niccolò was a diligent
and careful painter, whose colour wants force and blending,
though it has a certain liveliness of tints. In the draperies

* [1] See *antea* (p. 135) in the chapter on Taddeo Gaddi.
 [2] Sale dei Maestri Toscani. Sala Prima, No. 116. See *antea*.

changing hues prevail. The outlines and shapes are Giottesque, but inferior to those of Spinello, to whom, indeed, Niccolò was also second in composition. On the other hand, he tried to finish hands, feet, and articulations, and was in this not only above Spinello, but beyond Agnolo Gaddi. Still his painting, compared to that of either of those masters, is lifeless and third-rate.[1]

Reverting to the Entombment in the Academy of Arts at Florence, assigned to Taddeo Gaddi, we observe that it has many characteristics of Gerini.

We note in the composition, which is formed of life-size figures, complete want of rest and overcharge of figures. The Saviour, ascending in the upper part, is of noble and good proportions, the face youthful, and the attitude fair, but the angels are in vehement action. In the principal scene the Saviour lies very long on the tomb with hips enveloped in drapery, but the body is a stiff, hard corpse, of which the form has been sought out and studied without the genius so striking in Giotto. Some merit may be detected in the mild expression of the face, but the flesh tints are light and flat, and comparatively unrelieved. The remaining figures are long and slender, like those of Taddeo Gaddi, and affect his peculiarities of shape, but some of the types are very common, and the Virgin at the Saviour's head has the pointed chin usual in Niccolò Gerini. The outlines are well defined, but coarse. The picture as a whole does not improve on acquaintance, being at first sight more pleasing than on closer examination. The draperies are overcharged with lines and folds; and gay, changing hues are again prominent.[2]

[1] Pisa, San Francesco, chapter-house of San Bonaventura. Of the figures on the sides of the entrance, the Baptist is the best, the St. Laurence is all but gone. Parts of the colour and intonaco in the Entombment are gone. Two of the soldiers sleeping in the Entombment are reduced to mere outlines. In the Noli me Tangere the Magdalen is discoloured. In the Ascension the Saviour, of fair character and proportions in an elliptical glory, is surrounded by a choir of twelve angels playing instruments, whilst below, the Virgin, Marys, and apostles stand attended by two angels. The foreground is discoloured. RUMOHR (*Forschungen*, ii., pp. 224, 225) records that these paintings were executed for Lorenzo Ciampolini, on whose tomb are these words: . . . MCCCLXXXX DIE XX MENSIS APRILIS, QUI LAURENTIUS FECIT IPSUM CAPITULUM, PICTURA ET SEDIBUS ADORNARI.

[2] The white dresses of the angels are restored. The type of St. John is very common. The figure at the Saviour's feet is partly, and two figures more to the right totally repainted.

Analogy of manner connects Gerini again with the frescoes of the sacristy of Santa Croce at Florence, which not only resemble those of Santa Buonaventura at Pisa, but others to be mentioned at Prato. Here Gerini seems to have painted, by the side of a Crucifixion executed by a better Giottesque than himself, Christ carrying his cross, surrounded by the Virgin and Apostles, the Resurrection and Ascension. The Saviour turns to look at the Virgin stretching her hands towards him, the group of the Marys around her being sternly kept back by a soldier. In her action, the combination of vehemence, feeble form, and vulgar expression which characterises Gerini at Pisa, is again displayed. In the Resurrection the Saviour is but a repetition of that in the frescoes at San Buonaventura, and has the same type and character as that in the altarpiece assigned to Taddeo Gaddi at the Academy of Arts. Similar forms, spirit, and drawing again are noticeable in the Ascension.

At Prato, in the ex-chapter-house of the convent of San Francesco, Gerini's style may be studied with the certainty arising from the fact that beneath the figure of St. Bartholomew, which, with those of St. Clara, St. Catherine, and St. John the Baptist, stand guard on the lintels of the entrance door, the painter's name is inscribed. Scenes from the legend of St. Matthew, including his death, and scriptural incidents, are the subjects depicted.[1] Executed later than those of Florence and Pisa, these reveal an obvious decline. The figures are more slender, stiff, and lifeless, and less carefully executed than previous ones. A Crucifixion on the wall opposite the entrance, and the ceiling frescoes, are indeed so poor that they may be by Lorenzo. In this third-rate style it might be possible to quote, as by Niccolò, an infinity of works assigned in numerous galleries to Giotto, Taddeo Gaddi, and Orcagna.[2]

[1] On the wall facing the entrance the Crucifixion with the Magdalen at the foot of the cross and the usual attendant scenes, all but obliterated, and in the ceiling the four Evangelists. The inscription on the lintel post is NICHOLO DI PIERO GIERINI DIPINTURE, to which GUASTI (La cappella de' Migliorati, u.s., p. 6) adds the words, FIORENTINO, PINSE QUI CONSUS COLORE.

[2] In the gallery at Parma is a Death of the Virgin, together with a composition belonging to the same altarpiece, representing the gift of the girdle to St. Thomas, placed under the name of Giotto, but in reality by Niccolò Gerini. In a room called la Scoletta or Coro of the church of San Giovanni at Pesaro is an altarpiece by Niccolò with a mutilated inscription: ... DE FLORENTIA 1400. The Madonna is enthroned under the guard of two angels. In the side panels, the archangel Michael weighing the souls and St. Francis are placed.

A picture of the Coronation of the Virgin in the Zecca of Florence is noted by

Lorenzo di Niccolò succeeded to the mediocrity of his father. His most important labour is the Coronation of the Virgin and Adoration of the Magi, a predella altarpiece in the church of San Domenico at Cortona.[1]

Taken in 1438 from the convent of St. Mark at Florence, where it had once stood, it was sent by Cosimo and Lorenzo de' Medici to Cortona,[2] where it was long considered, in spite of the signature, to be an altarpiece by Angelico.

Imposing in its total aspect, and better than the work of Lorenzo in the joint altarpiece of himself, his father, and Spinello, this is still a third-rate Giottesque work, of which the best parts are the compositions in the predella and the figures in the pilasters.

A glory of St. Bartholomew by this master is preserved amongst a collection located in the Palazzo Comunale of San Gimignano.[3] It bears the master's name and the date of 1401.[4]

A Virgin and Child from the church of San Bartolo by the same hand, as well as four little pictures of St. Fina and St. Gregory, with a scene from the life of each of those saints, are likewise in the gallery at San Gimignano.

GAYE (*Carteggio*, ii., p. 433), who publishes a record proving that it was painted in 1373 by Jacopo Cini (can he be related to Jacopo Cini the carver of the altarpiece by Spinello? See *ante*), Simone, and Nicholaus, the latter supposed to be Gerini. CESARE GUASTI notes the recovery from whitewash of Niccolò Gerini's St. Christopher in the house of Francesco Datini, now the residence of the Ceppi (*La Cappella de' Migliorati, u.s.*, note to p. 7).

[1] The Virgin is between ten saints. Above, the angel and Virgin annunciate at each side of a Trinity. Below, the Adoration of the Magi, at each side of which are four scenes from the life of St. Dominic, octagonal pilasters, angels and saints.

[2] Beneath the Adoration is the painter's name: LAURENTIUS NICHOLAI ME PINSIT, and the following: CHOSIMO · E · LORENZO · DI · MEDICI · DA · FIRENZE · AÑO · DATA · CHUESTA · TAVOLA · A · FRATI · DI · SĊO · DOMENICHO · DLLOSSERVANZA · DA · CHORTONA · PER · LANIMA · LORO · E · DI · LORO · PASSATI · MCCCCXXXX (vide *Chron. di San Marco*, in annot. to VASARI, iv., p. 51). The letter of thanks from the Prior of Cortona for the present is published by GAYE in *Carteggio*, i., p. 140.

[3] Enthroned. With four scenes from his life; at the sides a Crucifixion and eight saints in the pediment. The altarpiece is No. 2 of the catalogue of a collection due to the care of the erudite and kindly Canon Pecori.

* The Pinacoteca is on the third floor of the Palazzo Comunale.

[4] The altarpiece was originally in the Collegiata of San Gimignano. In the hem of the saint's dress: LAURENTIUS NICHOLAI DE FLORENTIA PINSIT; beneath the central figure: S. BARTOLOMMEUS APOSTOLUS, AN. MCCCCI QUESTA TAVOLA FECE FARE NICHOLAJO DI BINDO KASSUCCI.

In the passage to the Cappella Medici at Santa Croce in Florence, a Coronation of the Virgin, with attendant saints and scenes,[1] may be seen. The style is a little better than at San Gimignano and Cortona, but the hand is the same. The faces are more regular and pleasing, and have more feeling. Of frescoes by Lorenzo di Niccolò none are known, but his manner is to be found in a Virgin, angels, and saints in a tabernacle at Sant' Andrea di Rovezzano near l'Anchetta at no great distance from Florence.[2] This is a fair fresco of the lower Giottesque manner at the close of the fourteenth century.

Lorenzo's pictures, without great excellence, are not disagreeable to look at. He was not a bad painter amongst the third-rates. His colour was warm and not without power and harmony, and his drawing bold. He was a man of considerable practice, but his work, though superior to that of Parri Spinelli, does not stand critical examination.[3]

The following selection may serve to illustrate the manner and school of Niccolò and Lorenzo Gerini.

In the Academy at Florence,[4] the Virgin and Child between St. Laurence and St. John Evangelist, St. James and St. Sebastian. In the predella, five scenes, more in the manner of the Gaddi and less defective. In the same gallery,[5] the Virgin and Child between St. Stephen and St. Reparata by the same hand as the foregoing. The Trinity[6] between St. Romualdo and St. Andrew, dated 1365, with three scenes from the life of the former in the upper spaces.[7] The Virgin and Child[8] between St. Laurence and St. Julian, Anthony and John the Baptist, dated 1404.

[1] St. Peter, St. Stephen, an apostle, and Mary Magdalen at side. Above, centre the Trinity, at each side of which the angel and Virgin annunciate, the prophet Jeremiah and Isaiah. A lozenge below bears the date 1410.

[2] Virgin and Child between four angels: St. Catherine, St. John the Baptist (right), Magdalen, St. Peter (left). Six saints in the vaulting, of which St. Bartholomew is still recognisable. Above arch, the Saviour in benediction between two medallions of saints.

[3] Lorenzo di Niccolò will be found registered in the painters' guild at Florence in 1410 (see GUALANDI, *Memorie*, vi., p. 185).

* [4] Sale di Beato Angelico e di altri maestri, Sala Terza, No. 7.

[5] No. 47. * This picture is not now on view in the gallery, nor can we find mention of it in the catalogue.

* [6] Sale dei Maestri Toscani, Sala Prima, No. 140. From the Angeli at Florence.

[7] Inscribed: ISTAM CAPELLAM FECIT FIERI JOHANNES GHIBERTI PRO ANIMA SUA A. D. MCCCLXV.

* [8] Sale di Beato Angelico e di altri maestri, Sala Terza, No. 11. The inscription is: SANCTA · MARIA · ORATE · PRO · NOBIS · ANNI · MCCC · IIII. This picture also came from the Convento degli Angeli.

Finally may be mentioned an altarpiece of some interest in the church of S. Maria all' Impruneta near Florence, superior to the last mentioned, representing the Coronation of the Virgin with the twelve apostles at the sides, and above and below, fourteen scenes from the life of the Virgin and Saviour, besides twelve apostles in couples and angels in the pilasters and pinnacles.[1] This picture, which bears the date of 1375, gives us the necessary clue to distinguish Pietro Nelli of Florence, who was born at Rabatta in Mugello about 1345, belonged to the guild of surgeon apothecaries in Florence in 1382, and was registered in the guild of painters in 1411. He received payment for a share in the execution of the altarpiece of the Impruneta in 1384. His style recalls that of Gerini.[2]

According to Vasari, Parri Spinelli of Arezzo was an artist whose talent as a colourist of fresco was unparalleled, whose fancy was, beyond measure, sparkling, and who was excellent as a designer.[3] Time has fortunately spared some of the works of the painter who is the subject of this flattery, and these enable us to assign to Parri his proper place in pictorial annals. Parri was born in 1387.[4] A great part of his works at Arezzo has perished, but some of those which he completed for San Domenico and Santa Maria della Misericordia, and others hitherto neglected in the Municipal Picture Gallery and in San Francesco, will be sufficient to establish his character.

* [1] This picture is not quite accurately described by the authors. It has, as it were, two stories in addition to the gradine. In the lower story is the Virgin and Child surrounded by a choir of angels. On either side are four compartments ; in six of these eight compartments are two apostles, in the others angels. In the upper story is a Coronation of the Virgin, with representations of angels in the compartments on either side. Above, in the ornamental framework of the ancona, are scenes from the life of the Virgin and two figures of saints. In the predella are represented scenes from the lives of St. Joachim and St. Anne.

[2] For records and notices of this painter see G. MILANESI's *Memoria intorno a Pietro Nelli* (8vo, Fir., 1872), p. 4 and fol. The picture is inscribed: AD HONOREM ET REVERENTIAM MATRIS DEI AC SEMPER VIRGINIS GLORIOSE HEC TABULA FACTA FUIT TEMPORE REVERENDI DOMINI STEFANI PLEBANI PRO REMEDIO ANIME SUE ET ANIMARUM MAJORIS SOCIETATIS ET OMNIUM BENEFACTORUM ISTIUS ECCLESIÆ. ANNO DOMINI MILLESIMO CCCLXX. V.

* For particulars in regard to the life and work of Pietro Nelli, see also P. LINO CHINI's *Storia del Mugello*, ii., pp. 237–41.

[3] VASARI, ed. Sansoni, ii., pp. 275-85. [4] TAVOLA, *Alfab.*

Entering San Domenico, and looking to the right of the entrance, we shall see a Crucifixion framed in a simulated panelling which now cuts off part of the picture, with the Virgin and a canonised bishop on one side, St. John Evangelist and another saint on the other. In this fresco the Saviour is depicted in a long, curved shape, by one who deserves to be called a second Margaritone. If we turn from this exhibition of low art to the figures at the foot of the cross, we find the forms of which Vasari truly says, "Parri painted figures much longer and more slender than any of his predecessors, and whereas others at the most gave them a height equal to ten heads, he made them of eleven and sometimes of twelve. Nor were they ungraceful, though lean; but they were invariably bent round to one side or to the other, because, as Parri himself used to say, they had thus more 'bravura.'"[1] Curved, distorted, and hideous, disfigured further by vehement action and grimace, these forms can excite but a smile when we think that Vasari, a critic of no common order, could find something to admire in them. In a lunette above this scene, two incidents from the life of St. Nicholas exhibit superabundance of false and exaggerated action, draperies so long and plentiful as to smother the frames, and contours of a wiry and endless line. Parri did not even retrieve these imperfections by a feeling for relief or colour. On the contrary, his tones are laid on in raw and gaudy contrasts, of a coarse substance, and with a flatness which betrays no notion of chiaroscuro.[2] As is too frequently the case with paintings of little interest, particular care has been lavished on their preservation, and a fresco, saved from the walls of Santa Maria delle Grazie,[3] is now preserved in the "Sala di Justizia Civile" at Arezzo. The Virgin Mary is represented, guarded by two angels in flight above her, in a cloak of such amplitude that beneath it the people of the city, a pope, and a cardinal find refuge. At the sides St. Gregory and St. Donato stand erect; and the whole is inclosed in a painted frame embellished with pinnacles, with four allegorical virtues in monochrome. Beneath this a view of the city completes a picture which caricatures the defects of Parri. An altar-

[1] VASARI, ed. Sansoni, ii., p. 276.

* [2] Even in the works of Italian art-historians and art-critics, it is impossible to find a more remarkable manifestation of parochial patriotism than Vasari's life of Parri Spinelli. It is inconceivable that an artist who had lived in Arezzo could say of Parri Spinelli, "Colorì benissimo a tempera ed in fresco perfettamente." After reading this "Life" in the presence of Parri Spinelli's masterpieces the student will be enabled to rate at their proper value Florentine estimates of Cimabue.

[3] VASARI, ed. Sansoni, ii., p. 280.

piece from the same church, representing the same subject, with St. Laurentius and St. Pergentinus[1] at the sides, resting on a predella in four parts containing scenes from the lives of the two saints, is a less defective, but still unpleasant work of the master now in the Municipal Picture Gallery. In the same building, again, a fresco of the Crucifixion, with St. John and the Virgin in the dislocated attitudes peculiar to Parri, is preserved. In San Francesco he painted the Last Supper[2] in a style reminiscent of the works of Bicci. It may therefore be one of Parri's early productions, as yet comparatively untainted with his later failings. The St. Christopher in the "Chiesa dell' Oblata," which is said to bear the date of December 4th, 1444, has been for some time invisible under a hoarding, the church having been occupied as a barrack. Italy is unfortunately full of such frescoes as these, time having spared the bad in many more cases than the good. But it is unnecessary to expend any further trouble in a search for frescoes or pictures like those of Parri, who is below the Gerini in talent, and inferior even to Cenni of Volterra. Without a reminiscence of Spinello's style, although it is on record that father and son painted together at Siena in the early part of the fifteenth century, Parri imitates the movements and draperies of Lorenzo Monaco. He may therefore have known that master. But if he studied under Lorenzo Ghiberti and Masolino,[3] which is improbable, he gained little profit by it, and merely imitated in the fifteenth the bad example which Tommaso Pisano had already set to the sculptors of the fourteenth century. His death occurred in 1452, and he was buried in the church of Morello.[4]

Parri's portrait was painted by Marco di Montepulciano in the cloisters of San Bernardo at Arezzo, and Marco[5] is mentioned as a pupil of Bicci in the life of that artist by Vasari. He painted, in 1448, in *terra verde*, scenes from the life of Benedict in the above-mentioned cloister. Those of the northern and three on the eastern face are preserved. The figures in the latter are short and coarse, large of head, and executed in a style recalling that of the school of Spinello. The painter may therefore have been one of Spinello's pupils, for he attempts to rival that master's dexterity of hand, and copies his movements. He has certainly less of Lorenzo di Bicci's manner. In

[1] VASARI, ed. Sansoni, ii., p. 283.
[2] The fresco is to the left of the entrance and in part damaged.
[3] VASARI, ed. Sansoni, ii., pp. 275, 276.
[4] VASARI, ed. Sansoni, ii., p. 285.　　　[5] VASARI, *ed. cit.*, ii., p. 285.

the frescoes of the northern side, on the contrary, the execution is nearer to that of Lorenzo di Bicci, and, though inferior, also like those which Bicci di Lorenzo left in the ceiling of a great chapel at San Francesco of Arezzo.[1]

The discovery by Signor Gaetano Milanesi of numerous records respecting the family of Bicci has thrown light upon a very serious error committed by Vasari. We are told by him that Lorenzo di Bicci was born in 1400, that he learnt under Spinello of Arezzo, and died about 1450,[2] bequeathing his practice to two sons called Bicci and Neri di Bicci.[3] On the very face of these statements lies a mistake; for Neri is called by Vasari son of Bicci, and thus his father must have gone by the latter name, not by that of Lorenzo. The fact is that Bicci was born in 1373 of Lorenzo di Bicci and Madonna Lucia d' Angelo da Panzano. He married, in 1418, Benedetta di Amato d' Andrea Amati, having issue Neri, who followed his father's profession. We have thus three members of this family—Lorenzo di Bicci the father, Bicci di Lorenzo the son, and Neri di Bicci the grandson. Many of the works which Vasari mentions in the life of Lorenzo di Bicci are proved by records to have been by Bicci di Lorenzo. Of the grandfather Lorenzo we know that he was a painter, and Vasari's text suggests a belief that he confounded the two elder members of the family together. For instance, he says that Lorenzo was a pupil of Spinello; and this might be true of one who lived in the fifteenth, less so of one whose works mostly date from the fourteenth century. Lorenzo di Bicci's name, coupled with the epithet of "pictor," has been found in records of 1370,[4] 1375, 1386, and 1398.[5] In that of 1386 he receives from the opera of Santa Maria del Fiore ninety florins of gold for paintings in that cathedral. In 1409 his name appears in the register of the company of St. Luke as "Lorenzo di Bicci dipintore."[6] Vasari himself in his first edition declares that Lorenzo died aged sixty-one, and was mourned by Bicci and Neri, thus proving that he

[1] Ceilings assigned by VASARI (*ed. cit.*, ii., pp. 56, 64, 65) to Lorenzo di Bicci, respecting whom and Vasari's error in nomenclature a word hereafter.

[2] VASARI, *ed. cit.*, ii., p. 58. [3] *Ibid.*, p. 58.

[4] *Vide* annot. to VASARI, ii., p. 49, n.

[5] BALDINUCCI, *Opera*, iv. pp. 498, 502, 503. [6] GUALANDI, vi., p. 185.

knew of Bicci's existence. It is a pity that no pictures can be
assigned to Lorenzo. If, however, he was a painter as early as
1370 he was a contemporary of Agnolo Gaddi. There are
numerous frescoes not mentioned in the life of Lorenzo di Bicci
by Vasari, nor in records as by Bicci di Lorenzo, which display
a common character with those of Bernardo Daddi, Parri Spinelli,
and Bicci di Lorenzo, but they have an appearance of greater age
than those which are proved to be by the latter. The chapel of
San Jacopo in the Duomo of Prato, for instance, is decorated with
frescoes illustrating the lives of St. James and St. Margaret.

On one of the walls St. James's call to the apostolic mission, his
baptism of Hermogenes, and martyrdom are represented; on the other
wall, three scenes of St. Margaret's legend, including her death.[1] The
laws of composition obeyed in the fourteenth century are here fairly
maintained by an artist of feeble powers, whose long, slender figures are
marked at times by exaggerated action. Unfused flesh tones of thick
substance and melancholy tinge, wiry but careful outlines, draperies
of gay changing tints are characteristic, whilst some heads are not
absolutely unpleasant to look at. The style is a mixture of that of
Daddi and Parri, less able than that of the Santa Croce frescoes by
the former, more talented than that of Spinello's son. Scenes from the
life of St. Cecilia recently rescued from whitewash in the chapel of the
sacristy of the Carmine at Florence, partake of the same character.

In Arezzo the ceiling of the choir in San Francesco is adorned with
the four Evangelists and their symbols. These Vasari assigns to
Lorenzo di Bicci,[2] but as he confounds invariably Lorenzo di Bicci with
Bicci di Lorenzo, one cannot say which of the two he intends. The
figures are long and slender, easily draped in festooned vestments.
Though a general resemblance may be found between them and the
frescoes at Prato and the Carmine, they are handled in a more modern
style, and make a near approach to the certain works of Bicci di
Lorenzo. Vasari, as we have seen, assigns these to Lorenzo di Bicci,
adding that the painting of the chapel was completed by Piero della
Francesca after he left Loretto for fear of the plague. It is on record
that the plague raged at Loretto in 1447–52. Bicci di Lorenzo was

[1] In the ceiling four evangelists, and in the thickness of the entrance wall eight
half-figures of prophets, complete the decoration of the chapel.
[2] VASARI, ii., p. 56.

then just dead (1452), so that the probability is Piero della Francesca
succeeded him, and not Lorenzo di Bicci, as Vasari would have us
believe, in the Cappella San Jacopo at Arezzo. If, however, this work
at Arezzo has a general resemblance to older paintings such as those of
Prato and the Carmine, it is possible that the latter may have been by
Lorenzo di Bicci, whom Vasari in this case, as in so many others,
confounds with Bicci di Lorenzo.

Bicci's birth has already been given; the following is a cata-
logue of his works, most of which Vasari assigns to Lorenzo.

In 1420 he painted for Bartolommeo di Stefano di Poggibonsi an
altarpiece for Sant' Egidio of Florence. In 1421 he painted scenes
from the life of St. Laurence in Santa Lucia de' Bardi. In 1423 he
sent to Empoli a picture ordered by Simone di Specchio. In 1424
he was registered in the guild of painters at Florence,[1] and he pro-
duced in terra-cotta a Coronation of the Virgin, now above the portal
of Santa Maria Nuova,[2] and the twelve apostles inside the same
church. In the same year he painted in fresco the outer sides and
façades of Sant' Egidio, representing there the consecration of the
church by Pope Martin V.[3] In 1425 he finished frescoes in the
chapel of Niccolò da Uzzano in Santa Lucia de' Bardi.[4] About
1427 he painted the initials of Christ, according to the fashion of
S. Bernardino, on the church of Santa Croce. In 1428 he commenced
the chapel and altarpiece of the chapel of Conte di Perino Compagni
in Santa Trinità[5] of Florence, with the assistance of one Stefano
d' Antonio. St. Cosmo and St. Damian, formerly on a pilaster in Santa
Maria del Fiore, and now in the Uffizi,[6] were done on commission from
Antonio della Casa about 1429. In 1430 Bicci began a series of
frescoes in San Benedetto de' Camaldoli, representing S. Giovanni
Gualberto and six incidents of his life; and he produced an altarpiece
for Ser Ugolino Pieruzzi.[7] In San Marco he decorated (1432) the

[1] GUALANDI, vi., p. 178.

[2] Assigned by VASARI to Dello (ii., p. 147).

[3] Assigned by VASARI to Lorenzo (ii., p. 55).

[4] Assigned by VASARI to Lorenzo (ii., p. 54).

* [5] Not at S. Trinità, but at S. Marco.

[6] No. 45. In the first corridor. In a predella are two scenes of the saints'
lives.

[7] With the assistance of Stefano d' Antonio and Bonaiuto di Giovanni.

chapel of the heirs of Ser Martino Martini, and he painted the chapel
of the Compagnia del Tempio in the church of the Camaldoles.[1] In
1433 Francesco Galigai commissioned him to paint his chapel in Santa
Croce. In 1438 he furnished an altarpiece for the chapel of Donato
Barbadori in Santa Felicita, and executed the frescoes in the chapel of
the Beata Giovanna at Signa. In 1439 he executed the design for the
tomb of Luigi Marsili in Santa Croce ;[2] in 1440, figures of apostles and
saints in a chapel of Santa Croce ; and in 1441, again in this church, the
Incredulity of St. Thomas and a colossal St. Christopher for Tommaso
and Leonardo Spinelli. He assisted Domenico Veneziano in the great
chapel of Sant' Egidio. In 1445 he began to paint at Arezzo ;[3] and in
1452 died at Florence and was buried at the Carmine.[4]

Of all these works some, as has been seen, remain. In the
St. Cosmo and St. Damian of the Uffizi the colour is a little
sombre, and wants relief, but the outlines are careful, and, though
in the same style, are more modern in appearance than those of
Prato and the Carmine. Of the other works in Santa Maria del
Fiore the saints beneath the windows of the chapel are in part
repainted, in part renewed altogether. The apostles in pilasters
noticed by Vasari have perished.[5] The terra-cotta above the
portal of Santa Maria Nuova or Sant' Egidio, as it is now called,
exists ; those originally inside the edifice are gone. To resume,
Bicci di Lorenzo shows himself connected with the schools of
Daddi and Parri Spinelli. None of the works assigned by Vasari
to Lorenzo di Bicci are by him, but, on the contrary, by his son.
Neither deserves to be classed above the third-rate artists of their
country.

As for Neri di Bicci, he brought art to the level of a trade, and

[1] Again with the aid of Stefano d' Antonio.

[2] Assigned by VASARI to Lorenzo (ii., p. 56).

[3] We may thus quote of Bicci di Lorenzo the joke arising from his rapidity of
hand applied by BALDINUCCI (*Opera*, iv. p. 508) to Lorenzo di Bicci : "Fill the
porringers (for dinner), I shall paint a saint and come."

[4] These facts are all taken from the *Gior. Stor. degli archivi Toscani*, *u.s.*
(3rd Quart., 1860), pp. 3–10.

* They are all to be found in the *Commentario alla vita di Lorenzo di Bicci* in
the Sansoni edition of VASARI (vol. ii., pp. 63–90).

[5] VASARI, ed. Sansoni, ii., p. 55.

his shop was that of a house painter. He has left a diary of his daily occupations, from which may be found large extracts in a good commentary to the life of Lorenzo di Bicci in the Sansoni edition of Vasari.[1] His numerous altarpieces and pictures merely prove that he knew the mechanical part of his business; and his industry was so great that he filled half Tuscany with pictures at the time when Ghiberti, Donatello, Paolo Uccello, Masaccio, and Angelico laboured. Those who should still desire to study his manner may look at his masterpiece in the cloister of old San Pancrazio at Florence, representing S. Giovanni Gualberto enthroned between ten saints in seats.[2] The abbot of San Pancrazio kneels at one side (the left), the scene being laid in a circular chapel. Two medallions above contain saints holding scrolls, and two curtains which hang in festoons at each side of the picture are inscribed with the names of the saints within. Though restored, this is a fair specimen of Neri's manner. S. Giovanni Gualberto is not without character, but the forms and details are false, the extremities ill-drawn, the movements exaggerated. A sad colour pervades the whole; and in general it may be said that Neri's work is flat, raw in tone, unharmonious, and mechanical. There are no less than four Annunciations by him in the Academy of Arts at Florence,[3] and numbers of pictures in churches besides.

[1] VASARI, ii., pp. 63–90.

* [2] Neri has left an account of this work in his notebook. He engaged to paint it on March 1st, 1454.

* [3] In the Academy as rearranged are to be found only two Annunciations by Neri di Bicci. They are both in the Sale di Beato Angelico e di altri maestri. One of them is in Sala Prima, No. 22, the other in Sala Terza, No. 28.

A large altarpiece by Neri di Bicci is in Lord Crawford's collection, and is now at Haigh Hall, Wigan. There is also a Madonna and four saints by the same master in the Wallraf Museum at Cologne.

CHAPTER XVII

ANTONIO VENEZIANO

THE gradual transformation of Giottesque art and its final disappearance in the fifteenth century at Florence is a very interesting subject of study. Giottesque art spreads at first over all Italy, and has strong representatives in the north as well as in the south of the peninsula. It descends with little or no variety to at least two generations of men of one family, all of whom are able representatives of the style of the great masters. It decays rapidly when practised by inferior disciples; but it assimilates new elements when practised by innovators of skill and power. Insensibly it gives out varieties under the influence of new studies based on a renewed appeal to nature, as distinguished from a servile clinging to traditional lessons. The steps by which progress is made are at first almost imperceptible. They begin to leave a distinct mark behind them at the close of the fourteenth century, and they lead to complete emancipation at the opening of the fifteenth.

We have had some evidence of the spread of new ideas and methods in Giovanni da Milano and Orcagna. Similar evidence will be found in the lives of Antonio Veneziano and Starnina, who are the direct precursors of Masolino, Masaccio, and Fra Giovanni of Fiesole.

It is not of importance to inquire, as Tuscan historians have done, whether Antonio Veneziano was bred to art in Central Italy. His name and parentage are written in Pisan and Sienese records, where he is called Antonio Francisci de Venetiis. In an altarpiece of small artistic merit, which we shall presently study at Palermo, he inscribes himself: " An(to)nis Lon(?ghi) da

279

Vinexia."[1] The earliest date in the narrative of his life is 1370,
at which period he was noted as the companion of Andrea Vanni
and painter of a ceiling in the cathedral of Siena.[2]

Vasari tells us that he was a Venetian who studied at Florence
under Agnolo Gaddi, and then tried his fortune as a master in his
native city. But an envious faction found fault with work which
he had been commissioned to execute in the hall of the great
council, and this induced him to resume his residence at
Florence.[3] The name of Antonio appears in no Venetian
documents, and we have no means of testing the accuracy of
the statement that he was employed by the Venetian Govern-
ment. At Florence his name is on the register of the barber
surgeons in 1374,[4] which is a later date than that of his
employment at Siena.[5] Frescoes which Vasari assigns to him
in the cloisters of San Spirito and Sant' Antonio al Ponte alla
Carraja at Florence have perished, likewise the predella of an
altarpiece in San Stefano al Ponte Vecchio in the same city.[6] It
is not quite certain that Antonio was a disciple of Agnolo Gaddi.
They were certainly contemporaries, and an attentive examination
of Antonio's frescoes at Pisa will show that he was a worthy
competitor of Giovanni da Milano and Giottino. One of his
manifest peculiarities is want of power as a composer and want
of selection in the definition of form. He had not much religious
feeling; but his observation of nature is conscientious and search-
ing for an age in which conventionalism was habitual. It is

* [1] See *postea*, p. 288, note 1.

[2] MILANESI, *Doc. Sen.*, *u.s.*, i., p. 305. These paintings no longer exist. A
fresco of the Nativity in the chapel of San Giuseppe in the convent of San
Francesco at Osimo is assigned to a painter called Antonio da Venezia; but the
treatment shows an artist of the sixteenth century, who must be distinguished
from his namesake of the fourteenth century.

[3] VASARI, ed. Sansoni, i., p. 662.

* [4] Another Antonio di Francesco matriculated in the Arte dei Medici e Speziali
on February 7th, 1382. Tanfani-Centofanti says that it is doubtful to which of the
two artists the Pisan documents refer; for the reason that Parasone Grasso, in his
Memorie, always speaks of Antonio as "da Fiorensa." But to us it seems there is
really no difficulty. In the books of the Opera del Duomo he is always spoken of
as "de Venetiis." Grasso speaks of the artist's adopted country, the place he came
from. The scribe of the Opera del Duomo, writing more formally and accurately,
gives the artist's native country.

[5] *Ibid.*, xiv. TAVOLA, *Alfab., ad lit.* [6] VASARI, *ed. cit.*, i., p. 663.

in this striving that we observe a progress which explains the gradual expansion of art in Masolino, Masaccio, and Angelico. Vasari says truly of Antonio Veneziano that he was a close student of emotional movement and a successful delineator of action and gesture, calculated to show persons depicted as moved or conversing.[1] He was also a master of the technica of his art, equalling the best disciples of Taddeo Gaddi in clearness, brightness, and transparence of colouring, and surpassing them in such methods of glazing and toning as afterwards distinguish Masolino and his contemporaries.

It appears from records that Antonio, on April 10th, 1386,[2] received 135 florins of gold from the superintendent of the office of works at Pisa on account of three stories of the life of San Raineri at the rate of seventy florins for each story.[3] This saint was in great honour at Pisa, where he lived in the twelfth century, and the early scenes of his legend had been illustrated on the walls of the Campo Santo, by Andrea of Florence, before Antonio was called to Pisa.

That portion of the story which refers to the saint's departure

[1] VASARI, i., p. 664.

* [2] In the account books of the Opera del Duomo at Pisa and in the *Memorie* of Parasone Grasso, *Operaio*, are to be found entries which range from December 7th, 1384, to March 28th, 1386 (common style). The two following from Parasone's *Memorie* are interesting :—

1. "Maestro Antone di Franciescho dipintore da Fiorensa lo quale dipingie in chaposanto la storia di santo Ranieri de' dare a di y di dicienbre 1385 fiorini dodici d' oro li quali diei per lui ad Aldrobandino spesiale per uncie vij d' azurro portòleli ser Giovanni fattore dell' opra a bottegha sua" (Arch. di Stato, Pisa, *Arch. dell Opera del Duomo, Memorie . . . di Parasone Grasso*, reg. 60, c. 18).

2. "Maestro Antone di Franciescho dipintore da Fiorensa lo quali dipingie in Chaposanto la storia di santo Ranieri de' dare a di vij di giugnio 1386 fiorini tre d' oro li quali li prestai soprascritto di in fiorini nuovi portò Checco suo figliuolo" (*Memorie cit.*, c. 35).

This last entry shows that a son of Antonio named Francesco worked with him at Pisa. The following entry in the *Libri d'entrata e uscita* of the Opera del Duomo proves that he was helped by two assistants :—

"Magister Antonius Francisi pictor de Venetiis habuit et recepit die suprascripta (21 Aprile), [a] suprascripta domino operario dante ut supra, pro se, Johanne et Piero discipulis pro diebus sex quibus laboraverunt ad pingendum in camposanto, ad ractionem librarum trium et soldi unius pro quolibet die, libras decemocto et soldos quactuor denariorum pisanorum."

[3] CIAMPI, *u.s.*, p. 151: and FÖRSTER, *Beiträge*, pp. 117, 118.

from the Holy Land, his arrival, miracles, and death at Pisa was represented by Antonio, and is described by Vasari as the finest and best work in the Campo Santo.

Of the embarkation, which is the first incident in the series, little remains.[1] The landing is then imagined as having taken place. On the shore an angler sits fishing. The saint performs the miracle of the wine and water. The host[2] starts back surprised as he sees the water separating from the wine, which he pours into the flap of Raineri's dress; and the saint, pointing to the devil on a cask, seems to threaten the host with eternal flames for his dishonesty.[3] A dame kneels to the spectator's left of Raineri, an old man sits to the right pensive, whilst a group of persons of both sexes stands around. The dame, of a graceful shape, is an accurate study of nature, and reveals a careful search for truth of form even in details. The saint has regular and pleasing features, and the remaining figures form a group full of interest. The aged man sitting pensive in the foreground wears a sort of turban, and reminds us of work by Taddeo and Agnolo Gaddi. As the angler parts the group of the miracle from that of the embarkation, so the pensive old man separates that of the miracle from a third scene, in which the canons of Pisa give hospitality to Raineri. The scene is an elegant verandah supported by slender pillars, in which a table is laid, at the head of which, to the right, Raineri sits in the act of benediction. Three guests are at the board, which is served by three or four monks, one of whom is seen coming down a flight of steps with a dish in his hand. Two fowls hang from a nail on the landing. The architecture of the verandah and of the convent on which it leans is careful, and the forms are made out with sharpness and precision. All the knowledge of perspective attained in Antonio's time is embodied in the buildings of the foreground and in the distant edifices of Pisa.[4] The science is not as yet matured, the true horizon is unascertained,

[1] But the outline of the figure of Raineri, two camels, and part of the buildings of a city. In the air may still be noticed the Redeemer in a circular glory pointing out to the saint the direction of his journey. On the sea beneath, a barque in full sail runs before the wind, and contains Raineri and five mariners in various and lifelike attitudes. The head of S. Raineri is, however, obliterated, and, with the exception of a mariner near the saint, the remaining figures are repainted.

[2] Vasari, who writes from memory, naturally conceives the host to be portly.

[3] The devil is represented in the shape of a cat, but this figure is repainted.

* [4] The architecture of Antonio's backgrounds merits the most careful study. In the second picture of the series are representations of the church of San Vito, of the Campanile, and of the Duomo. In the third the Pisa Baptistery is introduced.

yet the converging lines make as near an approach to the truth as could be expected at a period still distant from that in which Paolo Uccello strove to found the science upon a positive geometrical basis. The embarkation, landing, miracle, and entertainment of the saint are all episodes placed side by side within the compass of one painted frame. The next is devoted to the incidents of Raineri's death and his transfer to the cathedral of Pisa. Grief is well rendered in the group on the extreme left which surrounds the corpse of the saint. He lies at length in his pilgrim's skin, completely visible to the spectator except where a figure stoops over his right hand for the purpose of kissing it. On the opposite side another of his followers applies his lips to the left hand, and about the head a group of clergy and people is massed in natural attitudes and animated expression. A monk, bending forward, blows upon the coals of a censer; another holds the vase with holy water. Nearer the saint's feet an aged friar is helped forward with difficulty by one of fewer years, and seems beyond measure desirous of gazing at the features of the departed. A little in front of him a dropsical woman has been led by her mother to Raineri's feet. Her hands are raised and she looks up, grief and wonder commingled in her face. She evidently breathes with difficulty. Her forms are handsome, though swollen by disease, youthful, and in good contrast with the weather-beaten and timeworn ones of her mother, who stoops over her. The careful study and reproduction of nature in its singularity is excellent, and foreshadows the art of Masolino at Castiglione and of Masaccio in the Brancacci chapel at Florence. Nor is Antonio's attention confined to the rendering of living forms. In the frame of Raineri he imitates the aspect of a dead man whose calm features are relaxed by the absence of life-blood, whose jaw and eye have sunk, and whose body has not as yet become a cold and stiffened corpse. Here, indeed, we see the source which Starnina must have consulted, which Angelico and Masaccio drew upon. Here the key of their education is to be found.

Above the distance of houses and the steeple of the cathedral[1] appears the vision of Raineri, carried to heaven by the angels. Next comes, on the centre foreground, the saint carried on a stretcher and accompanied by magistrates and clergy to his final resting-place. Vestiges of players at the head of the procession may be discerned. Behind the body, to the left, three persons in grave converse proceed, and their faces as well

*[1] The vision of S. Raineri borne to heaven is above S. Vito, not above the steeple of the cathedral.

as forms are amongst the best productions of the time. A group of children in rear, again, is less happily rendered, the idea of youth being incompletely given. In a gallery forming the upper part of a house in the distance, the episode of Archbishop Villani's cure from sickness is depicted, and to the right leans the well-known campanile. In the third fresco, Raineri is exposed to public worship under a daïs in the Duomo. To the right a crowd kneels or sits; a female, evidently possessed, tears her dress and shrieks.[1] Near her a woman holds a sick infant, and there are traces of other figures.[2] The rest of the fresco, which has almost perished, is separated from the foregoing by the walls of the city of Pisa. A group of fishermen, humble worshippers of Raineri, angle in the foreground. In the distance are remains of a vessel tossed by the waves, whose crew are casting merchandise overboard, an episode related of a barque owned by one Uguccione, who saved it by appealing to Raineri as his patron saint.[3] The nude of the fishermen, their various age and action are given with some realistic truth. In the flesh and muscles, as in the extremities, the painter reveals a conscientious study of nature, whilst in the choice of square and unnoble form Antonio imitates, without attempting to idealise, nature.

Throughout the whole of these frescoes the figures are simply, but less grandly cast than those of the fine Giottesques, for instance, of Orcagna. More numerous folds and a greater study of their detail may be noticed, yet without detriment to the under forms. The nature of the stuffs is distinctly shown, and the flexibility of the thinner sort of textile fabrics worn by females is marked. It is a further peculiarity of Antonio, that his draperies cling and give to his shapes more than usual slenderness. The feet and hands are accurately drawn.

Antonio paints with light transparent and not tasteless combinations of tone; originally prepared of a light greenish grey, the flesh tints are put in with a body of rosy yellow, the shadows with thin warm glazes, the masses of light with broad, bold

[1] Her name, "Galliena indemoniata," may still be traced in the inscription at her feet. This figure is by Vasari transferred into the first fresco, whilst he introduces here the dropsical maid of the second.

[2] The names of these persons may be seen in ROSINI's *Descrizione delle Pitture del Campo Santo* (3rd ed., Pisa, 1829), pp. 88, 89, etc.

[3] The figure of S. Raineri may be traced as an apparition near the mast of the vessel.

touches. Each preparation is gently blended with the other, so that no abruptness mars the effect. A light gay tint marks the draperies, the reds tending to a soft rosy hue with lights resolutely touched in white, and shadows glazed of a deeper tinge, the outlines being strongly marked at last to complete the whole.[1] The utmost care was evidently applied to the mixture of the colours; and this confirms what Vasari says, that Antonio deeply studied the medicine or chemistry of the time.[2] Painters, indeed, were, as we have seen, usually members of the guild of Speziali in the fourteenth century, and it is obvious, from the study of the history of the period, that most painters had laboratories for the working up of chemical substances.[3] The disadvantage of Antonio's gay and lucid tones is their flatness. Lights and shadows are feebly defined, and the great quality of relief is wanting. The shadows are clear and transparent and too much confined in their surface, and these defects Masolino inherited, Masaccio alone avoiding them and mastering the perfect laws of balanced light and shade.

A glance at the frescoes of the ceiling in the Cappellone dei Spagnuoli in Santa Maria Novella may now be interesting. There the slender forms, encased in clinging draperies, the vestments themselves detailed in fold, the soft type of the heads, recall to our memory their counterparts in the Campo Santo of Pisa. That in the ceiling of the Cappellone the Giottesque spirit of Taddeo Gaddi, without his masculine forms, prevails, that the breadth of light and shade peculiar to the Florentine is absent, that the draperies betray a certain research in the definition of folds and are less firm than those of the first Giottesque, has already been remarked. Further, that softness of expression, light tender colour, and careful drawing of extremities are marked features, is certain. All these particularities reveal Antonio as possibly the author of the ceiling of the Cappellone; and it is not too

[1] The same process was used in the blues, whilst at times shot dresses were painted rose in shadow, yellow in light.

[2] VASARI, ed. Sansoni, i., p. 667.

* [3] On the chemistry of mediæval methods, consult Mrs. Herringham's edition of CENNINI's *Trattato* (London, Allen, 1899), and BERGER, *Beiträge zur Entwickelungsgeschichte der Maltechnik*, part iii., Munich, 1897.

much to assume that he decorated it previous to his visit to Pisa.[1]

The faults which Antonio displays by no means overshadow qualities which mark him as a man of superior genius not only in his own, but a subsequent age. Vasari truly said of the Pisan frescoes that they were the finest in the Campo Santo. They justify the assertion that, as regards artistic talent, Antonio Veneziano surpassed Benozzo Gozzoli. He was, as Vasari says, an excellent fresco painter;[2] and a careful examination of his work will prove that he disdained retouching a *secco*;[3] the damage done to his transparent colours arising from retouching and the damp which removed tones and intonaco.

Antonio himself was not only a painter but a restorer of the frescoes in the Campo Santo. He appears in the records of 1386–7 as the designer of the borders of many framings inclosing a Purgatory, an Inferno, and a Paradise.[4] According to Vasari[5] he executed anew " the body of the 'Beato' Oliverio with the abbot Panunzio, and many incidents of their life, in a 'cassa' of feigned marble beneath the frescoes of hermit life by the Sienese Pietro Laurato." It is quite easy to trace the portion of Lorenzetti's fresco repainted by Antonio, and beneath it the figure of the Beato Giovanni Gambacorti (whose remains are said to be

[1] It would be well to assign the section of the ceiling in the Cappellone devoted to the subject of the Ascension to another and less able hand.

* [2] VASARI, ed. Sansoni, i., p. 666.

* [3] This statement, though approximately true, is not altogether true. A careful examination of Antonio's frescoes discloses the fact that he did make a very limited and occasional use of painting a *secco*, as did the most orthodox exponents of the art of fresco-painting. This passage deserves careful study. Vasari is most interesting to the student when he discusses questions of technique and method. In regard to technique Antonio was not a radical, a daring experimenter like Baldovinetti or Leonardo ; nor was he a reactionary, as were some of the Sienese of the Quattrocento ; he was a progressive conservative, using and developing the good methods of Giotto. His art, in fact, is in more ways than one an important link in the somewhat feeble chain that links Giotto to Masaccio. We doubt not that one of these days some new critic will "discover" Antonio Veneziano. If only such discovery makes a real addition to our knowledge of him, all students of the history of Italian painting will be grateful to him.

[4] CIAMPI, *Not. Ined.*, *u.s.*, p. 151 ; and FÖRSTER, *Beiträge*, pp. 117, 118.

[5] VASARI, *ed. cit.*, i., p. 666.

buried within the wall itself[1]), between two flying angels.[2] Above this three hermits, two of whom sit at work, whilst the third is in a pensive attitude near a pool swarming with fish, are by Antonio, as well as the figure of St. Panunzius sitting in a palm tree. The latter figure is much damaged, but the remains exhibit the technical style, the character, peculiar to Antonio. Yet the Venetian, having to restore the work of Lorenzetti, which differed entirely from his own, repeated the original composition, producing in consequence a certain energy, wildness, and angularity of form, imitative of the Sienese manner. The drapery and extremities followed original lines different from those which he might have produced in a work of his own, and as regards colour, he strove to rival the warm vigour of the surrounding figures. The technical method, however, was entirely Antonio's, the intonaco having been renewed for him after the removal of a wooden sepulchre, which, for a time, covered the spot.[3]

In August of the same year, 1386-7, in which the frescoes of San Raineri were completed, Antonio painted an altarpiece for the chapel of the organ in the cathedral of Pisa, which has unfortunately disappeared.[4]

His picture at Palermo, to which allusion has been made, is dated 1388, and is of interest as having been executed later than the works of Pisa. The company for which it was painted was that of San Niccolò and San Francesco at Palermo, and the picture itself is a gabled square with two medallions at the gable sides containing the Virgin and Evangelist grieving. The rectangular space beneath is adorned with corner medallions, in each of which is an Evangelist. Three vertical pilasters stripe the square, each of which contains four apostles in medallions.[5]

[1] *Vide* Rosini, *Descrizione, u.s.*, p. 57.

[2] One of whom blows into a censer, whilst the other waves a similar instrument.

[3] See also in confirmation of this, Rosini, *Campo Santo, u.s.*, p. 57. This is the more obvious now, as it will be found that Lorenzetti painted on intonaco upon a groundwork of cane, Antonio on intonaco firmly fixed to the wall. As to the painter's portrait, which Vasari mentions as existing in the Campo Santo, it is no longer preserved even by tradition (Vasari, i., p. 668).

[4] Förster, *Beiträge, u.s.*, pp. 117, 118.

[5] In the corners the four Evangelists are depicted with their symbols in medallions. Between the pilasters the names of the deceased belonging to the

In the gable Christ receives the flagellation. The brethren kneel
in groups at the sides with their heads concealed in their cowls.[1]
The figures generally remind us of Taddeo Gaddi, but exhibit the
development of form which characterises the frescoes of the
Campo Santo.[2]

Two pictures in the style of this of San Niccolò may be seen
at Palermo in the palace of the Prince Trabbia,[3] but they are so
damaged as almost to defy criticism.

A Deposition from the Cross, at one time belonging to Mr.
Jervis at Florence, has altogether the character of the works of
Antonio.[4]

The last work of the painter that can be mentioned is a series
of frescoes decorating a tabernacle in grounds belonging to the
family of the Pianciatichi at Nuovoli, outside the Porta a Prato
at Florence. The Deposition from the Cross is depicted at the
bottom, the Judgment, the Death and Transit of the Virgin at
the sides of the tabernacle, but a great part of the principal scene
is now obliterated; and vestiges only of the others are preserved.[5]

At the right side of the arch of the tabernacle are traces of
nude figures rising from the earth, above which a female, partly
naked, covers with the folds of a white mantle a multitude of
small sinners.[6] So far as one can judge from the imperfect

company are inscribed. The whole painted in tempera on panel. Ground, gesso,
beaten upon parchment.

* [1] Monsignore di Marzo points out that the only legible letters in the first part
of the inscription on this picture are AN and LO ; and that the inscription as it
stands reads, on the one side AN . . . LO . . . , and on the other side DA VINEXIA
PINX A careful examination of the inscription shows that Di Marzo is right.
The illegible letter after LO is certainly not N. There is no ground, then, for the
assumption that the artist's name was Longhi. See DI MARZO, *La pittura in
Palermo nel Rinascimento*, pp. 48, 49.

* [2] I have to thank Mr. S. A. J. Churchill, His Britannic Majesty's Consul-
General for Sicily, for making the arrangements for the photographing of this
picture. Mr. Churchill confirms Di Marzo's statements in regard to the inscription.

[3] To whom, as well as to the Conte Tasca, public thanks are here tendered for
their kindness and assistance.

* [4] Signor Cavalcaselle denies that this picture is by Antonio Veneziano.

[5] In the Gallery of Modena an Annunciation and a Visitation are assigned to
Antonio ; but they are German, and probably Westphalian pictures.

[6] In the upper space again remains of heads of angels and apostles may be seen.
The Virgin in a glory, supported by six angels in the side to the left, is evidently
part of a subject, of which traces may be found lower down, as a tomb round which

preservation of this work, it is a careful study of form, less perfect in the extremities than others of Antonio, and somewhat feebly realistic; but the heads are fine, and are drawn with broad, open brows; the details of hair are minutely rendered as they were later by Masolino and his school. The colour seems to have been of a vigorous local tone, and the execution displays the care and boldness of a finished artist. Qualities akin to those of Giottino[1] may be traced in this as in the choice of certain types; but the perfection of the Campo Santo frescoes seems not as yet to have been attained. The tabernacle was painted by Antonio, says Vasari, for Giovanni degli Agli, of a Florentine family, which has either disappeared or lost its old possessions. Antonio was employed by the Acciaiuoli, in the Certosa of Florence, to paint an altarpiece, and a fresco of the transfiguration, which have perished. Vasari errs in affirming that he died in 1384, aged seventy-four.[2] Two years later he was still labouring in the Campo Santo.

figures stand, in whose faces one may still discern marks of grief. In the vault of the arch the Saviour sits with the book, in the act of benediction, between the four Evangelists.

[1] That is, of the works assignable to the last half of the century.

* [2] VASARI, ed. Sansoni, i., p. 667. In August, 1387, Antonio Veneziano was living in Pisa. See TANFANI-CENTOFANTI, op. cit., p. 40.

CHAPTER XVIII

GHERARDO STARNINA AND ANTONIO VITE

THE link which should connect the art of the Giottesques of the fourteenth century with Masolino and Angelico is unfortunately missing, because of the total loss of the works produced by Gherardo Starnina, whom Vasari describes as an apprentice and disciple of Antonio Veniziano. But it appears, beyond a doubt, that Starnina bequeathed his art to one of his pupils called Antonio Vite, and some clue to the style of the first may be found in the works of the second. Gherardo was born at Florence in 1354,[1] and having mastered design and painting under Antonio Veneziano, he settled in Florence, where, in spite of rude manners and a hot temper, he found patrons. Not long after the completion of a series of frescoes in the chapel of the Castellani at Santa Croce, which he executed for Michele di Vanni, the disturbances of the Ciompi (1378) occurred at Florence, and Starnina became involved in them. In danger of his life, he retired and journeyed under the protection of certain merchants to Spain. In 1387 he again resided in Florence, where he took the freedom of the painters' company.[2] He decorated the chapel of San Girolamo at the Carmine, in which he introduced Spanish costumes and displayed a certain versatility of humour.[3] He executed, in 1406, at the top of the steps leading from Santa Maria sopra Porta to the Palazzo della Parte Guelfa, a fresco

[1] VASARI, ed. Sansoni, ii., p. 6.

[2] He appears in the Libro de' Pittori in 1387, as "Gherardo d' Jacopo Starna depintore." GUALANDI, u.s., Ser. vi., p. 182.

[3] ALBERTINI, *Memoriale, u.s.*, p. 16. He died at the age of forty-nine, says VASARI (ed. Sansoni, ii., p. 9). But if he was born in 1354 and painted the St. Dionysius in 1406, he must have been older.

* Milanesi held that Starnina died in 1408. See VASARI, ii., p. 9.

commemorative of the sale of Pisa to Florence, representing St. Dionysius between two angels above a view of the city of Pisa. Many other works, says Vasari, were executed by him, and increased his fame, and he might have gained a higher position, but that he died and was buried in San Jacopo sopra Arno at Florence.

The dates we observe are sufficient to show that Starnina might have been a disciple of Antonio Veneziano. Masolino, being the pupil of Starnina, inherited much of Antonio's manner. Hence Starnina must have painted in a style not dissimilar from that of Antonio. Unfortunately, the very first set of frescoes which Vasari assigns to Starnina are to be considered as work of another painter. The Castellani chapel was founded and decorated in obedience to the last will of Michele di Vanni di Ser Lotto Castellani, who died in 1383.[1] Till a very recent period most of its frescoes were concealed under whitewash; but the four doctors and the four Evangelists in the ceilings, which escaped the brush of the whitewasher, were sufficient to show that that portion of the chapel at least was painted by an artist who was not Starnina. Since the recovery of the whole cyclus in 1869, it is more than ever apparent that the true painter of the series is Agnolo Gaddi. On the wall through which the entrance arch gives access to the chapel, there are now two fine figures of prophets with scrolls. The quadrangular space inside is divided into two by an arch on pilasters; but in describing the pictures which fill the courses on the walls we shall neglect this division and register the subjects as they appear when seen in a progress from left to right.

Inside and about the entrance arching is the Martyrdom of a Female Saint (lunette), beneath which is the Temptation of St. Anthony. To the right of the latter the miracles of St. Nicholas are illustrated in a lunette and two lower fields of compositions; whilst episodes of the life of the Baptist, beginning with the Annunciation to Zachariah, in a lunette fill the next series of courses. The wall in rear of the altar contains two scenes from the life of John, and two from that of St. Nicholas. The side wall to the left is almost exclusively filled with incidents from

[1] See the statement to this effect in ULDERIGO MEDICI's *La Chiesa di Santa Croce e il Municipio*, Florence, 1869.

the legends of St. Anthony and the hermits of the Thebaid Desert, one of the lunettes only comprising the Vision of Patmos on the lines of Giotto's composition in the Peruzzi chapel.

Judging of this series solely from a technical point of view, we shall observe that the whole series bears the impress of the hand of Agnolo Gaddi and his assistants, being more careful and more finished than the large and highly decorative cyclus in the choir of Santa Croce. We cannot, for this reason, accept Vasari's theory as to the authorship of Starnina, unless we affirm that Starnina was an exact adopter of Agnolo Gaddi's style.

A figure of a prophet in a recess of the Castellani chapel is represented in flight and holding a scroll on which Hebrew lines are inscribed. It is of a later date than the doctors and èvangelists of the ceiling, but being much damaged, no longer displays much relationship with the works of Antonio. The St. Dionysius, although in existence at the time of Baldinucci and described by Richa, is now obliterated.[1] In Spain no vestige of Starnina's works is to be seen.

A clue may perhaps be found to Starnina's manner if we examine critically the frescoes of Antonio Vite, whom Starnina once sent in his stead to paint the chapter-house of San Niccola at Pisa.[2]

We are told by Vasari that Antonio Vite executed a series of frescoes in the Palazzo al Ceppo at Prato.[3] Time has obliterated these paintings, but it is perhaps necessary to bear in mind that no documentary evidence can be found to corroborate Vasari, whilst there are proofs in records that two well-known artists worked at the Palazzo del Ceppo in 1411, and these are Niccolò di Pietro Gerini and the Portuguese Alvaro di Piero, whom we shall have to notice presently.[4] There are, however, frescoes in a chapel opening into the right transept of the cathedral of Prato which sufficiently illustrate Vite's manner.

¹ BALDINUCCI, u.s., iv., p. 516; RICHA, Chiese, iii., p. 252.

² VASARI, ed. Sansoni, ii., p. 8. These paintings in San Niccola represented scenes from the Passion ; they do not now exist. They were painted, according to MANNI (Notes to Baldinucci, iv., p. 537), for Giovanni dell' Agnello in 1403, and inscribed ANTONIUS VITE DE PISTORIO PINXIT.

³ VASARI, ed. Sansoni, ii., pp. 8, note, and 26.

⁴ See G. GUASTI, Memorie di Maria v. del Soccorso (Prato, 1871), p. 45 and postea.

According to Ciampi, Vite "completed the chapter-house of San Francesco at Pistoia which Pucci Capanna had left unfinished," and painted frescoes at Sant' Antonio Abate in the same city; unfortunately the remains which are still visible in that edifice[1] are not all by the same hand. In the ceiling, now divided into three parts by the reduction of the edifice to the form of a dwelling-house, the Saviour is depicted in glory presiding over Paradise; and above him, the signs of the Zodiac are represented. This much-damaged painting is by a feeble artist of the close of the fourteenth century, educated under Orcagna. But in other parts of the edifice, the creation of Adam and Eve, scenes from the life of the Virgin and the Saviour, and from the legend of St. Anthony, are also produced by one whose feeble style is repeated in the ceiling of the chapter-house of San Francesco. It has already been observed, when treating of Puccio Capanna, that these are feeble productions; and certainly the long, lean figures are ill calculated to arrest attention.

Yet these feeble works are of interest, because other somewhat similar productions may be seen in the chapel of the cathedral at Prato, to which reference has just been made.

The two walls of this chapel are divided into three courses of single frescoes. On the lunette at one side is the Birth of the Virgin, and beneath, the Presentation in the Temple and the Marriage of the Virgin; on the lunette of the other, the Dispute of St. Stephen, and beneath it the Stoning and wail over the saint. In the triangular sections of the ceiling, four figures symbolise fortitude, hope, faith, and charity; and in the vault of the entrance, four busts of saints are placed.[2]

Of all these frescoes, three—the Marriage of the Virgin, the Stoning of Stephen and the wail over his body—and the whole of the frames and medallions, are by a rude artist of the fifteenth century, whose style recurs in the scenes from the Old and New Testament and from the life of St. Anthony in Sant' Antonio of Pistoia. Having thus ascertained that Antonio Vite is a fourth-rate artist, it is of comparatively little interest to notice the few facts recorded of his life.[3]

[1] It is now No. 35, Piazza San Domenico at Pistoia.

[2] One of them St. Paul. In the painted frames are busts of prophets.

[3] See TOLOMEI (Guida), *u.s.*, p. 116, also MILANESI, *Doc. Sen.*, *u.s.*, i., p. 48. It will suffice to remark that the works of the Campo Santo at Pisa, *i.e.* scenes from

Neither frescoes of Vite in the chapel of the Duomo at Prato have an interest beyond their artistic value. They are the continuation of a series in part completed by another and abler painter. Without presuming to affirm that Starnina was originally employed to execute this work, it seems natural that Vite should be asked to finish what his master had left incomplete. The Birth of the Virgin, the Presentation in the Temple, and the Sermon of St. Stephen are frescoes which invite study. They are less attractive at a first glance than they become on a closer inspection. They are evidently the production of one of those artists who devoted themselves to the analysis and study of form and its appearance in perspective, and who belonged to that important class which led up to Ghirlandaio. The artist was a student of the anatomy of form like Paolo Uccello, Piero della Francesca, the Peselli, and others. In a composition of ten figures grandly distributed in the lunette, he represents the birth of the Virgin, and shows that he inherited the classic Tuscan style. In four figures of females advancing with offerings, we remark a certain realism in the profiles of the heads, but at the same time some of the characteristics which distinguish a similar incident in the Ghirlandaio frescoes of Santa Maria Novella at Florence. Whilst a certain affectation of bearing reminds us of the creations of Paolo Uccello or Piero della Francesca, the costumes and character are those of the rise of the fifteenth century. The chief interest of the piece lies in the composition and its combination with types less remarkable for beauty than for a realistic display of human form. Great elasticity and firmness of step may be found in a female figure, of slender and graceful stature, descending a flight of steps. St. Anna in bed washing, and attended by a maid pouring water over her hands, a female in the centre of the middle distance holding the new-born infant, are more in the feeling and habits of the fourteenth century. A

the Passion and the Crucifixion, by some assigned to Buffalmacco, though feeble productions, are yet not by Vite. Vasari dates the frescoes of the chapter of San Niccolò at Pisa, 1403. Tolomei states that Antonio lived as early as 1347, that he was of a family established at Lamporecchio, and that he was of the council of Pistoia in 1378. Della Valle supposes him to be the same who appears in 1428 under the name of Antonio di Filippo da Pistoia in the register of Sienese painters.

grand and finely draped figure, kneeling in the right foreground of the fresco of the presentation in the temple, exhibits all the intelligence of form that one might expect from the later painters above mentioned. The colourless head proves to have been prepared with the bluish grey common to this time; and a similar feature may be noticed in two figures standing to the right of the kneeling one on which the soft manner of Masolino is impressed. The painter's power in composition, his firmness in design, his relationship to the artists already named, may be further traced in the next lunette scene, where St. Stephen, with outstretched arms, preaches to an unruly crowd in front of a temple. The grandeur of certain figures, such as that of an old man in profile withheld by another from attacking the dauntless saint, cannot be denied. The technical process is here again revealed in parts which have been deprived by time of their colour. The bluish-grey preparation of rough texture has been laid bare, and where this has occurred the colour is somewhat weak and flat. But in the parts which are preserved the yellowish flesh tint, glazed with warm transparent tones, is light and clear, though not more relieved than in the frescoes of Masolino.

Combined with a certain originality, these frescoes reveal, as has been seen, a relationship with those of other painters of the early part of the fifteenth century whose connection with Antonio Veneziano through Starnina is asserted. It may therefore be inferred that they are by Starnina,[1] whose talent is celebrated by Vasari in terms of no common praise.[2]

* [1] In the present state of our knowledge it seems to us impossible to attribute any existing work to Starnina, except in the most tentative manner.

[2] We might neglect, but still cannot altogether omit, the following points. Dresden Museum, Nos. 17 and 18. These are circular pictures representing (17) St. Michael, (18) Raphael and Tobias. They are catalogued as by Starnina,* but as far as can be judged in their restored condition seem really to be by some continuator of the manner of Domenico Ghirlandaio or Filippino Lippi.

Florence, Lombardi collection. There was once in this collection a Deposition from the Cross of small dimensions, engraved in Rosini under Starnina's name. It is of the time and school of Cosimo Rosselli.

* The St. Michael and St. Raphael at Dresden are now catalogued as "School of Domenico Ghirlandajo."

CHAPTER XIX

LORENZO MONACO AND OTHER FRIARS OF THE
ORDER OF ST. ROMUALD.

OF the same age as Starnina, and better known than that master, because his works have been better preserved, Lorenzo Monaco inherited the manner of Agnolo Gaddi and Spinello Aretino, and carried into the fifteenth century remnants of Giottesque and old Sienese tradition. He was born at Siena, where he probably took his first lessons.[1]

Lorenzo Monaco's pictures are remarkable for extreme delicacy of outline and careful blending of tints, coupled with incorrect drawing of details and affected slenderness of stature. But, not unfrequently, expression is given with the force of Spinello. Lorenzo Monaco was a friar of the Camaldoles, and he entered the convent of the Angeli at Florence in 1390. Having finished his novitiate he professed on the 10th of December, 1391. His name as a layman was Piero di Giovanni del popolo di San Michele de' Bisdomini, and it is not without interest to note that an artist of that name was on the books of the guild of painters at Florence in 1396. The register of the brethren of his convent seems to confirm that he left his cell to labour in various parts of Italy. According to a recent chronology he painted an Annunciation in the Carmine of Florence in 1399–1400, and went to Rome, where he finished miniatures for Cardinal Angelo Acciaiuoli in 1402. He designed cartoons for glass windows at Orsanmichele

[1] In a book of records of the monastery of the Angels at Florence, to which Lorenzo was affiliated, a passage occurs in which he is called " Lorenzo dipintore du Siena del nostro ordine," and noted as the life purchaser of a house next door to the monastery on the 29th of January, 1414. See Gaetano Milanesi in Appendix to VASARI, ed. Sansoni, ix., p. 252.

of Florence in 1409; and distinct traces of his occupation as a miniaturist, or in the execution of frescoes and altarpieces, can be followed till 1422.[1] The cause of his clinging so long to the customs of earlier Tuscan painters is his choice of the monkish habit, which probably led to his adoption of monkish tradition, especially in miniatures. Though he was born before Angelico, he served that master as an assistant. But he also painted several excellent pictures which survived till our times, though the only work which bears his name is that of 1413 preserved in the abbey of the Camaldoles of Ceretto, between Florence and Siena. It was ordered for the great convent of the Angeli at Florence, and removed in the sixteenth century to the branch establishment of Ceretto, and it is marked by certain peculiarities which enable us to classify others that do not bear a signature. Amongst these we note, in the church of Monte Oliveto at Florence,[2] a Madonna and saints dated 1410, at Empoli, between Pisa and Florence, a Virgin and Child with saints dated 1404. Lorenzo shows himself in the last of these works a finished artist. Hence we may believe that he was born about 1370.[3] He so completely carried the manner of the Giottesques into the fifteenth century that a picture evidently by him at the Academy of Arts at Florence was assigned by Vasari to Giotto; and two of his panels at the National Gallery are still considered to be by Taddeo Gaddi.

The altarpiece in the collegiate church at Empoli represents the Virgin enthroned, with a book in her hand and the infant Saviour clinging to her neck, whilst his fingers are on the book. St. John the Baptist and a youthful saint carrying a sword attend on the left, St. Peter and St. Anthony the abbot are on the right. In the side pinnacles, which are alone preserved, we notice the angel and the Virgin annunciate.[4]

Of equal finish, but falsely catalogued under the name of Gentile da Fabriano, is a small gabled diptych in the Cluny

[1] Compare G. Milanesi's note to VASARI (Sansoni ed.), ii., pp. 18, 20, and 31; Gualandi's register of the Florentine painters' guild in *Memorie*, etc., vi., p. 187.

* [2] This picture is now in the Uffizi.

[3] We saw that Lorenzo Monaco professed in 1391. He could not have done so before he was of age, *i.e.* twenty-one. His birth is therefore antecedent to 1370.

[4] Empoli. The central pinnacle is gone. The figures are half life-size. The date 1404 is on the base.

Museum in Paris, in which there are Christ on the Mount and the Women at the Tomb of Christ.[1]

At Monte Oliveto the altarpiece is large and important.

The Virgin enthroned holds the Child in a standing attitude. Two angels support the tapestry behind her, on the left are St. John the Baptist and St. Bartholomew, on the right St. Thaddeus and St. Benedict, on the angles of the niches are medallions of prophets, in the apex the Eternal, the angel and Virgin of the annunciation.[2]

More important again is the work of 1413.

The form of Lorenzo's altarpieces is that of the fourteenth century, and that of the abbey or Badia of Ceretto, which is fifteen feet high, without the three pinnacles, and twelve feet long, is a triple gable on pilasters resting on a pediment. In the pediment the Adoration of the Magi and the Adoration of the shepherds are side by side in the centre, with two scenes from the life of St. Bernard on each hand. The pilasters, in three courses, are decorated with six prophets; the three pinnacles, with the Eternal in the centre, the angel, and the Virgin annunciate; the great central panel with the Coronation of the Virgin. Sixteen angels form a choir round the throne, which rests on a starred rainbow. In front, three angels wave censers; and at each side are the apostles and prophets, amongst whom are St. Benedict, St. Peter, and St. John the Baptist on the left, and St. Romuald on the right.

Lorenzo was not a master of composition. His long and slender figures are remarkable for an affected bend and an insecure tread; but his drawing is careful and minute, his general tone has the gay softness and transparence of a miniature, and his flesh tints are carefully blended. Draperies of breadth and mass close with a peculiar loop. His technical method of working is less Giottesque than his forms. The key of harmony in his altarpiece at Ceretto, as indeed in all those which he produced, is that of a miniaturist of the fifteenth century. In the small compositions of the pediment he reveals something of the religious

[1] Cluny. The date on the diptych is ANNO DOMINI MCCCCVIII.

[2] This perfectly preserved altarpiece is now at the Uffizi Gallery (No. 41). It is inscribed AVE GRATIA PLENA DOMS. TECUM. AN. D. MCCCCX. It is in tempera on gold ground.

feeling of the Sienese, especially of Traini, a peculiarity fitting
him at a later period to assist Angelico.[1]

A smaller Coronation of the Virgin, which evidently once
formed the centre of an altarpiece, is that which not long since
adorned a private church belonging to Signor Landi, near Cer-
taldo.[2] Three angels are in front of the throne.[3] The side panels
are probably those representing saints in the National Gallery
under the name of Taddeo Gaddi.[4] They have the same relation
to the central piece in possession of the Signor Landi as the
sides of the Ceretto altarpiece to its centre. Possibly the picture
before its dismemberment and the loss of its pediment and
pilasters had been in the Camaldole monastery of San Benedetto,
outside the Porta a Pinti in Florence, an edifice ruined during the
siege of 1529. Vasari states that the subject was the Coronation
of the Virgin, similar to the altarpiece of 1413, and exhibited in
his time in the Alberti chapel under the cloisters of the monastery
of the Angeli at Florence.[5] If restored to its original shape by
the junction of the centre to the wings in the National Gallery,
the altarpiece would differ in nothing from that of Ceretto, except
in being smaller and in having eight saints in each of the sides
instead of ten.

The picture of the Academy of Arts at Florence is an altarpiece
in three parts, representing the Virgin shrinking with terror in
her attitude from the visiting angel, a piece assigned by Vasari to
Giotto,[6] and praised by him because of the tremor expressed in

[1] The altarpiece of Ceretto is inscribed as follows:—

HÆC TABULA FACTA EST PRO ANIMA ZENOBII CECCHI, FRASCHE ET SUORUM IN
RECOMPENSATIONE UNIUS ALTERIUS TABULE PER EUM IN HOC . . . ($^{L.A.U.}$)RENTII
JOHANNIS ET SUORUM, MONACI HUJUS ORDINIS QUI EAM DEPINXIT ANNO DOMINI
MCCCCXIII MENSE FEBRUARII, TEMPORE DOMINI MATHEI PRIORIS HUJUS MONASTERII.

Of the three angels in front of the throne the central one is repainted. The
saints at each side of the coronation are ten in number, in all twenty. The saint's
head nearest the Virgin on the right is repainted. A choir of red seraphs surrounds
the Eternal in the pinnacle. The pediment panels are partly damaged.

* [2] It is now in the National Gallery ; but is not as yet joined to the two wings.

[3] The panel is mutilated, with a hole at the centre of the base. The Virgin's
red dress has lost its colour ; and the ashen preparation, retouched in lights, is now
to be seen. The green dress of the central angel is repainted.

[4] No. 215-16, National Gallery Catalogue ; restored.

[5] VASARI, ii., p. 211.

[6] *Ibid.*, i., p. 311. See also *antea*.

the action and features of Mary. In the side panels are St. Catherine of Alexandra, and St. Anthony and St. Paul and St. Francis.[1]

One of the finest and best-preserved altarpieces of Lorenzo Monaco is, however, the Annunciation in the Bartolini chapel at Santa Trinita of Florence, in which the angel kneels, whilst the Virgin, of a long and slender form, presses her right hand to her breast and raises her head to listen. The draperies are trailing, but fine in the round sweep of their folds. A soft expression, an air of questioning in the open mouth, are peculiar to this figure of the Virgin; whilst the character of the angel recalls that of Agnolo Gaddi at Prato, not only as regards type, but as regards outline and the swollen forms of the fingers. Lorenzo displays some religious feeling, but defective drawing. In this, and particularly in the mode of defining the eyes, he was especially influenced by Agnolo Gaddi. If his peculiar gaiety of tones and relationship in style to Spinello be considered in addition, Agnolo may well be described as the master of both. Eight saints in pilaster framings, and three prophets in the pinnacles are characteristic work of the master. The pediment scenes representing the Visitation, the Nativity, the Epiphany, and the Flight into Egypt, are most carefully executed; and the Adoration of the Magi especially combines all the artist's meditative calm with warm harmonious colour.

The church of the Trinity at Florence was one of Lorenzo Monaco's most frequent haunts. He painted several chapels in it; and not long since a fragment of his frescoes in the Bartolini chapel was rescued from oblivion by the removal of a layer of whitewash. Amongst the remnants is a composition in the upper course of the building representing the Virgin's death. The couch on which she lies is surrounded by the twelve Apostles, whilst her soul, in the form of an infant, is taken by the Redeemer to heaven.

* [1] Florence Academy, Sale dei Maestri Toscani, Sala I., No. 143, from the Badia of Florence. The figures are of half life-size.

Three pinnacles of an altarpiece (in the Florence Academy, No. 166) are by Lorenzo Monaco, and form part of a Deposition from the Cross by Angelico. In the same collection are predella pictures by Don Lorenzo, representing the Nativity (No. 145), scenes from the lives of St. Onofrio (No. 144), and St. Martin quelling a storm (No. 146).

Part of a predella in the convent of Vallombrosa, with St. Francis receiving the Stigmata, well represents Lorenzo's manner. St. Francis kneels and receives the rags from a crucified seraph. In the foreground is a fountain in a rocky landscape, on one side the sea agitated by a storm, a vessel tossed on the waves, and St. Nicholas holding the boom to which the sail is attached, and so saving the ship. Further back the same vessel approaches the shore, and a rainbow indicates the passage of the tempest. There is much energy in the form and expression of the principal figures.

Two small panels, Nos. 1,123 and 1,136, not now exhibited in the Berlin Museum, representing St. Mary Magdalen and St. Lawrence, at whose feet a cardinal kneels, and an Annunciation are correctly assigned to Lorenzo Monaco.[1]

The same may be said of an Adoration of the Magi, now belonging to the Prussian State, and lately in the Raczynski collection at Berlin.[2]

In the Lindenau or Pohl collection at Altenburg is a small but exquisite and well-preserved little picture representing the Virgin and Child on an ass led by St. Joseph, and attended by two women bearing palms. This piece, numbered thirty-one, is classed as a work of the Sienese school, but may well be by Lorenzo Monaco.

The same style is apparent in an Adoration of the infant Saviour by the Virgin and St. Joseph in front of the stable of Bethlehem, above which eleven angels appear—a capital altarpiece, in the palace of Meiningen, that recalls Angelico, but is most probably by Lorenzo Monaco.[3]

* [1] The Annunciation is now at Göttingen, in the University Gallery.

* [2] This picture is now in the Nazional Galerie, Berlin.

[3] At the Uffizi is a series of three pinnacles, formerly in San Jacopo Sopra Arno, in one of which the Saviour appears crucified, with two angels gathering the blood from the wounds of the hands, and in the two others are St. John and the Virgin in grief (dress of the latter injured). The fragments sold by the fathers of St. Michele of Pisa, and lately in the hands of Signor Toscanelli in that city, are in Lorenzo's manner, but of less talent than he usually exhibited. We shall have to note, in a sketch of the works of Taddeo Bartoli, a Virgin and Child with four saints, attributed to Lorenzo Monaco, in San Michele of Pisa.

In the corridor of the Uffizi, No. 39, may be seen an Adoration. It is a pretty picture, gay and soft in colour, and flat in general tone. The Annunciation, the prophets, and the Eternal on the frame are, however, by Cosimo Rosselli.

The company of St. Luke at Florence (near the Annunziata) also owned a work

Two pictures in the Municipal Gallery at Prato deserve attention. One represents the Virgin and Child between saints,[1] and has all the character of the master; the second is in the manner of one of his pupils, of whom we shall speak presently.

That numerous painters laboured in the Camaldole convents of Italy is evident from numerous records. The annotators of the last edition of Vasari[2] notice miniatures by a friar of the order in the choral books of Santa Croce, signed DON SIMON ORDINIS CAMALDULENSIS. Vasari mentions as a forerunner of Lorenzo Monaco[3] one Don Jacopo, who had executed numerous miniatures at Florence, Rome, and Venice, and a pupil of Lorenzo,[4] one Francesco, who in the fifteenth century painted

of Lorenzo, being the central composition of a series of three in the pediment of an altarpiece. This central scene represents the birth of the Saviour, whilst the side scenes taken from the lives of St. Cosmo and St. Damian are by Angelico.

* The editor was unable to find the picture of the Nativity. The six small pictures representing scenes from the lives of SS. Cosmo and Damian which once formed part of the predella are now in the Florence Academy (No. 243).

[1] St. Benedict, St. Catherine (left), Giovanni Gualberto and St. Agatha (right). Two angels in rear. The Annunciation in side gable; central gable gone. In the style of Lorenzo is a so-called Taddeo Gaddi at the Louvre, representing St. Lawrence, St. Agnes, and St. Margaret. [* This picture, No. 1,348, is now given to Lorenzo Monaco in the official catalogue of the Louvre. We do not regard it as a work executed by Lorenzo.] We may add the following: A picture formerly at Glentyan, in Scotland, predella assigned to Masaccio, representing a novice entering orders (thirteen figures), a small panel with the genuine character of Lorenzo. Copenhagen Museum, No. 161, a fragment representing the Annunciation, a nun in prayer, and St. Benedict [* ? St. Bernard]. This also is a work by Lorenzo. Perugia Gallery, Nos. 102, 103, 104, from the Carmine of Perugia. This is an altarpiece in three parts, representing the Virgin, Child, angels, and saints. It is wrongly attributed to Lorenzo, being by a poor Umbro-Sienese painter of the fourteenth or fifteenth century. Lorenzo, says Vasari, painted the Cappella Fioravanti in San Piero Maggiore (VASARI, ii. p. 211; and RICHA, Chiese, i. 142), the altarpiece of the chapel of the Sangaletti in San Piero Scheraggio, representing the Virgin and Child between saints (VASARI, p. 211), and the frescoes of the Ardinghelli chapel in Santa Trinità (Ibid., pp. 211, 212), frescoes in the Certosa (Ibid., p. 212), and a Crucifixion at the Romiti. All these have perished.

* In Sir Frederick Cook's collection is a beautiful little Madonna by Lorenzo Monaco. There are two remarkable drawings by him, representing the Journey of the Three Kings and the Visitation, in the Berlin Museum. In the same gallery is a small Madonna which is closely related to that in the Cook collection. Mr. Charles Loeser has a similar picture. These three Madonnas are early works. Another Madonna, dated 1404, is in the possession of Dr. Oswald Sirén, of Stockholm, a learned authority on Lorenzo's art. In the Morelli collection at Bergamo is a Dead Christ by Lorenzo Monaco.

[1] Note 1 to p. 213, ii. [3] VASARI, ii., p. 213. [4] Ibid., p. 214.

a tabernacle at the corner of Santa Maria Novella. Vestiges of the frescoes of this tabernacle remain,[1] perhaps, originally tastily coloured.[2]

One Andrea da Firenze existed at the latter period, whose style might lead to the belief that Vasari intended to speak of him when alluding to a pupil of Lorenzo Monaco. A large altarpiece, signed ANDREAS DE FLORENTIA 1437, may still be seen in a room, once a chapel, contiguous to the church of Santa Margarita of Cortona. It is a large composite work by an imitator of Masolino and Angelico.[3] The weak, slender, and mechanically executed figures with their long necks are reminiscent of Masolino. The outlines are minute and tenuous, like those of Angelico, but the draperies are curved and poor, though carefully detailed. The light, warm, and rosy colour is grey in shadow and generally flat, the dresses being in light keys of colour. The finest parts are the pediment scenes, one of which, representing the death of the Virgin, is almost a copy of the same composition by Angelico. The artist, who reminds us so much of less able portions of Masolino's work or of Masaccio's at San Clemente, was of Lorenzo Monaco's time, and may have been an assistant to Angelico. It is very likely, indeed, that many feeble pictures assigned to the latter are by this Andrea.[4]

The Conversion of Constantine, in which the Emperor kneels at the feet of St. Sylvester between St. Peter, St. Paul, and two angels, a picture in the Casa Ramelli at Fabriano, is inscribed CONVERSIO CON-

[1] The Virgin and Child is still represented by the head of the former, and at the sides a figure of St. John the Baptist may be distinguished.

[2] Two panels, with numerous angels, much restored, in this manner, were once in the Ugo Baldi collection at Florence. In Pisa, Signor Toscanelli once possessed a picture signed by Francesco and dated 1417, representing four saints, showing a decline from the style of Don Lorenzo Monaco. By Francesco, because of the certainty arising from the foregoing, are doubtless inferior panels in the manner of Don Lorenzo. We may thus assign to him a Virgin and Child between saints, with legendary scenes in the predella, originally in San Girolamo outside Gubbio.

[3] In the centre the Virgin, in an elliptical glory, is taken to Paradise by six angels, St. Thomas kneeling beneath receives the Virgin's girdle, and St. Francis and St. Catherine pray at his sides. In the upper ornament the Annunciation and Moses and Daniel are represented. The pilasters in four courses contain (left) St. Anthony the Abbot, St. Benedict, St. Fabian, and St. Peter (right), St. Sebastian, St. Nicolas, St. Jerome, and St. Paul. Peter and Paul are in the uppermost division at each side. On the pediment, immediately beneath the pilasters, are two kneeling females, probably the donors; and three scenes representing the death of the Virgin (centre), the martyrdom of St. Catherine (left), and St. Francis receiving the Stigmata (right).

[4] The whole of this altarpiece is preserved in its original frame, with an overhanging entablature.

STANTINI. HOC OPUS FECIT ANDREAS DE FLORENTIA, and is by the author
of the altarpiece of Cortona. The conversion is, however, comparatively
rude in execution.[1]

A small picture of the same class, by a Camaldole friar, may complete
this series. It is in the choir of the church of the Camaldole convent,
two miles from Naples, and is inscribed: PETRUS DOMINICI DE MONTE-
PULCIANO PINXIT MCCCCXX. Here the Virgin sits on a piece of gold
brocade, with the infant Saviour on her lap, and throws back with one
hand the veil from his shoulder.[2] Four angels playing music at the
sides, two above, suspend a crown over the Virgin's head. The work is
that of a miniaturist. It has something in colour approaching to that
of Lorenzo Monaco, the tone being rosy, flat, light, and greatly fused.
The slender figures are beneath even those of Lorenzo, the draperies
circular in fold, like some in the Sienese school. The finish is beyond
description minute, and reveals great patience in the artist. The form
of the Infant is by no means pleasing. This Petrus was a monk at
Naples, but a Tuscan by birth, Montepulciano being at no great distance
from Siena.

[1] In the Municipal Gallery at Prato is a picture already referred to, represent-
ing the Virgin and Child enthroned between saints, and subordinate episodes in
pinnacles, pilasters, and predella, which has the character of Andrea's altarpiece
at Cortona. At Florence, in an upper cloister of the Badìa, are scenes of the life
of St. Benedict in the style of Andrea. The same manner is displayed in the pictures
of the Campana collection, subsequently in the Louvre, in Paris, which were falsely
assigned to Angelico.

[2] Her blue mantle is adorned with angels' heads.

INDEXES

II.—X

INDEX OF PLACES

[1] It may be remarked here that it is a peculiarity of Florentine nomenclature that "S. Trinita" of Florence has no accent.

INDEX OF PERSONS

PLYMOUTH
WILLIAM BRENDON AND SON
PRINTERS